A RENAISSANCE TREASURY

The Flagg Collection of European Decorative Arts and Sculpture

A Collection of the Milwaukee Art Museum

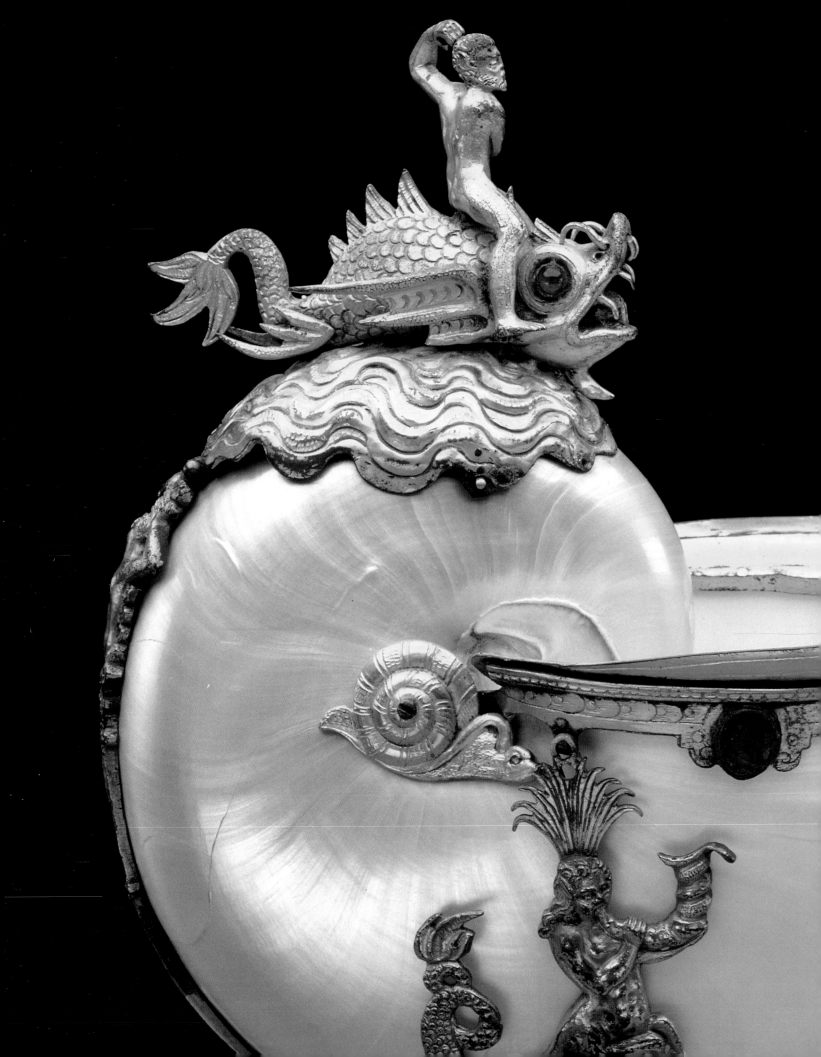

A Renaissance Treasury

The Flagg Collection of European Decorative Arts and Sculpture

Laurie Winters

in collaboration with
Joseph R. Bliss

essays by
Charles Avery
Russell Bowman

entries by
Joseph R. Bliss
Jody Clowes
Elizabeth Ourusoff de Fernandez-Gimenez
Annemarie Sawkins
Jennifer Van Schmus
W. David Todd
Barry Wind
Laurie Winters

Hudson Hills Press, New York
in association with Milwaukee Art Museum

This publication is issued in conjunction with the exhibition "A Renaissance Treasury: The Flagg Collection of European Decorative Arts and Sculpture," held at the Montgomery Museum of Fine Arts, Montgomery, Alabama, April 17–June 14, 1998; The Dayton Art Institute, Dayton, Ohio, August 1–November 1, 1998; Smith College Museum of Art, Northampton, Massachusetts, December 11, 1998–March 14, 1999; Honolulu Academy of Arts, Honolulu, Hawaii, April 29-June 20, 1999; Memphis Brooks Museum of Art, Memphis, Tennessee, July 11–September 12, 1999; Iris & B. Gerald Cantor Center for Visual Arts at Stanford University, Stanford, California, October 12, 1999–January 2, 2000.

First Edition

Published in the United States by Hudson Hills Press, Inc., 5th Floor, 122 East 25th Street, New York, NY 10010.
Editor and Publisher: Paul Anbinder

Distributed in the United States, its territories and possessions, and Canada by National Book Network.
Distributed in the United Kingdom, Eire, and Europe by Art Books International Ltd.

ISBN: 1-55595-174-0

Library of Congress Catalog Card Number: 98-75247

Edited by Terry Ann R. Neff, t. a. neff associates, inc.,Tucson, Arizona
Design and production by Michael Dooley, Milwaukee Art Museum

European maps: Reprinted from *European Glass in the J. Paul Getty Museum* © 1997 The J. Paul Getty Museum.
Maps designed by Susan Kujawa and the DLF Group.

CONTENTS

PREFACE

It is with great pride and deep gratitude to Richard and Erna Flagg and their family that the Milwaukee Art Museum presents *A Renaissance Treasury: The Flagg Collection of European Decorative Arts and Sculpture*. This carefully researched and richly illustrated book celebrates the passion, commitment, and generosity of these major art patrons. The bulk of the Flaggs' exceptional gift of almost one hundred works of medieval and Renaissance decorative arts and sculpture came to the museum in 1991 and was installed in two galleries devoted to earlier European art and dedicated in their honor. Their daughter, Gabriele Flagg Pfeiffer, has also made numerous gifts, continuing the tradition of her parents' generous support. Without the Flagg collection, the museum would not be able to represent to its public the phenomenal artistry of late medieval and Renaissance craftsmen. Richard and Erna Flagg have truly broadened and transformed the Milwaukee Art Museum with this gift of national and international import.

This catalogue of the Flaggs' European collection represents the continuation of a series of scholarly catalogues that the museum has produced in recent years; other examples include *American Furniture with Related Decorative Arts, 1660-1830: The Milwaukee Art Museum and the Layton Art Collection* (1991); *Common Ground/Uncommon Vision: The Michael and Julie Hall Collection of American Folk Art* (1993); and *Landfall Press: Twenty-five Years of Printmaking* (1996). These publications reflect the goal of providing in-depth studies of those collections that distinguish the Milwaukee Art Museum among American institutions. The second major collection that Richard and Erna Flagg gave to the museum, eighty-nine works of Haitian and folk art, will be the subject of an upcoming catalogue in this series.

A Renaissance Treasury could not have been realized without the untiring dedication of Associate Curator of Earlier Art Laurie Winters. She not only developed the concept of the tour of the Flagg collection, which this publication accompanies, but she also built upon the earlier efforts of consultant Joseph R. Bliss and former Research Assistant Elizabeth Ourusoff de Fernandez-Gimenez to shape a serious and fine book with a number of contributing scholars, a clear format, and an elegant design. In addition to her own insightful entries and introduction, her hand is evident everywhere in this publication.

Finally, I would like to dedicate this book to the memory of Richard Flagg. Few individuals have had a deeper passion for art and a wider range of interests–from Renaissance Europe to modern-day Haiti and beyond–and few have had so profound a commitment to bringing art to a broader public. Richard Flagg frequently spoke about creating a gallery in which younger visitors would find delight. With the support of his wife, Erna, and his daughter, Gabriele, his vision has been expanded and realized at the Milwaukee Art Museum. Now all of us–children and adults alike–are able to share his joy in art and in his collection.

Russell Bowman
Director

ACKNOWLEDGMENTS

The seed for this collection catalogue was sown more than seven years go when Richard and Erna Flagg formally donated a large part of their collection of European decorative arts to the Milwaukee Art Museum. At that time Joseph R. Bliss was hired as a project consultant to produce a catalogue of the collection. Well launched though the catalogue now was, the project soon faced a number of obstacles, not the least of which was the death of Richard Flagg in 1994. Shortly after my arrival at the Milwaukee Art Museum in 1997, I realized that the extraordinary caliber of this collection not only warranted but demanded that the catalogue be completed. To facilitate that end, I proposed that part of the collection circulate in a national exhibition during a period of construction and gallery closures at the museum. Although this proposal served to present an entirely new set of seemingly insurmountable obstacles, Director Russell Bowman's perspicacity helped to make the impossible possible. His unwavering and wholehearted commitment to the entire project has been much appreciated. I am also deeply indebted to Erna Flagg and Gabriele Flagg Pfeiffer for their continuing support and patience throughout the many delays of this publication.

A catalogue of this scale, particularly given the diversity of the objects, is a large effort, one that has called upon the expertise and knowledge of many people here at the Milwaukee Art Museum and elsewhere. I would like to thank first of all Charles Avery and Russell Bowman for essays that give dimension to the Flaggs both as collectors and exceptional individuals. I also give special thanks to the numerous authors who contributed entries to the catalogue; without their dedication the project would never have been realized. First and foremost is Joseph R. Bliss, who initiated the research for the catalogue and graciously collaborated when work on the project resumed. His

conscientious research conducted throughout the catalogue's maturation has helped to make it a work of genuininely solid scholarship. His participation is acknowledged on the title page of this catalogue, but I wish to take the opportunity here to thank him for his extraordinary commitment to the project. Former Research Assistant Elizabeth Ourusoff de Fernandez-Gimenez also deserves special mention, not only for her entries but for her research on the entire collection during the initial period of the catalogue's preparation.

Special thanks also go to David Todd, in the Departmart of Horology, The National Museum of American History, for his superb entries on the clocks, which make even the most technical aspects of clocks and clock-making accessible to the average reader. His good humor in the face of difficult time constraints was appreciated. Acknowledgments must also be extended to Jody Clowes, associate curator of decorative arts; Annemarie Sawkins, research assistant, and Jennifer Van Schmus, curatorial assistant, the Milwaukee Art Museum; and Barry Wind, professor of art history, the University of Wisconsin-Milwaukee. Their generous spirit of collaboration helped refine the quality of this book in ways too numerous to recount.

On behalf of the catalogue's authors, I would like to thank the many scholars and specialists who contributed to this publication with their opinions and expertise in various fields. I am especially grateful to Françoise Baron, Gerhard Bayer, Silvio A. Bedini, Anthony Blumka, Robert H. Brill, Barbara Butts, Susanna Bede Caroselli, Alan Chong, Paul Connor, Sylvia E. Crane, Spencer Crew, Craig Deller, James David Draper, Richard Edgcumbe, Philip M. Fenn, Steven Fliegel, Ilene H. Forsyth, William H. Forsyth, Mark Frankel, Helen Frink, Jean-René Gaborit, Marie-Madeleine Gauthier, Jane Glaubinger, Mina Gregori,

Yvonne Hackenbroch, Ben Hanson, David Harvey, Comte Othenin d'Haussonville, the late John F. Hayward, Joan Holladay, Ian Irving, Bjarne Jørnaes, Walter Karcheski, Jr., Jill Kunsmann, Donald R. Laing, Myron Laskin, Jr., Edward R. Lubin, Alison Luchs, Robert E. McVaugh, Patricia Marquardt, Richard Nelson, Anthony North, Véronique Notin, Jutta-Annette Page, the late John Pope-Hennessy, Keith Raddatz, the late Richard H. Randall, Ernst-Ludwig Richter, Alexandre P. Rosenberg, Pierre Rosenberg, Sheila Schmitz-Lammers, Timothy Schroder, Lorenz Seelig, Linda Seidel, Manya Sheehan, Carlene E. Stephens, Christian Theuerkauff, the late Howard Wilbur Thompson, Kevin Tierney, Mark Wilchusky, and Paul Williamson. I thank also Ann B. Abid and her staff at the The Cleveland Museum of Art Library and the staff of The Ryerson Library at The Art Institute of Chicago for their unstinting assistance to the authors of this catalogue. I am also extremely grateful to Nancy Greenway, who placed at our disposal research materials for a biography of the Flaggs currently in preparation.

At the Milwaukee Art Museum, an army of staff members and assistants worked tirelessly behind the scenes to help bring the exhibition and the catalogue to fruition. I am particularly grateful to James de Young, senior conservator, and Therese White, objects conservation technician, and the entire conservation team for their meticulous preparation and care of the objects in spite of what could only be described as a daunting exhibition and publication schedule. I am also indebted to Elizabeth Schmoeger, librarian, who somehow managed to meet every request with diligence and an unassailable patience. For her energy and enthusiasm, I also thank Kerri Leo who took charge of the bibliography and countless other details that ultimately made this book possible. Among the many others who provided assistance are Leigh Albritton, Dawnmarie Frank, Sue Kujawa, Laura Ramos, Jean Rasmussen, Dean Sobel, and Gundega Spons.

Finally, it has been a pleasure collaborating on the design of the catalogue with Michael Dooley, director of design and publications. His sensitivity and clear-sightedness have benefited the book at every turn. I want also to acknowledge Paul Anbinder of Hudson Hills Press, who recognized the true value of the Flagg collection and enthusiastically agreed to copublish this book with the Milwaukee Art Museum. My greatest debt of thanks, however, is in many ways to Terry Ann R. Neff of t. a. neff associates, who shepherded the manuscript to completion with the assurance of a seasoned but benevolent general. She not only immeasurably improved the text, but her support, encouragement, and wit often spurred me on when the details of the book seemed at times overwhelming. What I owe to everyone who has been involved in this project is far greater than I can adequately express in these acknowledgments.

Laurie Winters
Associate Curator of Earlier Art

NOTE TO THE READER

A *Renaissance Treasury* consists of two essays and a series of entries on seventy-seven pieces of European decorative arts and sculpture in the Richard and Erna Flagg collection that were made between 1450 and 1900. Maps of Western and Central Europe are located near the front of the publication. A list of additional works in the Flagg collection, a glossary of technical terms, an extensive bibliography, and an index are grouped at the back.

The objects discussed are arranged in six chapters according to the function of the pieces; within these sections they are organized by chronology. This arrangement has been varied when it seemed beneficial to group works of a similar type, medium, or function. The following conventions have been used in the attributions. A description of a work as "by" an artist indicates the existence of evidence in the form of a signature, a document, or a relationship to securely documented works that is sufficiently compelling to justify a firm ascription. In some cases this may be qualified by "probably" or "possibly," registering increasing degrees of doubt. "Workshop of" indicates that the object was produced in a particular artist's shop, although not necessarily with the intervention of that artist. The use of the term "after" indicates that the object was based on a work by the artist specified, but produced at a later date and often in a different medium. When the artist and workshop are unknown, the object is identified as fully as possible by the location of its production and approximate date. Dimensions are given in both inches and centimeters; height precedes width and depth. Diameter and other dimensions are given as appropriate.

The text of each entry begins with a description of the physical characteristics of the piece, followed by sections on its condition and marks and inscriptions when the latter are present. Information on the object's provenance, exhibition history, and previous literature are provided when known. Commentaries on the objects vary in focus from entry to entry, though all address issues related to the object's production and larger social function. The common thread throughout these often seemingly disparate entries is an emphasis on how these works, secular and religious, were used and meaningful in daily life. Sources are cited throughout in an abbreviated author-date form; full citations are given in the Bibliography. The authors of the catalogue entries are identified by initials at the end of each entry: Joseph R. Bliss (JRB); Jody Clowes (JC); Elizabeth Ourusoff de Fernandez-Gimenez (EFG); Annemarie Sawkins (AS); Jennifer Van Schmus (JVS); W. David Todd (WDT); Barry Wind (BW); Laurie Winters (LW).

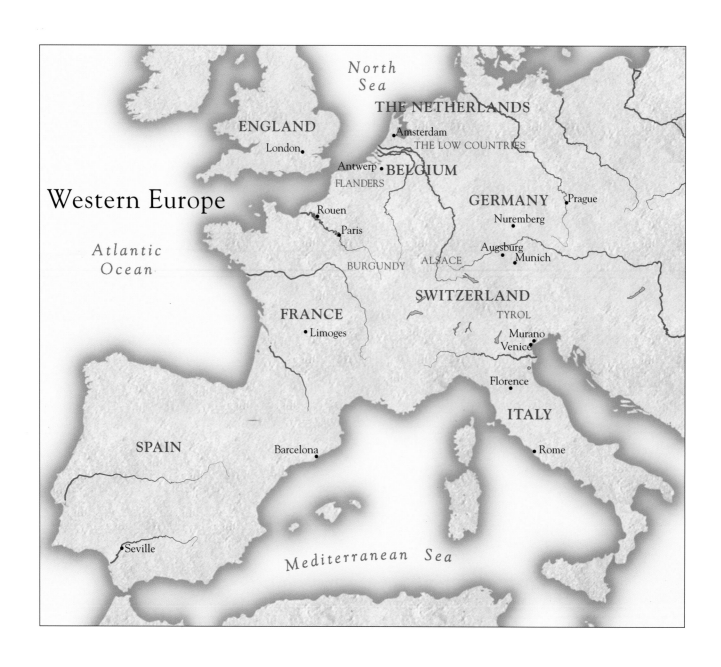

Western Europe

INTRODUCTION

Laurie Winters

Over six decades Richard and Erna Flagg assembled one of the foremost collections of earlier European decorative arts in North America. This publication honors and documents their extraordinary gift and loan of over one hundred Renaissance and Baroque artworks to the Milwaukee Art Museum in 1991. The majority of the works are decorative arts objects, but there are also a number of sculptures, some larger pieces of furniture, and a few paintings. Although astonishingly varied in style and country of origin, these diverse works are united in their emphasis on fine virtuoso displays of craftsmanship, technical innovation, and intricate artistry. As the title of this book is intended to suggest, the preciousness of the materials and the splendid displays of skill associated with the Flagg collection evoke the same sumptuousness and mastery found in the princely collections of the Renaissance known as "cabinets of curiosities" (*Raritätenkabinetten*) and "art and curiosity chambers" (*Kunst- und Wunderkammern*). The rarity and historic significance of the objects place the Flagg gift among the most important donations of European decorative arts to a museum in North America.

The German-born Flaggs shared at a very early age an inspired vision to build a collection of decorative arts. The youthful pleasures of their early married life in Germany, however, were dramatically cut short by the outbreak of the Second World War. The escalating dangers associated with Richard's Jewish ancestry ultimately forced the Flaggs, then in their early thirties, to flee to the United States, where they eventually settled in Milwaukee, a city that offered them the familiarity of a German heritage and the opportunity to rebuild the family tanning business that had thrived in Europe. Many of the treasures they had amassed in Germany became casualties of the war. Possessed of a gregarious and determined spirit, however, the Flaggs quickly triumphed over the financial struggles they found in their new home and gradually resumed their collecting activities. In the three decades following the war, they furnished their Milwaukee home and a New York apartment with a dazzling array of clocks and an abundance of domestic and liturgical artworks. Their Milwaukee residence, in particular, filled with their treasures, became a welcoming place where new-found friends, collectors, museum professionals, and scholars would gather in the gracious and sophisticated company of the Flaggs.

At a time when most private collectors in America fashionably pursued English silver and porcelain, the Flaggs were unusual in their acquisition of decorative arts from the European continent. They also, unlike many of their contemporaries who focused on a narrow area of specialization in the hope of attaining a complete mastery, selected a broad range of objects that were desirable for their excellence or difficulty in workmanship. The guiding principle in their acquisitions was always the individual object's demonstration of artistry and technical achievement. They responded to works that were capable of sparking wonderment or awe in the viewer. Among the best examples of their extraordinary taste are a number of German Renaissance clocks, which were especially prized by Richard for their combined feats of mechanization and surface embellishment. Perhaps not coincidentally, the Flaggs' first acquisition was a clock, and by the early 1960s, clocks and timepieces constituted the nucleus of their collection. In later years the Flaggs were widely recognized for possessing one of the largest collections of South German clocks outside of Europe. The exceptional breadth of their collection also encompasses numerous examples of intricately tooled metalwork; glasswares with gilded and enameled ornamentation; table cabinets with exquisite inlays of ivory and precious stones; delicately carved and

polychromed wood sculptures and house altars; larger furniture with complex intarsia inlays and carved moldings; and even a few Renaissance panel paintings. In today's art market, even with unlimited funds, it would be impossible to duplicate a group of objects comparable to those that the Flaggs spent a lifetime collecting.

Thanks to the Flaggs' generous gift, the Milwaukee Art Museum is able to make available to the public a wealth of valuable objects not easily seen in American collections. Throughout their lifetime the Flaggs were increasingly courted for donations by major American museums, but they firmly believed that the rich diversity and educational value of their collection would best be served by the Milwaukee Art Museum. In keeping with the spirit of their donation, this publication aspires not only to document their collection with the scholarly interpretation that the objects merit, but to place them within the social and cultural context of their time. Of the one hundred and twelve artworks documented in this book, seventy-seven pieces are featured with photography and extended entries that not only describe their formal significance, but provide commentaries on their larger social or religious significance during the Renaissance and Baroque periods. It is hoped that the research that has shaped this publication will be both useful to scholars of the decorative arts and of general interest to the casual reader.

As with any project of this scale and diversity, a number of scholars and experts in various fields have been called upon to contribute to this publication. The research and collaboration among these many scholars has resulted in a number of remarkable discoveries. As with any collection, there are always a few disappointments when objects are proven to be of a later date or by a lesser artist, and the Flagg collection is no different. However, there have also been a number of major discoveries. Numerous unnoticed or previously unidentified maker's marks have now been established for the first time and provenances successfully traced to some of the most important European collections of the nineteenth century. Several of the clockmakers have also been identified for the first time, and Ludwig Hyrschöttel's magnificent *Table Clock with Astronomical and Calendar Dials* has been convincingly put forth as the clockmaker's "masterpiece," or examination piece for admission into the Augsburg clockmakers' guild in 1658 (see entry 10). One of the most remarkable

discoveries, however, has concerned the glass *Nef Ewer* (see entry 27). Long dismissed as a nineteenth-century copy or at best an example of seventeenth-century *façon de Venise*, the *Nef Ewer* is here proposed as an extraordinarily rare example of sixteenth-century Venetian glassmaking, perhaps one of only three examples in the world.

Our task as historians and curators throughout this book has been to reconstruct the origins and contexts of these works, and to bring these important new discoveries to the attention of a wider public. It is with the hope of furthering that process that we offer this publication of the Flagg collection.

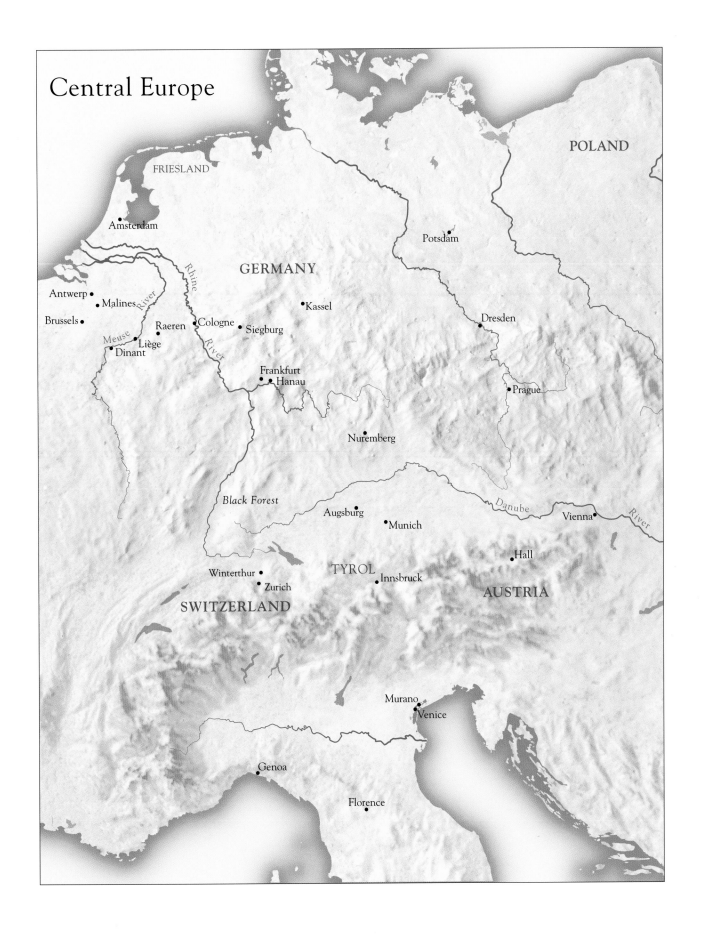

Central Europe

POLAND

FRIESLAND

Amsterdam

Potsdam

GERMANY

Antwerp
Malines
Kassel
Dresden

Brussels
Raeren
Cologne
Siegburg

Liège
Dinant

Frankfurt
Hanau

Prague

Rhine River
Meuse River

Nuremberg

Black Forest

Danube

Augsburg
Munich
Vienna
River

Hall

Winterthur
TYROL
Innsbruck

Zurich
AUSTRIA

SWITZERLAND

Murano
Venice

Genoa

Florence

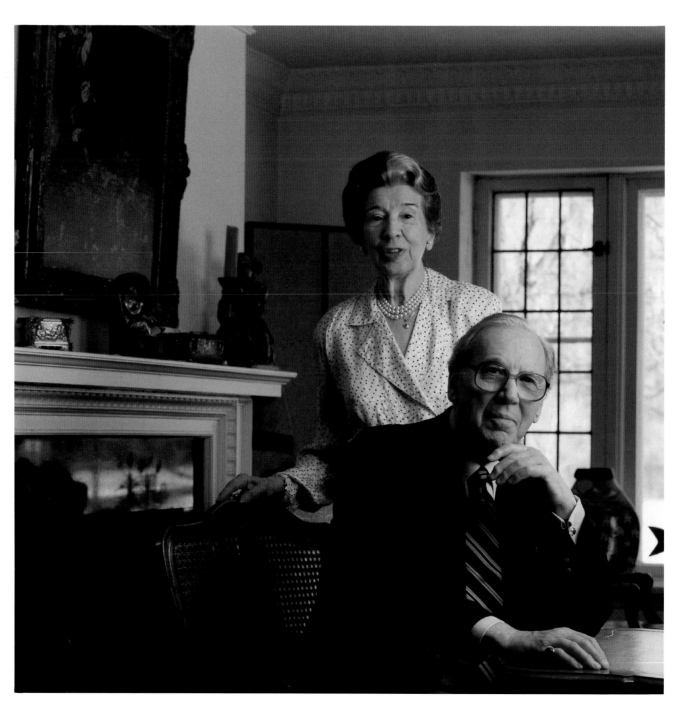

Richard and Erna Flagg in their home, 1992.

A PASSION FOR COLLECTING: RICHARD AND ERNA FLAGG

Russell Bowman

One cannot enter a great museum in this country without becoming aware of the collectors whose vision and generosity gave it shape. The Milwaukee Art Museum is no different; it would not have assumed its present character without the founding benefaction of Frederick Layton, the magnificent gift of Mrs. Harry Lynde Bradley, and the generosity of so many others. To the line of great collector/donors who have established the quality and character of the Milwaukee Art Museum must be added the names of Richard and Erna Flagg.

In fact, their commitment to and support of the arts over the years earned the Flaggs a position central not only to the museum, but to the entire Milwaukee community. The Flaggs–and they always acted in unison as a couple–began their gifts to the museum in the late 1960s. Richard served as a member of the Board of Trustees from 1977 to 1983 and 1987 to 1994, and Erna from 1983 to 1986. While their "first" collection, of European decorative arts, grew out of their own heritage and experience, they formed their "second" collection, of Haitian and folk art, essentially for the museum, placing it on extended loan and public view with the opening of the museum's major addition in 1975. In 1979, when the museum reinstalled its European galleries, the long-term loan of a significant portion of the Flaggs' collection of medieval and Renaissance decorative arts and sculpture formed the centerpiece, a treasury, within those galleries. Both the "treasury" and the Haitian collection now form exceptional "collections within the collection" of the museum and constitute a unique, specialized offering to the Milwaukee community and beyond. Neither collection could be duplicated today, because the objects simply are not available. Thus the Flagg collections have few parallels, certainly none in Milwaukee, despite its Germanic

heritage, and only a limited number in North America.

Both their "first" and "second" collections define the Flaggs' particular attributes as collectors. Their openness to aesthetic experience allowed them to move from the traditional, largely European, connoisseurship-based world of late medieval, Renaissance, and early Baroque objects to the relatively unstudied and open area of Haitian naive art. Yet they approached both collections with the same emotional need for objects that spoke to them. Indeed, Richard Flagg often spoke of works that "sang" to him, suggesting that his response began, like a response to music, with an emotional rather than an intellectual chord. While the expressive aspects of the Haitian collection are perhaps more obvious, the same emotive response seems the key to the Flaggs' initial impulse to collect decorative arts objects and sculpture. The Flaggs most likely were drawn to these objects both for their strong emanations of their own European cultural roots and for their suggestions of technical and material innovations that would have appealed to the industrialist in Richard Flagg. The religious and mythological subject matter and emphasis on craftsmanship would have spoken to the Flaggs' sense of tradition, and the exploration of technology and materials would have engaged their equally strong pull toward modernity.

Both Richard and Erna Flagg were born in 1906 and raised in Frankfurt, Germany. They belonged to upper middle-class families who, despite the dislocations of World War I and the ruinous inflation that followed, lived comfortable, affluent lives. Richard was the son of a self-made man whose tanning factory just outside of Frankfurt was one of the leading businesses of its kind. The fact that his father was Jewish was of little account in a household oriented to the secular world. Erna Flagg's father, Bernhard Zubrod, was an architect and interior designer highly

regarded for his taste and erudition; both Erna and Richard Flagg remembered fondly his lessons in connoisseurship. Richard attended Frankfurt's leading gymnasium (secondary school), and Erna went to private schools in Switzerland and England. The two met at a neighborhood dancing class when both were seventeen; they became almost daily companions, their interaction extending to both their families.

Richard Flagg had always been a collector, first of butterflies, then stamps and Greek and Roman coins. As a young apprentice in his father's tanning business, he did the banking and collected *Notgeld*, the elaborately designed emergency money unique to each village in Germany during the French occupation following World War I. According to his recollections, Richard Flagg's first purchase was a clock, acquired at auction shortly after he met Erna. As the couple left the auction, they were approached by a gentleman who told them that the beautiful clock was a reproduction of a well-known example in the Kunsthistorisches Museum in Vienna. Learning from this first experience, Richard and Erna spent a good deal of time learning about the intricacies of clocks as both technical and aesthetic objects. Interestingly, at the age of twenty-one, Richard asked to take a year off from his father's company to study art and voice in Vienna. Returning to Frankfurt and the family business, Richard set aside his artistic ambitions but not his collecting interests.

Richard and Erna Flagg were married in 1932. Though marriages between Jews and Protestants were prohibited in both religions, Richard Flagg touchingly recalled that following a civil ceremony, his father performed a celebration in their home with elements incorporated from both traditions. In setting up their household, the young couple pursued their collecting, mostly of clocks and some decorative items. Their relatively limited means as young marrieds and the arrival in 1934 of their daughter, Gabriele, necessarily delayed their collecting—but not nearly so much as the global events of coming years.

In 1933 Richard Flagg lost both his parents and began to share the management of the family business with his older brother, Kenneth. By 1939, due to the deteriorating political situation, his brother and his family had already immigrated to America and, though he resisted, Richard Flagg realized that he, too, had to sell the business and leave the country. In the fall of that year, as the invasion of Poland initiated World War II, the Flaggs managed to leave Germany for Holland just before the borders closed. In Holland, Richard Flagg began again, establishing a partnership with a Dutch tanning firm. With the Nazi invasion of Holland in 1940, the Flaggs fled the destruction of their new homeland, only to be detained at the Belgian border as German nationals. Richard Flagg's passport also identified him as Jewish. His memories of his internments, which he revealed only toward the end of his life, were clearly almost too painful to recall. His accounts record the separation from his wife and daughter in an Antwerp prison, his concern over their whereabouts and safety, and his own struggle for survival in situations and conditions he could never have imagined. After a week of incarceration in Antwerp, the Flagg family, still separated, were evacuated from the prison along with convicts and the other refugees, following an attack by the Nazis. The inmates were herded into railroad cars and shipped to France. Finally, during a flood at the infamous prison camp Camp-de-Gurs, Richard Flagg escaped and subsequently reunited with his wife and daughter. They fled from the south of France to Casablanca, where they spent an excruciating six months waiting for visas to sail to America. Richard Flagg believed that what helped him most to get through his incarceration was his ability to draw.

Arriving first in New York, Richard Flagg traveled to Milwaukee, in early 1942 a well-established center for the tanning industry. Perhaps based on the existing tanning facilities, the strong German heritage of the city, or, as he often recalled, because of its beauty and friendliness, Richard Flagg determined to relocate in Milwaukee. One of the key attributes that drew him to Milwaukee was its sense of quality, of pride in workmanship and performance. For Richard Flagg, the importance of quality had its roots in both his education and business experience; it was this sensibility that guided his collecting in his adopted country.

A number of years passed before the Flaggs could again pursue their commitment to collecting. They learned that a crate of objects from their home in Germany, which had been stored in the garage of acquaintances in Holland, had survived the war years only to be destroyed subsequently in an ordinary house fire. On a trip to Europe in 1950, Richard Flagg viewed the remains of the crate and found only molten metal. That same year he saw some Renaissance clocks in the window of an antique shop in

New York. It was still some years before he could begin purchasing, but the knowledgeable Viennese dealer, who had been able to bring much of his inventory to America, reignited Richard Flagg's collecting interest.

By the mid-to-late-1950s, Richard and Erna Flagg were making relatively frequent trips both to New York and to Europe, often associated with business, which allowed them to search out antique clocks and other objects. In 1958 they were able to purchase a number of works from the well-known Fränkel collection (coincidentally also from Frankfurt) through a Swiss dealer. The Flaggs also formed close relationships with New York dealers Edward R. Lubin, Rosenberg & Stiebel, French & Company, and especially with Leopold and Ruth Blumka. By the early 1960s the Flaggs had an apartment in New York and visited regularly with dealers, friends, and colleagues in the fields of medieval and Renaissance art collecting. In 1968 several of their works were included in the important exhibition "Medieval Art from Private Collections" held at The Cloisters of The Metropolitan Museum of Art, New York.

A survey of the Flaggs' European collection in the Milwaukee Art Museum, including both the major 1991 gift and donations over the years, reveals a number of interesting factors. While there are some significant paintings, the group is composed primarily of decorative art objects and sculpture. This type of collecting seems to partake of certain turn-of-the-century models—one thinks of J. Pierpont Morgan or Henry Walters on a larger scale—and it is undoubtedly the type of collecting that existed as a model in Frankfurt in the early part of the century, likely reinforced by the professional practice of Erna Flagg's architect father. Also, such objects, particularly the clocks and other mechanized or articulated pieces, probably appealed to Richard Flagg's artisan and technical interests. He described his inability as a child to keep his hands off objects in shops, his keen curiosity to know their materials or how they worked. One can imagine this desire still animating his adult collecting interests, for he always wished to handle his objects, to know them physically. While his interest in clocks was never solely scientific—he appreciated them primarily as aesthetic objects—their technical aspects were still something that intrigued him, that piqued his curiosity.

Above all, Richard Flagg valued quality workmanship. In his professional life, he frequently took quality as his byword, knowing that as a smaller producer of leathers, it was through exceptional quality that he could compete. Furthermore, their traditional European educations gave the Flaggs the knowledge to understand and appreciate the historical, mythological, and religious references in so many of the works in the collection. In fact, it is hard to resist speculating upon whether the collection to some degree reflected and fulfilled a world that they had been forced to leave behind. Moreover, the origin of a good deal of the work is German. It may seem a cliché to suggest that the Flaggs' collection of medieval, Renaissance, and early Baroque objects and sculpture constituted an attempt to re-create the "Old World" in their new home in Milwaukee, but such a conclusion perhaps carries an element of truth.

Richard and Erna Flagg ultimately took a somewhat romantic view of their collection. In a 1978 speech, Richard Flagg offered an insight into his own motivation as a collector: "Collecting is like hunger that wants to satisfy your heart and soul and feast your eyes. It is an appreciation of what the Good Lord has created and what his children have and still are creating. In fact, collecting itself is a very creative activity. You are creating an entity which did not exist before. Collecting, in itself, however, would be unfulfilling unless one can share that joy with others."

The Flaggs' deep appreciation and understanding of works of art did not stop with how and why one should collect. Rather, they saw collecting as a way to share their knowledge and their pleasure with a broader community. In making the gift of both the Renaissance and Haitian collections to the museum in 1991, Richard Flagg wrote: "In my experience [collecting] is a matter of such strong love that you hardly know how to resist it. This act, then, combined with a true love that we have for this city, that we have for this country, and that we have for our friends, is the great satisfaction for us to be able to do what we have done." One can imagine no clearer statement of the determination to share one's passion with the community. Richard and Erna Flagg, through their generous gifts, are models of both connoisseurship and leadership, in Milwaukee and beyond, for generations to come.

Author's note: I would like to thank Nancy Greenway for sharing with me her research for an upcoming biography of Richard and Erna Flagg.

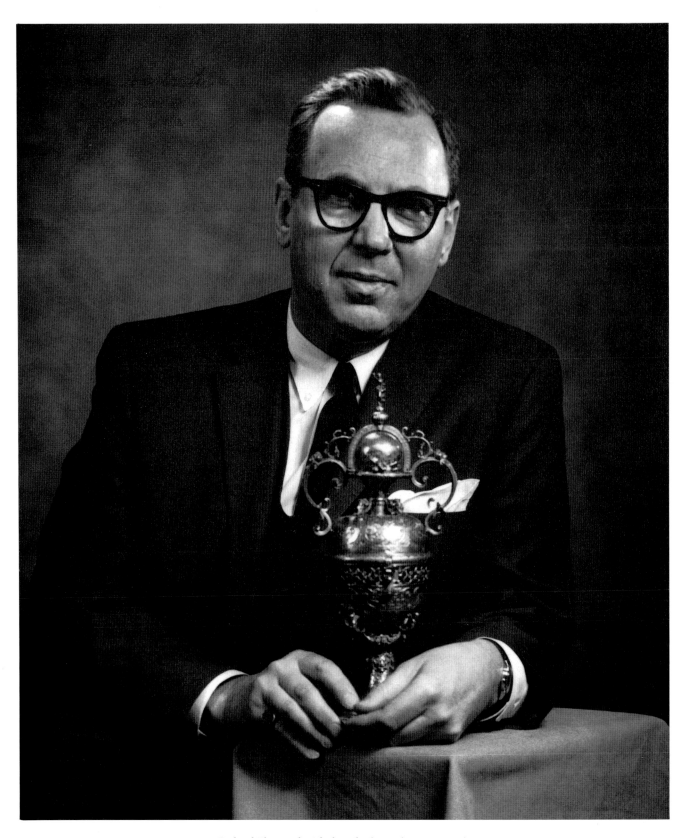

Richard Flagg with a clock in the form of a vase, 1965.

AMERICAN COLLECTORS OF EARLY EUROPEAN DECORATIVE ARTS

Charles Avery

The history of collecting medieval and Renaissance artifacts in America has ranged from the acquisition of whole buildings, or at least chapels, cloisters, and paneled rooms, to miniatures such as ivory mirror-cases, Limoges *champlevé* or "painted" enamels, rock-crystals, and goldsmiths' and jewelers' work. It has been brilliantly expounded by previous writers in their introductions to catalogues of important holdings similar to those of Richard and Erna Flagg.[1]

In amassing works of decorative art, the two world-famous, archetypal American collector-heroes are John Pierpont Morgan, who specialized in "collecting collections" for the sake of simplicity and speed (rather as the J. Paul Getty Museum does today, whenever possible), perhaps also in order to benefit shrewdly from the reduced global price that this could achieve; and Henry Walters of Baltimore, who preferred to make "carefully considered individual purchases." The phenomenon of American collecting per se– especially of medieval works of art–and how it grew out of the fashion for historical revival architecture has also been well discussed.[2] In the case of the Flagg collection, however, the profile tends towards the Northern Renaissance and early Baroque fields, with which the previous authors were not concerned, but here too, the great collectors of the turn of the century made various purchases, according to the availability of such material.

A fascination with antique clocks, early scientific instruments and strongboxes, locks and keys, armor and weaponry, seems to be the starting point for many a collector. Traditionally the bread-winners or the main inheritors of wealth and possessions, men seem to be ineluctably drawn to these hard-edged items, fashioned with painstaking precision out of durable metals–iron, steel, or brass–and enhanced with engraved ornaments and gilding. Certainly two or three of the greatest postwar American collectors of medieval and Renaissance art have admitted to an initial fascination with timepieces and their elaborate clockworks.

Peter Guggenheim, late of New York, who began with clocks and still preserves a great collection of them, has created alongside it and jointly with his friend John Abbott an important and still growing collection of Renaissance and Baroque bronze statuettes, aided by the January 1996 sale of the late Ruth Blumka's antiquarian stock and private collection. Their remarkable collection of bronzes was exhibited in the Fine Arts Museums of San Francisco in 1988; the catalogue is a major work of reference.

A similar pattern holds true for Chicago manufacturer Thomas F. Flannery, Jr. (1926-1980). Flannery began his collection of medieval art with clocks, as related in the preface to the signal sale of his collection.[3] He was also intrigued with the practicalities of the craft involved in producing the masterpieces he collected–an interest in the technical side of the art that was shared by princes and other collectors of the past.[4]

Richard and Erna Flagg, like these other collectors, began with clocks, and at one time had over one hundred stunning examples from sixteenth-century Germany. They also collected medieval coffrets and missal boxes as well as some later miniature examples from the Nuremberg workshop of the celebrated maker Michael Mann (ca. 1589-1630). As an industrialist Richard Flagg was no doubt impressed by these examples of early modern technology.

Also bearing some affinities to the Flagg collection is that of another important collector of today, the Toronto newspaper magnate Kenneth R. Thomson (in England a peer of the realm titled Lord Thomson of Fleet), who has been collecting since 1953, that is to say, over basically the same span of years as the Flaggs. His extraordinary collection of European "small sculpture" (the Germans

have a proper word for this: *Kleinplastik*) is on loan to the Art Gallery of Ontario.

Indeed, despite very different personal backgrounds, Thomson's and the Flaggs' tastes prove to have been not dissimilar because of their respective admiration for, and growing knowledge of, German art in all its manifestations. Thomson, however, has preferred items fashioned out of organic matter, principally wood and ivory, to ones made of inorganic materials such as terra cotta, marble, or bronze. For sculpture the latter materials have traditionally been regarded–under the old hierarchy derived from the classical world–as superior, in the ascending order listed. Pliny the Elder, interestingly enough in view of the wonderful discoveries of ancient Greek bronze statuary through recent marine archaeology in the Mediterranean Sea, rated bronzes as the finest form that sculpture could take.[5] Nevertheless, it should be recalled that ivory has since Old Testament times and until the eighteenth century been regarded on account of its great rarity and cost as synonymous with affluence, and indeed with culpable excesses of luxury.

Thomson's approach to collecting is sensuous rather than intellectual, and none the less valid. The Flaggs also had a discerning eye for quality and for rarity. Their taste, within their chosen two or three centuries, was eclectic: with a few exceptions–the locks, the coffrets, the German stonewares, and the glass–they bought individual items of outstanding quality and visual appearance as representatives of a whole field, rather than interrelated series. This is particularly so in their sculpture: *one* alabaster *Virgin and Child* of the late fourteenth-century; *one* Malines *Virgin and Child* in polychromed and gilded wood; *one* Antwerp house altar; and from the Italian Renaissance, *one* bronze crucifix, *one* terracotta model, *one* polychromed terracotta portrait-bust; there are a *couple* of devotional ivories and *three* Limoges "painted" enamels. The collection is thus remarkable for its diversity and provides an invaluable resource for the teaching and appreciation of the decorative arts and sculpture in Europe from the later Middle Ages to the Baroque.

The Flagg collection has the added advantage of being rather untypical of American taste in general, in any case that of the collectors of the first two-thirds of this century, which tended to favor the "Age of Elegance"–the porcelain, furniture, tapestries, ormolu ornaments, and bijoux of the style that has amusingly been dubbed "tous les Louis!" The Flagg objects are much earlier and are harder to appreciate since they spring from less easily accessible cultures; they are far rarer, if not necessarily more valuable, in the marketplace of today.

The Flaggs were motivated by a desire to reconstruct the cultural background of Germany, the homeland from which they had emigrated to the New World in 1941. This meant not only concentrating on acquiring the best that they could of the art of the German-speaking lands–the former Holy Roman Empire–but also judiciously selecting items from other historical cultures that had traditionally been admired in Germany, notably from the Renaissance in Italy. This field had been studied and hence opened up to modern collectors by the great late nineteenth-century generation of art historians, museum curators, collectors, and dealers who were active in Berlin, Frankfurt, and Vienna. Wilhelm von Bode (1845-1929), founder/director of the Berlin museums, was the pioneering acquisitor and cataloguer of many types of artwork from the Renaissance in Italy, and inspired both contemporaries and successors (including J. P. Morgan) to follow his taste. The Flaggs would have been well aware of this extension of German taste and expertise and they had the distinct advantage of being able easily to read the great publications and catalogues written in German, the prime language of the nascent discipline of art history– *Kunstforschungen*. They may also have been aware of the prestigious sales at which many of the turn-of-the-century collections were summarily dispersed during the 1920s and 1930s in the inflationary aftermath of the Great War. Later on, under the Nazis, further sales were held of "non-German" works of art, partly to raise money to purchase from private hands a great national treasure, the *Welfenschatz*.

Most of the collections in the United States of German art have been built up by people from Germany. Swabian limewood sculpture–often polychromed and gilded relief panels from altarpieces or individual statues of saints from niches–would typically form the nucleus of a collection, along with a selection of miniature carvings (*Kleinplastik*), pottery, and domestic brassware. One such collection, from the Heinemann family, was quite recently dispersed at Christie's New York.[6] While the second generation of an immigrant family may retain a collection and even add to it occasionally out of an affection for their

parents and their land of origin, it is rare for a third generation to do so. The younger members, by now totally integrated into American society, normally prefer to liquidate what they feel to be the "dead weight" of such ancestral treasures, in order to finance another collection of their own choosing without specific links to their past—quite possibly one of modern or contemporary art.

Other families from Germany have sometimes turned their back on their native heritage out of shame or disgust at the recent history of their nation. They have therefore directed their collecting instincts towards other European art, particularly Italian specialties, such as bronze statuettes, majolica, and occasional pieces of furniture: the late Hugo Klotz, who worked on Wall Street, and the late Heinz Schneider of Cleveland were two such collectors. As mentioned above, until around 1960, the majority of the literature about these fields was available only in German. It is extraordinary that catalogues of Italian bronzes still today are peppered with references to previous ones by Bode in Berlin, or Planiscig in Vienna, dating from as long ago as the 1920s and 1930s. The only full-scale postwar book about bronze statuettes in general was published in 1967 in German by Professor Hans Weihrauch. It has never been translated, let alone replaced.

The same is true of Italian Renaissance furniture, where the standard works are still those by Bode and by Frida Schottmüller, while the only corpus of an important class of furniture (of which there is a fine example in the Flagg collection), namely wedding-chests (*cassoni*), is that by Paul Schubring. Otherwise it is in the main only catalogues of great private collections (sometimes ones that have been donated to museums) or of temporary exhibitions that have appeared in English, notably those by John Pope-Hennessy and other authors on the Kress and Frick collections. This absence of ready reference books has inevitably discouraged collectors without a good knowledge of the language, leaving the field mostly to those familiar with the German tongue.

The other side of the coin is the fact that many collectors, not wishing to enter the more "difficult" fields where a knowledge of German and in-depth connoisseurship are required from the outset, and with different European backgrounds, have preferred fields such as silver or porcelain, where the majority of individual items are marked clearly as to their place—and often period

—of manufacture, or furniture and tapestries, which are intended to enhance the interiors of houses. They indicate a level of affluence more directly, and are more readily appreciated. English eighteenth-century paintings (by Reynolds, Gainsborough, Constable, or Turner) and English silver might sit alongside Sèvres porcelain, with its prettily colored borders and dainty ornamentation; light-hearted groups or statuettes with charming subjects in terra cotta by or after Clodion could all be set off by Louis XV or XVI furniture, tapestries, and carpets. A handful of what was then "modern art"—canvases by Monet and an occasional bronze cast by Rodin, most of which carry obvious signatures—would enhance the collector's reputation for perceptiveness and chic.

Inevitably, therefore, with the passage of time, it is these kinds of material that have come to form the backbone of most museum collections of European decorative art in America. The earlier periods of European art are usually encountered only through paintings and engravings. With the gift of the Flagg collection, therefore, the Milwaukee Art Museum gains a very particular profile that now sets it apart from many other institutions of equivalent size, and automatically situates it at the cutting edge of international scholarship in various less studied and appreciated fields of artistic endeavor.

Collectors with the necessary means (which need not have been so tremendous in the postwar years, when myriad works of art had been displaced willy-nilly in the wake of the war in general and the Holocaust in particular) are often tempted to surround themselves with the physical trappings of life in their chosen period, often the Late Gothic of Northern Europe or the Renaissance in Italy. In the United States self-evidently appropriate environments to ensconce such collections of works of art are lacking and some collectors rectify this absence by actually constructing pseudo-manors or castles, often in an approximately authentic style. After all, the demands of twentieth-century living and its expected conveniences differ radically from the circumstances in which life was lived in days of yore. While the extraordinary edifice of Hearst Castle in San Simeon, California, is the most famous example, a less immensely rich collector, George R. Hann, a Pittsburgh aviation pioneer, also built himself out of local stone and slate an impressive pseudo-Jacobean pile called "Treetops" (described by the real estate agents in 1980 as a "Regal

English-Style Residence") in Sewickley, Pennsylvania among the Allegheny foothills. Indeed, parts of his collection were physically incorporated, as appropriate, into the structure, even if they did not really fulfill the function that they appeared to, for example, medieval sandstone corbels–or columns with Romanesque capitals–that seemed to support oak beams or coffered ceilings. I wrote in my "Introduction" to the sale of the Hann collection:

> The statuary in the Hann collection tends to be predominantly of Eastern and South Eastern French origin, polychromed and carved in fine-grained limestone or sandstone characteristic of those areas, the departments of Lorraine, Aube, Champagne and Burgundy. While Mr. Hann secured early Gothic sculpture in the form of architectural components and the magnificent limestone retable, the major works date from the late 15th, early 16th century.... In addition, while there is a fine collection of German wood and stone sculpture, equally important are the fine tapestries, the imposing andirons and majolica of the 15th and 16th centuries, some from the Pierpont Morgan collection. The collection however is not confined to the medieval works of art, and includes European arms and armour, furniture, and textiles....This collection, like those of J. P. Morgan and William R. Hearst, is characteristic of a period in which there was increasing interest in medieval sculpture and works of art further stimulated by the Rockefeller sponsored purchase of the George Gray Barnard collection in 1925 and the subsequent development of the Cloisters, New York.[7]

Sadly, after the sale, many of the ancient architectural components had to be chiseled out of the wall for removal by their new owners.

Certainly there is a feeling of genuine regret that something impalpable but of great value has been lost when any well-thought-out collection is dispersed, however good or inevitable the reasons. Even the auctioneers and dealers (most of whom are more sensitive to this than they are often credited with), who stand to earn their living and profit by such dispersals, tend to regret the necessity.

Some collectors, however, like Thomas Flannery,

Heinz Schneider, Peter Guggenheim, or John Abbott, like to think that the eventual dispersal of their beloved collections will enable others (lucky enough to possess the means and intelligent enough to cultivate the taste) to acquire them in turn and enjoy them in different settings and novel juxtapositions, which may lead to further perceptions about them. Other collectors, happily for the majority of us (not only Ameri-cans, but visitors from abroad, who are well aware of the wealth of European cultural treasures in the United States), prefer altruistically to preserve their lifetime's careful assemblage of works of art *en bloc*, believing, like the Flaggs, that the sum is more than the total of its parts.

In building their collection, Richard and Erna Flagg were reviving the past as a challenge and key to the present, in an intelligent, sensible, and highly attractive manner. They were reliving also its cultural and social aspirations, and lending credence to its permanent values, though obviously within the bounds of modern democratic society. They were able, however–and thanks to their generosity in donating to a public museum so are we–to keep a sense of proportion and stability, founded on centuries of hard-won human experience, when confronted with the worst aspects of life in the middle and late twentieth century. Contemplation of these carefully conceived and lovingly wrought artifacts from the past enables us to imagine how our ancestors coped with the problems of everyday life, which were, if anything, far more difficult than for those living in affluent Western society today. Nonetheless, the basic human psyche has changed little and it is our own recognition of this central fact, and of the community with past generations of our joys and sorrows, spiritual and social experiences, successes and traumas, that can help to restore our sense of balance in the hectic world of high technology, multimedia communications, and over-rapid travel.

1. See Lugano (Paul Williamson) 1987, pp. 12-14: "By the beginning of the twentieth-century a new factor was starting to affect the market–the American collector of medieval works of art....Walter Cahn and Linda Seidel have shown how the interest in medieval architecture–and more specifically Romanesque architectural forms–had spread from contemporary American architects at the end of the nineteenth century to those with sufficient means to collect original specimens of the medieval mason's craft. The first collector in America to collect medieval sculpture in a serious manner was Isabella Stewart Gardner, who in the late 1890s made a number of trips to Venice and Northern

Italy to purchase architectural sculpture; this was set into the walls of Fenway Court, her residence in Boston, rather as the sculpted reliefs and roundels were applied to the walls of Venetian palazzi. In this way her collection has more to do with the taste of Stuckley and Walpole than with those collectors who studiously concentrated on the Middle Ages. This purchasing of large-scale, often architectural, pieces of sculpture became something particularly associated with American collectors in the early years of the present century. This was undoubtedly due to the distance between America and the cloisters and cathedrals of Europe, which prompted the reconstruction of a number of derelict cloisters from Europe in American settings in an attempt to fill the lacuna. The most famous of these is the Metropolitan Museum of Art's branch museum of medieval art at Fort Tryon Park in New York, simply known as "The Cloisters," the nucleus of which was acquired by the sculptor George Gray Barnard between 1903 and 1925. Other notable ensembles are at Toledo and Philadelphia, and the hugely successful business magnate William Randolph Hearst energetically bought large amounts of this kind of material to furnish his castle-like residences at San Simeon and elsewhere. John Pitcairn and, after his death in 1916, his son Raymond likewise purchased medieval sculpture and stained glass in Europe for their church and scholastic institution at Bryn Athyn, Pennsylvania.... However, the two collectors who stood head and shoulders above all others in the early years of the twentieth century in America (and indeed anywhere else) were J. Pierpont Morgan and Henry Walters, whose collections now form such important parts of the Pierpont Morgan Library, the Metropolitan Museum of Art and the Walters Art Gallery in Baltimore."

2. See Durham (Caroline Bruzelius and Jill Meredith) 1991, pp. 2-3: "Until the late nineteenth century, America seemed largely indifferent to collecting medieval art. The Middle Ages had, after all, played no part in the familiar American landscape. Indeed, Americans, exhilarated by liberation from the yoke of England in the eighteenth century and confident of the limitless possibilities of the future, had no reason to cultivate a nostalgia about a past that had at one time meant servitude and injustice. To the contrary, it was towards the architecture of democracy, the neo-classical versions of Greek prototypes, that they turned. Sometimes, too, medieval art might have seemed too redolent of Catholicism. Large-scale medieval sculpture was architectural and in this country divorced from its original context; it thus had the disadvantage of appearing fragmentary, incomplete, and therefore unsatisfactory to the American eye....With the exception of a few enlightened souls and a taste for the 'Gothic' in country houses and Episcopal churches, an indifference to the art of the Middle Ages continued until the first decades of our own century, when the combined influence of a new phase of Romanesque and Gothic Revival in the buildings of Henry Hobson Richardson and Stanford White (among others) along with the publication of Henry Adams's *Mont Saint-Michel* and *Chartres* in 1903 began to create a taste for the Middle Ages in the United States."
After mentioning the pioneering activities of Isabella Stewart Gardner in Boston and of Mr. Morgan at The Metropolitan Museum of Art in New York, Bruzelius continues: "The Boston Museum of Fine Arts acquired its first works of Romanesque sculpture in 1919. The William Hayes Fogg Museum at Harvard obtained its head from the west portals of Saint-Denis in 1920, and The Philadelphia Museum of Art purchased in 1923 some panels from a north Italian pulpit. By the twenties, collecting medieval art had become noteworthy in this country for private collectors and donors as well."

3. Sotheby's London, December 1-2, 1983.

4. For others who were fascinated by the process of making such objects, see Philippowich 1961, pp. 315-17.

5. See Houser 1983, *passim.*

6. Christie's New York, January 28, 1998, lots 41-48.

7. Christie's New York, May 19, 1980, p. vii.

Clocks and Scientific Instruments

1. *Wall Clock with Automation*

Southern Germany
ca. 1550-1600
Iron, bell metal, brass, gilt copper, and polychrome decoration
14 x 6 x 6 1/2 in. (35.6 x 15.2 x 16.5 cm)
L289.1993

DESCRIPTION: This weight-driven, hour-striking clock with lunar indication has three human faces in the arch of the dial and a pair of *jacquemarts* on either side of the movement that are animated by the going and striking of the clock. The clock's iron posted frame has diagonally set buttressed pillars surmounted by finials, while the movement has two trains of iron wheels, for timekeeping and for striking the hours. An alarm mechanism, since removed, was located behind the dial. The escapement's suspended balance wheel is finely decorated, with its upper edge cut to resemble canine teeth.

Two *jacquemarts* sound the hours on a bell located above the movement within openwork iron strapping.[1] The *jacque-marts*, dressed as feudal serfs and animated by a linkage from the striking train, hit the bell alternately with their hammers. The linkage also activates the automated heads on the clock dial.

The gilt copper dialplate is decoratively edged and finely engraved with foliage and long-necked birds. It has two dials, each with a single steel hand, while above them in the arch are the automated heads. The main dial indicates the hours and the time for which the alarm is set. A narrow chapter ring is engraved with the hours I-XXIIII and has touch marks at each hour for nighttime use. Within this ring is a large alarm disc numbered 1-24 and decorated with pierced, interwoven circles. A subsidiary dial above the main dial has numbers indicating the phase of the moon in days. Within its chapter ring an aperture reveals a gilt copper disc with engraved stars and a now missing silver moon. Between the small mechanical heads is a dedicatory inscription, and below the main dial an Italian coat of arms is engraved within a cartouche.[2]

CONDITION: The four-vaned fly, three wheels, the bell, and both hands have been replaced. The polychrome finish of the *jacquemarts* is abraded and faded, and the silver surface representing the moon has been lost. All of the alarm work is missing except for the alarm disc. The tongue of the right serpent has been lost and there are repairs to the automated heads and their linkages.

MARKS AND INSCRIPTIONS: M.RFO.DCATA, probably "*Morfeo dedicata*" [dedicated to Morpheus or sleep], is inscribed below the uppermost central face on the dial.

PROVENANCE: Purchased from a dealer, London.

COMMENTARY: In the trade centers of southern Germany during the Renaissance, clockmakers and blacksmiths often belonged to the same guild, and in this clock the blacksmith's style is evident. The wheel rims, into which the teeth are hand-filed, are iron strips beaten into a circle and forge-welded into a hoop, with the crossings, or spokes, hammered to shape and hot-forged in place. The hexagonal wheel arbors and the frame with its delicate finials are further examples of the high-quality work regularly produced by clockmaker/blacksmiths.

Jacquemarts have long been used to sound tower clock bells, perhaps in an attempt to "humanize" a machine that appeared to think and act of its own volition. Automated scenes have been documented as far back as 1325 and are thought to have elevated the intellectual status of their makers.[3] They too were usually activated by a striking train, though occasionally they had their own wheelwork and motive power. The migration of *jacquemarts* and other automata from their lofty towers to the more lowly house clock probably took place during the early sixteenth century.

The center head on the clock dial has eyes continually moved from side to side by the escapement. As the clock strikes each hour, the two small heads, activated by the striking train, tilt up to open their mouths and poke out their tongues, while the center head drops its lower jaw to achieve the same effect. At the same time, a pair of serpents descend from windows to bite the noses of the small upturned heads. The mouths of the serpents drop open as they descend, revealing their forked tongues.

While the movement of this clock is typical of southern German work, its dial is more akin to Swiss or Italian styles. The use of a twenty-four-hour chapter ring, the decoration of the alarm disc and lunar subsidiary dial, the coat of arms, and the dedication all suggest the possibility of an Italian commission.[4] The unusual form of the dial automata and its wry sense of humor also indicate a commissioned, rather than an off-the-shelf, clock. WDT

1. The bell is a replacement. The original would have been a deeper, lugged bell.

2. I would like to thank Silvio A. Bedini for research on the coat of arms.

3. Beeson 1977, p. 133.

4. Renaissance Italy divided the day into twenty-four hours. It began a half-hour after sunset when clocks were wound and set. As the hours were of equal length (like present-day hours), it can be seen that "noon" would fall in mid-morning during the summer, but before dawn in the winter. The clocks were reset each evening to "24." This system of time computation was known as "Italian Hours."

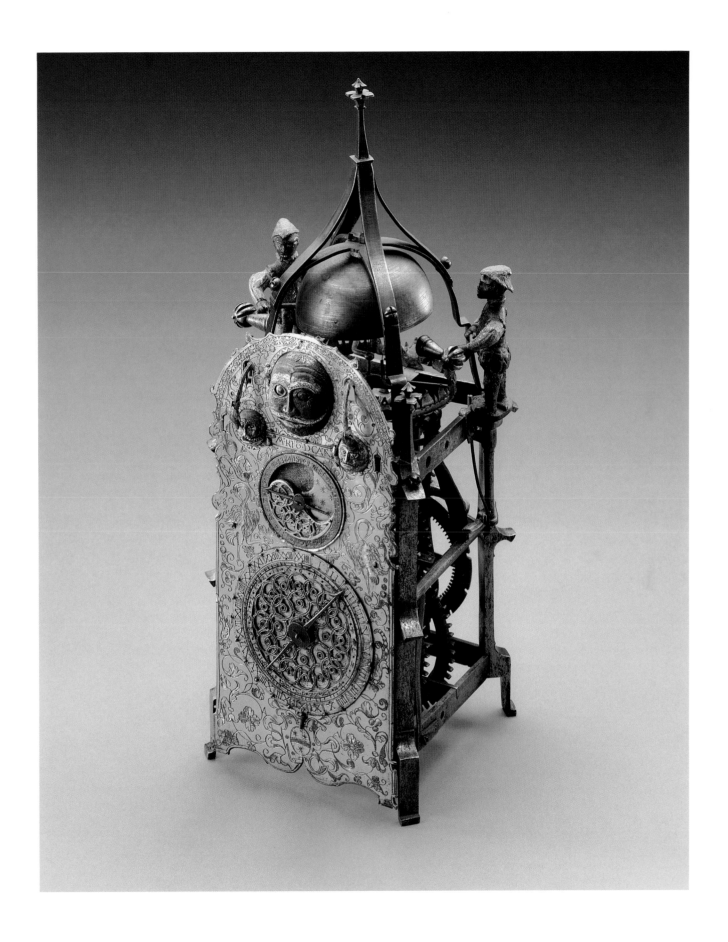

2. *Table Clock in Tower Form*

Probably Augsburg
ca. 1580
Gilt copper, gilt brass, brass, iron, blued iron, and bell metal
12 1/2 x 7 7/8 x 7 7/8 in. (31.8 x 20 x 20 cm)
L283.1993

DESCRIPTION: This unsigned table clock has six dials. The main dial indicates the hours and quarter-hours, and has an alarm disc at its center and a silencing lever set into the base of the lower cupola. Below the main dial is a small subsidiary dial designed to indicate how many hours have passed since the clock was last wound.[1] On the clock's right side is a dial engraved with the days of the week and their relevant gods. The hand on the left-side dial was once used to regulate the clock's accuracy.[2] Separate dials at the back of the clock have hands to show the last hour and quarter-hour struck on the bells.[3]

The movement is set within an iron posted frame and has trains for timekeeping, hour-striking, quarter-hour-striking, and an alarm. During the eighteenth century, the timekeeping train's verge escapement was altered by removing the balance wheel with its bristle regulator and replacing it with a pendulum. The hour-striking and quarter-hour-striking trains control their functions by count wheels; a small, high-toned bell sounds the quarters and a larger, lower bell, the hours and the alarm. The bells are encased in the two lowest stages of the cupola.

The gilt brass and copper case has removable side panels for movement access. The lower section features repoussé and engraved decoration, while the central part of the clock is engraved and chased. The upper section comprises a three-stage cupola with pierced and engraved decoration.

CONDITION: The escapement was altered to accept a pendulum, probably during the eighteenth century. The quarter-hour hand has been replaced. The stackfreed, some minor parts, and the figurine finial from the cupola are missing.

PROVENANCE: N. R. Fränkel, Frankfurt; purchased from a private collection, Switzerland.

PUBLICATIONS: Frauberger, Heinrich. *N. R. Fränkel's Uhrensammlung.* Düsseldorf, 1913, vol. 1, p. 39, no. 362; vol. 2, p. 262, pl. 32 (as *"Turmartige Standuhr"*).

COMMENTARY: Since the Renaissance, towers and spires have dominated the townscapes of Germany and liberally littered the countryside, so it is hardly surprising that clockmakers chose to create the form in miniature to house the complex mechanisms of their table clocks. Such a shape is ideally suited, mechanically and aesthetically, for enclosing a spring-driven movement and displaying its indications. These miniature clock towers came in many shapes and sizes. Square and rectangular towers with plain round, bell, or onion-shaped domes were common, as were concave and straight-sided spires. Cupolas, often double and sometimes triple, were colonnaded and surrounded with balustrades, and a fondness for finials developed in the seventeenth century. Other forms were also used for clock cases, but the tower retained its popularity into the eighteenth century.

By the late sixteenth century, southern Germany was a prolific producer of clocks and watches and was well informed of advances in technology, but clockmakers occasionally resorted to outdated solutions to mechanical problems, when better ones were readily available. An example can be seen in the movement of this clock: a stackfreed was used to regulate the lessening force of the clock's mainspring as it unwound, even though the more efficient fusee had been in use for more than a century. In this instance the retrogressive step saved space and allowed the fitting of a dial to indicate when the clock required winding, a useful aid in a short-duration clock. Greater efficiency was here readily sacrificed to convenience.

This clock belongs to the earlier school of clockmaking in Augsburg. Its movement is made almost entirely of iron and predates by about twenty years the general introduction of brass components into clock movements. At this date, the more expensive brass was employed only where its beauty would be fully appreciated, in the clock's case. The decorative elements of this case are relatively simple when compared, for instance, to the case of the Hyrschöttel clock (see entry 10). The multiplicity of balustrades and finials had not yet come into fashion and clock cases relied for visual appeal upon their proportions and the type and texture of surface decoration. This is exemplified here by the strapwork and floral engraving combined with low-relief repoussé work and elaborate cast corner pillars. Background surfaces have a punched matte finish to accentuate the burnished highlights of the decoration. WDT

1. This dial's hand is connected directly to the cam of the stackfreed, a device to equalize the force of the unwinding mainspring. As the cam is designed to make only one rotation when the clock is wound, it is not difficult to fit a hand to indicate when rewinding is necessary.

2. The hand on the regulating dial was connected through a linkage to the hog bristle which regulated the balance wheel. When the escapement was changed, the bristle was removed and the hand no longer serves any purpose. The pendulum is regulated by moving its weight up or down the pendulum rod.

3. As the count wheel–governed striking trains are not self-correcting, it is useful to be able to check visually that the hands and bells indicate the same hour and quarters.

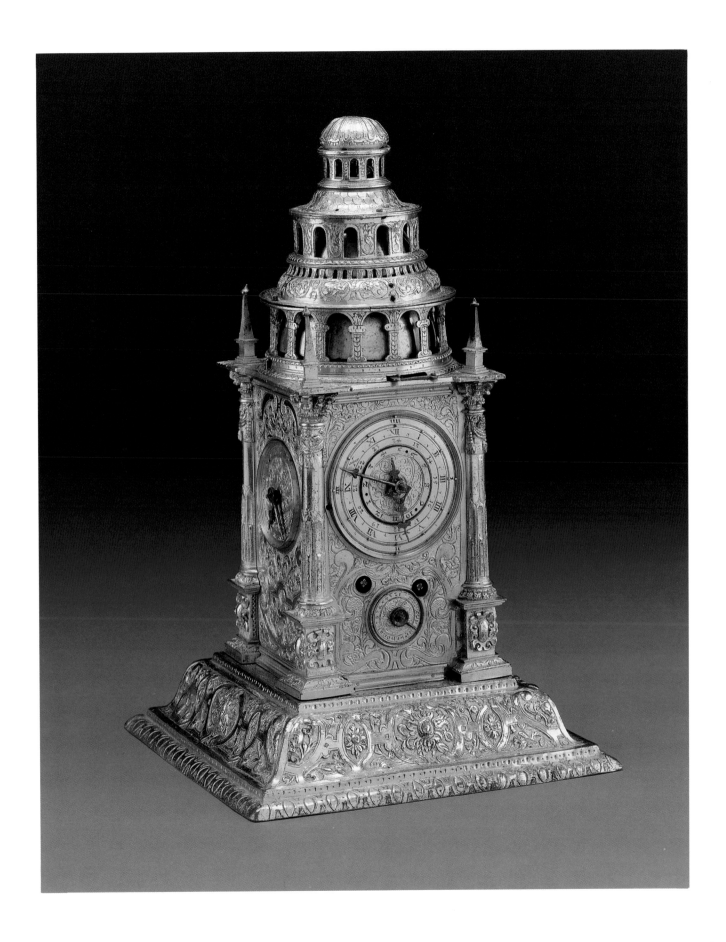

3. *Table Clock with Orpheus Frieze*

Probably Nuremberg
ca. 1560-80 with later movement
Gilt brass, brass, steel, blued steel, silver, and blue enamel
3 1/2 x 9 3/4 x 9 3/4 in. (8.9 x 24.8 x 24.8 cm)
Dia. of face: 8 1/2 in. (21.6 cm)
M1991.84

DESCRIPTION: This spring-driven, drum table clock has a replacement movement by the eighteenth-century German clockmaker Johan Lehr of Jaegerndorff. The movement's square brass plates have four sectors soft-soldered to the backplate to enable it to fit the circular case. The clock has three bells to strike the hours, quarter-hours, and to sound an alarm. Its single horizontal astrolabe dial has a pair of hands for indicating the positions of the sun and moon in the zodiac. These same two hands also show the age and phase of the moon and the planetary aspects. Below the sun and moon hands is a dragon-shaped hand to show the nodes of the moon and thereby predict the dates of possible lunar eclipses.

Beneath the dragon hand a star map, the rete, shows important named stars and the circle of the zodiac. The stars are given their celestial coordinates by reference to a tympanum, an engraved plate, below the rete. This silvered brass plate is engraved with the lines of declination and right ascension. The topmost, and longest, hand shows the time on a chapter ring engraved with the hours of I-XII, twice. This same hand also indicates the day of the year on a six-month reversible calendar ring immediately within the chapter ring. A minute ring, engraved with two hours in half-minute increments, forms the outermost dial.

The historically important gilt cast brass case of this clock depicts a frieze of Orpheus charming the animals with music. This scene from Greek mythology was an oft-repeated Renaissance motif, and similar friezes for nine other table clock cases are thought to have come from the same southern German workshop during the third quarter of the sixteenth century.

CONDITION: Although the case has been regilded, the details remain crisp. The movement, parts of the dial, and the dragon and time-indication hands are replacements. The sun and moon hands are also probably replacements. Only the time-indication hand is functional.

MARKS AND INSCRIPTIONS: The name JOHAN LEHR JAEGERNDORFF is engraved on the replacement movement.

PROVENANCE: Purchased from Dr. Lewis Rosenberg, Elizabeth, New Jersey, 1962.

PUBLICATIONS: Coole, P. G. and Neumann, E. *The Orpheus Clocks*. London, 1972, *passim*.

COMMENTARY: This German Renaissance clock is one of ten housed in cases featuring scenes from the Greek myth of Orpheus. These scenes effectively link together a series of clocks that are presently scattered throughout Europe and North America.[1]

With Augsburg as its cultural center, a triangle in southern Germany encompassing the towns of Ulm, Nuremberg, and Munich was one of the most important areas for clock and scientific instrument manufacturing in Europe during the hundred years between 1550 and 1650. The region was well blessed with skilled artisans in all branches of the metal-working trades. This fortunate gathering was not accidental, for the area had long been mined for its metals and other minerals, and Augsburg lay at a major crossroads of important international trade routes. Possibly most important to the advancement of both technical and artistic skills, and so to the continued success of the region, was the prolific trade with the East. This was due in no small measure to the "Turkish Honoraria" exacted annually by the sultans of the Ottoman Empire between 1548 and 1606 as tribute for halting their invasive forays into the West. Gold and silver works of art, clocks, and automata were among items specifically demanded by the sultan.

A legendary hero of ancient Greece, Orpheus is the subject of a number of myths, two of which are illustrated on the Orpheus clocks. The best known myth is that of Orpheus' skill with the stringed instrument, usually depicted as the lyre or, as on these clock cases, the bowed foot lyre.[2] His music was said to be so remarkable that birds and wild beasts would gather to listen, and even trees and rocks would fall under its spell.

Another myth recounts Orpheus' descent into Hades in an attempt to restore to life his wife, Eurydice, who had died of snakebite. Orpheus so charmed the rulers of the underworld, Pluto and Persephone, with the power and beauty of his music that they allowed Eurydice to follow him back to earth, provided that he not turn to look at her until their journey was complete. But, doubting the veracity of a promise made in Hades, he did look back to check that Eurydice was indeed following him. Pluto immediately reclaimed her and she was lost to Orpheus forever. The collective myth of Orpheus, with the power of his music perhaps seen as a metaphor for the triumph of art over nature, was a common theme in sixteenth-century Italy and Germany and appears in many Renaissance works of art.

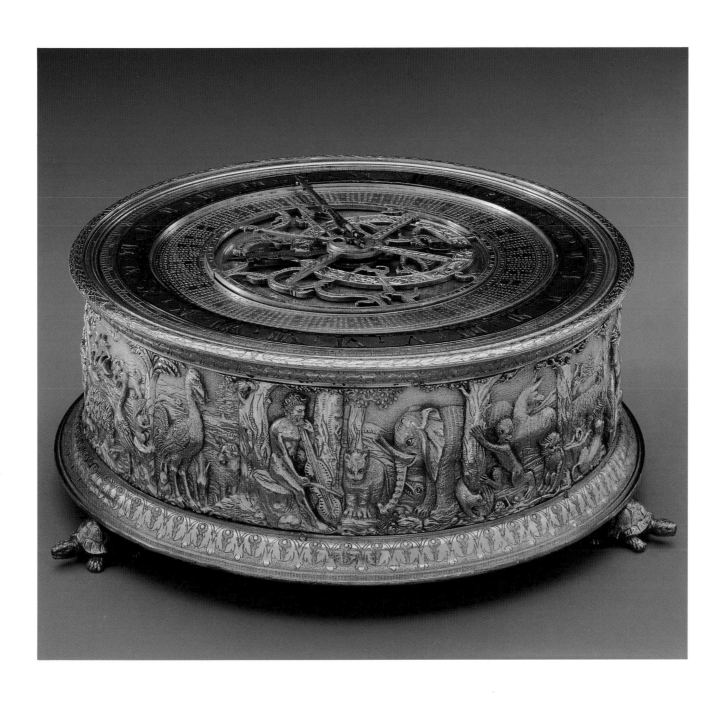

The wooden molds from which the Orpheus friezes were cast have been associated with the workshop of Hans Kels the Elder (ca. 1480-1560), whose game board of 1537 appears to be the source for the motifs of the elephant and the tree-climbing monkey.[3] The other animals in the friezes appear in a pair of copper engravings by the Nuremberg artist Virgil Solis, who died in 1562.[4]

The friezes for the ten Orpheus clock cases were made by combining two separate plaquettes, a primary plaquette showing Orpheus and Eurydice flanked by animals, and a secondary one consisting only of animals. In the eight round clocks, these were brazed together to fit the relevant movement and were deliberately cut short so as to require an insert to allow for the proper continuation of the procession of animals. In some of the clocks, the insert was decoratively pierced and used as a sound fret. The frieze of the Flagg clock is unique in that it is made up of two secondary plaquettes, with the seated Orpheus at his lyre cut from a primary plaquette inserted between them. Neither Pluto nor Eurydice is present, and there are no morbid undertones to spoil the harmony of Orpheus' spell over nature.

This clock and one privately owned in Luton Hoo, England rest upon feet fashioned in the form of tortoises.[5] Though they were a popular ornamental motif in sixteenth-century German art, the presence of tortoises on only these two clocks is noteworthy when other factors common to them are taken into consideration. The Orpheus clocks are generally individual in the layout and execution of their dials. However, the dials of these two clocks have some interesting similarities.[6] The two chapter rings bear almost identical engraving, and the division of each of the chapter ring hours into eleven and nine parts respectively makes little horological sense. Both clocks have very similar dragon hands, although there has never been the required motion work for a dragon hand on the Luton Hoo clock. Additionally, the time-indication hands of both clocks appear to be identical, though the hand on the Flagg clock is known to be later. The two pairs of sun and moon hands, with their planetary aspects and moon phase functions, appear to be almost exact copies of each other, particularly in decoration. Since some of these hands are relatively modern, it is interesting to speculate that both clocks may have passed through the same restoring hands.

The use of a modified square table clock movement in the Flagg clock, the standard and style of the engraving on its added sectors, and the general lack of artistic layout in the relocation of various backplate decorative elements together suggest that the present movement and hands could well have been fitted at the same time, probably late in the nineteenth century. To so considerably alter a well-made square table clock movement and to undertake such an extensive and

costly renovation to the dial in order to preserve its external appearance suggest that a substantial value was placed upon this clock case even in the nineteenth century. WDT

1. The two most important clocks are in the Fremersdorf Collection, Lucerne, Switzerland. There is one at the Bayerisches Nationalmuseum, Munich, another at the Kunsthistorisches Museum, Vienna. Two are in England, at the British Museum, London, and in a private collection in Luton Hoo, Bedfordshire. There are also two in the United States, one at the Adler Planetarium, Chicago, and this clock in the Milwaukee Art Museum. The clock formerly in the Georgi Collection was last seen early in this century, and a tenth clock recently passed through the salerooms.

2. Coole and Neumann 1972, p. 101, n. 51.

3. Ibid., pp. 107, 109-116, figs. 70-76.

4. Ibid., p. 108.

5. Ibid., pp. 140-41.

6. Ibid., pp. 38-40, fig. 15.

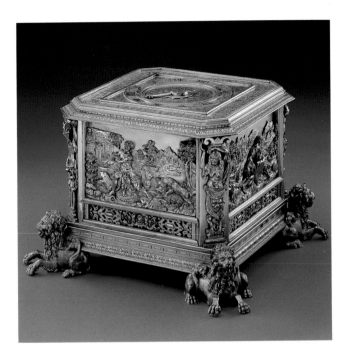

4. *Horizontal Table Clock with Plaquettes*

(Plaquettes after designs by Maerten van Heemskerk, 1498-1574)
Probably Brussels
ca. 1580
Gilt brass, brass, and wrought iron
7 3/4 x 12 1/8 x 12 1/8 in. (19.7 x 30.8 x 30.8 cm)
M1991.67

DESCRIPTION: This unsigned square table clock strikes the hours and is fitted with an alarm. The movement has three trains of iron wheels and gilt brass plates. The time-keeping train has a fusee with gut line, and a balance-wheel verge escapement once regulated by a hog's bristle. In the striking train there is a count wheel to control the number of hours struck on a high-domed bell located between the movement plates. A gilt brass spherical fly governs the speed of the striking.[1] The alarm train's verge escapement has a double-ended hammer which sounds the alarm on the hour bell.

The movement is housed in a gilt cast brass case set upon four gilded recumbent lion feet. The skeletal frame of the case may be later than the movement, but it incorporates four beautiful sixteenth-century plaquettes. The high relief chapter ring cast as part of the dial and the substantial brass hand are unusual.

CONDITION: The balance wheel has been replaced, probably during the nineteenth century when the balance staff was repaired. The hog's bristle regulator and its arm are missing. Vanes have been added to the fly, probably to accommodate an overly strong replacement mainspring. The lion feet on the case have been relocated and may be from a different clock. The gilt plaquettes are in excellent condition.

PROVENANCE: Frédéric Spitzer, Paris (sale, Spitzer Legacy, Anderson Galleries, New York, January 9-12, 1929, lot 446); purchased from French & Company, New York, 1955.

PUBLICATIONS: Weber, Ingrid Szeilklies. *Deutsche, Niederlandische, und Franzosische Renaissanceplaketten 1500-1650.* Munich, 1975, vol. 1, pp. 21, 34, 41, n. 120, fig. 39a-d.

COMMENTARY: Together with Italy, The Low Countries were largely responsible for the development of the earliest clockwork. The fourteenth and fifteenth centuries saw many blacksmith/clockmakers travel far afield to provide tower clocks for prominent public buildings, but by 1550 clockmakers in The Low Countries were concentrating on small table clocks and clocks with elaborate cases such as this one.[2]

The most interesting features on this clock are the four plaquettes, based on drawings by the Dutch Mannerist Maerten Van Heemskerck (1498-1574), for his series *The Twelve Patriarchs*. The plaquettes feature allegorical representations of Levi, Benjamin, Judah, and Issacher, four of the twelve sons of Jacob, known as the Patriarchs of the Twelve Tribes of Israel.[3]

The imagery is based upon Jacob's metaphorical character-izations of his sons as he gives them his last prophetic blessing. Levi brandishes a flaming sword, while his twin brother, Simeon, spears a fallen man. Benjamin, the favored youngest son, turns away from a pagan altar. Beside him, the wolf attacking a lamb illustrates Jacob's words: "Benjamin shall consume as a wolf...." Judah, who led the tribes of Israel through the wilderness, holds a compass, possibly referring to his role as founder of the kingdom of Judah, and thus architect of the promised nation of Israel. Finally, Issacher the land-lover is "a strong ass crouching down between two burdens... bowed his shoulder to bear, and became a servant unto forced labor." Atlas and leg-irons symbolize the bowed shoulder and servitude.[4] WDT

1. A spherical "ball" fly was sometimes employed in early clocks. As it utilizes the force of inertia, it is less effective than the usual vaned fly which uses air resistance to govern its speed.

2. Bruton 1989, ch. 3.

3. Weber 1975, vol. 1, pp. 21, 34, 41, n. 120, fig. 39a-d.

4. Gen. 49:5-6, 14-15, 27.

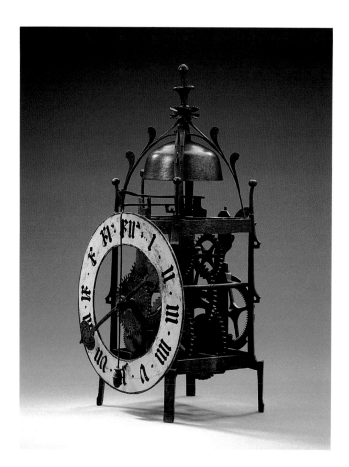

5. *Swiss Striking Wall Clock*

Andreas Liechti (1582-1650)
Winterthur, Switzerland
1603 with later dialplate
Iron, bell metal, and polychrome decoration
15 3/4 x 8 1/4 x 8 1/4 in. (40 x 21 x 21 cm)
L291.1993

DESCRIPTION: This signed and dated, weight-driven, hour-striking clock, once fitted with an alarm, has an iron posted-frame movement with diagonally set buttressed pillars, each terminating in a ball finial. The movement has two trains of wheels, for timekeeping and for striking the hours. The clock's wheelwork is of iron, each wheel being made by beating an iron strip into a circle and inserting a similarly made crossing. Joints were forge-welded, and teeth cut into the periphery of the wheel rim with a file.

The driving weight for the timekeeping train was probably a cloth or leather bag filled with small gravel so that the clock could be regulated.[1] During the eighteenth century, the suspended balance wheel was removed from the clock's verge escapement and the present pendulum was fitted to improve timekeeping accuracy.[2]

A hammer strikes the lugged bell suspended above the movement to sound the hours. The bell is contained within an openwork strapping and surmounted by a stylized floral finial. A count wheel at the back of the movement governs the number of hours struck. The present painted sheet-steel chapter ring replaces an earlier rectangular dial. Twelve holes in the hand-wheel indicate that this clock was once fitted with an alarm.

CONDITION: A pendulum now regulates the verge escapement. The dial and hand are later replacements and the motion work has been recently altered. The alarm is missing.

MARKS AND INSCRIPTIONS: The clock is signed and dated 16 AL 03 on each of the lower side movement frames. Curvilinear inscribed patterns decorate the upper frames.

PROVENANCE: Purchased from Karl Lenger, Frankfurt, 1959.

COMMENTARY: At the turn of the seventeenth century, the Swiss, so famous for their automated tower clocks, had not developed a significant market or a national style for their house clocks. The few that they made, such as this example, followed the south German style.[3] Much like the earlier south German *Wall Clock with Automation* (see entry 1), this clock reflects the influence of blacksmiths, who often belonged to the same guild as the clockmakers. The wheelwork of this clock and the frame with its delicate finials exemplify the high-quality work regularly produced by clockmaker-blacksmiths.

The Liechti family was unique in producing twelve generations of clockmakers, from 1477 until after 1857, all of them working in the Swiss town of Winterthur.[4] Their early wall clocks were usually signed and dated, a prick punch being used to produce their characteristic signatures and accompanying curvilinear decoration. This distinctive form of signature may have been born of necessity, but soon became family tradition. The Liechti clockmakers produced many wall clocks, some of them far more decorative than this one. They were also known for their tower clocks. WDT

1. Many early clocks were fitted with an oscillating foliot arm having small movable weights used to make the frequent adjustments necessary when using the unequal hours system of time measurement. However, to regulate the clock initially, the weight of the motive power was adjusted.

2. The use of a frontal "cow's tail" pendulum suggests that the work was done in Germany.

3. Tait 1983, pp. 13-14, fig. 12; Maurice 1976, pp. 19-20, figs. 65-70; Washington 1980, pp. 166-67.

4. Schenk 1970, p. 28.

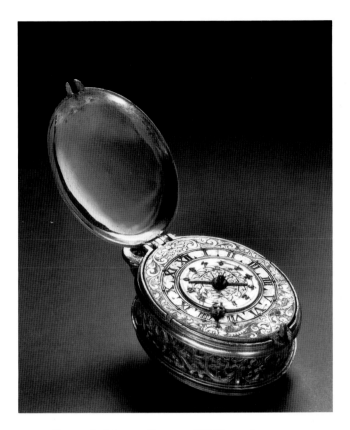

6. *Oval Pendant Watch*

Matthaus Buschmann (ca. 1598-1636)
Augsburg
ca. 1625
Gilt brass, wrought iron, and bell metal with silver or silver-plated dial
2 1/4 x 1 3/4 x 2 3/4 in. (5.7 x 4.4 x 7 cm)
M1991.93

DESCRIPTION: This oval pendant alarm watch was designed to be worn around the neck or in a pouch at the waist. It indicates the time, and sounds an alarm on an oval bell inside the case. The lid and the back of the case are of undecorated gilt brass with the movement hinged between them, but a band of pierced floral decoration gives depth to the body of the case and allows the alarm bell to be clearly heard. The gilt brass dial has a silver chapter ring engraved with the hours I -XII, the time being shown by a small gilt indicator attached to the numbered alarm disc which fills the center of the dial. The iron hand indicates the time to which the alarm is set. A pendant finial was once attached at the bottom of the case.

CONDITION: The alarm hand and much of the escapement have been replaced. Some other parts are repaired. The pendant finial is missing.

MARKS AND INSCRIPTIONS: The backplate is signed MATTHAUS BUSCHMAN [sic].

PROVENANCE: N. R. Fränkel, Frankfurt; purchased from a private collection, Switzerland.

PUBLICATIONS: Frauberger, Heinrich. *N. R. Fränkel's Uhrensammlung.* Düsseldorf, 1913, vol. 1, p. 19, no. 9 (as Augsburg, ca. 1560); vol. 2, pl. 2; Bobinger, Maximillian. *Kunstuhrmacher in Alt-Augsburg.* Augsburg, 1969, vol. 2, p. 116.

COMMENTARY: It is not known when a coiled metal spring was first used as a motive power source for clockwork, but Tait writes that the Italian architect Brunelleschi was experimenting with spring-driven mechanisms in Florence prior to 1450.[1] Together with the balance-wheel regulator, the spring gave an important new dimension to clockwork–portability. Clocks no longer needed to be attached to a wall to allow their driving weights room to descend. They could now be placed on a table or any other surface and the advantages of a personal timepiece were soon realized.

By 1512 timepieces small enough to be carried in a pouch were being made in Nuremberg, and there are records of a payment made to an H. Henlein for a "gilt musk-ball with a timepiece" in 1524.[2] Further development and miniaturization quickly led to the oval watch, sometimes still worn like the musk-ball on a ribbon around the neck, but more often in a pouch at the waist. By 1580 the oval watch, smaller, less obtrusive, and more delicate than its spherical or drum-shaped antecedents, was being made by clockmakers in most of the larger European towns.

Matthaus Buschmann (d. 1636) was the son of Caspar Buschmann (1512-1613), and a member of one of Augsburg's more prominent watch and clockmaking families.[3] However, this watch, which bears his signature, is very similar to those made during the early 1600s in the French towns of Abbeville, Blois, Lyons, and Strasbourg. Like them it incorporates the fusee, and the decoration of the case and movement suggest that this watch may have been made in France, but was signed and sold by Buschmann.[4] WDT

1. Tait 1983, pp. 20, 42-45.

2. Ibid., p. 43.

3. Baillie 1969, p. 47.

4. The stackfreed was more commonly used in German watches. For comparable examples of oval watches, see Guye and Michel 1971, pp. 71-75, figs. 46, 50, 56, pl. 3.

7. *Figure Clock with Moor*

Nikolaus Rugendas the Elder (1585-1658)
Augsburg
ca. 1620
Gilt brass, gilt copper, iron, blued iron, and polychrome decoration
11 1/2 x 6 x 5 1/4 in. (29.2 x 15.2 x 13.3 cm)
M1995.670

DESCRIPTION: This spring-driven automated figure clock features a standing Moor who holds a lance to indicate the time on a revolving globe atop a stylized palm, and moves his head when the hours are sounded on a bell in the clock's base.[1] An ape sits at his feet.

The two-train movement, set between circular gilt brass plates, is contained within a round upper part of the hexagonal gilt brass case. The brass wheels are gilded, and some of the iron parts retain their heat-blued finish. The timekeeping train has a balance-wheel verge escapement, which was improved in the past by the removal of its hog's bristle regulator and the substitution of a hairspring.[2] A line of index marks within an engraved rectangle remains on the backplate as evidence of the bristle regulator. A leading-off rod extends up through the palm trunk to terminate in a gilt brass globe which revolves once in twelve hours and has engraved hour numerals and half-hour marks. The time is indicated by the tip of the Moor's lance.

A count wheel controls the number of hours struck on the straight-sided bell by the striking train's hammer. A lever attached to the hammer also moves the brass fork of a leading-off rod. This rod passes up through a leg and the body of the Moor and is attached to his head to give it a sideways movement at each stroke of the bell.[3] A small brown painted brass ape holding an apple is seated at the Moor's feet and does not appear ever to have been automated. The Moor is of painted brass and is dressed in a gold tunic, dark blue skirt, red boots, and a white-rimmed blue turban.

Both figures are attached to a ground of repoussé snakes and snails, a latched platform which opens to reveal the clock's movement secured to its underside. The bell is set mouth upwards and both movement and bell are contained within the round portion of the clock's case, a pierced arcade serving as a sound fret for the bell. The hexagonal base contains no mechanism, but provides stability and proportion to the clock.

CONDITION: Except for the repainted figures, the clock retains its original appearance. There are minor repairs to the movement and the escapement regulator is a replacement.

MARKS AND INSCRIPTIONS: The punch mark of Nicholas Rugendas, the initials N R within a shield, is stamped on the movement backplate.[4]

PROVENANCE: N. R. Fränkel, Frankfurt; purchased from a private collection, Switzerland.

PUBLICATIONS: Frauberger, Heinrich. *N. R. Fränkel's Uhrensammlung.* Düsseldorf, 1913, no. 271, pl. 40; Maurice, Klaus. *Die deutsche Räderuhr.* Munich 1976, vol. 2, p. 54, fig. 369.

COMMENTARY: By 1600 the clockmaking trade in south Germany was characterized by extreme division of labor, with many artisans manufacturing specific parts for sale to other clockmakers. Many of the cast figures for automated clocks were made this way with interchangeable parts, the units being sold semifinished in the same manner as components for the clock movements. Though not cost-effective, this style of manufacture ensured work for more people. Workers specialized and so were able to develop a higher level of skill in their particular tasks, and the correspondingly higher quality of work enhanced the reputations of the clockmakers who sold the finished clocks and automata.

Small figure clocks were an important source of income to south German clockmakers and were produced in large quantities, particularly in Augsburg. More affordable, they made social statements for the middle classes similar to those the more spectacular and entertaining pieces made for the aristocracy. Many of these small clocks reflected the then fashionable motif of the Moor or Turk. The central figure here probably represents the Christian saint Maurice, an Egyptian serving in the Roman army, who later became a popular militant saint for Imperial Germany. With his spear in hand and the ape with its apple at his feet, the scene might be considered symbolic of the triumph of faith over original sin.[5] WDT

1. "Moor" is the name usually given to these figures. It is used as a convention to describe inhabitants of the Near and Middle Eastern countries.

2. Such a conversion so dramatically improved accuracy that it is rare to find a clock with its original hog's bristle regulator intact.

3. For an illustration of the automaton mechanism of a typical Augsburg figure clock, see Munich 1986, p. 38. In many of the figure clocks from this period, the small animal at the figure's feet was also moved by the lever attached to the hammer.

4. Baillie 1969, p. 277. Nikolaus Rugendas (1585-1658) of Augsburg was made a master in 1610. He had an excellent reputation, particularly for watches. His son Nikolaus died in 1694; a fine table clock by him is in the Neue Hofburg, Vienna. Another Nikolaus Rugendas, a grandson, became an Augsburg master in 1699 and died in 1745.

5. Réau 1958, vol. 3, pt. 2, pp. 935-39.

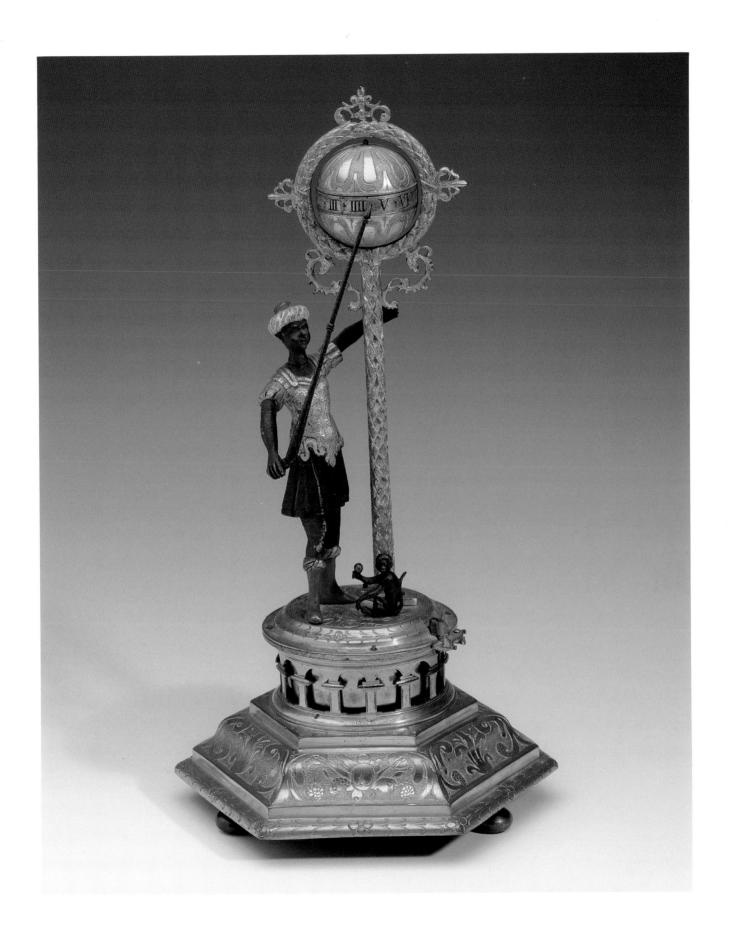

8. *Automated Clock in the Form of a Dromedary*

Southern Germany
Early 17th century with later movement
Gilt brass, gilt copper, brass, iron, silver, and ebony-veneered wood base
17 1/2 x 14 3/4 x 13 in. (44.5 x 37.5 x 33 cm)
L282.1993

DESCRIPTION: This automated figure clock has the form of a gilt brass and silver dromedary standing on a gilt repoussé ground. A nineteenth-century movement now occupies the body of the dromedary. In addition to indicating the time on a dial set within the caparison, the movement animates the camel's eyes and indicates the days of the week through an aperture in the hump. A youthful driver in Roman costume with staff in hand leads the animal by a twisted wire halter. The clock's ebony-veneered base, resting upon eight gilt brass bun feet, once contained a music-playing mechanism activated at predetermined times by the clock movement.

CONDITION: The original clock movement and the music mechanism have been removed, and the clock dial now has two hands instead of one to indicate the time.

PROVENANCE: Dr. Antoine-Feill, Hamburg; purchased from Edgar Mannheimer, Zurich, 1963.

PUBLICATIONS: Donath, Adolf. *Psychologie des Kunstsammelns*. Berlin, 1911, p. 53, pl. 16; Maurice, Klaus. *Die deutsche Räderuhr*. Munich, 1976, vol. 2, p. 49, no. 299.

COMMENTARY: Mythic and exotic animals were often the subject of the automated figure clocks popular throughout Europe during the sixteenth and seventeenth centuries. The European aristocracy enthusiastically commissioned mechanical versions of the wondrous birds and beasts of Arabia and the Orient, either to present as gifts or to keep for their own amusement as status symbols. The main center for their production was southern Germany, with Augsburg, Nuremberg, and Ulm considered as the well-springs of technical and artistic execution. Located at the crossroads of major trade routes, Augsburg was well placed as a center for the manufacture of such mechanical exotica: brown bears in their natural pelts, enameled scarab beetles, stags with coral antlers, leather-skinned dogs, and gilded cockerels, parrots, eagles, ostriches, turtles, dogs, camels, elephants, griffins, lions, and unicorns, all in abundance.

Timekeeping was usually of secondary importance on figure clocks. The clock movements were often required to perform functions quite detrimental to good timekeeping. The escapement's oscillating balance wheel, the critical factor in a clock's ability to keep good time, is almost invariably modified so that it may move the eyes of the figure. Considerable friction, the enemy of accuracy, is incurred by the lifting of levers and linkages used in automating the figure. Clock dials are often small and sometimes even hidden. These impressive gilt figure clocks conveyed the elevated status of their owner, and were staples of the cabinets of curiosities popular during this period.[1]

During the eighteenth and nineteenth centuries, many figure clocks such as this one were modified and technically brought up to date. The nineteenth-century movement in this clock was specially designed and works in the same way as its seventeenth-century predecessor. An oscillating balance wheel regulated by a hairspring ensures that the clock keeps reasonable time, and also moves the camel's eyes. Each day a carousel in its hump rotates one-seventh of a turn to show the day of the week, which is represented by an engraving of the god governing that day.

It is unlikely that the movement in this camel's body was ever equipped with an hour-striking mechanism. Instead, a linkage descended inside the right front leg to a separate music mechanism, which was once secured within the clock's large octagonal ebonized base.[2] Every hour, or perhaps every third hour, the linkage unlocked the spring-driven music box, allowing it to play a predetermined program. A series of unobtrusive holes near the edge of the base ensured that the instrument could be clearly heard. The camel's tail, which is not securely fastened to its rump, may have swung from side to side while the instrument played. A simple cord linkage and two levers could have accomplished this seemingly remarkable feat. The camel driver was never automated.

Gilt brass repoussé animal and insect life, low rocks, and foliage cover the base on which the camel stands. All of nature's creatures coexist here in apparent peace and harmony. Even the snake seems to pose little threat to the lizard, grasshopper, turtle, frog, toad, and sundry snails, all of whom keep him company in this miniature Eden.

Around the sides of the base are eight gilded, pierced, repoussé brass panels. Their subjects refer to the four elements—earth, air, fire, and water—and probably the four seasons. Although these panels would have made excellent sound frets, the wood base has no corresponding apertures. WDT

1. "Cabinets of Curiosities" were usually one-room private museums, largely intended to portray the intellectual and heightened social status of the owner. See Washington 1998, pp. 12, 17, figs. 1, 6.

2. For an example of a musical mechanism, called a "metallophon" by Maurice, see Washington 1980, p. 171. A smaller version of this instrument, was probably once fitted within the base of this clock.

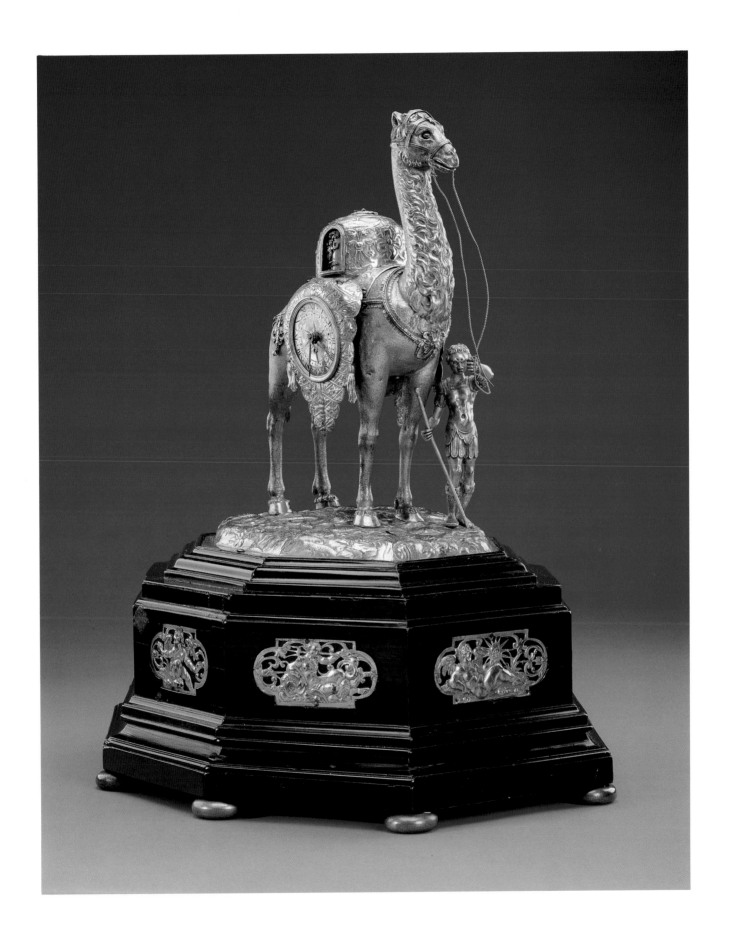

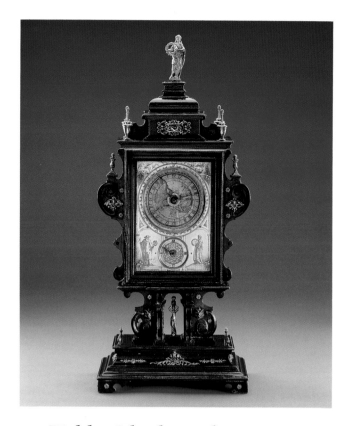

9. *Table Clock in the Form of a Tabernacle*

Augsburg
ca. 1630
Gilt brass, gilt copper, brass, wrought iron, silver, and ebonized fruitwood
21 x 9 1/4 x 5 1/2 in. (53.3 x 23.5 x 14 cm)
M1991.95

DESCRIPTION: This table clock indicates hours, quarter-hours, minutes, and seconds on two dials. An extensively modified single-train movement is set between narrow rectangular brass plates in a tabernacle-form ebonized fruitwood case. The case, probably of pear, is embellished with silver and gilt brass furniture.

During the late seventeenth or early eighteenth century, the clock was altered to include a pendulum and a seconds hand, the period's technical advances in timekeeping accuracy. Only the wheel of the fusee has been retained from the clock's original timekeeping train. The tall, thin movement plates were further lengthened to accommodate a new mainspring barrel. Two iron straps, secured with four gilt brass nuts, attach the movement to the clock dial. Three uncrossed iron motion work wheels lie directly behind the dial and are probably original.

The copper-colored center of the clock's dial was taken from another clock of about the same period. Four hands now indicate time on the five chapter rings. The two inner rings show the hours 1-24 and I-XII twice. Minutes are shown 1-60 on the third ring, while a similar outer ring indicates seconds. Below the central dial, a subsidiary dial shows quarter-hours. The gilded dial's original outer areas are delicately engraved with figures: a geographer with his globe and an astronomer holding an armillary sphere and compasses.

CONDITION: Little remains of the original movement. In addition to the alterations already mentioned, all of the clock's hands are replacements, the seconds and quarter-hour hands being modern. The case has been refinished and repaired inside the movement cavity, and the back door is possibly a replacement.

PROVENANCE: N. R. Fränkel; Frankfurt, purchased from a private collection, Switzerland.

PUBLICATIONS: Maurice, Klaus. *Die deutsche Räderuhr*. Munich, 1976, vol. 2, p. 84, fig. 662.

COMMENTARY: Wood-cased domestic clocks from early seventeenth-century south Germany are less common than those with metal cases. The earliest clocks had no cases and were open on all sides, but by the second quarter of the fifteenth century elaborate and delicate metalwork often surrounded the movements. By 1600 the majority of house clocks were encased. From about 1550 onward Augsburg clockmakers collaborated increasingly with furniture and cabinet makers who produced clock cases and bases veneered in highly polished ebony or black-stained fruitwood.[1] The contrast of such a case with the brilliance of the silver and gilded dials and case furniture is striking, and it poses a question as to why this black wood and metal combination was not more widely employed.

This tabernacle clock is so named from the resemblance of its case to the cupboard containing the consecrated wine and host in a Roman Catholic church. Its "eared" tabernacle form is similar to other Augsburg cases of the same period and, like them, is well adorned with rosettes and finials.[2] Within the alcove beneath the dial, a small female figure supports an urn on her head. Atop the urn is a pine cone, the symbol of Augsburg. The case is unusual in having both gilt and silver furniture. The clock's crowning finial, a female with a laurel wreath, is probably a replacement. WDT

1. Washington 1980, p. 121.

2. Maurice 1976, vol. 2, pp. 83-84, figs. 660-62.

10. Table Clock with Astronomical and Calendar Dials

Ludwig Hyrschöttel (Eirerschöttel)
Augsburg
ca. 1658
Gilt brass, gilt copper, brass, iron, blued iron, bell metal, and silver
25 1/2 x 16 x 16 in. (64.8 x 40.6 x 40.6 cm)
M1991.94

DESCRIPTION: This spring-driven table clock is in the form of a tower, with astronomical and calendar indications. The movement, set between gilt brass train bars, has trains for timekeeping, hour-striking, quarter-hour-striking, and alarmwork.

The timekeeping train with its chain fusee formerly had a balance-wheel verge escapement with a bristle regulator, but the complete escapement was removed during the nineteenth century. It was replaced by an anchor-recoil escapement regulated by a pendulum to improve the clock's timekeeping. A line of index marks for the bristle regulator remains on the upper plate of the movement frame, and a deeply scratched, dated inscription on this same surface suggests that the escapement conversion was done in 1855.[1]

The hour-striking and quarter-hour-striking trains also have chain fusees. Their functions are controlled by count wheels and they strike on separate bells in the two-stage cupola above the movement. Both of the finely finished bells have straight sides and are well tuned. The alarm train uses a verge escapement with a double-ended bell hammer to sound the alarm on the hour bell.

There are twelve dials for the clock's indications. The central dial on the front has an annual calendar and shows the sunrise and sunset hours throughout the year. A chapter ring, with hour hand, is engraved twice with the hours I-XII. Another chapter ring, also with its own hand, is engraved for the quarter-hours. At the upper corners are two subsidiary dials engraved 1-15 and 1-20. Neither dial has ever been connected with a mechanism and they exist solely to balance the appearance of the dial. The lower corners have dials to show the days of the week at the left, and the zodiac at the right. The last quarter-hour struck is indicated on the quarter-hour dial on the left side of the clock, while the indicating dial for the last hour struck is on the right side.[2]

One of the Augsburg masterpiece specifications stipulated that the clock must be able to strike both 1-12 twice, and 1-24.

The setting dial in the upper left corner at the back of the clock permitted the user to select either striking style. In the upper right corner is the regulation dial which was used with the previously fitted bristle regulator. A slight movement of the dial's hand would have moved the regulator to make the clock run faster or more slowly. The bottom left corner features a dial for the Dominical Letter and Epact Number, used for determining the date of Easter.[3] At the bottom right is the alarm-setting disc and the dial to show the hour for which the alarm is set. The central dial at the back of the clock has the rete and its tympanum, though the dragon hand is missing.[4] There is a chapter ring engraved 1-12 twice, with gilt brass sun and moon hands. These hands incorporate a disc showing the planetary aspects and the age and phase of the moon.[5]

The clock has a gilded brass and copper case with removable side panels for access to the movement. The lower section of the case contains repoussé cartouches of the Four Seasons, while at the corners of the ogive are four identical putti. Feet, in the guise of winged seahorses, must have been added to the case sometime after 1893 when the clock was published with a bronze and ebony base in the Spitzer sale catalogue.[6] Commonly, a four-dialed clock was placed on a base incorporating a turntable, and it is likely that this clock originally had such a base.

The upper parts of the case, including a double cupola over the clock's two bells, feature pierced and engraved floral decoration, baluster railings, finials, and pipe-playing putti. The lower part of the cupola is a gallery, while the upper part is surmounted with an empty cage of alternating, lathe-turned finials and pillars. Upon the top of the cage is an engraved dome, capped with a cast figure of a warrior.

CONDITION: The clock case is in good condition, with only minor damage and repairs. The dragon hand and the hands for the zodiac, Easter, and regulation dials are missing. The alarm hand is a replacement and the hour-striking-indication hand is broken. The pendulum is missing, as are the centers of the Easter and zodiac dials. The four feet of the upper section of the cupola are replacements and have not been drilled for the pins necessary to secure this part to the rest of the case. The warrior figure appears to be a replacement, but of the same period as the clock. One finial in the upper gallery is a replacement, and the lower case putti may originally have held musical instruments like their counterparts above. The winged seahorses are from a different clock, and the wood base for the clock is now missing.

MARKS AND INSCRIPTIONS: LUDWIG HYRSCHÖTTEL is signed on the quarters-striking train side, and AUGSPURG [sic] appears on the striking train side bar.

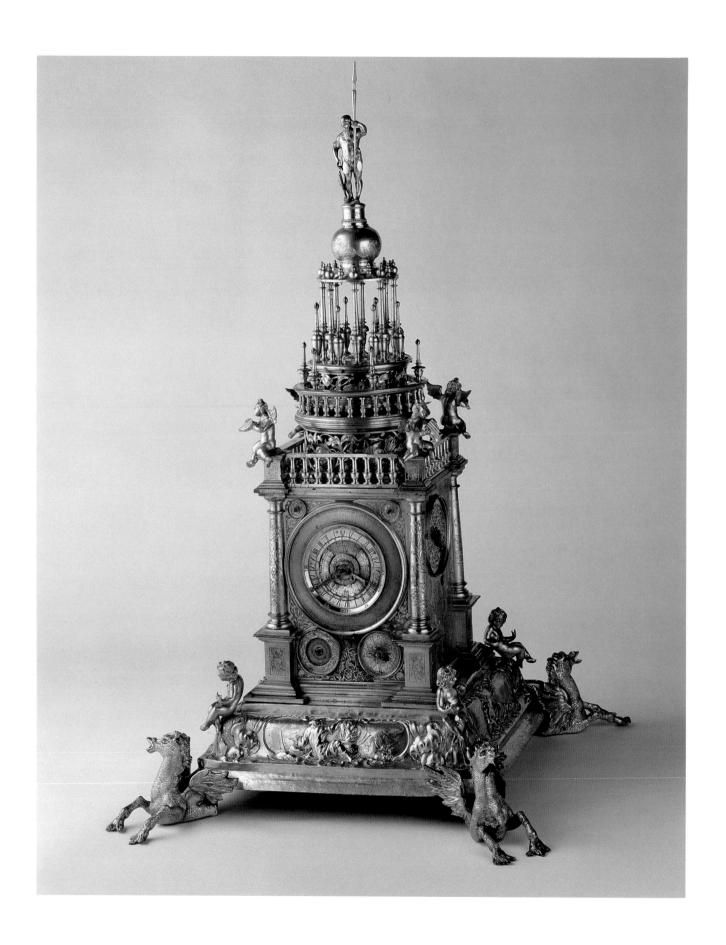

PROVENANCE: Frédéric Spitzer, Paris (sale, Paris, June 5, 1893, vol. 1, no. 2639, published as sixteenth-century German; illustrated with base, vol. 2, fig. 2639); Alfred Pringsheim, Munich; purchased from Rosenberg & Stiebel, New York.

PUBLICATIONS: *Catalogue des objets d'art…Collection Spitzer.* Paris, 1892, vol. 5, p. 35, no. 1; Maurice, Klaus. *Die deutsche Räderuhr.* Munich, 1976, vol. 2, p. 42, fig. 243.

COMMENTARY: The beginnings of Augsburg's craft guild system go back to the fourteenth century when clockmakers were included in a guild of general smiths sanctioned in 1368. The clockmakers gained autonomy in 1564, giving them complete control over their affairs.[7] To become an independent master within the Augsburg guild, an aspiring clockmaker was required to follow carefully prescribed steps. The first step was apprenticeship. An apprentice worked under a guild master for three years, learning the basic skills of the clockmaker. He then left to work as a journeyman for a further three or four years, honing his new-found skills. He could then apply to the guild for permission to make a masterpiece that demonstrated his understanding of the mechanical aspects of the trade. The guild assigned the journeyman to a master and he was given six months to complete his clock. If his masterpiece was passed and certain social obligations met, the new master was entitled to open his own workshop.[8]

The regulations governing Augsburg masterpiece clocks were strictly enforced and technical specifications changed little during the hundred years prior to Hyrschöttel's successful submission. By this time the process had become so ossified that working drawings of the required clock movement were readily available to aspiring masters. It was no longer necessary to design the movement, only to make it.[9] Many master clockmakers were incapable of calculating and designing the mechanism of a complex clock.

The case for a masterpiece clock was not subject to rigid constraints and a number of forms were popular. Here the clockmaker could demonstrate his individuality, although he often chose the tower form, as in this clock. By 1658 the Augsburg masterpiece was an obsolete horological *tour-de-force*, but updating the specifications was not undertaken until 1703.[10] The clocks, which were required to use the balance-wheel verge escapement, were outdated even as they were being made.[11] In 1657 at The Hague, Salomon Coster's simple timepiece had made its appearance. This little clock incorporated Christian Huyghens's most radical idea for the improvement of timekeeping accuracy: the use of a pendulum as the regulator. The pendulum's superiority over any other form of regulation then known was immediately apparent, with a daily timekeeping variation of fifteen to twenty minutes being instantly reduced to only one or two minutes.

Ludwig Hyrschöttel is documented among the clockmakers who worked for the Munich court of the Wittlesbach dukes of Bavaria.[12] He was granted his mastery in Augsburg on August 8, 1658, having fulfilled the examiners' requirements.[13] It is probable that this clock was his submitted masterpiece.
WDT

1. The choice of the "tic-tac" escapement (a member of the anchor-recoil family), and the style and manner of its execution, suggest a French origin for the conversion. The prominence and location of the cleaning mark, together with the lack of other marks on the movement, point to the likelihood of its inscriber being the converter. The date is in keeping with the use of this escapement in French clocks.

2. As the count wheel system of striking is not self-correcting, it is useful to indicate the last hour or quarter-hour that was struck.

3. For an explanation on the use of this dial, see Bassermann-Jordan 1964, pp. 47-57.

4. For information on astrolabe and astronomical dials, see King 1978, pp. 184-87, fig. 143.

5. For an explanation on the use of this dial, see Bassermann-Jordan 1964, pp. 81-83.

6. Spitzer 1893, vol. 2, fig. 2639.

7. Washington 1980, p. 58.

8. Ibid., pp. 59-62.

9. Ibid., p. 78, n. 134, p. 88, fig. 33.

10. Ibid., p. 68.

11. A similar masterpiece clock in the tower form by Matthaus Greillach of Augsburg appeared in Christie's New York, October 28, 1991, lot 183. The clock is remarkable in having retained its ebony turntable base and is thought by Maurice to be the only existing tower-form masterpiece clock to do so. Although it was made in 1668, the balance-wheel verge was still the mandated escapement. This clock was also once part of the Flagg private collection.

12. Maurice 1976, vol. 1, p. 135.

13. Ibid., vol. 1, p. 296. He registered in the Augsburg guild in 1658 as Ludwig Eirerschöttel.

11. *English Longcase Clock*

James Markwick (active 1666-1698)
London
ca. 1690-95
Brass, iron, silvered brass, blued iron, oak, walnut, and
laburnum veneer with boxwood and fruitwood inlay
84 1/4 x 17 1/2 x 10 1/2 in. (214 x 44.5 x 26.7 cm)
M1996.498

DESCRIPTION: This English eight-day longcase clock has
an anchor-recoil escapement regulated by a pendulum and is
driven by two weights. Six delicately turned brass pillars
separate the tall rectangular movement plates.[1] A striking
train sounds the hours 1-12 on a bell above the movement, a
count wheel determining the number to be struck. Blued iron
hands indicate the time on the clock's brass dial. The number
for the day of the month appears in a small aperture near the
bottom of the dial.[2] Large cast brass cherub-head spandrels fit
closely to the corner edges of the dial, suggesting that the
movement was initially housed in a case with a slide-up hood,
a style fashionable during the late 1680s and early 1690s.[3]

The present case features floral marquetry panels and the
ebonized twisted hood pillars typical of London clock cases
from the 1690s. Although made contemporaneously with the
movement, it is not the original case. The brass pendulum is
visible through a glazed window in the trunk door.

CONDITION: The escapement, date wheel, and bell are
replacements, and the weights are modern. Small, bun-shaped
feet were originally fitted to the case plinth.[4] The sound frets
and the hood's caddy top are replacements and the finials are
missing. The hood has been extensively repaired, and the
trunk door hinges are nineteenth-century replacements.

MARKS AND INSCRIPTIONS: IACOBUS
MARKWICK LONDINI is engraved at the bottom of the
dialplate.

PROVENANCE: Purchased from Callard of London
Galleries, Chicago, 1960.

COMMENTARY: The longcase clock probably originated
in Germany a little before 1600 as the pillar or pedestal clock,
its free-standing case designed to accommodate a weight-
driven tower-form clock.[5] Around 1658 Ahasuerus
Fromanteel, a Dutch clockmaker working in London,
developed an ebonized, architectural-style case, probably from
the German form, designed to completely enclose the clock's
movement and stand against a wall for stability.

This new style became particularly popular in Holland and
England, where it evolved in step with the brightening social
mood of the period. The severe proportions were softened,

and black gave way to lighter finishes. Geometric marquetry
was in use by 1675, followed by floral marquetry panels before
1685. James Markwick not only witnessed this evolution, but
also, more importantly, the introduction of the pendulum to
English clockmakers in 1657, less than a year after Dutch
mathematician Christian Huyghens had introduced it as a
workable regulator of the clock's escapement.

James Markwick was apprenticed to Richard Taylor on June
25, 1656, only one year after Taylor's own admission into the
Clockmakers' Company, London's trade guild for clock-
making. He was later transferred for further training to
Edmond Gilpin and attained his Freedom within the
Company on August 6, 1666, less than one month before the
disastrous Great Fire of London.[6] He made mostly spring-
driven clocks and watches, and died in 1698. Markwick's
work is often confused with that of his more famous son, also
James, who was admitted to the Freedom in 1692 and rose to
become Master of the Clockmakers' Company in 1720.

Markwick reportedly had an unpleasant manner and was often
at odds with his fellow clockmakers. During a ceremonial feast
at Goldsmiths' Hall on July 26, 1677, he and two other
Stewards slandered the Master of the Clockmakers' Company,
Jeremy Gregory. Markwick was fined the considerable sum of
five shillings, which he refused to pay. The case dragged on
until the following year, during which time the fine was raised
to twenty shillings. The Master for 1678, Nicholas Coxeter,
settled the matter by offering Markwick a compromise, which
he accepted: a fine of ten shillings, half to be donated to the
Company's Poor Box.[7]

This clock is an example of good London work. Its movement
is substantial, but delicately made, while the case, unsigned
like almost all London cases, is of the best construction with
well-executed marquetry and veneer work. WDT

1. The use of six pillars indicates good quality in a London clock. Tall
plates with latches securing the front plate suggest a date prior to 1695.

2. The layout and execution of the movement, the chapter ring's half-
hour marks, and the design of the hands are signatures of the Knibb
workshops. This clock movement may have been made by them for retail
sale by Markwick. For information on John and Joseph Knibb, see Lee
1964, pp. 40, 42, 48-51, 98, pls. 39, 41, 47-50, 93.

3. For the weekly winding, such a clock required a stepladder, a latch to
hold up the hood, and a high ceiling. Most lift-up clock hoods were later
altered to slide forward, or were fitted with a hinged door.

4. Frequent floor washings often caused clock case feet to rot. Moldings
replaced the feet and also made the case more stable.

5. Bassermann-Jordan 1964, p. 33, figs. 21a-b.

6. Atkins 1931, p. 191. The Company's Freedom entitled a clockmaker
to open a workshop, take apprentices, and employ journeymen.

7. Atkins and Overall 1881, p. 79.

12. *Astrolabe*

Italy or Germany
Late 16th century with later rete
Gilt bronze, brass, and brass polychrome
16 1/2 x 13 1/4 x 1 5/8 in. (42 x 33.7 x 4.1 cm)
Dia. of face: 13 1/4 in. (33.7 cm)
M1991.100

DESCRIPTION: This astronomical instrument consists of a cast bronze body, called the mater, and a rete, a fretted grille or star map. The mater dates from the late sixteenth century and the quality of its engraving would place it among the highest caliber of European scientific instruments of that period. The limb or rim of the mater is engraved on the rete side with an hour scale and, on the reverse, with a zodiacal calendar; the back is engraved with a shadow square, an unequal hour scale, and a personal emblem. The rete is imaginatively adorned with zoomorphic pointers that represent the brightest stars. A cast ring is attached for suspension.

CONDITION: The engraved latitude plates essential to reading an astrolabe are missing and the present brass rete is a nineteenth-century replacement. Its Neo-Gothic style is a product of the late nineteenth-century fascination with imaginative and usually nonfunctional "re-creations." The entire surface of the bronze mater has been coated with brass paint, probably to match the lighter tone of the brass rete. The alidade, or sighting bar, on the front appears to be original, but the pivoted rule and pin on the back probably are not. The mater of the astrolabe is an important example of Renaissance instrument-making; the later rete is equally important as an example of Gothic Revival metalwork.

MARKS AND INSCRIPTIONS: The limb is engraved on the reverse with a zodiacal calendar, each sign represented by its figure and inscription. The latter read: LIBRA, CANCER, ARIES, CAPRICO followed by the word MOBILE, LEO, SCORPVS, AQVARI, TAVRVS followed by FIXVM, and VIRGO, SAGITT, PISCES, GEMINI followed by COMVNE. The shadow square and unequal hour scale are flanked by the inscriptions VMBRA VERSA and UMBRA RECTA. Near the bottom is a cartouche with a bear licking her cub and the Italian motto DI GIORNO IN GIORNO [from day to day] written above in a scroll. This is probably the personal emblem and motto of the owner.[1]

PROVENANCE: Frédéric Spitzer, Paris (sale, Paris, June 5, 1893, lot 2781); N. R. Fränkel, Frankfurt; purchased from a private collection, Switzerland.

EXHIBITIONS: New York, The Metropolitan Museum of Art, The Cloisters, "Medieval Art from Private Collections," 1968-69.

PUBLICATIONS: *Catalogue des objets d'art...Collection Spitzer.* Paris, 1893, lot 2781 (as Italian); Frauberger, Heinrich. *N. R. Fränkel's Uhrensammlung.* Düsseldorf, 1913, no. 368 (as possibly from Augsburg); New York, The Metropolitan Museum of Art, The Cloisters, *Medieval Art from Private Collections.* Text by Carmen Gómez-Moreno. New York, 1968, no. 128 (as possibly Italian).

COMMENTARY: The astrolabe was once used to measure the positions of the heavenly bodies without mathematical calculation. Its name means "star-taking" in Greek and it is the oldest of all scientific instruments, probably originating in Alexandria in the first or second century AD.[2] The earliest surviving astrolabes are Islamic, and it is believed that the Muslims first introduced the instrument to medieval Europe when they occupied Spain in the tenth and eleventh centuries. The use of astrolabes spread quickly throughout Western Europe, with important centers for their production emerging in France, Germany, Flanders, and England.[3]

In its most usual form, the astrolabe is composed of two superimposed discs that reduce the celestial and terrestrial spheres to two plane surfaces by means of stereographic projection. The rete, or star map, is a stereographic projection of the positions of the brightest stars. The rete is cut away to show the earth with the circles on which astronomical measurements are taken: horizon, equator, meridians, and *almucantarats.* By turning the rete over these latitude plates, it is possible to reproduce the configuration of the sky in relation to the earth. Thus, the position of the stars and sun, the amplitude of their trajectory, and other astronomical facts can be determined. The backs of Renaissance astrolabes are usually outfitted with shadow squares used to measure angles and a zodiacal calendar.[4]

The astrolabe was the single most important scientific instrument available to astronomers, navigators, and surveyors until superseded by the telescope and sextant in the mid-eighteenth century. LW

1. Since it was believed that bear cubs were born formless and were literally "licked into form" by the mother, the emblem served during the Renaissance as a metaphor for the merits of daily progress in education and Christian conversion. Paul Connor has identified four families in Italy who used this emblem: Costa della Trinità, Malingri, Occlerio, and the Venetian painter Titian, who also used this emblem but with a different motto. Further research is needed to establish any links.

2. Turner 1987, p. 11. For the Islamic influence, see Pope 1939, vol. 3, pp. 2531-35.

3. Turner 1987, pp. 53-45.

4. Ibid., pp. 11-16. For additional examples of astrolabes, see Washington 1991, figs. 112, 121, 123.

Vessels, Tankards, and Tablewares

13. *Ewer Stand with the Judgment of Moses*

Pierre Reymond (1513-ca. 1584)
Limoges, France
1559
Enameled and gilded copper
2 1/4 x 18 1/3 x 18 1/3 in. (5.7 x 46.6 x 46.6 cm)
L290.1993

DESCRIPTION: This enameled ewer stand with scenes related to the Judgment of Moses is painted in grisaille on a black ground with gilded details. The central boss is set with a profile portrait of a woman, who is identified by an inscription as the Old Testament heroine Judith. Surrounding the boss is an opaque white border, a band of gold arabesques, and a second white band with a guilloche pattern. Moses on the Seat of Judgment and the related scene of Jethro's Counsel are represented against a continuous landscape on the plate around the center boss. Attendant figures include Moses's wife Zipporah, their two sons, Gershom and Eliezer, her handmaid, and surrounding supplicants. The cavetto is decorated with a gold arabesque design on a black ground. The surrounding flat border displays a grotesques procession of fanciful beasts: cynocephalic creatures, harpies, dragons, half-centaurs, dancing satyrs linked by fetters, and fauns and satyrs drawn by chariots. The rim has an opaque white edge.

The underside of the stand is ornamented on the convex plate with a laurel wreath entwined with heavy strapwork punctuated by alternating putto heads, lion masks, and draped Diana masks surmounted by crescent moons. The interstices are filled with gold foliate scrolls, and the rim is bordered by an acanthus frieze interspersed by four inscribed cartouches. Inside the boss is a horrific medallic portrait of the helmeted Assyrian general Holofernes, who was decapitated by Judith in a plot to liberate the Israelites from Assyrian oppression.

CONDITION: The ewer stand has been recently conserved and is in very good condition. There are minor cold repairs and enamel losses around the perimeter of the basin as well as some denting and slight warping. Spur marks on the underside probably resulted from stacking in the kiln during the firing process.

MARKS AND INSCRIPTIONS: The center medallion is inscribed IUDI VINCIT ..LOFERNES [Judith Conquers Holofernes] around the outer edge, revealed after conservation and not visisble in this photograph. MOYSE is written at Moses's feet and EXODE. 17 appears below the judgment seat. Two border cartouches on the back of the vessel bear the date 1559 and two others respectively PIERE/REXMON [sic] and P. R.

PROVENANCE: Baron Lionel de Rothschild, London; Mallet & Son, London; William Randolph Hearst, San Simeon, California; Parke-Bernet, New York, December 7-8, 1951, lot 203; purchased from French & Company, New York, 1958.

COMMENTARY: Throughout the later Middle Ages and Renaissance, the city of Limoges in south central France was the most important center in Europe for the production of enamelwork. The earliest *cloisonné* and *champlevé* methods of enameling were used during the Romanesque and Gothic periods in the embellishment of ecclessiastical objects such as reliquaries, shrines, and chalices. Following a lengthy decline in the fourteenth century, enamelwork was reinvigorated in the late fifteenth century by the creation of painted enamels on small copper plaques that emulated the pictorial effects of painting. Instead of the earlier cumbersome metal divisions to hold the enamel designs, this new technique relied on networks of drawn lines or grisaille underpaintings for the adhesion and division of the enamel colors.

Limoges School paintings in the late fifteenth and early sixteenth century were typically devotional in subject and were often created to be set into altarpieces in imitation of painted panels (see entry 59). In the course of the sixteenth century, grisaille, or monochromatic, under-paintings emerged from beneath the colored enamels as a separate and highly favored technique. Concurrent with this stylistic development was the soaring demand for luxury goods among a rapidly growing class of secular patrons. By mid-century, the religious component of Limoges production had all but evaporated.[1]

Among the aristocratic necessities of this new clientele were beautiful enameled tablewares in the form of chargers, ewers, *tazze*, and candleholders. Ewer stands with convex bosses and their matching ewers probably originated from the practical function of washing one's hands between dinner courses. However, contemporary documents suggest that Limoges vessels were rarely commissioned as sets for daily usage, but were instead sold and displayed separately as works of art on sideboards or buffets.[2]

Pierre Reymond headed the most prolific enamel workshop in sixteenth-century Limoges, and is best known for the creation of exquisite tablewares.[3] He is also credited with popularizing, if not originating, the grisaille and tinted grisaille techniques. His compositions are typically drawn from sixteenth-century engravings of the Old Testament and engravings associated with the Italian Mannerists at the court of François I and the School of Fontainebleau. This seemingly odd marriage of Old Testament subjects and bizarre, antique-inspired embellishments on the underside of these vessels may be seen as a reflection of the tensions that existed between Counter Reformation and Renaissance values at mid-century.

The subject of the Flagg ewer stand is based on the engravings by Bernard Salomon (ca. 1508-after 1561) that accompanied Claude Paradin's *Quadrins historiques de la Bible*, first published in Lyons in 1553, and again in an expanded edition in 1556 and 1558.[4] Paradin's *Quadrins* are simple narrative summaries of the biblical stories in the form of short, four-line verses known as quatrains. The Judgment of Moses on the Flagg ewer stand is derived from Paradin's narration of Exodus 18 and Salomon's print, in which Moses, judge of the Israelites, is urged by his father-in-law Jethro to appoint judges to help counsel in all but the most difficult cases.[5] Both the ewer stand and Salomon's print depict a similarly enthroned Moses, an elderly Jethro seated on the right, and adjacent figures that may be identified as Moses's wife, their children, and supplicants awaiting judgment. An error in the inscription on the Flagg vessel that misidentifies this subject as from Exodus 17, rather than 18, may have been a workshop mistake.[6]

Scenes from the life of Moses are common in the work of Pierre Reymond as well as in the workshops of other enamel painters, such as Jean de Court, Pierre Courteys, and Jean Reymond.[7] The rise in popularity of Old Testament imagery and especially the life of Moses have been attributed to the sobering influence of the Counter Reformation and the new emphasis on a stern and vengeful god.[8] The Flagg vessel's juxtaposition of Judith and Holofernes with the Judgment of Moses may initially seem unrelated and even a little disconcerting, but both Moses and Judith were widely recognized during the Counter Reformation for their acts of good judgment in the championship of an oppressed people. Both figures could be viewed as liberators and moral exemplars

in a time of spiritual turmoil.[9] LW

1. I would like to thank Susanna Bede Caroselli and Myron Laskin, Jr. for their assistance in preparing this entry. For a general discussion of the development of Limoges School painting, see Los Angeles 1993, pp. 11-43; Speel 1998, pp. 88-93.

2. Los Angeles 1993, p. 29.

3. The best sources on Pierre Reymond are Los Angeles 1993, pp. 80-133; Baltimore 1967, pp. XXIII-XXIV, 213-59.

4. Los Angeles 1993, pp. 124-25.

5. Ibid., p. 125. Paradin's quatrain for the Judgment of Moses reads: *Moise entend tout Israel plaider, Dequoy Iethro, esbahi de ses peines, Lui fait creer, pour en ce lui ayder, Bons & loyaux Iuges & Capiteines* [Moses hears all Israel plead their cases, whereupon Jethro, amazed at his labors, has him appoint good and loyal judges and captains to help him].

6. Similar images with the correct biblical citation appear on a number of vessels by Reymond. For these related examples, see Los Angeles 1993, pp. 122-23, no. 18; Moscow 1969, no. 36.

7. Los Angeles 1993, p. 124.

8. Susanna Bede Caroselli, letter, September 7, 1998.

9. For further information on Judith, see Stocker 1998, *passim*.

14. *Tazza with Moses Striking the Rock*

Jean de Court (active 1555-1585)
Limoges, France
ca. 1560
Enameled and gilded copper
4 1/4 x 9 1/2 x 9 1/2 in. (10.8 x 24.1 x 24.1 cm)
L279.1993

DESCRIPTION: This shallow footed bowl, or *tazza*, is painted in grisaille with salmon-pink flesh tints and gilded details. The interior scene of the basin represents the moment when Moses strikes water from the rock of Horeb at the command of God, who emerges from the clouds on the upper right (Ex. 17:5-6). Three elders of Israel observe the miraculous event while other bystanders and a dog in the foreground begin to quench their thirst. The background scene depicts the Israelite encampment and the subsequent Battle of Rephidim. The low wall surrounding this scene is decorated with an ornamental border of gilt arabesques on a black ground. The rim is edged in an opaque white enamel.

The underside of the basin is embellished with sculpturesque, scroll strapwork accented with four cartouches that contain respectively a reclining figure of a female river-god, a corresponding figure of a male river-god, a charging stag, and a charging bull. Directly under the cartouches are four grotesque masks—a horned satyr, a faun, and two devilish lions—that are linked by additional strapwork with cascading swags of fruit. The interstices and the upper wall are adorned with gold foliate scrolls on a black ground. An egg-and-dart border encircles the rim and an ovolo border articulates the junction of the bowl and foot. Small gold fleurs-de-lys and a center sunburst cover the interior of the foot.

CONDITION: The piece is in excellent condition. The foot has been reattached to the bowl with the aid of a visible tube and sprue reinforcement. Minor losses of white enamel occur around the edges of the bowl and foot ring, and there are a few cold repairs in the area where the foot has been reaffixed to the basin. The gilding is especially well preserved.

MARKS AND INSCRIPTIONS: The initials I. C. are painted on the underside in the border of the cartouche containing the stag.

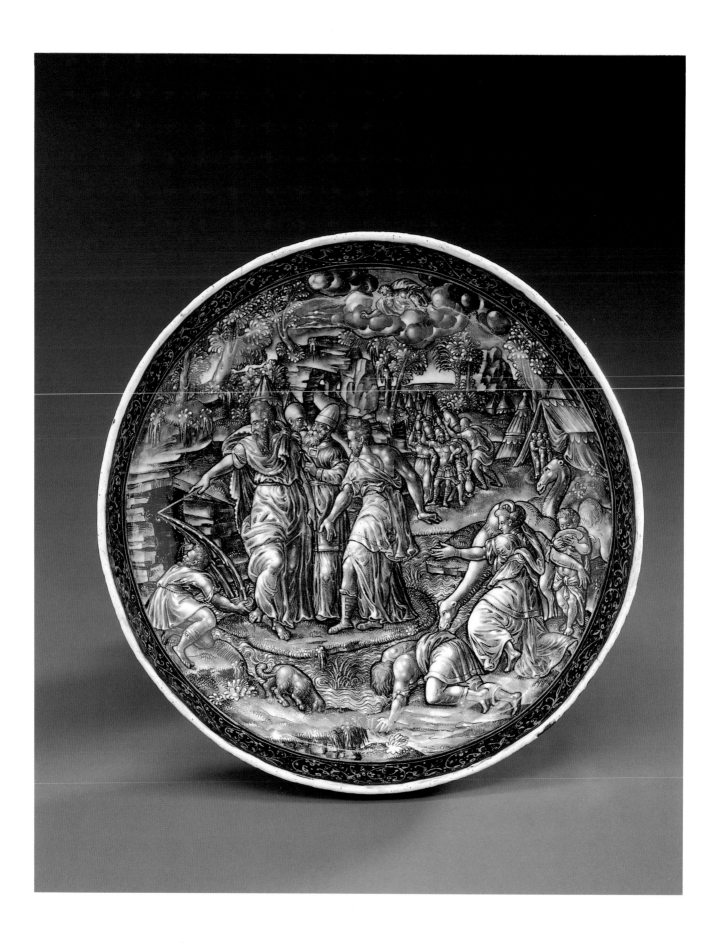

PROVENANCE: Purchased from French & Company, New York.

COMMENTARY: Today most scholars agree that the initials I. C. on the underside of this piece belong to Jean de Court, whose work was once erroneously attributed to two or three different Limoges artists.[1] The confusion about his identity arose from the various spellings and initials he used to sign his works. Celebrated as court painter to Mary Queen of Scots, from 1562 to 1567, and to Charles IX, de Court was also renowned as the director of a leading workshop in Limoges. The relatively few enamels produced by de Court and his workhop rank among the greatest masterpieces of the painted enamels of Limoges.[2]

Works attributed to de Court excel in the method of grisaille. Complex designs such as those on the Flagg *tazza* were achieved by covering a thin layer of opaque white enamel over an area of fired ground color, either a mulberry "black" or a dark blue. The resulting gray tone was further adjusted by additional layers of white enamel or by using a needle to scratch through the surface to reveal the dark enamel ground below, in a process known as *enlevage*. Successive firings of white enamel brushwork and dark cross-hatchings created refinements and nuances of detail and tone in the finished piece. Flesh tones were attained by adding thin washes of red enamel mixed with clear flux to the desired figures and details.[3] The effect of this painstaking buildup of layer upon layer was an exquisite range of pearly blue-grays, glossy blacks, and salmon-pinks. The taste for painted enamels in grisaille has been variously explained by the new religious conservatism of the Counter Reformation, the somber elegance of influential Spanish fashion, and the style and techniques of contemporary prints.[4]

The subject of the Flagg *tazza* is a much enriched version of Bernard Salomon's illustration for Exodus 17:5-6 in Claude Paradin's *Quadrins historiques de la Bible*, first published in 1553 and again in later editions.[5] Although Salomon's illustrations circulated widely as sources for the painter-enamelers of Limoges, each artist responded to them in a highly individualized manner. In contrast to Pierre Reymond's narrative scenes, which are characterized by a fluid and painterly perspective (see entry 13), de Court covered his vessels with calligraphic patterns of decoration and rich modulations in color that create a jewellike surface. His compositions typically appear crowded, yet animated by the elongated figures and elegant exaggerations of form and movement that he gleaned from the Mannerist figure style of Fontainebleau. The undersides of de Court's vessels are especially notable for their repertoire of inventive and bizarre motifs—strapwork, grotesques, cartouches, and arabesques—also derived from the School of Fontainebleau and the *maîtres ornemanistes*, who disseminated their designs throughout Europe in the form of prints.[6]

The Flagg *tazza* is related by its subject and exterior decoration to de Court vessels in the Walters Art Gallery in Baltimore, The Frick Collection in New York, and The Art Institute of Chicago.[7] Important collections of grisaille painted enamels are located in the Los Angeles County Museum of Art, the Walters Art Gallery, The Frick Collection, and in Europe in the Musée du Louvre in Paris, and The British Museum and the Victoria and Albert Museum in London. LW

1. De Court is also known as Jean Court, Jean Courteys, Jean Courtois, I. Curtius, Master I. C., and Master I. D. C. See Los Angeles 1993, p. 156.

2. Baltimore 1967, p. XXV.

3. For an explanation of the grisaille technique and its developmnet, see Los Angeles 1993, p. 21; Speel 1998, pp. 69-71.

4. Los Angeles 1993, pp. 27-28.

5. For a general discussion of Salomon's prints as a common source for Limoges painter-enamelers, see Los Angeles 1993, p. 28. Solomon's print of Moses Striking the Rock is cited in New York 1977, pp. 194-96.

6. Los Angeles 1993, pp. 32-35.

7. Baltimore 1967, pp. 316-19, nos. 172, 173; Chicago 1991, pp. 22-23; Bliss 1990, pp. 28-33, Monroe 1977, pp. 12-14; New York 1977, pp. 194-96, no. 16.4.38. For a ewer stand by Pierre Reymond with the same subject, see New York 1977, pp. 140-43, inv. no. 16.4.25.

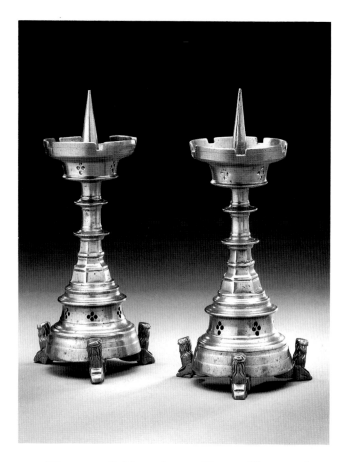

15. *Pair of Pricket Candlesticks*

The Low Countries
ca. 1400-50
Brass
Each: 10 1/4 x 4 1/2 in. (26 x 11.4 cm)
M1991.66a,b

DESCRIPTION: This pair of brass pricket candlesticks is composed of cast elements. In both, a shaped concave drip pan with a crenellated rim surmounts a five-part shaft that tapers upward in multifaceted tiers. The bases and drip pans are perforated by repeating designs of quatrefoil clusters. The prickets were cast independently and soldered into position. Each base rests on three stylized supports, fronted by separately cast slanted feet ornamented with squatting lions.

CONDITION: Both candlesticks show casting flaws and signs of wear. Their originally hollow stems have been weighted with lead to prevent them from tipping over. (a) Approximately half of the crenellated rim and a portion of the under edge of the candlestick lip have been reset with solder, and a crack in the pricket has been repaired. (b) A section of crenellation is missing from one side of the candlestick, and the pricket has been reattached.

PROVENANCE: Cassel van Doorn Collection, New York; purchased from Parke-Bernet, New York.

COMMENTARY: Light was a matter of social class during the Middle Ages. "The poorer the man, the darker his existence," writes Otto Borst in *Alltagsleben im Mittelalter* [*Daily Life in the Middle Ages*].[1] Windows were rare in fifteenth-century dwellings, and window openings covered with oiled canvas or tanned hides admitted little daylight into dark rooms. Candle illumination provided some relief, but since wax candles were beyond the means of the average person, most people made do with hearth fires, torches, and tallow candles, whose smoke and odor contributed little to the quality of life. Expensive brass candlesticks such as the Flagg pair were typically made for use in churches and were fitted with tall, straight candles made of beeswax.[2]

The earliest European candlesticks consisted of a candle impaled upon an iron spike called a pricket which projected from a block of wood. In the thirteenth century, the pricket was often supported by figures of animals or monsters which reappeared in the fourteenth century as the feet of tripod bases. At the end of the fourteenth century, candlesticks developed drip pans for catching wax and the flat base plate was replaced by a more stylish conical base, apparently inspired by traditional Middle Eastern designs. By the early fifteenth century, the conical candlestick had evolved into a tall, often lion-footed, bell-shaped base surmounted by a drip pan, as seen in the Flagg examples.[3]

Most brass candlesticks found in Western Europe were exported from the Meuse valley in The Low Countries, a region rich in calamine and copper used in brass production. The Flemish town of Dinant was the largest brass-producing center in Europe throughout the fourteenth and early fifteenth centuries. Metalwork from this region is known as *dinanderie*, a collective term which has now somewhat misleadingly been extended to the output of similar production centers in Western Europe.[4] The precise origin of the Flagg candlesticks is not known, but they represent a fairly common type and are nearly identical to two examples in the Rijksmuseum, Amsterdam, which are in turn related to candleholders in the churches of St. Nicolaas in Kalkar and St. Leonardus in Zoutleeuw.[5] EFG & LW

1. Frankfurt 1987-88, p. 25; Borst 1983, p. 248.

2. New York 1975, p. 22, no. 2; Turner 1982, p. 7.

3. For the evolution of European candleholders, see Frankfurt 1987-88, *passim*.

4. Ibid., p. 24.

5. Amsterdam 1986, nos. 109, 110, 117.

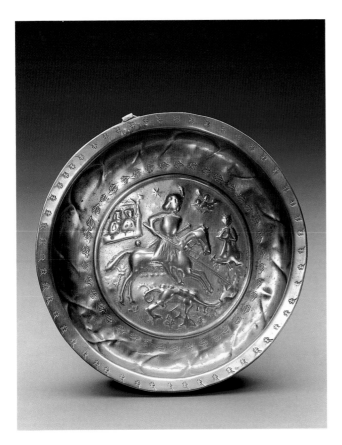

16. *Bowl with St. George Slaying the Dragon*

Probably Germany
ca. 1500
Brass
2 1/2 x 9 1/4 x 9 1/4 in. (6.4 x 23.5 cm)
M1991.79

DESCRIPTION: Formed of sheet brass hammered over an anvil, this deeply recessed basin was shaped in repoussé form from the back to create the scene of St. George Slaying the Dragon. Armed with lance and sword, the saint wears plate armor, datable to 1460-70, with a skirt and plumed beret from the period of the Emperor Maximilian I (1459-1519). The narrative scene is encircled by a chain of leaves punched into the raised metal. The sides of the basin are further embellished with encircling gadroons, and the rim is stamped with a repeated pattern of fleurs-de-lys. A suspension ring is attached to the rim.

CONDITION: The bowl is well worn. The faces and details of the narrative are severely rubbed. There are also a number of small cracks in the brass, probably the result of the painstaking and stressful technique employed.

PROVENANCE: Purchased from Blumka Gallery, New York, 1957.

COMMENTARY: This type of brass tableware is called *dinanderie* after the town of Dinant (in what is now Belgium), which from the thirteenth century until its destruction by the duke of Burgundy in 1466 was the chief producer of hand-hammered metal dishes such as this one. After 1466, many of the uprooted Dinant metalsmiths settled in the mineral-rich area of Nuremberg where they established themselves as *Beckenschlaege* or brass beaters.[1] These artisans eventually located throughout Europe, so distinguishing the country of origin and precise date of such objects is often problematic.

The Flagg bowl is an excellent example of the kinds of more modest, less profusely decorated *dinanderie* that were made for domestic use. Its worn condition suggests that it may have functioned as a water basin or been used to serve food. Despite the great demand for these dishes (which appear in countless fifteenth- and sixteenth-century paintings and figure in numerous collections), the strenuous brass-beating process was not replaced by casting until well into the sixteenth century. Until then the same scenes were "mass-produced" by hand.[2]

A favorite subject in later medieval art, St. George is shown here as a medieval knight slaying the dragon in order to rescue the endangered princess. A metaphor for the triumph of good over evil, this popular story embodied the chivalric and religious ideals of feudal Europe.[3] The design on this bowl was probably based on early fifteenth-century religious woodcuts, such as those distributed at pilgrimage centers, or possibly a small roundel of *St. George Slaying the Dragon* by Martin Schongauer (ca. 1430-1491).[4] This scene occurs on a number of bowls variously dated in the fifteenth and sixteenth centuries and attributed to Nuremberg and Flemish workshops. Closest to our piece in its more restrained ornamentation is a sixteenth-century example from Nuremberg, located in the Rijksmuseum, Amsterdam.[5] EFG

1. New York 1962, p. XL. The distinctive yellowish tinge of the copper alloy from which they are made comes from the zinc found in the Dinant region.

2. Ibid., pp. XL-XLVI.

3. For a discussion of the dragon and its morphology, see White 1960, pp. 164-67.

4. For reproductions, see Bartsch 1978, vol. 8, pt. 1, p. 186, no. 057.

5. Amsterdam 1986, no. 229. For reproductions of bowls with nearly identical center designs, see Katonah 1995, p. 15, fig. 37; Sotheby's New York, May 31, 1995, lot 71; "Die Sammlung Dr. Albert Figdor," Paul Cassirer Vienna, September 29-30, 1930, vol. 5, lot 509.

17. *The Erb Tankard*

Kornelius Erb (ca. 1560-1618)
Augsburg
1580-85
Silver
5 3/4 x 7 1/4 x 5 1/8 in. (14.6 x 18.4 x 13 cm)
M1991.85

DESCRIPTION: Resting on a splayed foot with plain ribs and decorative moldings, this forcefully profiled and extravagantly embellished tankard is of gently tapering cylindrical form. Its central barrel is raised from a single seamed sheet of silver bisected with a radiating ribbed collar. Two intervening tiers are each inset with four cast portrait medallions depicting Central European monarchs within tied laurel wreath borders flanked by recessed zones of etched moresques. Ascending in a series of ornamented domes, the flat platform of the cover is inset with a medallion depicting Adam and Eve in Paradise on the obverse and the Expulsion from the Garden on the reverse. The cast thumb-lift of a Bacchanalian infant atop a keg alludes to the tankard's function. From the riveted hinge issues the independently cast handle enlivened by a griffinesque creature with a tubular appendage protruding from its mouth. Immediately overhead is a cherub mask, and the lowermost scrolled portion of the handle terminates in a stylized lion's head.

CONDITION: The surface ornamentation is severely blurred due to overcleaning. Vestiges of gilding remain on the lid medallion and on a few portrait roundels.

MARKS AND INSCRIPTIONS: The maker's mark of Kornelius Erb appears on the tankard, as does the assay mark for Augsburg, 1580-85.[1] The legend on the medallion's obverse reads: DIXIT DOMINVS ECCE ADAM QVASI VNVS EX NOBIS FACTVS EST SCIENS BONVM ET MALVM GEN[ESIS] III [The Lord said Behold Adam has become like one of us knowing good and evil. GEN. 3:22]. The date 1549 appears in the exergue. The legend on the reverse states: ET DOMINVS EIECIT ADAM EX PARADISO ET COLLOCAVIT ANTE PARADISVM CHERV[BIN] ET [FLAMMEVM] [GLADIVM] GE[NESIS] III [And the Lord ejected Adam from Paradise and placed in front of Paradise a cherub and a flaming sword. GEN. 3:24].

PROVENANCE: Purchased from James Graham and Sons, New York.

COMMENTARY: Tankards–drinking vessels with a single handle and usually a hinged cover–were produced in large quantities throughout the German-speaking countries and elsewhere in Northern Europe, where beer and ale were preferred to wine.[2] Those in silver were the most highly favored because their costliness reflected the exalted social standing and cultivated taste of their owners.

Originating in Germany, silver tankards remained a staple commodity of goldsmithing workshops throughout the Renaissance and Baroque periods. Elongated, slender examples prevailed in North Germany, whereas squatter, broader proportioned examples like this one were popular in South Germany. The basic form, the fanciful handle, and the infant Bacchus thumb-grasp of the Flagg tankard share an affinity with those recorded in a drawing of a now destroyed tankard by the German painter Hans Mielich (1516-1573).[3] The portraits derive from engravings of European nobles from about 1541 by the Nuremberg ornamental designer Virgil Solis (1514-1562). The upper register portrays King Sigismund II of Poland, the Queen of Poland (Barbara Radziwill?), and King Christian III and Queen Dorothea of Denmark, and below are the Emperor Charles V, his wife Isabella of Portugal, the King of Sweden (Gustaf I?), and the Queen of Sweden (Margareta Eriksdotter?).[4] The biblical scenes on the Genesis medallion are adapted from two prints from 1540 by the German print-maker Heinrich Aldegrever (1502-1555/61).[5]

Tait has judiciously referred to Kornelius Erb as "one of the most talented craftsmen that this great centre [Augsburg] could boast."[6] Born in Genoa, Erb settled in Augsburg, where in 1586 he wed Magdalena, daughter of the goldsmith Marx Grundler I (master before 1560- died 1596). Erb's master-works certainly include the silver ewer and basin and the six *tazze* created for Wolf Dietrich von Raitenau, the Archbishop of Salzburg (1587-1612).[7] Erb's oeuvre demonstrates his propensity for ostentatious surface enrichment and a reliance on the graphic arts as direct sources of inspiration. JRB

1. Seling 1980, vol. 3, pp. 18, 541, nos. 1009, 13.

2. Regarding the development of early European tankards, consult Hernmarck 1977, vol. 1, pp. 120-25; Newman 1987, pp. 314-315; Coradeschi 1994, pp. 23-27.

3. This sheet is reproduced by Schroder 1983, pp. 81-83, no. 19.

4. For the portrait designs, see O'Dell-Franke 1977, p. 49, ns. 31, 33, pp. 52, 57, 156, nos. H50, H51, H53, pl. 94. For the similarity of the moreseque strapwork to designs by Solis, see ibid., pp. 27, 63, 193-94, nos. M67, M68, pl. 146.

5. Aldegrever's prints are illustrated by Hollstein 1954, vol. 1, pp. 6-7, nos. B4, B5. For plaquettes based on these prints, consult Weber 1975, vol. 1, pp. 137-38, nos. M198, 2, M198, 4, M198, 5, 198, 2, 198, 4, 198, 5; vol. 2, pls. 60, 61.

6. London 1988, vol. 2, pp. 153-60, nos. 22, 23, col. pl. 6.

7. Works by or attributed to Kornelius Erb are published in Weber 1969-70, pp. 323-68; Seling 1980, vol. 1, pp. 64, 67-69, 71, 80, 240, 242, 248, 252-53; vol. 2, pls. 69, 70, 89, 132, 182-84.

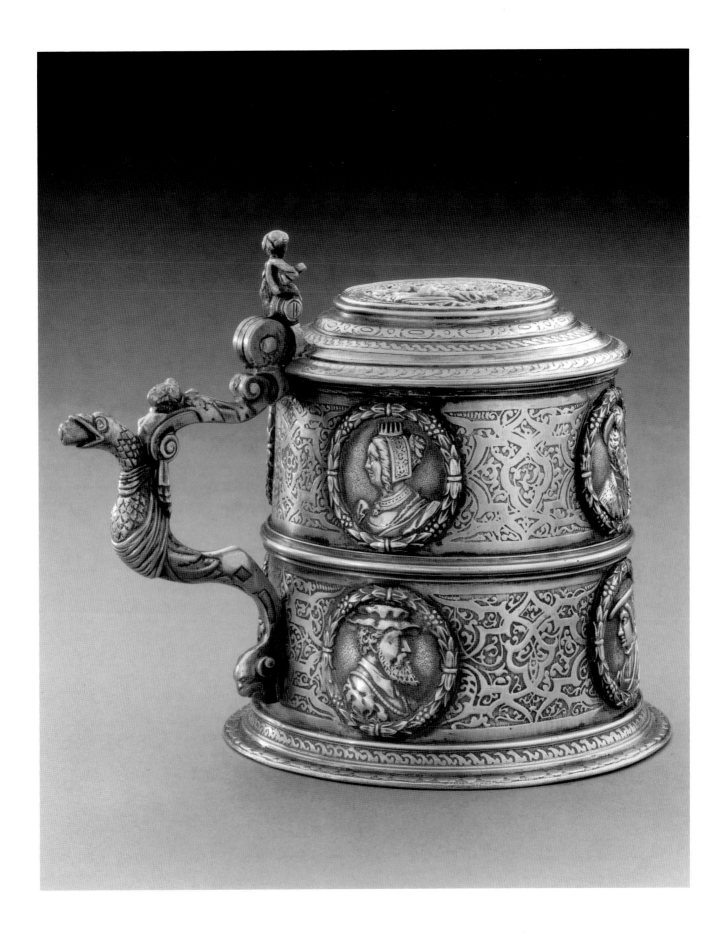

18. *Ivory Tankard*

Possibly Nuremberg, Regensburg, or Coburg, Germany
ca. 1600-25
Ivory with silver gilt mount
8 x 7 x 5 1/8 in. (20.3 x 17.8 x 13 cm)
L286.1993

DESCRIPTION: This finely grained ivory tankard has a lathe-turned ripple pattern on the drum and lid. The color is primarily a yellowish white with veining. The gadrooned lid, base, and two innermost sections of the lid are separately worked pieces. Silver gilt mounts encase the edges of the base and lid, and narrow bands along the edges of the body create junctures for the attachment of the lid and handle. The finial surmounting the vessel is composed of five separate openwork petal clusters. On the scrolling handle are two playful putti. The thumb-grasp is volute-shaped with winged cherubs at the upper corners flanking an acanthus scroll.

CONDITION: There are some losses to the points of the scalloped mount encircling the foot. A small chip in the ivory lies beneath the lower silver band, and minor cracks are discernible underneath the base near the edges. The floral finial and its retaining screw are probably modern replacements. The ball-bearing-like hinge attaching the handle to the lid is also of later date. Variations in the color of the ivory may indicate that some areas have been repeatedly handled.

PROVENANCE: Purchased from Blumka Gallery, New York, 1968.

COMMENTARY: Ivory drinking vessels with hinged lids were fashionable necessities of the aristocratic lifestyle in the late sixteenth and seventeenth centuries. The silver gilt mount was designed to join the pieces as well as create a noble frame for the rare and exotic ivory. Such works rarely functioned as daily beermugs, but were instead collected by princes and wealthy patricians for display in their "cabinets of curiosities" (*Raritätenkabinetten*) and "art and curiosity chambers" (*Kunst- und Wunderkammern*).[1] These ingeniously turned and carved vessels were admired as much for their artfulness as for their scientific and technical achievement.

Lathe-turning as an art form originated in the fourteenth century and reached its zenith in popularity during the seventeenth century. This was due in great part to the late sixteenth-century invention of a more efficient machine lathe that incorporated steel leaf springs instead of simple poles for turning, thereby permitting the creation of extravagant hollow-turned spheres-within-spheres, helical spirals, and other displays of virtuosity.[2] While most ivory vessels combine lathe-turning with carving, the Flagg tankard is rare in its emphasis on the purity of the turned ripple design, a motif that may also whimsically allude to the beverage inside.

The leading center for the production of lathe-turned vessels was Nuremberg, followed closely by Regensburg and Coburg.[3] Nuremberg's Zick family worked in ivory carving and turning for more than two hundred years, through five generations, from the mid-1500s to the mid-1700s. Other renowned turners worked in Regensburg where the Teuber family's output spanned three generations, and in Coburg where noted artists Marcus Heiden and Johann Eisenberg were active from the early- to mid-seventeenth century.[4] Although the absence of a maker's mark, which may have appeared on the original finial, now makes it impossible to distinguish a specific hand or even location, the Flagg vessel's emphasis on an abstract, geometric vocabulary is more characteristic of the genenera-tion of turners working around 1600 than the generation later, who embraced a figurative, more flamboyant style.[5] LW

1. Hartford 1986, p. 104.

2. MacGregor 1985, p. 59.

3. Christian Theuerkauff, letter, April 28, 1998.

4. Burack 1984, p. 22; Philippowich 1961, pp. 306-310.

5. For examples of later carved ivory vessels with figurative handles, see Hartford 1986, nos. 31, 32.

19. *Tankard*

Fridrich Vicke (master 1615-died 1666)
Breslau, Germany (Wrocław, Poland)
ca. 1620
Parcel-gilt silver
5 3/4 x 6 3/4 x 4 7/8 in. (14.6 x 17.1 x 12.4 cm)
L288.1993

DESCRIPTION: This stout, cylindrical tankard is surmounted by a baluster finial set within openwork brackets and bolted inside the multistepped, domed cover. Above the flaring brim of the lid is an embossed frieze of strapwork and fruit sprays which corresponds to one encircling the wide convex dome immediately over the spreading foot ring. Enframed by narrow borders of twisted wire, the sheeted body is flat-chased with a carefully spaced register of cherub heads, fruit baskets, dangling festoons, and curvaceous strapwork on a matted ground. A thumb-lift cast in the form of a mermaid appears above the swivel-pin hinge from which springs the scrolled and beaded handle.

CONDITION: Slight scratches and dents are evident, and the gilding is rubbed. The head of the thumbpiece is lost.

MARKS AND INSCRIPTIONS: The maker's mark of Fridrich Vicke and the assay mark for Breslau appear on the tankard.[1] Scratched beneath the base plate are the letters R.D.M.G.F., presumably the initials of a previous owner.

PROVENANCE: Possibly from the collection of P.A. Kotschubey, St. Petersburg, 1885; purchased from Blumka Gallery, New York, 1968.

COMMENTARY: Due to Poland's turbulent history and constantly shifting geographical boundaries, most of the silver plate created there has perished.[2] What has survived consists mainly of liturgical objects from secluded church treasuries, creating a distorted impression of its once thriving goldsmithing industry, which was sponsored by princely rulers, such as King Sigismund III (1566-1632), himself an amateur goldsmith.[3]

This rare tankard was created in Breslau, a significant cultural and commercial city on the Oder (Odra) River. Its shape and ornamentation betray its artistic indebtedness to tankards that first appeared in Nuremberg and Augsburg, and were widely imitated throughout Northern Europe, with individual examples often incorporating regional characteristics.[4] The Flagg tankard is most closely related to two other tankards made in Breslau, one dated to about 1599 and the second to about 1695, and less specifically to a number of tankards produced in Danzig (Gdansk).[5] This wide chronological span underscores the longevity of this class of tankard, while confirming the somewhat conservative nature of the goldsmiths active in Breslau. Regrettably, little is known about Fridrich Vicke. Rosenberg records only two works by him: a chalice dated 1620 at the Muzeum Archidiecezjalne in Breslau and a tankard formerly in the Kotschubey Collection in Russia, which may in fact be the one published anew here.[6] JRB

1. Rosenberg 1922, vol. 1, pp. 310, 318, nos. 1416, 1367.

2. On Polish goldsmithing, see Wyler 1937, pp. 157-58; Gündel 1940, *passim*; Cracow 1972, *passim*; Hayward 1976, pp. 276-79.

3. Regarding Sigismund III, consult Wisner 1984, *passim*; Hayward 1976, pp. 277, 279, ns. 42, 43.

4. Similar works are published by Hayward 1976, pp. 355, 386, pl. 503, Seling 1980, vol. 1, pp. 248-49, nos. 134, 135, 137-39, 143,144; vol. 2, pls. 134, 135, 137-39, 143, 144; Nuremberg and Munich 1985, pp. 117, 252, no. 68, figs, 22, 89. Surviving pattern designs for this kind of tankard are reproduced in Hayward 1976, p. 355, pl. 181; Nuremberg and Munich 1985, pp. 146, 381, no. 393, fig. 118.

5. Consult Gündel 1940, pp. 26-27, 36, pls. 37, 63; Cracow 1972, pp. 58-62, nos. 23-27, figs. 22-26.

6. Rosenberg 1922, vol. 1, p. 288, nos. 1366, 1367; Thieme-Becker 1940, vol. 34, p. 328.

20. *Beaker*

Norway
Possibly ca. 1600
Parcel-gilt silver
6 5/8 x 3 5/8 x 3 5/8 in. (16 x 9.2 x 9.2 cm)
L284.1993

DESCRIPTION: This relatively small, gracefully proportioned, and austerely ornamented beaker is uplifted on three feet cast in the form of lions crouching on top of rectangular plinths. The hand-raised body of the goblet is of inverted trumpet shape with subtly tapered contours. Two independently worked bands envelop and invigorate the otherwise sleek outer surfaces of the bowl. The upper one is composed of a pierced Gothic frieze studded with three stylized leonine masks interspersed within a rhythmically spiraling network of interwoven scrolls and branches. The narrower, corded trail below is positioned at the point where the vessel begins to widen again. Plain, multitiered moldings are applied to the upper edge of the brim and to the bottom of the outwardly flaring base above the feet. The interior of the receptacle descends only to the level of the corded fillet.

CONDITION: A small area of the brim is dented. Tinges of gilding are barely detectable on the lip, decorative bands, foot ring, and lion supports.

MARKS AND INSCRIPTIONS: Three unrecorded hallmarks are punched on the circular disc underneath the beaker. The initial M engraved on the face of the bowl is apparently that of a later owner.

PROVENANCE: Purchased from Blumka Gallery, New York, 1968.

COMMENTARY: Whether intended as ceremonial or everyday drinking receptacles, beakers are normally deeply elongated, broadly lipped, and handleless vessels. Of ancient origin, beakers were highly esteemed as treasury pieces during the Middle Ages, but in the Renaissance, Baroque, and subsequent epochs they were more often used as modest cups.

This beaker was created in Norway, where silversmithing was centered in major urban locations such as Bergen, the largest city in Scandinavia during the Renaissance. It belongs to a special category of Norwegian or "Hanseatic" beakers of Late Gothic character that were produced in significant quantities from the sixteenth through the eighteenth century.[1] With the emergence of historicism in the nineteenth century, copies and imitations of these medievalizing objects–many with the addition of forged Bremen, Lübeck, or pseudo-hallmarks–were abundantly manufactured. Even as recently as the period between 1960 and 1980, clever forgeries were marketed openly as Renaissance pieces.[2]

The Flagg beaker was examined by emission spectroscopy, atomic absorption spectroscopy, and potentiometric titration. The results provided no clear indication that the beaker dates to the nineteenth or twentieth century. The marks were also examined by a special microscope combined with a video camera and a thermo-transfer printer, but they remain untraced. Dr. Ernst-Ludwig Richter cautiously summarized that "the question of [the] authenticity of the Norwegian beaker of the Milwaukee Art Museum strongly depends on further research and final interpretation of the marks. If it is possible to identify these marks and to find a relation to a certain town, the beaker may be authentic."[3] JRB

1. The literature pertaining to these beakers includes Richter and Kommer 1979, pp. 63-76; Richter 1982, p. 105, nos. 95, 96, both with citations to further bibliographical materials.

2. See Richter and Kommer 1979, pp. 68-69; Richter 1982, p. 105, no. 96.

3. Dr. Ernst-Ludwig Richter, Scientific Examination Report, Stuttgart, Germany, July 12, 1998, p. 3. Richter points out that the unrecorded town assay mark on the Flagg beaker is also found on two beakers at the Kunstindustriemuseum in Oslo (inv. nos. 9726 and O.K. 14316), and on two other examples currently in Scandinavian private collections.

21. *The Leipzig Pokal*

Christoph Leipzig (master 1639-1678)
Augsburg
1635-45
Silver gilt
24 x 8 x 8 in. (61 x 20.3 x 20.3 cm)
M1991.92

DESCRIPTION: This magnificently decorated, soaring *pokal* or standing cup with cover is expertly constructed from nine individual sections screwed and bolted together. A cast putto standing on a simple sleeve encircled by pierced and voluted brackets serves as the finial on the double-domed lid. Repeating ovolos adorn the uppermost zone of the smaller dome, and the larger dome below is embossed and chased with three cartouches of tritons, each separated by reserves with fruit and gourd clusters. The overhanging flange of the cover is articulated with a simple band of dentil ornament, but the inverted dome immediately below the lip of the cup is once again decorated with three cartouches containing the reclining mythological figures of Mercury, Neptune, and Ceres–personifications of the natural elements of air, water, and earth–set between three cast and applied cherub-head surrounds.

Enframed by projecting moldings with leaf-and-petal flourishes, the recessed central drum of the *pokal* is dominated by three standing and twisting female figures beneath arcaded niches with richly tooled backgrounds flanked by registers filled with fruit sprays. The convex dome at the bottom of the bowl is embellished with scrolls carrying male and female busts alternating with female herms. The complex, spoolform stem below is composed of an upper shaft encased behind open-work brackets, a middle knop ornamented with strapwork and female busts, a lower shaft rising from tiered moldings, and a dentilated and scallop-edged platform. A spreading circular base with rosette-headed brackets and a lower band of interspersed strapwork, foliage, and leonine masks supports the entire vessel.

CONDITION: The *pokal* is in excellent condition and lacks only the staff originally held in the raised hand of the putto. In isolated areas the gilding is worn, and there are scratches to the metal surface. Minor warpage is apparent on the outermost edges of the cover and along the foot ring.

MARKS AND INSCRIPTIONS: The maker's mark of Christoph Leipzig and the assay mark of Augsburg for 1635-40 or 1640-45 are punched on the vessel.[1] The family crests of the Dukes of Buckingham–Grenville, Temple, and Brydges– are engraved beneath a ducal coronet on the waisted stem of the base.

SCRATCH WEIGHT: 7O x 5d (70 oz., 5 dwt.).

PROVENANCE: Richard Grenville (1776-1839), Second Marquess of Buckingham, KG, Earl Temple of Stowe, Second Duke of Buckingham and Chandos, Stowe Manor, Buckinghamshire (Christie's London, August 15-October 7, 1848, lot 326); R. Harvey, Esq., Langley Park (1848); purchased from S. J. Phillips, London, 1971.

PUBLICATIONS: Forster, Henry Rumsey. *The Stowe Catalogue. Priced and Annotated.* London, 1848, p. 123, no. 326.

COMMENTARY: A *pokal* was one of the most spectacular and characteristic types of secular treasures fashioned by the Renaissance goldsmiths active in Augsburg, Nuremberg, and elsewhere in Germany.[2] Evolving from medieval prototypes and produced in prodigious numbers, these lavish vessels were an explicitly Germanic invention which continued to be created throughout the German-speaking world for centuries in a wide variety of forms. These range from the early Gothic cups of spiraled lobate shape to the more symmetrically balanced Renaissance *pokals* with gadrooned domes embossed and chased with classically inspired Italianate motifs. The latter gave way to Mannerist cups of extraordinarily complicated design with multiple levels and flamboyant surface ornamentation–of which *The Leipzig* Pokal is a stellar example.

Never intended for mass-consumption or daily use, these highly prized vessels were presented as gifts to visiting dignitaries and ambassadors by members of the nobility or city officials, or used in special ceremonies conducted by the guilds or fraternal organizations which often commissioned them. Rich burghers exchanged them as wedding gifts or retained and cherished them as reminders of their own wealth and lofty social status. Membership in the goldsmiths' guilds in Augsburg and Nuremberg required that a candidate submit a masterpiece *pokal*, a gold ring, and a seal-die before being admitted as a master goldsmith.[3]

The Flagg *pokal* bears an Augsburg town assay mark consistent with the ones punched on goldsmiths' works created there in or around the year 1639, suggesting that this is conceivably the masterpiece *pokal* of Christoph Leipzig, whose mark appears on the piece. Although only a few biographical facts about this somewhat elusive goldsmith are recorded, we know that he was born in Calw, a small town in southwestern Germany.[4] Leipzig was first married in 1639, a factor consistent with the Augsburg guild stipulation that prohibited a potential member from marrying before finishing his masterpiece, and he wed again in 1675, three years prior to his death in Augsburg in 1678.[5]

His oeuvre numbers fewer than a dozen surviving works found in major European collections.[6] These include several tankards and at least two other *pokals*–one in the form of a cock crowing and the other in the shape of a ship–neither of which might be regarded as his masterpiece *pokal*, because unlike the Flagg *pokal*, they do not adhere to the traditional designs for such works.[7] Interestingly, one of Leipzig's tankards at the Museum für Kunsthandwerk in Frankfurt is decorated with mythological deities in a style akin to those that fill the cartouches on *The Leipzig* Pokal.[8] Moreover, our *pokal*'s basic form and salient ornamental features share an affinity with the specific sort of *pokal* first popularized by the Nuremberg goldsmith Wenzel Jamnitzer (1508-1585).[9] Similar covered cups are often depicted in seventeenth-century Dutch still-life paintings, whose viewers were meant to ponder the vanity of such earthly splendors.[10]

The desirability and historic distinction of the Flagg *pokal* is further enhanced by its noble pedigree. It descends from the vast art collections of the Dukes of Buckingham.[11] When they acquired it is uncertain, but the crests of Grenville, Temple, and Brydges must have been engraved after Richard Grenville (1776-1839), Second Marquess of Buckingham, wed Lady Anna Eliza (1779-1836), daughter and sole heiress of James Brydges (died 1789), Third and Last Duke of Chandos, in April 1796.[12] JRB

1. Seling 1980, vol. 3, pp. 20, 533, nos. 62, 63, or 65, no. 1497.

2. Concerning the history and development of the *pokal* in Renaissance Germany, see Hayward 1976, *passim*; Hernmarck 1977, vol. 1, pp. 89-109; Pechstein 1978, pp. 180-87; Seling 1980, vol. 1, pp. 72-81; Nuremberg and Munich 1985, pp. 107-122.

3. On this requirement for guild membership, consult Weiss 1897, p. 49; Hayward 1976, pp. 38-39; Pechstein 1978, p. 181.

4. For information about Christoph Leipzig's life and work, see Rosenberg 1922, vol. 1, pp. 116-117, nos. 584, 585; Thieme-Becker 1928, vol. 22, pp. 597-98; Seling 1980, vol. 1, pp. 112, 114-115, p. 216, n. 497, p. 217, ns. 519, 521; vol. 3, pp. 186, 517, 533, no. 1497; Seling 1994, vol. 4, pp. 36, 111, no. 1497.

5. Regarding the severe guild stricture pertaining to marriage, see the comments of Hayward 1976, p. 43.

6. Lists of Leipzig's known works are provided by Rosenberg 1922, vol. 1, pp. 116-117, no. 584, 585; Seling 1980, vol. 3, p. 186, no. 1497, Seling 1994, vol. 4, p. 36, no. 1497, both of which also cite bibliographical references to the literature dealing with individual pieces by this goldsmith.

7. Some of the tankards and *pokals* by Leipzig are published independently, for instance, in Amsterdam 1952, p. 67, no.170; Augsburg 1968, pp. 331-32, no. 480, fig. 273; Munich 1970, pp. 350, 376, no. 1174.

8. Frankfurt 1981, p. 25, no. 35.

9. For the influence of Jamnitzer's work on *The Leipzig* Pokal, compare the latter with Jamnitzer's *pokal* of ca. 1565-70 and designs from his workshop published by Hayward 1976, pp. 350, 354, pls. 128, 169-72; Nuremberg and Munich1985, pp. 230-31, 339-40, nos. 25, 295, col. pl. 14. The aquatic figures on the lid of our *pokal* also recall those in an engraved design by Adriaen Collaert of Antwerp, illustrated in Hayward 1976, p. 356, pl. 195.

10. For the representation of cups similar to ours in Dutch paintings, consult Nuremberg and Munich 1985, p. 7, fig. 6; San Francisco 1990-91, pp. 160, 162, 211, nos. 7, 16, figs. 2, 4.

11. The best source for the art collections of the Dukes of Buckingham remains Forster 1848, *passim*.

12. Our *pokal* is described in Forster 1848, p. 123, no. 326, and in Christie's London, August 15-October 7, 1848, lot 326, as "A superb chalice and cover–embossed with figures, scrolls, and arabesques of very fine ancient work, the cover surmounted by a figure of a child– a magnificent ornament: 71 oz." For the genealogy of the Dukes of Buckingham, consult Forster 1848, particularly pp. xix-xx; Nicolas 1857, vol. 1, pp. 150-53, with illustrations of the crests on p. 152.

22. *Nautilus Cup*

Flanders or Southern Germany
ca. 1575-1625
Shell, gilt bronze, copper, silver, and semiprecious gems
12 1/2 x 7 1/2 x 3 3/4 in. (31.8 x 19.1 x 9.5 cm)
L287.1993

DESCRIPTION: Perched on the summit of a curvilinear nautilus shell is a sculptural mount of Neptune riding a jewel-eyed sea-monster soldered to the top of an oceanic support, which is pinned to a caryatid-headed strap that travels down behind the shell. The lower ledge of the shell is encased within a broad-lipped, hooded, horizontal mount issuing from two snail surrounds affixed to the shell by a rod that passes through it. The recessed, volute-edged border that partially engulfs the cup below the brim is engraved with strapwork and inset with five bosses containing faceted, semiprecious gems. Two appliqué mounts of tritonesses blowing conch shells and another plain copper strap attached to the sides and the front are connected by loops to the band at the top of the cup and to the conjoining strap underneath the shell.

Below a foliated knop of curled silver strips, the stem is cast in the form of Hercules wearing a lion-skin headdress. Leaning on his walking stick, he strenuously lifts the nautilus shell. The tiered base is cast in three sections assembled by rivets, bolts, and screws. The uppermost segment consists of a turtle with an ornately compartmentalized, perforated shell housing a movable head, legs, and tail. A frieze of simple circles adorns the retracted middle component, and the upper zone of the flaring footrim below is enhanced with rosettes. Interestingly, the precise pattern of the turtle's underbelly is visible inside the sunken bottom of the base.

CONDITION: This fragile cup has survived relatively well. The shell is cracked in several areas, most conspicuously at the front. Later plaster fills appear around the crest of the shell close to the snail surrounds. The tritoness mounts are original, but the gilding has been totally effaced from the one at the front. The copper strap on the right side is a fairly recent replacement. Only three of the five original gems remain on the brim mount, and Neptune's trident has disappeared.

EXHIBITIONS: The Milwaukee Art Center, "The New Milwaukee Art Center Inaugural Exhibition," 1975.

PUBLICATIONS: The Milwaukee Art Center, *The New Milwaukee Art Center Inaugural Exhibition*. Milwaukee, Wisconsin, 1975, p. 2.

PROVENANCE: Purchased from Blumka Gallery, New York.

COMMENTARY: During the Age of Discovery, the influx into Western Europe of variegated minerals, ivories, ostrich eggs, coconut and nautilus shells, and other exotic wonders staggered the imaginations of artists and their patrons. These foreign objects–some believed to be imbued with quasimagical or medicinal forces–were transformed by goldsmiths, gem cutters, enamelers, and other artists into opulent works of art. The mania for these intriguing oddities spread throughout the courts of Europe. In Germany, a highly treasured and remarkably encyclopedic collection of this sort–uninhibitedly juxtaposing natural and manmade creations with scientific instruments such as astrolabes and clocks–was proudly displayed in a *Wunderkammer*, the privately owned predecessor of the modern-day museum.[1]

Nautilus shells from the depths of the Pacific and Indian oceans were revered since antiquity for their iridescence, geometrical precision, and the romantic notion that they possessed miraculous power. These qualities were innovatively enhanced by Renaissance and Baroque goldsmiths, who fashioned for these shells stunningly ostentatious but necessarily protective mounts. Enframing elements were almost always at least partially nautical in their design so that they might complement the natural marine forms they embellished.

The Flagg nautilus cup is a prime example of an enormously popular Mannerist conceit that superbly integrates novel artistic expression with exquisite proportions and splendid craftsmanship. Due to the striking uniformity of these internationally produced vessels, it is difficult to localize or date examples like ours that lack hallmarks. Nevertheless, the sea-monster, tritonesses, and snail mounts are stylistically analogous to a group of bronze plaquettes tentatively assigned to Nuremberg and dated to the third quarter of the sixteenth century by Weber.[2] Conversely, the distinctive turtle foot and other features correspond closely with engraved designs for cups by Antwerp artists such as Cornelis Floris (1514-1575) and Erasmus Hornick (died 1583).[3] Other nautilus cups with mounts or turtle bases similar to the Flagg example include one in the British Museum in London that was probably made in Utrecht in 1594, and another unmarked cup at the Los Angeles County Museum of Art believed to have been created in England or Flanders in about 1585.[4] JRB

1. Information about *Wunderkammern* can be found in London 1981, *passim*, with extensive reference to the earlier literature on this subject.

2. Weber 1975, vol. 1, pp. 187-88, nos. 335, 3, 335, 5, 335, 6; vol. 2, pl. 98.

3. See Hayward 1964, pp. 93-94, fig. 3; Hayward 1976, pp. 352, 356, pls. 145, 153, 196-99; Hackenbroch 1986, p. 245, fig. 172.

4. Consult London 1991, vol. 3, pp. 87-94, no. 7, col. pl. 5, figs. 87-96; Schroder 1988, no. A.

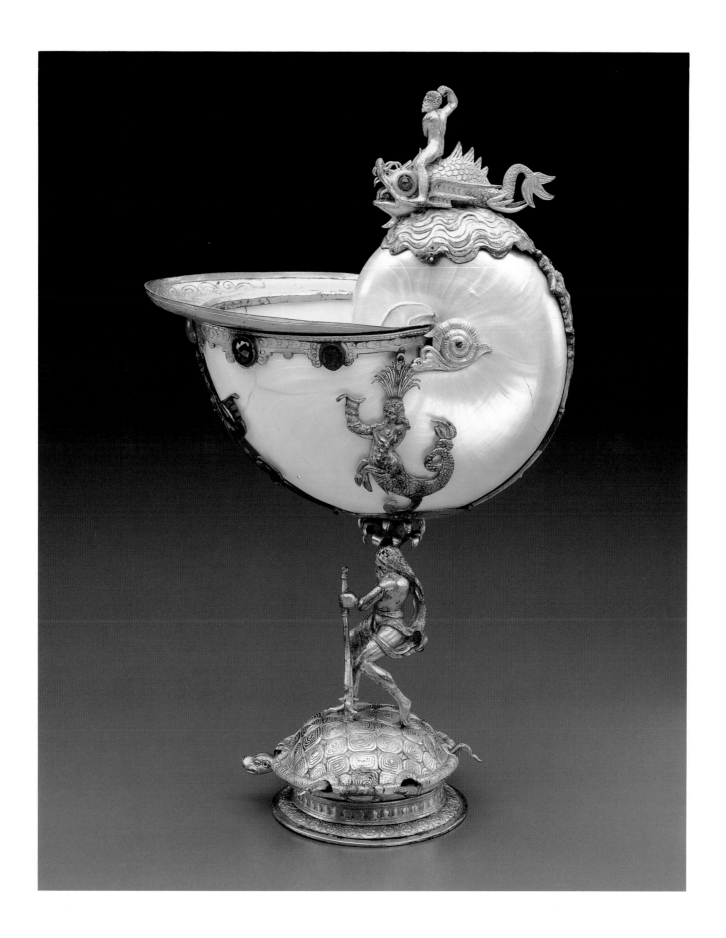

23. *Cup in the Form of a Rampant Lion*

Southern Germany or Switzerland
ca. 1625-50
Parcel-gilt silver with later enamel
9 1/8 x 4 1/2 x 6 1/4 in. (20.6 x 11.4 x 15.9 cm)
L285.1993

DESCRIPTION: This silver vessel is modeled in the round as a sculpture in the form of a majestic lion. Standing on its hindlegs, the beast is momentarily poised in a state of nervous agitation with a fierce scowl, bared fangs, and out-thrust tongue. Its right forepaw is uplifted, and its left one extends outward to clutch the voluted top of a shield-shaped escutcheon. This free-standing armorial component is riveted at the bottom to an elaborate, spindle-formed pedestal bisected by two convex domes skillfully embossed and chased with panoramic views of a tiny village or town. The animal's lush mane is richly chased and tooled, and the textured fur of its agile body is likewise fastidiously finished. Separately wrought, the hollow head is easily removable, so that the deep interior cavity of the lion's body might occasionally be filled with spirits. Each of the four legs is independently worked and joined to the body, and the curving tail is bolted into position on the inside of the lion's rump. The sharp fangs are formed from a separate piece pegged inside the head, and the tongue is composed of a sideward sliding bar pinned through the reverse of the beast's mane. Hand-wrought screws are used to mount the figure to its underlying socle.

CONDITION: The cup has undergone a number of later alterations. The enamel coat of arms is entirely new, but the cartouche is original. Initially, the tail would have been positioned so that it flared outward behind the beast. A now missing scepter or orb was once held in the lion's raised paw, and the gilding has been partially refreshed. At some point the head was drilled so that it could be permanently attached to the body with screws, which have since been removed.

MARKS AND INSCRIPTIONS: An indecipherable maker's mark or town assay mark is punched on the lion's head, body, and tail, and on the foot ring of the base. A nineteenth-century Netherlandish control mark is stamped on top of the pedestal.[1]

PROVENANCE: Purchased from Blumka Gallery, New York, 1968.

COMMENTARY: With the onset of the seventeenth century, imposingly sculptural cups in silver taking the three-dimensional forms of owls, bears, unicorns, stags, lions, and other zoomorphic creatures become increasingly prevalent.[2]

These whimsical and imaginative objects readily conform to the Mannerist taste for artistic novelty coupled with technical artifice. They were produced in astonishing numbers by goldsmiths situated in southern Germany and Switzerland, and less frequently in The Netherlands. While such works are designed as drinking vessels with hollow bodies and detachable heads, their often overtly extravagant shapes and volumetric properties render them somewhat impracticable to serve this purpose. Instead they are more ideally suited to function as table ornaments for display at festive banquets, where they would have amazed and delighted Renaissance monarchs and patricians.

These partly sculptural and partly functional objects would also have been used on special occasions as "Welcome Cups" or *Willkomm* to toast the health of visiting nobles, dignitaries, or other esteemed guests.[3] Although this genteel practice was initially started by governmental and institutional authorities, the custom rapidly gained momentum, and soon these cups were being commissioned independently from goldsmiths by the most prominent families in Northern Europe for individual use and as presentation gifts.

In the case of the Flagg cup, the shield grasped by the lion is too conspicuous to be merely ornamental, establishing that it was originally conceived as a "Welcome Cup." Unfortunately, it is no longer possible to ascertain whether its escutcheon once bore the coat of arms of a particular city or one belonging to a specific family, so that the exact details pertaining to its historic patronage are irretrievably lost to posterity. It is worth noting, however, that the bases of some of these cups are decorated with townscapes that reproduce the actual appearances of the places in which they were created.[4] Therefore, it is tempting to speculate whether the small village or town that is represented on our cup might likewise be a faithful rendering of the specific location where it was made. In this connection, it is worthwhile to remember that the lion is not only a universal symbol of individual strength and courage, but also an omnipresent emblem of collective civic pride. JRB

1. Voet 1966, p. 47, no. 5.

2. For lion cups related generically to ours, see Seling 1980, vol. 1, pp. 249, 282-83, nos. 150, 460, 462, 463; vol. 2, pls. 150, 460, 462, 463; Nuremberg and Munich 1985, pp. 236-37, no. 40; Hartford 1987, p. 89, no. 19. An assortment of cups in the form of other animals can be found in Schroder 1983, pp. 55-57, 61, 99, 156-58, nos. 11, 12, 28, 61; London 1988, vol. 2, pp. 134-53, 268-70, 292-305, nos. 18-21, 50, 55-57.

3. A useful overview of Renaissance "Welcome Cups" is provided by Pechstein 1978, pp. 180-87.

4. See, for instance, Hartford 1987, pp.100-101, no. 25.

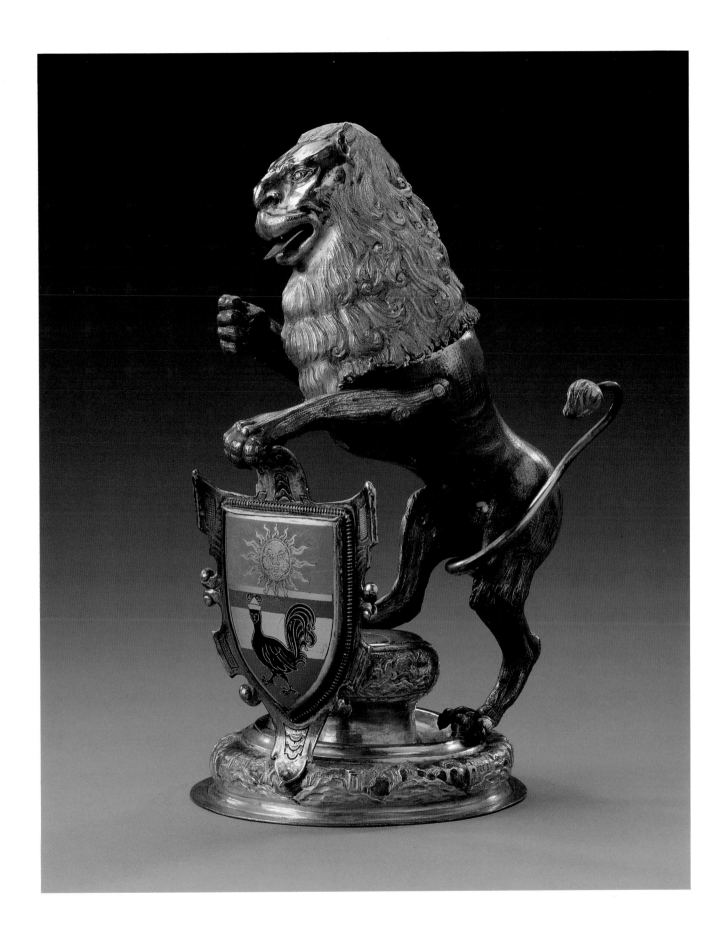

24. *Display Platter with the Meeting of Jacob and Joseph*

Augsburg
1670-74
Silver gilt
1 1/2 x 19 1/3 x 17 1/8 in. (3.8 x 49.1 x 43.5 cm)
M1983.359

DESCRIPTION: The deeply recessed and narrowly rimmed cavetto of this thinly gauged, oval display platter or *Schauplatte* is embossed, chased, stippled, and punched in high relief with a theatrically charged representation of the reunion of Jacob with his long-lost son Joseph (Gen. 46:29). On a mountainous ledge strewn with grass, rocks, and trees, the two chief protagonists tenderly embrace at the direct center of the composition. They are surrounded by two of Jacob's other sons and by individuals from Joseph's military and courtly retinue, including helmeted and spear-bearing soldiers, a turbaned groom, a page boy, and horses. Encircling the narrative scene is a wide, uplifted, and ripple-edged border similarly worked and filled with repeating clusters of fruits and vegetables representing the varying harvests of the four seasons. Inset at regular intervals are six wreathed and cast medallions containing the profile portrait busts of ancient Roman emperors with identifying inscriptions.

CONDITION: The outer edges of the platter are slightly bent in select regions. The gilding on the reverse of the platter is not original.

MARKS AND INSCRIPTIONS: The assay mark for this platter indicates that the piece was produced in Augsburg between 1670 and 1674.[1] The maker's mark is illegible. Moving clockwise from the top, the Latin legends for the emperors read: THRASIBVIVS, ANTONINVS, NERO CLAVDIVS, NERVA COCCEI, TITVS VESPASIAN, and DIOCLETIAN.

PROVENANCE: Purchased from Blumka Gallery, New York, 1981.

COMMENTARY: Prior to the seventeenth century, much of society ate their meals with the aid of a pair of skewing knives and a spoon, which necessitated the use of ewers and basins filled with perfumed water for cleaning food-soiled hands during and after dining.[2] When forks began to be employed with increasing frequency during the mid-seventeenth century, the primary role of the ewer and basin as a utilitarian fixture at the table had already substantially diminished. Instead, they evolved into glamorous showpieces proudly displayed on buffet sideboards by their wealthy owners. During the Baroque period, basins were not always accom-

panied by ewers, but were created as independent works of art often outfitted with a suspension ring, so that they might be hung like a painting. The form and fabrication changed dramatically, as they were now viewed from the front only and from a distance. Most often they are of oval shape and made from thin metal with a sunken center that was no longer equipped with an emplacement boss to hold a ewer, but completely embossed in high relief with crowded pictorial scenes from the Bible or ancient Greek and Roman mythology. Their broad outer borders were also embellished with radiating and naturalistically embossed floral or fruit sprays, sometimes incorporating busts of ancient Roman emperors, as is the case with the Flagg platter.

This platter belongs to a large group of similarly designed and executed works that were undertaken in Augsburg during the Baroque period.[3] It was here that these remarkably ornate and exuberantly unrestrained creations that so confidently combine such disparate elements as realistically rendered fruits and vegetables, classically inspired portrait medallions, and biblical imagery were mass-produced and widely exported. Although the commercial output of these platters was largely monopolized by the Augsburg goldsmiths, other examples were manufactured elsewhere in Germany, and in other Northern European countries by itinerant German goldsmiths.[4] The decoration on some is coarsely handled, but this is certainly not the case with the Flagg example.[5] Its lucidly defined forms and superb surface enrichment attest to the brilliant results that could be obtained by the Augsburg goldsmiths who specialized in the fabrication of these embossed or repoussé ornamental platters. The high quality of the workmanship suggests that it was created by one of the foremost Augsburg goldsmiths engaged in the making of these grand chargers, such as Hans Jacob Baur II (master ca. 1652-died 1679), Heinrich Mannlich (1658-1698), Hans Jacob Mair (ca. 1641-1719), or Abraham Warnberger II (1632-1704). JRB

1. Seling 1980, vol. 3, p. 21, no. 112 or 115.

2. For the historic and stylistic evolution of European silver ewers and basins, see Hayward 1976, *passim*; Hernmarck 1977, vol. 1, pp. 230-50, 300-301.

3. Concerning the embossed decorative platters that were manufactured in Baroque Augsburg, consult Hernmarck 1977, vol. 1, pp. 24-25, 52, 57-58, 237-38, 240-45. A small but spectacular group of Augsburg platters from the second half of the seventeenth century is examined in detail in Munich 1994, pp. 190-200, nos. 28-32.

4. Two fine examples created in mid-seventeenth-century Nuremberg are catalogued and discussed in Nuremberg and Munich 1985, pp. 291-92, 314, nos. 152, 229, col. pl. 19.

5. A sampling of other platters that are particularly close in terms of their decoration to the Flagg example includes Moscow 1975, no. 67; Seling 1980, vol. 1, p. 288, nos. 503, 505; vol. 2, pls. 503, 505; Brett 1986, pp. 64-65, nos. 78, 79.

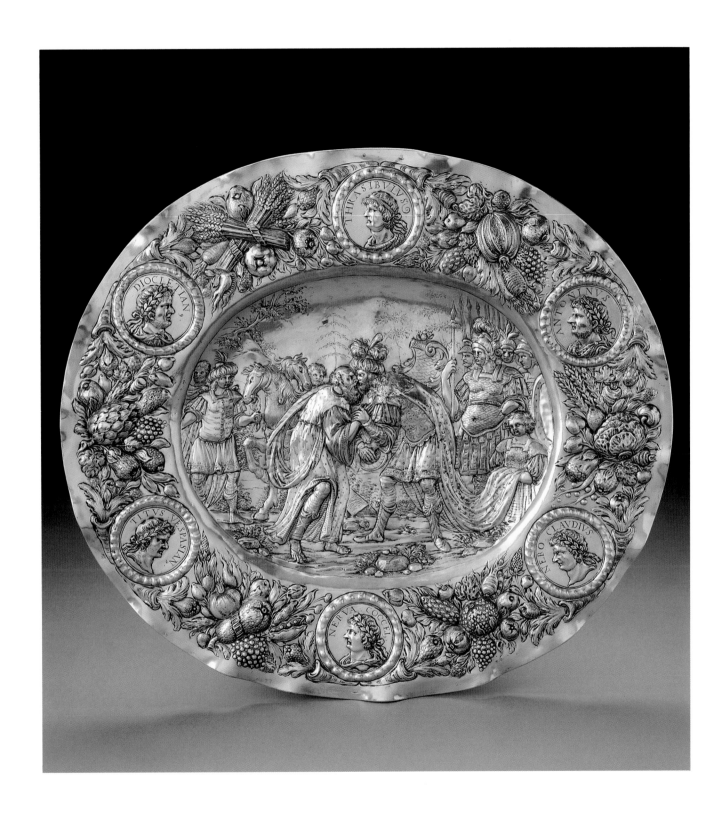

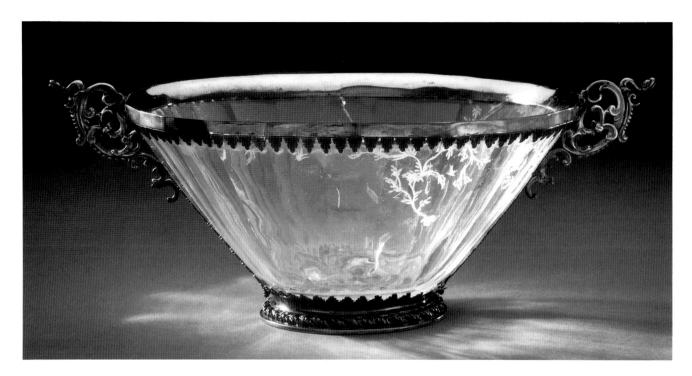

25. *Rock-Crystal Bowl*

Probably Germany
ca. 1650
Rock-crystal with silver-gilt mount
3 1/2 x 8 7/8 x 6 1/8 in. (8.9 x 22.5 x 15.6 cm)
M1991.96

DESCRIPTION: This oval, rimmed bowl with faceted, tapering sides is cut from a single piece of rock-crystal. The vessel's mouth and foot are encased in silver-gilt mounts pinned at the top and bottom to two vertical bands that connect the mounts and support cast handles in the form of ornamented volutes that terminate in serpent heads. The undulating pattern of the facets is repeated in the scalloped border of the mount covering the lip and in the applied twisted rope ornamentation along the footrim. The exterior is engraved with a delicate pattern of trailing vines.

CONDITION: The bowl has a series of cracks and minor chips along one side that are partially camouflaged by later engraving of foliate design. The silver-gilt mounts are unmarked, and in excellent condition.

PROVENANCE: Purchased from Blumka Gallery, New York, 1965.

COMMENTARY: Rock-crystal, a colorless, transparent quartz, was prized from early antiquity for its extreme hardness and resistance to discoloration. Its purity made it a favored material during the later medieval period for religious objects,

and subsequently the market for rock-crystal objects expanded to include the wealthier secular world.[1]

The appeal of hardstone vessels was based as much on the extreme difficulty in working the material as in the exquisite effects of the finished piece. A sculptor cut and polished the stone, then a goldsmith typically designed a mount that would protect the edges of the vessel as well as provide handles or spouts. Such mounts are usually minimal, so that the translucent properties of the stone are maintained.[2]

Few Renaissance vessels remain in their original condition. Many have been stripped of their original mounts, which were replaced by cheaper metals or removed entirely.[3] Repairs sometimes fundamentally changed the appearance of the piece: the Flagg vessel was engraved with trailing vines at a later date in an effort to mask the cracked and chipped areas. The cost and demanding nature of rock-crystal may have contributed to the fifteenth-century invention of Venetian *vetro di cristallo* or *cristallo*, a glass with the translucent properties of rock-crystal, but cheaper and easier to work.[4] (see entries 26 to 28). LW

1. For highlights of the history of rock-crystal carving and related examples, see Osborne 1985, pp. 670-71; Sanz 1979, pp. 66-79; Los Angeles 1984, p. 304, no. 45b; Sotheby's New York 1990, lot 123; Milan 1981, vol. 2, p. 416, no. 271.

2. Hayward 1976, p. 127.

3. Ibid., p. 14.

4. Osborne 1985, p. 670.

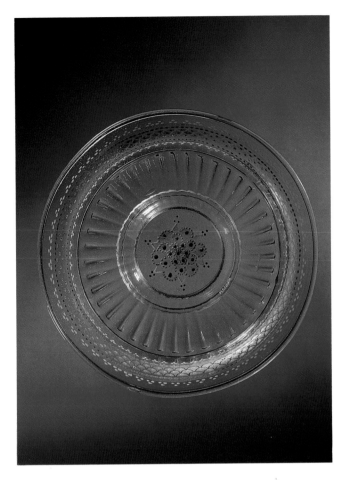

26. *Tazza*

Murano, Italy
First quarter of the 16th century
Colorless *cristallo* glass with enameled and gilded decoration
2 5/8 x 10 1/4 x 10 1/4 in. (6.7 x 26 x 26 cm)
M1987.24

DESCRIPTION: This *tazza* is composed of a shallow bowl
with enameled and gilded decoration and a low cylindrical-
shaped foot with folded rim. The ribbed bowl was mold-blown
and the foot added separately. Gilding and enamel dots of
blue, white, and red create a petal or star formation on the
bottom center of the bowl; "fish-scale" gilding punctuated by
enamel dots encircles the underside of the rim. The footrim
has a gilded band.

CONDITION: There are a few small chips under the brim's
outer edge and a sizable air bubble is located on the bottom of
the bowl.

PROVENANCE: Collection of Lord Astor of Hever;
purchased from Edward R. Lubin, New York, 1972.

COMMENTARY: During the Italian Renaissance, luxury
glass reemerged in Europe for the first time since the eclipse of
the Roman world. Glass production as a minor craft can be
traced uninterrupted throughout the Middle Ages in Venice,
but the full artistic potential of glassmaking was not realized
until Venetian artisans came into contact with Near Eastern
practices and techniques, probably around 1200, during the
Fourth Crusade. This influence became heightened around
1400 when Islamic and Byzantine glassmakers, fleeing from
the Mongols, made their way to Venice.[1]

Venetian glassmakers quickly absorbed the new knowledge
and moved beyond utilitarian wares to the production of
exquisite *objets d'art*. Among the most important techniques
inherited from the Near East were gilding and enameling. The
Flagg vessel's "fish-scale" gilding or gadrooning along the rim
and the brightly colored rows and borders of enamel dots have
their origin in Near Eastern prototypes. With these tech-
niques, the goldleaf is applied first and welded to the glass
surface by placing the vessel quickly in the furnace. Enamel
patterns are subsequently laid over the gilded areas and
permanently fused with additional short periods of heating.[2]

The fifteenth-century Venetian invention of *cristallo*, a clear
colorless glass, provided an attractive surface for such
decoration.[3] The glass, free of impurities of any kind, was
named because of its resemblance to rock-crystal. Its creation
was considered a technical *tour de force*: among the many
complicated steps in its production were the use of maganese
dioxide as a decolorizing agent, the purification of a soda flux
made from marine plant ashes into an alkali salt, the mixing of
alkali in high proportions with silica, and the fusion of the
batch in a quartzose pot. The center of this activity was the
island of Murano, where the Venetian glasshouses had been
ordered by the city council to move in 1292 because of the risk
of fire created by the increasing numbers of glass furnaces.[4]

By the late fifteenth century, Venetian glass was in demand
throughout Europe. Among its most famous collectors were
Louis XII of France, Ferdinand and Isabella of Spain, and
Henry VIII of England. LW

1. Los Angeles 1997, pp. 5-6.

2. For a short discussion of these techniques, see London 1979, pp. 26-27.

3. Los Angeles 1997, p. 8. The administrative authorities of Venice
granted the privilege of making *cristallo* to its inventor, Angelo Barovier,
in 1457.

4. For a brief history of the Venetian glass industry and related *tazze*, see
London 1979, pp. 9-12, 37, nos. 25, 26; Los Angeles 1997, pp. 104-105,
no. 26.

27. *Nef Ewer*

Murano, Italy
Late 16th century
Colorless cristallo and blue glass with gilded ornamentation
12 1/4 x 10 1/2 x 5 in. (30.8 x 26.7 x 12.7 cm)
Dia. of foot: 5 1/2 in. (14 cm)
M1988.135

DESCRIPTION: A *cristallo* glass bowl forms the hull of a fanciful rigged sailing vessel or nef. The spout of the ewer creates a graceful arching prow while tooled latticework of clear and blue glass forms the triple-tiered "rigging" of the vessel. The hull is decorated with applied blue glass raspberries and clear glass prunts in the form of alternating satyr and lion masks with traces of gilding. The stem consists of a large ribbed ball-knop above a wide trumpet-shaped foot with a folded rim. Remnants of a curled dragon surmount the masthead, and a blue raspberry prunt at the stern indicates where a handle with a finial was once attached.

CONDITION: The rudder and dragon atop the masthead are now missing, but as late as 1902, when the vessel was sold as part of the Thewalt collection, the dragon was still largely intact and only the rudder had been broken. Traces of the original gilding remain on the prunts and stem knop. The vessel's hull is hazy and cloudy in areas and shows signs of "crizzling," a condition of internal deterioration caused by chemical instabilities in the glass composition. The silvery rays in the cloudy areas are actually microscopic fissures. This structural weakening may have contributed to the cracks along the lateral side of the vessel's hull, above the spout, and along the bottom.

PROVENANCE: Collection of Karl Thewalt (sale, Lempertz' Buchhandlung & Antiquariat, Cologne, November 4-14, 1902, lot 473); purchased from Edward R. Lubin, New York, 1972.

PUBLICATIONS: *Katalog der Reichhaltigen, nachgelassenen Kunst-Sammlung des Herrn Karl Thewalt in Köln.* Cologne, 1903, p. 32, lot 473, illus. no. 473.

COMMENTARY: The Flagg nef ewer once belonged to the collection of Karl Thewalt, one of the most important collectors of decorative arts in late nineteenth-century Germany.[1] His collection included everything from ivories and marbles to books and clocks, but most significant and comprehensive were his holdings of Rhenish stonewares and glass. At the time of Thewalt's death in 1902, his glass collection contained more than three hundred pieces dating from antiquity to the early eighteenth century.[2]

The Flagg nef ewer and the winged goblet (see entry 28) were not only both part of the Thewalt collection, but were both documented in a rare, early photograph of the collection from 1868, later published in Lempertz's auction catalogue of 1903 (see page 75).[3] The winged goblet appears on the left middle shelf (no. 522), and the nef is featured at the pinnacle of the center shelving unit (no. 473). The photograph verifies the early history of these two vessels, and suggests that the nef, already lacking its rudder-shaped handle, was a highly prized possession in an extraordinary collection of Venetian glass.

The early date of the photograph also helps to identify the nef's date of manufacture. So many historicized versions generated in the late nineteenth century subsequently entered collections with erroneous dates that authentication of sixteenth-century pieces is often next to impossible.[4] However, the Thewalt photograph diminishes the possibility of a nineteenth-century date, since copies were only made a decade or two later, and the Flagg vessel's appearance even here is visibly cloudy from crizzling. During an examination of the vessel, Jutta-Annette Page concluded that its structural composition and ornamentation were consistent with the other two nef ewers firmly identified as late sixteenth-century Venetian, one in The British Museum, London and the other in the Museum of Applied Arts, Prague.[5]

The origin of these fantastic vessels is traditionally attributed to Armenia Vivarini, who allegedly was granted the exclusive right to make such objects in Murano in 1521. There is, however, no documentary evidence that women ever worked as glassmakers during the Renaissance.[6] It is possible that this ornate form may have emerged from boat-shaped lamps, but it seems more likely that it developed either in imitation or in direct competition to Gothic precious metal nefs used at royal banquets to serve wine and other beverages.[7] The glass nef may have also functioned as a container for spirits or for washing one's hands between dinner courses. LW

1. I would like to thank Jutta-Annette Page of The Corning Museum of Glass for examining the nef and identifying the Thewalt collection's significance in its dating.

2. Thewalt 1903, pp. VII-VIII.

3. Ibid., pp. 32, 35, ill. nos. 473, 522.

4. Jutta-Annette Page, letter, December 10, 1997.

5. For the nefs in London and Prague, consult Hetteπ 1960, no. 19; London 1979, pp. 166-67. For an extensive list of related vessels, consult Los Angeles 1980, p. 215.

6. Jutta-Annette Page, conversation, August 4, 1998.

7. For an example of a goldsmith's nef, see Washington 1991, pp. 238-39, no. 137.

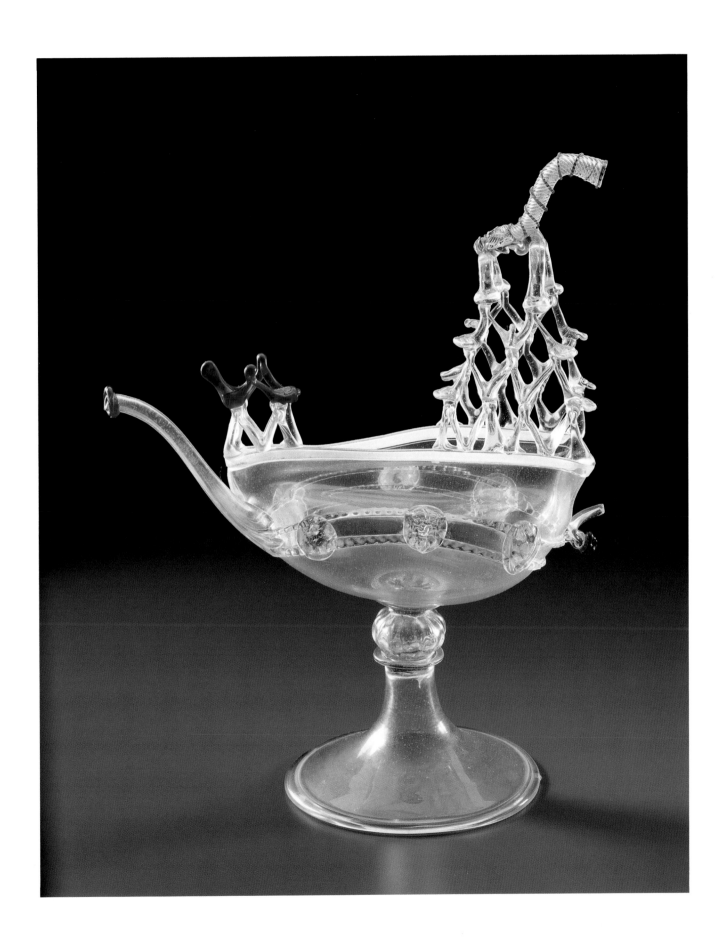

Karl Thewalt glass collection as photographed in 1868, published in 1903.

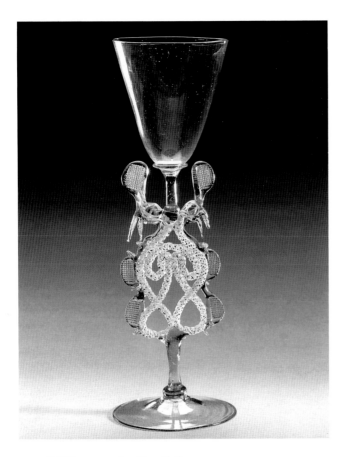

28. *Winged Goblet*

Probably Germany, *Façon de Venise*
Third quarter of the 17th century
Yellowish colorless *cristallo* with wrought decoration
11 1/4 x 3 3/4 x 3 3/4 in. (28.6 x 9.5 x 9.5 cm)
Dia. of rim: 3 1/2 in. (8.9 cm)
M1987.25

DESCRIPTION: A funnel-shaped bowl surmounts an elaborate stem composed of a single coil of plain glass embedded with spirals of opaque white (*lattimo*) glass threads that terminates in two outward-facing eagle heads with tooled crests. The outer edge is ornamented with four tooled plumes of plain colorless glass. The whole is supported by a plain wide foot.

CONDITION: The goblet is in good condition. Swirling patterns of air bubbles or "seed" are evident in the glass bowl and one of the wing's uppermost tips is chipped.

PROVENANCE: Collection of Karl Thewalt (sale, Lempertz' Buchhandlung & Antiquariat, Cologne, November 4-14, 1902, lot 522); purchased from Edward R. Lubin, New York, 1972.

PUBLICATIONS: *Katalog der Reichhaltigen, nachgelassenen Kunst-Sammlung des Herrn Karl Thewalt in Köln.* Cologne, 1903, p. 35, lot 522, illus. no. 522.

Venetian glassware was at its height in the sixteenth and seventeenth centuries and was widely copied throughout Europe as glassware *à la façon de Venise*. The Venetians' artistry with clear thin *cristallo*, white filigree patterning, and the fanciful ornamentation of vessels made their wares highly prized commodities among the royalty and merchants of Northern Europe. So popular were these delicate objects that cities in Germany and The Low Countries started their own competitive glasshouses in the sixteenth century with important glass centers emerging at Leiden, The Hague, Rotterdam, Antwerp, Liège, Brussels, Kassel, and Cologne. Many of the earliest glasshouses actually employed Venetian artists who had traveled northward with their trade secrets despite an edict from the Venetian Signoria that threatened emigrant glass artists with assassination.[1] The very best glass *à la façon de Venise* is often indistinguishable from true Venetian glassware.

Winged goblets are characterized by their winglike designs that flare outward in elaborately patterned loops and snakelike twirls; occasionally the coiling design is so complex that the traditional stem completely disappears. The wings are usually composed of colored or threaded glass for contrast, with additional tooled trailing or cresting of clear glass along their profile. The delicate tips just below the glass bowl often end suggestively in the form of seahorses, dragons, or eagles, and have inspired such colorful terms as *verres à serpent* in French, and *Flügelglas* in German.

The production of these vessels was labor intensive, with the stems worked separately on a marver before the addition of the bowl or foot. Winged goblets with a more robust three-dimensionality to the stem formation are usually credited to Venetian glasshouses, while those with flat "pastry-cook" stems, such as ours, are attributed to glass factories in Germany or The Low Countries. The total number of these goblets made in Northern Europe may be gleaned from the official figures of glass sales in Brussels between 1659 and 1663, when nearly eight thousand winged vessels were sold.[2] The Flagg goblet is distinguished among these numerous vessels by its prestigious provenance in the famous nineteenth-century glass collection of Karl Thewalt. It is not only listed in the Thewalt auction catalogue of 1903, but is illustrated in an accompanying photograph of the collection (see vessel no. 522 on page 76).[3] LW

1. Norfolk 1989, p. 23.

2. London and Fribourg 1977, p. 119. This number contrasts with some 426,000 *verres ordinaires* sold during the same period. See also Los Angeles 1980, pp. 67-80; Pholien 1899, p. 81.

3. Thewalt 1903, p. 35, lot 522, illus. no. 522.

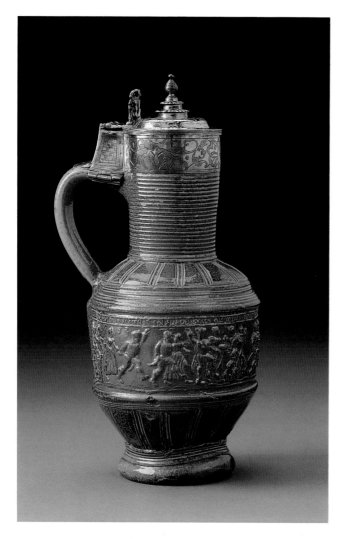

29. *Jug*

Raeren, Rhineland, Germany
ca. 1583
Salt-glazed stoneware with later silver mount
10 1/2 x 6 x 4 3/4 in. (26.7 x 15.2 x 12.1 cm)
M1991.86

DESCRIPTION: This baluster form jug, or *Krug*, has sharply defined contours. Its ceramic body is composed of a multitiered series of carefully balanced horizontal and vertical sections. Resting on a bulbous foot with plain molded bands, the upwardly flaring zone above is decorated with a simple interplay of ribs alternating with blank panels. This ornamentation is repeated on the curving shoulder of the jug. The major compartment on the belly bears a narrative relief of dancing peasant couples. The long neck is reeded, and a separately attached loop handle springs from the neck and conjoins with the sloping shoulder. Surmounted by a baluster finial, the hinged silver mount has a thumbpiece in the form of

a sea nymph and is engraved with foliated and checkered motifs. It is of German or Dutch origin, and of later date.

CONDITION: The vessel is chipped and substantial abrasions appear on the handle and around the foot ring. Minor warpage appears along the perimeter of the foot, which was probably once encased within a mount.

MARKS AND INSCRIPTIONS: The inscription reads: GER[H]ET DV MVS DAP[E]R BLASEN SO DANS[S]EN DEI BVREN ALS WEREN SI RASEN ERS VF SPRICHT BASTOR ICH VER DANS DI KAP MIT EN KO[R]. [Gerard, you must blow bravely; the boors dance as if they were mad; up speaks the pastor, I dance away my cowl and surplice]. An escutcheon appears on the silver collar, and the vessel is dated 1583.

PROVENANCE: Purchased from Ernst Pinkus Antiques, New York, 1967.

COMMENTARY: In Renaissance Europe, the Rhenish potteries at Raeren, Siegburg, and Cologne were esteemed for their jugs, tankards, and flasks. These early stonewares were created from a combination of clay and feldspar fired at kiln-temperatures of 1200 to 1400 degrees, which produce a hard, nonporous pottery. The industry flourished in Germany well into the seventeenth century, and contributed to the eighteenth-century discovery of the first true European porcelains at the royal factory at Meissen.

The Flagg jug is from a distinctive class of drinking wares used in homes and taverns that were made in Raeren. The leading potters active at this site–the Emens and Mennicken families–excelled at embellishing their wares with relief decoration by using clay matrices that were impressed into the body of each vessel before firing.[1] The molded band of reveling peasants on our example was based on *Das Bauerenfest* [The Peasant Festival] print series of 1546 by the Nuremberg graphic artist Hans Sebald Beham (1500-1550).[2] The honey coloration of the jug was achieved by an iron stained slip, and the stippled surface resulted from the salt used as a glazing agent during firing. Countless closely related jugs are recorded in public and private collections.[3] (For a modern counterpart, see entry 30). JRB

1. For surviving clay matrices and master models after Beham's prints, see Falke 1908, vol. 1, pp. 13-14, fig. 4; Cologne 1976, p. 193, no. 239, pl. 25.

2. Regarding the prints by Beham and their use by Rhenish potters, see Zschelletzschky 1975, pp. 344-48, figs. 284-305; Cologne 1976, pp. 242-43, 282, nos. 360, 451, 451a, pls. 24, 25; Lawrence 1988, pp. 208-11, no. 57.

3. Comparable examples are published in Koetschau 1924, p. 43, pl. 45; Rackham 1935, vol. 1, p. 261, no. 2034; vol. 2, pl. 146D; Cologne 1976, pp. 242-43, no. 360, pls. 24, 25.

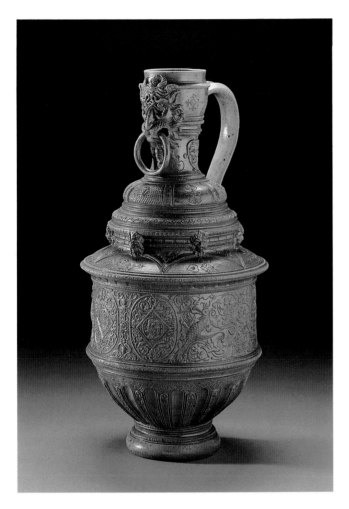

30. *Jug*

Probably Raeren, Rhineland, Germany
1870-1900
Salt-glazed stoneware
20 3/4 x 10 1/2 x 10 1/2 in. (52.7 x 26.7 x 26.7 cm)
M1991.87

DESCRIPTION: The ovoid body of this *Krug* rises from a rounded foot and culminates in a narrow neck embellished with a lion mask. A molded ring hangs from a hole poked through the lion's muzzle. Vertical seams from a five-part mold are evident on the body, which is divided into a series of horizontal bands punctuated by sharply defined profile moldings. Most of the decoration was created in the mold, but applied, stamped, and rolled elements were also added after the jug was unmolded. The lion mask and the five grotesque masks at the waist, along with the foliate elements between them, were molded separately and applied.

Linear elements were stamped on each band except the belly frieze, where profiles of two soldiers within medallions are flanked by rampant griffins, urns, scrolling foliage and, at proper right, a woman's profile. The dentil ornament above this frieze was hand-stamped, and a pointed tool was used to clarify many of the molded lines. Patterns were impressed on the projecting moldings with rollers, masking the vertical seams. The pulled handle terminates in a scroll. The buff colored clay is naturally spotted with iron; a thin salt glaze deepens it to warm brown. There does not appear to be a slip coating under the glaze and the interior is unglazed.

CONDITION: There is minor wear to the footrim. Lack of wear to the rim and handle suggests that the jug may never have been fitted with a metal cover, although there is a small hole in the upper portion of the handle to accommodate one.

INSCRIPTIONS AND MARKS: The inscriptions HECTOR and ANNO D. 1596, respectively, accompany the soldier's profiles. Within the medallions enclosing each profile are the initials R T and W M. On the proper right W M appears below the woman's profile and an urn; the initials T K appear above the same urn. Faintly visible on the base are the numbers 36 or 38 and J [?] 84, apparently written in underglaze.

PROVENANCE: Probably purchased from Blumka Gallery, New York, 1968.

This impressive jug's sharp profile, molded construction, and precise, crisp relief ornament are clear indicators that it was made in the nineteenth century. While obviously modeled after salt-glazed stonewares from the Renaissance potteries at Raeren, it is unlikely that this piece was intended as a forgery. A broad spectrum of historicist ceramics were sold during the late nineteenth century as evocative ornaments for revival-style interiors, often in direct competition with their antique counterparts.[1]

Renaissance stonewares were especially prized by nineteenth-century collectors, and by the 1870s celebrated pieces by master potters such as Jan Emens Mennicken (active 1566-1594) and Baldem Mennicken (active 1575-1584) had been widely exhibited and published in Northern Europe. The potter who designed this jug combined signature elements from several of the best-known types to create an intriguing hybrid form. The high-relief lion mask is characteristic of Mennicken's work, the griffins on the belly are similar to those on jugs attributed to his son, Jan Baldems Mennicken, and the vessel form is essentially one developed by Emens in the 1560s.[2] JC

1. For related historicist stonewares, see Höhr-Grenzhausen 1986; Unger 1990, pp. 7-93; Molthein 1905, pp. 289-91, 301-303, 313-17.

2. For examples of these types, see Amsterdam 1996, pp. 69, 71, 76, 84. Important collections include the Rijksmuseum, Amsterdam and the Victoria and Albert Museum, London.

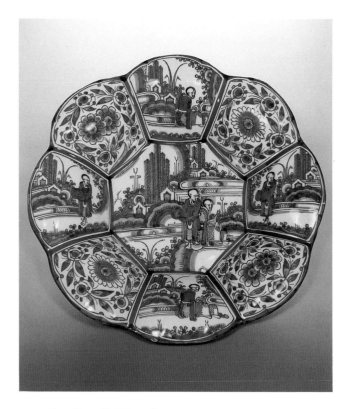

31. *Lobed Dish*

Probably Frankfurt, Germany
ca. 1666-1730
Tin-glazed earthenware
3 1/2 x 15 1/4 x 15 1/4 in. (8.9 x 38.7 x 38.7 cm)
M1997.228

DESCRIPTION: This eight-lobed dish has a deep octagonal well and a circular footrim pierced to accommodate a hanging wire. It was created with a simple press-mold; the footrim was added after unmolding. The clay is a pale buff color, and both sides of the dish are coated with a milk-white glaze. The hand-painted decoration, shading from pale grayish-blue to nearly black, is done in cobalt oxide and either black iron oxide or a related compound. The well is decorated with two Chinese male figures, one standing, one sitting, in a landscape dotted with small buildings. These figures are repeated, with variations, in four of the lobes: the seated figure above and below the well, and the standing one to the right and left. The intermediate lobes are filled with daisy and foliate motifs. Wide, dark outlines surround each section of the dish.

CONDITION: There are small chips around the rim. The glazed surface exhibits only minor wear.

PROVENANCE: Probably purchased from Blumka Gallery, New York.

COMMENTARY: Huge quantities of Chinese blue-and-white porcelain were imported to Europe throughout the seventeenth century, and demand did not abate when civil unrest and war in China periodically interrupted the supply. Potteries working in tin-glazed earthenware were quick to offer substitutes like the Flagg dish which, far from being mere imitations, have their own peculiar beauty. This large dish was intended primarily for display: it is pierced to hang on a wall, and has a strong vertical orientation. The design is closely related to typical Wan Li porcelain dishes with segmented painted borders, and the explicitly Chinese figures offer a fantasy of an exotic, alien paradise. The lobed form, however, is based on a European metal prototype, and the swirling daisy motif which alternates with the Chinese scenes is taken from the local vernacular. This intriguing hybrid of Chinese and European types was shortlived: the vogue for blue-and-white ceramics, as well as such overt *Chinoiserie*, was outmoded by the mid-eighteenth century.

Stoneware and slipware potteries had been well established in Germany since the fifteenth century, yet potteries devoted to tin-glazed earthenware did not arise until the 1660s.[1] Within a hundred years they were being nudged out of the market by rapid improvements in refined earthenwares and porcelains produced in Europe. Although specific attributions to the potteries at Hanau, Frankfurt, or the many less prolific centers elsewhere in Germany are treated more conservatively now than previously, the distinctive towering conifers and striped hills on this dish have generally been associated with Frankfurt.[2]

It is intriguing that the seated figures on this dish each hold slightly different ceramic vessels in their laps. Perhaps the decorator intended this detail as a subtle comment on connoisseurship and the contemporary fascination with Chinese porcelains. JC

1. For a discussion of these potteries, see Ducret 1962, pp. 358-72. See also Caiger-Smith 1973, pp. 127-60, for the relationship between Dutch and German tin-glazed earthenwares.

2. For a similar example, see Bayer 1959, p. 29, fig. 8.

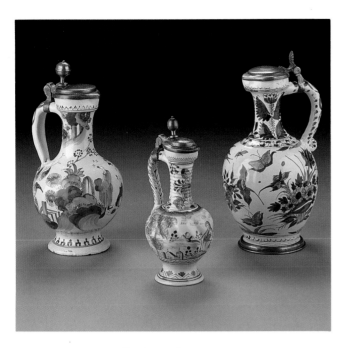

32. *Covered Pitchers*

a) Germany
1700-1740
Tin-glazed earthenware and pewter
10 1/2 x 5 x 5 in. (26.7 x 12.7 x 12.7 cm)
M1997.226

b) Probably Ansbach, Germany
ca. 1742
Tin-glazed earthenware and pewter
8 3/8 x 3 1/2 x 3 1/2 in. (21.3 x 8.9 x 8.9 cm)
M1997.225

c) Probably Hanau, Germany
1700-1740
Tin-glazed earthenware and pewter
11 x 5 x 5 in. (28 x 12.7 x 12.7 cm)
M1997.224

DESCRIPTION: These three pitchers, or *Enghalskruge*, are full-bellied forms with flared footrims, long necks, and flattened lips. Their basic forms were hand-thrown on a potter's wheel. The clay is a pale buff color; the pitchers are coated with a thick white glaze and hand-painted with cobalt oxide in shades of blue. Each pitcher has a pewter lid. (a) The applied pulled handle ends in a point. The body is decorated with two Chinese male figures in an exotic landscape. The thumbpiece is a banded knop. (b) The belly is diagonally lobed, and the applied plaited handle ends in a point. The body is decorated with floral motifs on the neck and, on the belly, a priest or monk in a landscape dotted with

buildings. The thumbpiece is acorn-shaped. (c) The applied pulled handle terminates in a volute. The body is decorated with bouquets and butterflies. The thumbpiece is shaped like a scallop shell, and the foot is encased in a pewter foot ring.

CONDITION: Minor wear is seen on all three pitchers. (a) The rim, handle, and foot are chipped. (b) The rim is chipped, and the pewter strap around the handle has been repaired. (c) The handle has been broken and restored; both handle and rim are chipped. The pewter strap around the handle has been repaired. There are losses to the pewter foot ring, which is also loose.

MARKS AND INSCRIPTIONS: (a) An indistinct mark including the letters A S appears on underside of the lid. (b) The top of the lid is engraved A B H/1742. (c) The underside of the lid has an indistinct pewterer's mark, and the foot ring is marked with an F within a crest.

PROVENANCE: Purchased from Blumka Gallery, New York.

COMMENTARY: These covered pitchers derive from a Gothic metal prototype, its lines softened in the transition to ceramics. Called *Enghalskruge*, they were particularly popular in Germany, where this form had been produced in stoneware since at least the second half of the sixteenth century. German tin-glazed earthenware became competitive with Dutch wares in the 1660s, when the potteries at Hanau and Frankfurt were founded. This form became a mainstay of their production.[1]

The two larger pitchers are decorated with motifs derived from Chinese blue-and-white porcelains, yet the fluid, practiced brushwork with rapid dashes and squiggles that define the horizontal bands and handles relates to European slipwares rather than Chinese prototypes. It is difficult to attribute these wares to specific potteries, particularly since decorators moved so freely between them. But the smaller pitcher's ribbed neck, lobed belly, plaited handle, "lollipop" and sponged trees, and Catholic motif all point to the pottery at Ansbach, southwest of Nuremberg.[2] The simplicity of this image of a priest or monk belies the bitter religious divisions of this era, which the potters at Ansbach, situated between the Catholic south and the largely Protestant north, could not have ignored. JC

1. See Ducret 1962, pp. 358-60; Klein 1975, pp. 1-37.

2. See Bayer 1959, esp. pp. 193-96; figs. 184 and 185 are similar to this example.

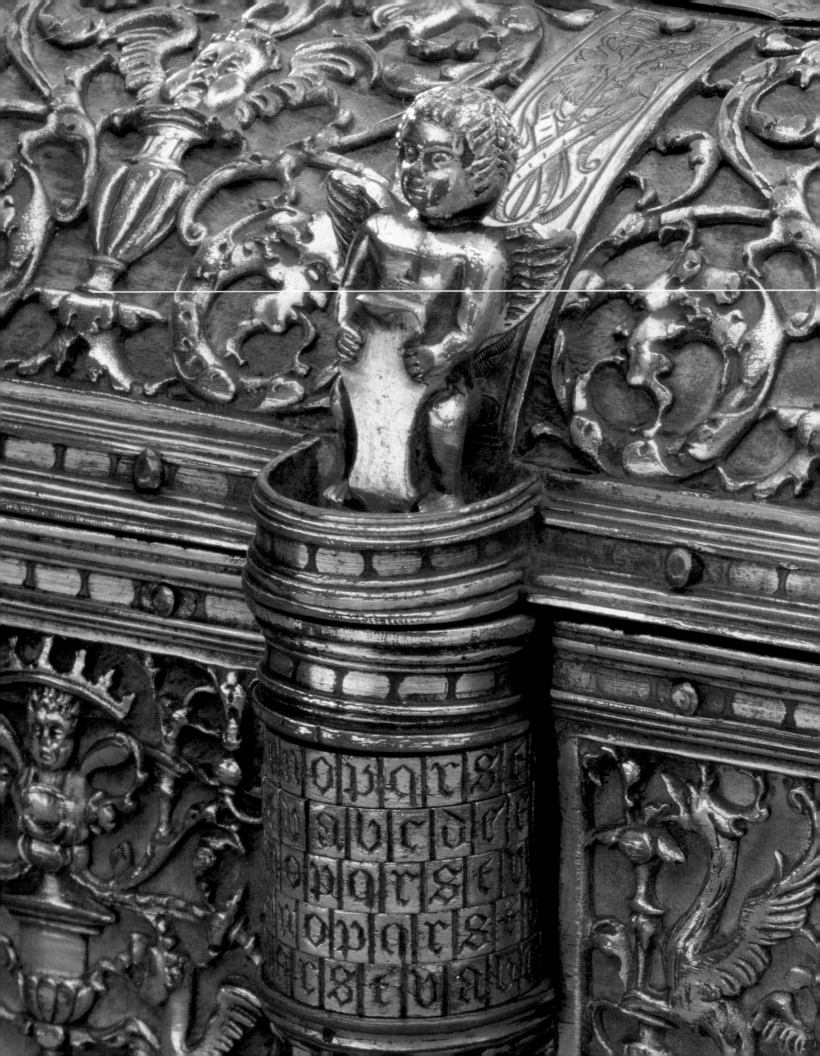

BOXES, LOCKS, AND KEYS

33. *Coffret*

France
15th century
Wrought, cut, and chiseled iron with traces of fiber lining
5 3/4 x 7 x 4 3/4 in. (14.6 x 17.8 x 9.5 cm)
M1991.73

DESCRIPTION: A swing handle centered with a gadrooned knop surmounts the trunk-shaped lid of this coffret. The shorter sides of the box are elaborately pierced with traceried canopies in the upper gables and rows of lancet windows below. The lower, crocketed buttresses terminate at the four corners in angled feet which support the coffret. Reinforcing straps with studs and rivets traverse the cover, back, and front sides of the receptacle. At the outer perimeters of the long sides, these bands are partially ornamented with tracery reserves filled with undulating trelliswork patterns. Three decorative pinnacles are applied to the lower front face of the coffret. In order to deactivate the interior locking mechanism, the hinged right strap at the front lifts to reveal a disguised keyhole. When the key is inserted and turned, it releases a retractable metal bar inside of the coffret, allowing both of the hinged straps and the cover to be raised and opened.

CONDITION: Despite numerous scratches and a stud missing from one of the front straps, the box is in good condition. There is an original repair in the form of an inserted patch of metal skillfully pinned inside the lid, and some metal surface corrosion is evident in the interior chamber. The outer surfaces were wire-brushed and lacquered at some later date.

PROVENANCE: Purchased from Blumka Gallery, New York.

COMMENTARY: Early artisans and craftsmen created a profusion of different kinds and sizes of boxes from an equally diverse range of materials so that both mundane and precious objects could be safeguarded during and after transport. While large, iron-strapped trunks and eventually wood *cassoni* (see entry 76) held the bulk of an owner's belongings, the sheer weight and cumbersome nature of such caskets prompted the making of more readily portable containers, like this coffret.

Although iron is not a precious metal, it was used extensively in medieval and Renaissance Europe for the production of monumental architectural components, including lavish church altar screens, cloister gates, grilles, and stair railings. Iron was also widely employed for less imposing, but often equally sumptuous objects, such as jewelry, cutlery, domestic utensils, lockplates, and coffrets. The creation of wrought iron necessitated that the metal be extracted from iron ore and mixed with charcoal. When subjected to intense heat, this compound could be more readily worked by the blacksmiths in order to fashion both decorative and utilitarian works. In the late fourteenth century, the introduction of the blast-furnace, with its capacity of reaching even higher temperatures, enabled the iron to liquify so that it could be poured into molds that were then cast. Casting permitted European iron-workers to maufacture more easily and cheaply a wide range of objects.

This wrought-iron coffret is a superb example from a specific group of caskets that were made in France during the fifteenth century.[1] They are united in that their general architectonic structure and the details of their ornamental repertoire mimic some of the monumental architectural features of the Late Gothic cathedrals of Europe. The Flagg coffret is most closely related to at least four other examples. One is at the Saint Louis Art Museum, and the other three are located in private collections.[2] Two other examples belonging to the Musée Le Secq des Tournelles in Rouen are slightly less compatible, but they are still in general agreement with these coffrets.[3] Another two boxes at The Cloisters in New York and the Musée Le Secq des Tournelles, as well as one that appeared at auction in 1991, can also be included tentatively within this series.[4] These last three are decisively more rustic in design and execution in comparison with the Flagg coffret and the other commensurately sophisticated examples cited above, all of which are more consummately worked and richly embellished with tracery.

It has been suggested that these iron boxes were intended to store the profits or valuables belonging to business establishments, guilds, and other fraternal organizations. Some of them bear pseudo-personalized inscriptions reading O MATER DEI, MEMENTO MEI [O Mother of God, remember me] or MISERERE MEI DEUS [God have mercy on me], intimating that they were also used in individual households.[5] JRB

1. For the defining characteristics of this series, see London 1978b, pt. 1, pp. 115-116.

2. Consult Saint Louis 1953, p. 50; Houston 1966, p. 190, no. 305; Bergamo 1984, pp. 173-74, figs. 202, 203.

3. See Rouen 1924, vol. 2, p. 23, nos. 1356, 1376, pl. 398; Rouen 1968, pl. 398.

4. New York 1975, p. 28, no. 12; Rouen 1924, vol. 2, p. 23, no. 1361, pl. 396; Rouen 1968, pl. 396c; Sotheby's New York, June 1, 1991, lot 125. It remains possible that these three coffrets are of Spanish and not French derivation.

5. The inscribed caskets appear in Rouen 1968, pl. 398; Bergamo 1984, p. 174, fig. 203.

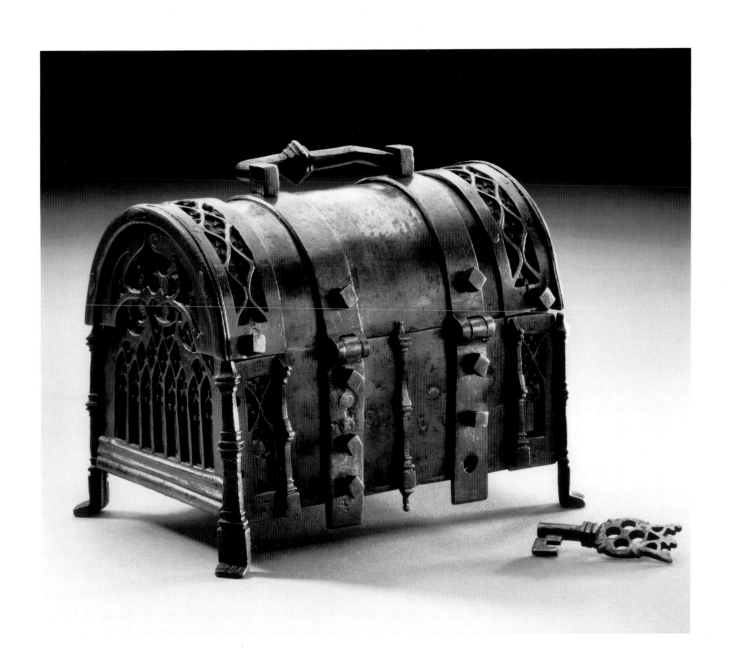

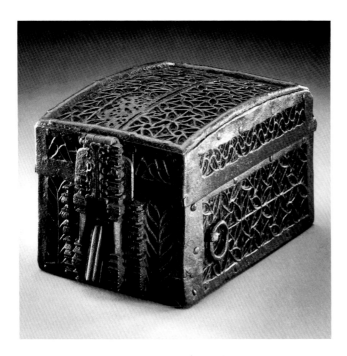

34. *Missal Box*

France
15th century
Wrought, cut, and chiseled iron with fabric over an oak core
3 7/8 x 4 1/2 x 7 in. (9.8 x 11.4 x 17.8 cm)
M1980.178

DESCRIPTION: This rectangular missal box has a gently domed and slightly recessed hinged cover. The core of the box, constructed from precut planks of wood covered with a coarse fabric, is sheathed with two layers of openwork iron panels adorned with swirling Gothic tracery patterns of trefoils, quatrefoils, and stalks enframed by plain bands. These outer panels and the lid are reinforced by iron bars and fixed into position with tiny nails. The front of the container is outfitted with a richly ornamented lockplate of architectonic form composed of crocketed buttresses arranged in stages. Entrance to the interior chamber is reached by lifting the buttressed hasp and a second inner lift, which reveals a concealed keyhole. Suspension rings for ease of transport are attached to the box's long sides and the back panel. A simple, loop-handle iron key accompanies the box.

CONDITION: The iron panels have sustained losses to the traceried reserves and the iron straps have split in several locations. Portions of the flat metal plate on the bottom of the casket are missing, exposing portions of the wood core and fragments of the original fabric lining, which is badly deteriorated. The wood on the lid interior has a long split along the grain. The top of the once elongated buttress on the left side of the lockplate has broken away.

PROVENANCE: Purchased from Blumka Gallery, New York, 1967.

COMMENTARY: One primary challenge confronting medieval and Renaissance travelers was the storage and protection of their possessions during their journeys. Craftsmen responded to this need by producing a broad assortment of different boxes. The Flagg missal box represents one of the most popular types of metal containers made during this period, and, as its name implies, was probably used to store an individual's missal as well as other personal effects. It has been suggested that the suspension rings permitted this kind of box to be strapped to a belt, saddle, or possibly to the inside of a trunk too ponderous to be readily stolen, where it would also have been safe from the inevitable buffeting and jostling of the trip.[1]

The major stylistic features of the Flagg box—the elaborate tracery in the panels and the crocketed buttresses of the lockplate—recall the corresponding architectural elements that grace the facades of contemporaneous French Gothic cathedrals. Missal boxes echoing this monumental style were generated in vast quantities.[2] Scholars have debated whether their origin was in France and/or Spain during the fifteenth and sixteenth centuries. D'Allemagne, Starkie Gardner, and others have postulated that these caskets, like those itemized in contemporary inventories, are decorated in the Spanish manner, but the enchanting character and use of Late Gothic motifs that distinguish these boxes are comparable to caskets universally accepted as French.[3] It remains reasonable to conclude that the Flagg example was created by a blacksmith active in France during the fifteenth century. JRB

1. New York 1975, p. 149, no. 169a,b.

2. Select examples include Rouen 1924, vol. 2, p. 23, nos. 1366-69, 1371, 1375, 1379, 1389, pls. 397-99; d'Allemagne 1928, vol. 1, pp. 116, 141-61; vol. 3, p. 487, no. 8, pl. 316; Bergamo 1984, pp. 254-58, figs. 318-24; Florence 1989, p. 281, no. 74.

3. See d'Allemagne 1928, vol. 3, p. 487, no. 8, pl. 316; New York 1975, p. 149, no. 169a,b; London 1978b, pt. 2, pp. 74-75.

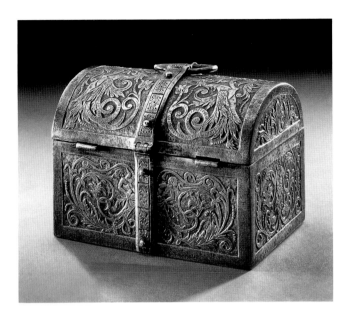

35. *Strongbox*

Nuremberg
Late 16th to early 17th century
Wrought, cut, and chiseled iron
5 1/4 x 7 5/8 x 5 in. (13.3 x 19.4 x 12.7 cm)
L280.1993

DESCRIPTION: This stout, trunk-shaped strongbox is outfitted with a rudimentary oval handle that passes under a slender, prolongated strap band studded with bosses and chiseled with tiny registers of quatrefoil flourishes. One side of the box is hinged, and the other has two thumb pushes to release the strap handle. Originally, the strongbox was opened by inserting and turning several separate keys into three holes of varying sizes on the box's bottom. The central stippled fields of the iron panels on the vaulted roof and the body of the strongbox are masterfully and painstakingly cut and chiseled with addorsed chimeras, anthemion clusters, and counterpoised tritons and tritonesses amid stalk-and-thistle-sprays.

CONDITION: The metal surfaces are slightly abraded from overcleaning with a wire brush. One thumb push is locked in place.

PROVENANCE: Samuel Yellin, Philadelphia; purchased from Blumka Gallery, New York, 1967.

COMMENTARY: For centuries Nuremberg, together with neighboring Augsburg, was one of the major metal producing centers in Europe. This imperial city provided a fertile and hospitable climate for master artisans and craftsmen working in base metals. These armorers, locksmiths, and founders carried out official monumental commissions, while supplying smaller functional and luxury objects such as swords, pistol-mounts, locks-and-keys, door-knockers, and statuettes made from iron, steel, or brass. One of the most popular items created throughout the sixteenth and seventeenth centuries was iron or steel caskets with engraved or etched designs.

The Flagg strongbox comes from the important collection of historic ironwork assembled by Samuel Yellin (1885-1940), the distinguished American designer of architectural decorative ironwork.[1] Its basic shape, ornamental vocabulary, and the virtuosity of the cut and chiseled relief decoration find compelling analogies with a select number of other caskets.[2] The motifs on the Flagg box were influenced by ornamental patterns invented by Nuremberg graphic artists such as Peter Flötner (1493-1546) and Hans Sebald Beham (1500-1550).[3] Surviving ornamental plaquettes and goldsmiths' models with similar decorative schemes known to have been executed in Nuremberg at the end of the sixteenth century indicate that the strongbox in Milwaukee was also created there.[4]

German blacksmiths consistently demonstrated the ability to devise complicated interior locking devices such as the one employed on this strongbox. This technology culminated eventually in the intricate locks with multishooting bolts used on the delicate miniature boxes by the Nuremberg artist Michael Mann (see entry 36). JRB

1. Regarding Samuel Yellin, see Flint 1985, *passim*; Ocean City 1992, *passim*. Concerning Yellin's collection of historic ironwork, consult Taylor 1929, pp. 7-15; Vincent 1964, p. 272; Allentown 1980, pp. 108-109, 117-118, nos. 116, 123-24; Flint 1985, pp. 28-29; Ocean City 1992, pp. 8-10, 15-17, figs. 16-18, 21, 33.

2. Related strongboxes are published by d'Allemagne 1928, vol. 1, pp. 116, 141-61, no. 8, pl. 128; vol. 3, pp. 427, 487, nos. 3, 5, pl. 316; Rouen 1968, pls. 399, 400, 404H, 404I; Bergamo 1984, pp. 321-22, 326-29, figs. 436, 440, 451, 457.

3. For their prints, see Bange 1926, pp. 28, 37, 40, 53, 55, nos. 36, 37, 51(6), 52; Butsch 1969, pls. 208, 209.

4. See Weber 1975, vol. 1, pp. 196-97, nos. 376, 377; vol. 2, pls. 102,103; Nuremberg and Munich 1985, pp. 410-411, no. 511.

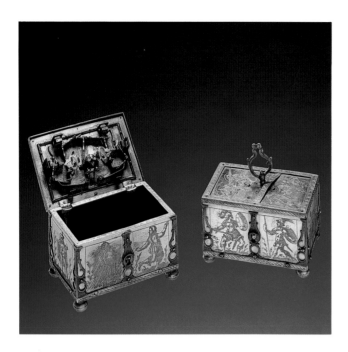

36. *Miniature Boxes with Keys*

Michael Mann (ca. 1589-1630)
Nuremberg
ca. 1630
Gilt brass, copper, silver, iron, and steel
Each: 2 1/2 x 2 7/8 x 1 7/8 in. (6.4 x 7.3 x 4.8 cm)
M1991.101, M1991.102

DESCRIPTION: Resting on ball feet, these two tiny rectangular caskets have flat lids ornately hinged at the back. Although not a pair, both boxes are the same size, identical in construction, and similar in ornamentation. The corners and the centers of the front and reverse sides are encased and reinforced with voluted, appliqué mounts in silver pinned into position with iron screws. Most of the slightly recessed brass panels on the tops, sides, and bottoms are engraved with military men or fashionable ladies and gentlemen. These plaques are enclosed and protected by narrow bands decorously engraved with guilloche or wave motifs. The elaborate, partially etched, steel locking mechanisms are located on the undersides of the covers. Each box is opened from the top by means of a florid, scroll-headed key, which activates a series of either six or nine shooting bolts, triggering the disarmament of the complex, interior locking devices.

CONDITION: One of the boxes lacks its loop handle. The metal surfaces are marginally scratched, the gilding is slightly abraded, and some of the bands are bent. Wear has slightly distorted and flattened the ball feet to varying degrees on both pieces. The interior walls of one of these caskets was painted red, probably during the nineteenth century.

MARKS AND INSCRIPTIONS: Engraved on the narrow copper strap traversing diagonally across the lid of each box is the signature: MICHEL [sic] MANN.

PROVENANCE: Purchased from A la Vieille Russie, New York, 1971.

COMMENTARY: These two daintily lightweight boxes are distinguished by their artistic sensitivity and technical sophistication. Miniature boxes such as these were intended to delight the eye and intrigue the mind. Their intimate appeal lies in their precious dimensions and contrasting metals, each of which adds its own distinctive coloration and luster. Equally engaging is the unbridled spontaneity of the engraving on the individual plaques. They feature people from all walks of life–dueling soldiers, lute-playing cavaliers, romantically cavorting couples, and a kneeling bird-catcher– as well as a leaping stag and a rustic farmhouse. These diverse images are copied from at least three series of prints dating from 1579, 1586, and 1590 by the Nuremberg-based artist Jost Amman (1539-1591).[1]

Miniature caskets of this specific caliber are generically referred to as "Michael Mann Boxes," because so many of them, including the two Flagg examples, carry the signature or initials of this master metalsmith.[2] Active in Augsburg by 1589, Mann thereafter relocated to Nuremberg, dying in nearby Wöhrd sometime after 1630.[3] He manufactured a number of iron pistols, and other works in diverse metals, but his major contribution consisted of these small boxes. These showpieces of virtuosity and ingenuity might also have functioned as repositories for small pieces of jewelry or other cherished miscellaneous trinkets. JRB

1. A few of these prints are illustrated in Hollstein 1954, vol. 2, pp. 17, 48, nos. 73-80, 233; Becker 1961, pp. 91-93, 133-36.

2. Closely related examples are published by Philippovich 1966, pp. 207-208, fig. 141; Pankofer 1973, pp. 58-59; Bergamo 1984, p. 324, fig. 447.

3. On Michael Mann, see Thieme-Becker 1930, vol. 24, p. 20; Philippovich 1966, pp. 207-210; Pankofer 1973, p. 15; Cleveland 1975, no. 191, Augsburg 1980, p. 296, no. 893; Bergamo 1984, pp. 320, 323, 325, 327.

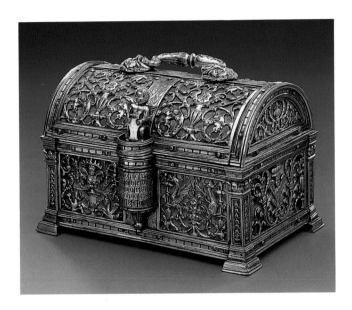

37. *Coffret with Revolving Combination Lock*

Probably Paris
Mid-16th century
Gilt bronze, copper, and velvet over a wood core
5 1/2 x 7 x 4 1/2 in. (14 x 17.8 x 11.4 cm)
M1991.76

DESCRIPTION: This oblong, gilt bronze coffret has a turreted and lettered combination lock topped by a putto clasping a shield. The red velvet, which originally covered the entire wood substructure, would have shown through the openwork bronze panels as an attractive backdrop. Each plaque is pierced with fanciful motifs, including cherub heads, sea-and-air creatures, and grotesque masks that rise from or flank central urns engulfed within rinceaux of acanthus sprays. The intersecting bands on both the gabled cover and lower receptacle are embellished with dentils, and the copper straps that crisscross the lid are finely engraved with whimsical candelabra and grotesque masks. Mounted on the cover is a swing handle bisected by a middle ring and acanthus loops protruding from the mouths of two grotesques. Columns terminating in padded supports accentuate the four corners.

CONDITION: Little remains of the velvet lining. The metal surfaces are lightly scratched, and the gilding has been partially rubbed away. Some of the attachment pins are missing, and the escutcheon held by the putto may have once been painted with the owner's coat of arms.

PROVENANCE: Purchased from Blumka Gallery, New York, 1967.

COMMENTARY: Unlike the earlier French coffrets in the Flagg collection, the overall style and individual details of this resplendent coffret are based on antique and Renaissance architectural sources rather than late medieval ones. Here, the grotesques–those curious medleys of human and semihuman figures, fabulous beasts, and exaggerated plant forms–have their roots in the painted and stuccoed interiors of ancient buildings excavated during the Renaissance. By the mid-sixteenth century, these motifs had spread north from Italy to the rest of Europe through prints, drawings, and ornament pattern books. While the grotesques on the Flagg coffret are reminiscent of those found on ornamental plaques of sixteenth-century German and Netherlandish origin, they are more closely related to the grotesques in decorative pattern and other books that were printed in sixteenth-century Paris.[1] Thus, our coffret was most likely produced there.

The casket belongs to a small group of little-studied coffrets created in France during the sixteenth century. They share an identical or similar skeletal framework, but often differ markedly in their ornamentation. Closest to the Flagg example is a coffret at the Bargello in Florence which is also fitted with openwork bronze plaques.[2] Four other comparable coffrets with similar frameworks and locks should also be considered part of this series.[3] A proper, but hitherto overlooked, connection certainly exists between the design, style, and technical fabrication of the skeletal frameworks of this group of coffrets and the caskets bearing enameled plaques that were produced in the workshops in Limoges during the sixteenth century.[4] JRB

1. For the plaques, see Weber 1975, vol. 1, pp. 135-36, 260, 267, nos. 195,1-195, 4, M548, 577; vol. 2, pls. 58, 156, 160; for the Parisian book illustrations, see Butsch 1969, pls. 106, 109, 111-113, 115, 119, 128.

2. Unpublished, the coffret at the Museo Nazionale del Bargello in Florence is part of the Carrand Collection, inv. no. 789c.

3. For these other examples, see Frederik Müller et cie Amsterdam, November 23-25, 1937, p. 45, lot 392; Bergamo 1984, pp. 192-93, fig. 229; Sotheby's London, December 12, 1985, lot 22. The fourth one is at the Victoria and Albert Museum, London, inv. no. M.3627-1856.

4. Compare the skeletal structures of the Limoges caskets catalogued in Baltimore 1967, pp. 92-94, 132-37, nos. 45, 67.

38. Coffret with Tooled Hunting Scenes

Possibly Friesland, Northeastern Flanders
Late 16th to early 17th century
Tooled, stamped, and gilded leather over a wood core
7 x 9 1/2 x 6 3/4 in. (17.8 x 24.1 x 17.2 cm)
M1991.74

DESCRIPTION: Luxuriously tooled, stamped, and gilded leather completely swathes the wood foundation of this trunk-shaped casket. Hinged at the reverse, the high-arched lid is mounted with a central swing handle headed by a gadrooned knop flanked by terminal finials. The cover has an intermediate beveled ledge that is repeated at the bottom immediately above the ball feet of the receptacle. The leather surfaces of the casket are neatly subdivided into separate, symmetrically disposed fields. Metal punches were used to stamp the leather surfaces with tightly interwoven and continuously repeating ornamental patterns and narrative vignettes, and goldleaf was then applied with heated tools. Vitruvian scrolls, double-voluted arabesques, sprig-and-petal sprays, and diaper reserves occupy the narrower bands enframing the larger central fields decorated with scenes of falcon hunts, flocks of falcons, and jousting knights. The leather panel on the right side is detachable, disclosing a hidden drawer that runs the entire length of the casket. Loop handles are affixed to the short ends of the coffret, and its front side is outfitted with a shield-shaped keyhole.

CONDITION: The leather has dried, warped, and darkened with age, and the lower right front corner has been repaired. A missing iron element in the form of a crown served originally as the upper component of the lockplate above the still preserved shield-shaped keyhole device below. Modern red paper lines the main chamber of the casket and drawer.

PROVENANCE: Purchased from Edward R. Lubin, New York, 1971.

PUBLICATIONS: Worcester, Massachusetts, Worcester Art Museum, *The Virtuoso Craftsman: Northern and European Design in the Sixteenth Century*. Text by John David Farmer. Worcester, 1969, pp. 170-71, 173, no. 90.

EXHIBITIONS: Worcester, Massachusetts, Worcester Art Museum, "The Virtuoso Craftsman: Northern and European Design in the Sixteenth Century," 1969.

COMMENTARY: During the medieval and Renaissance periods, European leather workers generated a prodigious array of luxury goods for both secular and ecclesiastical use. Such objects often bear eloquent testimony to the genteel social customs or the sacred ministerial rituals enacted during the ages in which they were created. Parade shields, helmets, sword-scabbards, and a host of other ceremonial leather artifacts satisfied the then prevailing passion for civic pageantry. Sumptuously ornamented coffrets like the Flagg example, as well as flagons, quivers, quill cases, document containers, and bookbindings, were some of the other secular necessities produced from leather. Simultaneously, the Church required durable leather receptacles to house costly liturgical treasures made from precious metals and other materials. Often these leather repositories were molded to the shape of the ecclesiastical splendors that were to be stored inside.

This casket is part of a stylistically and technically unified series of elegant leather coffrets widely regarded as being of Flemish, French, or Italian origin.[1] Although they date from the late Renaissance, their picturesque hunt and joust scenes clearly evolve from the earlier amorous and chivalrous depictions found on the *Minnekastchen* or medieval caskets that were presented by suitors courting their ladies.[2] Thus, the themes and motifs on the Flagg coffret openly allude to love and romance. The knights are meant to be interpreted as gentlemen pursuers, the falcons as beloved damsels, and the animals, such as the dogs symbolizing fidelity, all reflect contemporary social mores pertaining to the coquettish chase and capture associated with youthful courtship and marriage.

Farmer publishes the Milwaukee coffret as having been made in Antwerp, but no convincing proof exists to substantiate this claim[3]. More compelling are the opinions about this group of leather coffrets set forth by Gall.[4] He points out that the costumes worn by the hunters are datable to the close of the sixteenth century, and he calls attention to one example from the series in Munich that bears the arms of Charles V (1500-1550) and the fleurs-de-lys of the House of Bourbon. These factors persuade him to conclude that these coffrets were created by late sixteenth-century Flemish leather workers. Storm van Leeuwen notes stylistic and technical parallels between the way in which these coffrets are decorated by means of metal stamps and the same technique used in the ornamentation of an extant leather bookbinding, which he postulates was made in Friesland in about 1625.[5] Quite plausibly, these coffrets were fabricated in or at least received their surface embellishments in bookbinders' ateliers. JRB

1. See d'Allemagne 1928, vol. 1, pp. 116, 141-61, no. 6, pl. 128; vol. 3, p. 427; Gall 1965, pp. 232-35, figs. 171, 172; Bergamo 1984, p. 167, fig. 195.

2. Concerning *Minnekastchen* and the symbolism inherent in their decorative vocabulary, see Kohlhaussen 1928, pp. 11, 13, 38-61; Gall 1965, pp. 31, 33; Gall 1967, pp. 261-63.

3. Worcester 1969, pp. 170-71, 173, no. 90.

4. Gall 1965, pp. 232-35, figs. 171, 172.

5. Antwerp 1983, pp. 47, 127, no. 56.

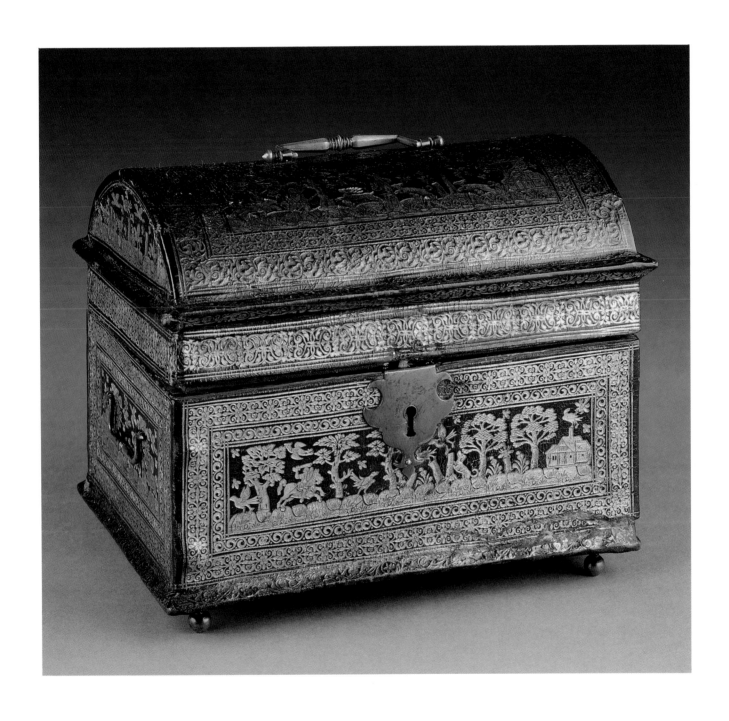

39. *Wild Man Chess Box*

Alsace, France or Black Forest, Germany
ca. 1440-70
Polychromed and gilded bone over an oak core
2 3/4 x 6 1/8 x 7 1/4 in. (7 x 15.7 x 18.4 cm)
M1991.77

DESCRIPTION: This rectangular chess box is composed of carved bone plaques that depict wild men and scenes related to the theme of the hunt. The six panels on the lid represent wild men, bearing shields and clubs, and two dragons, one of which has the characteristics of a wyvern, a winged, dragonlike monster. These panels are enframed by a carved border of vine scroll design. On the front of the box, two men with snares flank the now missing lock; on the back side are leaping hounds. The lateral sides are decorated with a huntsman blowing a horn, accompanied by a running hound, and a hunter armed with a spear and pursuing a wild boar. The bottom of the box has a chess board formed of bone and wood squares. Five rings located along the sides of the box once held a carrying cord for convenient transport. Traces of original red, green, and brown polychromy and some gilding remain on the carved surfaces.

CONDITION: Miscellaneous areas of bone loss have been replaced with ivory or synthetic resin in early repairs. The present hinges are of later date and the original hasp lock is no longer extant. Drill holes from the original hinges and the gap left by the missing lock have been plugged or covered with pieces of ivory. Early repairs can also be discerned on the upper right corner of the lid and just above the back rear hinge. There is a surprising amount of surviving polychromy and some traces of gilding on all surfaces. The original wood core is still intact, and the box overall is in very good condition.

PROVENANCE: Purchased from Blumka Gallery, New York, 1968.

PUBLICATIONS: Randall, Richard H., Jr. *The Golden Age of Ivory: Gothic Carvings in North American Collections.* New York, 1993, pp. 129-30, no. 197.

COMMENTARY: Known in Persia as the Play of the King, the ancient game of chess was a popular courtly entertainment and pastime in fifteenth-century Europe. Small carrying boxes like this one with a chess board on the bottom were made to satisfy the demand for the convenient transport and ready play of the game.

Game paraphernalia of this type as well as a variety of secular objects were originally made of ivory, but as the market for these items grew, artisans switched from ivory to the cheaper and more plentiful material of polished bone.[1] The widespread production of bone artifacts from this period often makes it difficult to ascertain a country of origin, however, the similarity of our box to one with a coat of arms from the region of Strasbourg and Baden-Baden would place it and several related chess boxes solidly in the Black Forest or Alsace regions of the Upper Rhine. The use of stock images and motifs may even indicate a single workshop.[2]

The carvings on these chess boxes typically have a rough, folk-art charm, featuring somewhat crude but vigorous figures of the hunt, wild men, musicians, jesters, or dancers, typically set in outdoor scenes of merriment, romance, or an abundant hunt, all bordered by vine scrolls. While on some boxes from this workshop wild men appear to guard the locks, ours is the only one where they are featured prominently on the lid.

These mythic, forest inhabitants are identifiable by their long beards and the shaggy hair that covers their bodies. Originally considered cave-dwelling monsters, these men and women were viewed as primitive, aggressive, and lustful, and were often held responsible for the calamities of nature. By the fifteenth century, however, increasing urbanization had transformed wild men into emblems of primeval strength and endurance romanticized for their virility and carefree lifestyle. Their superhuman and erotic exploits were especially favored themes in courtly literature, illluminated manuscripts, and domestic artifacts ranging from candleholders to tapestries.[3] Their appearance on the Flagg box may function as a metaphor for the thrill of risk accompanying the pleasures of chess, itself a contest where a quarry is the goal.[4]

Related chess boxes are located in the Fine Arts Museums of San Francisco, the Princeton University Art Museum, and The Metropolitan Museum of Art.[5] The Metropolitan example is particularly close to the Flagg box, with almost identical figures of hunters, leaping dogs, and wild men. (For further discussion of Renaissance games and game boards, see entries 40 and 41.) EFG

1. Detroit 1997, p. 16.

2. Randall 1993, pp. 128-30; Beard 1935, pp. 238-39; Lawrence 1969, p. 72, no. 86; New York 1975, no. 220; Koechlin 1924, no. 1317.

3. Durham 1991, pp. 246-48.

4. It has also been suggested that the dragons may represent vice, which is here symbolically kept in check by the wild men. See New York 1980, pp. 77-78.

5. Randall 1993, pp. 128-29, nos. 195, 196; New Brunswick 1989, p. 60, no. 24.

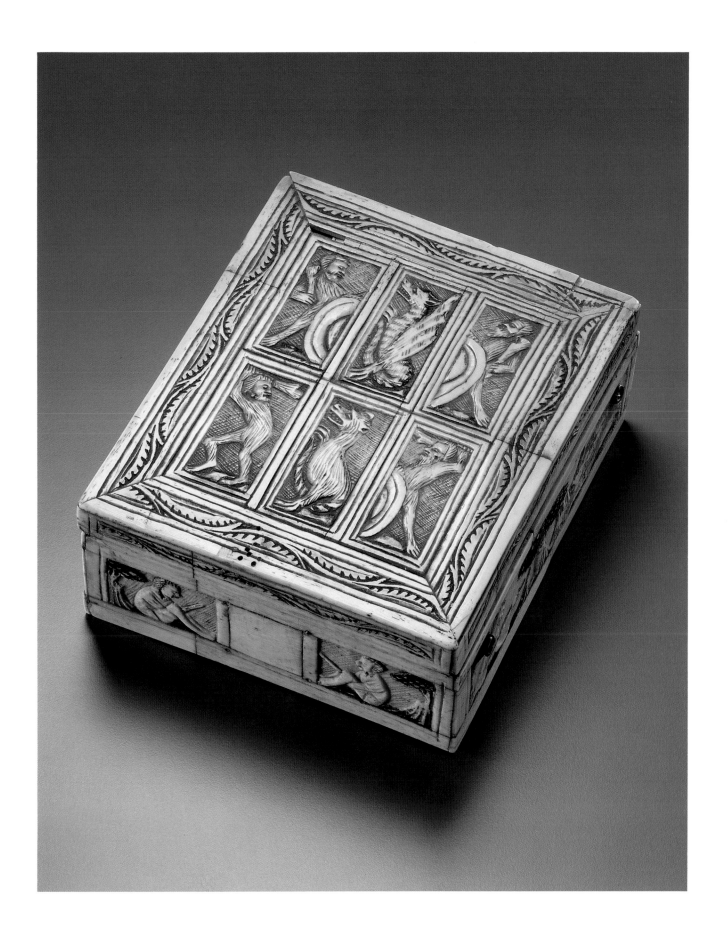

40. *Game Box with Hunting Scenes*

(After engravings by Virgil Solis, 1514-1562)
Germany
After 1540
Ebony with mahogany and ivory inlay
Closed: 2 1/4 x 16 x 16 in. (5.7 x 40.6 x 40.6 cm)
Open: 1 1/8 x 16 x 32 in. (2.9 x 42.9 x 43.2 cm)
M1981.164

DESCRIPTION: This hinged triple games box with exterior nine-men's morris and chess boards opens to form a double backgammon game board. The inside borders are inlaid with ebony and ivory and beautifully engraved with scenes of stag, bear, boar, and hare hunting. The board itself is composed of marquetry inlays of mahogany and ivory wedges ornamented with hop-leaf vines and fleurs-de-lys. Strapwork cartouches with the chariots of Mars and Apollo respectively adorn the center of each inner board; these are flanked by birds set within medallions. The exterior nine-men's morris board incorporates a number of cartouches and Latin proverbs. The ivory squares of the exterior chess board are decorated with medallions containing antique- and Renaissance-style profiles. The borders framing the outside games all have a central cartouche representing one of Aesop's fables flanked by birds, animals, or acrobat grotesques, with a full-length allegorical figure with a musical instrument or attribute in each corner.

INSCRIPTIONS: MARS and SOL are separately inscribed in the two central cartouches of the backgammon board. The name ESOPI [Aesop] appears eight times in the center cartouches on the outside borders of the chess and morris boards. The following Latin inscriptions appear in a clockwise orientation: NECESSARIVS EST NECESSARIVS / VNVS VIR NVLLVS VIR / NE BENE MEREARE DESINE / FESTINA LENTE / VNA HIRVNDO NON FACIT VER / SINAPI NICTITAT / FIGVLVS FIGVLVM ODIT / AEQNA LANCE / NE PATRIS SVI NOMEN NOVIT / REMACV TETIGISTI / LONGE REGVM MANVS / GEDENDUM MALIS / SIMILIS SIMILI GAVDET / IN DIEM VIVERE / MALO ASINO VEHITVR / LEX ET REGIO / SACIETAS FEROCIAM PARIT / CHARETVS POLLI ITAT IONES / SAT CITO SI SAT BENE / IN AQVA SEMEMENTM FACIS / DIMIDIVM PLIVS TOTO / DII BONA LABORIBVS VEHITVR / SAPERE POST FACTVM. [What must be must be / One man no man / Cease that I may not be beholden / Make haste slowly / One swallow does not a springtime make / Mustard (makes one) blink / A potter hates a potter / With an equal platter/ Let him not know the name of his father / You have hit the nail on the head / The hands of kings reach far / One must yield to misfortune / Like delights in like / Live for the day / He is transported by a bad donkey /

Law and boundary / Closeness breeds fierceness / Charms and promises / Quickly enough is well enough / You are sowing your seeds in water / The half is greater than the whole / Good is conveyed through toil / To know after the fact.][1]

CONDITION: The inner backgammon boards are well preserved. There are some cracks along the central reserves, and several areas in the upper-right inner corner and along the edges where missing strips of ivory have been replaced. The exterior panel with the nine-men's morris game has some inpainting, and some of the profiles on the chess board have been over painted to recapture lost details. There are a number of minor cracks throughout the exterior boards.

PROVENANCE: Frédéric Spitzer, Paris (sale, Spitzer Legacy, Anderson Galleries, New York, January 9-12, 1929, lot 258); purchased from Edward R. Lubin, New York, 1971.

PUBLICATIONS: *La Collection Spitzer: Antiquité, Moyen-Age, Renaissance.* Paris, 1892, vol. 5, p. 253, no. 2, pl. 64; *Catalogue des objets d'art…Collection Spitzer.* Paris, June 16, 1893, vol. 1, p. 217, lot 2989, vol. 2, pl. LXIV.

COMMENTARY: Board games–originally laid out on the ground or on a table–are as old as human history. Some were enjoyed as brief respite from toil by ordinary people, but, as the elaborately decorated game boards and pieces found in 3,000-year-old royal tombs in Mesopotamia and Egypt attest, the more time-consuming games were long associated with privileged leisure. Contrasting with a chaotic world, these boards and their successors represent a beautiful and orderly microcosm.

Chess and backgammon, favorite pastimes of the upper classes in the Middle Ages, were even more popular in the sixteenth century, despite long-standing religious strictures against game playing and gambling. Prompted by the Church's disapproval, a number of manuals and treatises were written justifying the moral and educational values of chess and other games.[2]

Then as now with game theory, board games were viewed as a serious as well as entertaining pursuit, a sort of training for the game of life. The pieces and moves in chess, for example, were seen as analogous to good and bad characters, behaviors, and situations. It is thus not surprising to find on sixteenth-century game boards fables and proverbs underscoring such values. The character-building aspects of the game are further emphasized on the Flagg box by the medallion-type portraits of Renaissance and ancient rulers considered worthy of imitation. Inspirational portraits such as these were also frequently carved on game pieces.

The depiction of the hunt as recreation fits the aristocratic milieu for which game boxes such as this one were intended. Not only are game playing and hunting symbolically analo-

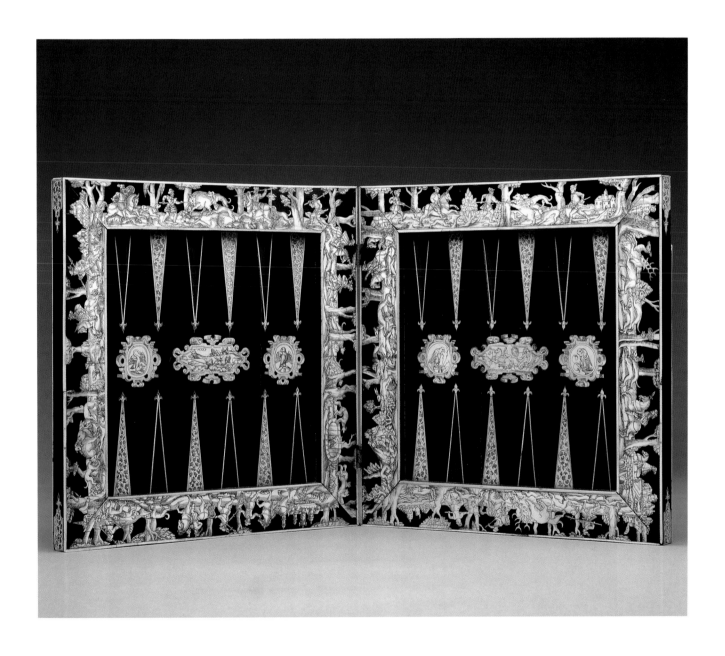

gous, but both were considered arts as well as pastimes. The presence of the war god Mars refers to the combat element in games like chess, itself originally a model of military strategy. The god Apollo, also identified as the Roman sun god Sol, controls the daylight hours and also stands for the arts and all that is rational and civilized in society. Sol may also function as a witty play on the name Virgil Solis.

Hinged triple game boards folding to form a shallow portable box were popular in Europe from the fourteenth century on, providing a choice of games as well as storage for pieces and counters. Most triple games boxes have a chess board (a war game) on one side, a nine-men's morris board (a game of position like tic-tac-toe) on the other, and backgammon (a race toward a goal game) inside. While French game boards might be adorned with enamel plaques, the intimate qualities of ivory inlay were preferred for game board decor in southern Germany.

Game boards such as this one were favorite vehicles for craftsmen's skills, which thrived in a flourishing art market nourished by the wealth brought into southern Germany by the Fugger banking family of Augsburg. Made of costly imported ivory, ebony, and other fine woods, they were commissioned by kings and wealthy merchants. They were often made by artisans using pattern books who worked in a variety of related crafts, including glass, metal, cabinet- and gunstock-making. One of the most famous game boards is the 1537 carved wood backgammon board made for King Ferdinand I by the Augsburg sculptor and medallist Hans Kels the Younger, now in the Kunsthistorisches Museum in Vienna. Like the Flagg board, it is adorned with portrait medallions of Renaissance and ancient rulers.[3] There is also the possibility that another game box, attributed to Caspar Lickinger of Gunzburg, cabinetmaker and keeper of the Tirolean Archduke Ferdinand's arsenal, is a pendant to the Flagg box.[4] It too is adorned with inlaid portrait heads and hunting scenes, and all three of these boards are ornamented with the hop-leaf vine motif, a distinctively German form of rinceau or foliated scroll.

German craftsmen also made use of decorative motifs taken from a set of over 600 ornamental and figurative prints by the engraver Virgil Solis (1514-1562). His Nuremberg workshop produced a huge repertoire of Mannerist ornament used well into the seventeenth century. The finely modeled and detailed hunting friezes on the Flagg box correspond loosely to designs by Solis dating from the 1540s.[5] Such hunting scenes often adorned the parade arms and armor of emperors and kings.[6] The decoration of this type of game box also has certain affinities to the workmanship of inlaid gunstocks made during the period. To appreciate the significance of depictions of the hunt on sixteenth-century game boards and armor, one has only to view Hans Burgkmair's celebrated woodcut series the *Triumph of Maximilian I* (1512) in which the main body of the 131-section procession is led by

contingents representing falconry, ibex, deer, boar, and bear hunting.[7] The Triumph was planned by the emperor himself to commemorate his reign as a great knight, huntsman, and patron of the arts–roles perpetuated by his successor Charles V, during whose reign the Flagg game board was probably produced. EFG

1. I would like to thank Patricia A. Marquardt for her translation of these Latin inscriptions.

2. Bell 1960, pp. 60-61.

3. Smith 1994, pp. 342-45, fig. 305.

4. Sotheby's London, May 18-23, 1977, vol. 2, p. 157, lot 1061; Edward R. Lubin, oral communication to Joseph Bliss, October 1994.

5. For friezes of the hunt by Virgil Solis, see O'Dell-Franke 1977, pp. 74-76, nos. g21, g24, g26, g33, g45, g46. Solis is probably the source of similar scenes in the engravings of Franz Brun, which inspired a number of relief plaquettes of ca. 1560. See Berlin 1923, nos. 5757-5759.

6. For an example of a parade shield of Philip II of Spain with a hunting frieze border and triumphal chariots, dated 1552 and signed by the Augsburg armorer Desiderius Helmschmid and the goldsmith Jörg Sigman, see Barcelona and Madrid 1992, pp. 174-83, no. 40.

7. Reproduced in Appelbaum 1964, pls. 5-13.

41. *Pair of Game Boards*

Italy
ca. 1650
Black marble with *scagliola* inlay and ebony frames
a) 1 3/4 x 16 3/4 x 16 7/8 in. (4.4 x 42.5 x 42.9 cm)
b) 1 3/4 x 16 7/8 x 17 in. (4.4 x 42.9 x 43.2 cm)
M1990.149 a,b

DESCRIPTION: This pair of ebony-framed black marble gameboards are inlaid with *scagliola* and decorated with ink in imitation of engraved marble. Both boards have sides for chess that are identically bordered by a grotesquerie frieze of hunting scenes with animals in combat. Their reverse sides have boards for nine-men's morris (a) and backgammon (b), both shown here. The former is ornamented in the center with a battle scene and is bordered by aquatic putti and horse-drawn chariots amidst scrolling acanthus. The wedges of the backgammon board are decorated with rosette-centered rinceaux while birds, putti, and scrolling acanthus fill the border.

CONDITION: The decoration on both boards is rubbed and stained. Old restorations have discolored parts of the chess board (a) and the backgammon board (b). The frames show normal wear through use, and the game boards are generally in good condition.

PROVENANCE: Purchased from Blumka Gallery, New York, 1978.

COMMENTARY: Marble is a favored material in Italy and these game boards continue the tradition of decorated marble furnishings. They also exemplify the taste for simulation characteristic not only of first-century Italy, but of late sixteenth- and seventeenth-century styles in their use of the artificial marble *scagliola*. Invented by the ancient Romans, this technique was rediscovered at the end of the sixteenth century by Florentine artisans in the Medici workshop (Galleria dei Lavori) and was used in table-tops, cabinet inlays, altar fronts, and game boards such as these. Composed of pulverized marble, selenite, glue, and plaster of Paris, *scagliola* was applied to a prepared surface, then heated and polished to a marblelike smoothness.[1] The drawings on the surface imitate engraving–a conceit that appealed to the Baroque fascination with illusionism and witty deception.

The battle scenes and animal combats on these game boards complement the symbolic strife enacted in serious game playing during the Renaissance. Such designs were commonplace by the seventeenth century and those by painter/printmakers such as Antonio Tempesta (1555-1630) are especially close in their ferocity. This severity of the boards is mitigated by the ornamental, curvilinear rhythms of the acanthus, rinceaux, and fantasy figures. Their prototypes are Roman, though they were widely available from the sixteenth century onward through engraved pattern books. In seventeenth-century Bologna and Venice, such works as Odoardo Fialetti's *Grotesques in Friezes* after Poliphilus Giancarli (1608) might have served as models.[2] (See entry 40 for a fuller discussion of Renaissance game boards.) EFG

1. Riccardi-Cubbitt 1992, p. 220.

2. Gruber 1992-94, vol. 1, pp. 120-58; Bartsch 1983, vol. 38, pls. 243-49.

42. *Table Cabinet with Allegorical Figures*

Probably Antwerp
ca. 1625
Ebony, ebonized wood, and ivory over a pine core
21 7/8 x 26 1/2 x 12 1/2 in. (55.6 x 67.3 x 31.8 cm)
M1991.70

DESCRIPTION: The architectural form of this table cabinet opens to reveal a surprisingly complex series of richly ornamented drawers and compartments. The exterior is sheathed in an ebony veneer and inset with engraved ivory panels of varying size over a pine substrate. The back side of the cabinet is ebonized wood. The tripartite facade is adorned with three molded pediments and three large ivory panels that depict the allegorical figures of Faith, Hope, and Charity, surrounded by subsidiary panels of floral, figure, and bird motifs. Geometric bands of engraved ivory animate the facade and create starkly contrasting areas of ebony and ivory.

The center door unlocks to display a series of four drawers decorated with birds and animals of the hunt. These drawers pull out individually and as a single unit to reveal three secret drawers behind them. On the reverse of the center door is an ivory inlay of an urn with flowers. The two flanking panels have the appearance of doors, but are actually drawers fitted with locks that also release the smaller pedimented drawers directly above them. All three of the bottom drawers unlock in the center to pull out as a single unit and are ornamented with animal vignettes. The hinged lid of the gabled roof lifts upward to reveal a recessed chamber and an interior mirror, flanked by ivory panels of a gentleman and a lady. A secret drawer from inside the roof slides to the right by pressing the left end. Both sides of the cabinet have bronze volute handles attached to lion mask bosses. The cabinet rests on wood bracket feet covered in ivory.

CONDITION: The table cabinet has been recently conserved and is in very good condition. Due to shrinkage of the wood substrate, the veneer needed to be stabilized, and numerous loose pieces of ebony and ivory were resecured. One small ivory loss on the right outer edge and another along the edge of the lower-left drawer were filled with a synthetic resin and ornamented. One of the three secret drawers behind the center door is missing. All of the mounts, except for the hinges of the lid and door, are of later date. The lower-left drawer pull is a replacement. The mirror is cracked and discolored. The marbleized paper lining the upper chamber is nineteenth century. The key is original.

PROVENANCE: Purchased from Blumka Gallery, New York, 1968.

COMMENTARY: The concept of the "cabinet," a chest with compartments and drawers, is as old as ancient Egypt. Thirty such chests were discovered in the tomb of Tutankhamen, and in the Old Testament the Ark of the Covenant is described as a cabinet. Similar storage chests existed throughout the Middle Ages, subject to various aesthetic influences, until in the early sixteenth century they came into prominence in Western Europe. In Renaissance Europe the table cabinet first served as a portable writing desk and a place to store writing materials and other valuables. However, during the sixteenth century, the concept of the "writing box" quickly expanded and diversified to include table cabinets for personal valuables, a woman's jewelry, and the specialized "curiosities" of the collector.[1]

Extraordinary efforts were lavished on the decoration of the table cabinet during the Renaissance and the Baroque periods. Gold- and silversmiths, lapidaries, ivory engravers, and sculptors, all contributed to their ornamentation and increasing artistic complexity. Architectural elements were often employed in their design and interiors were commonly made to resemble miniature palaces, with concealed secret drawers and compartments, lending a magical quality to the cabinet and enhancing the virtuosity of the cabinetmaker's art.[2] Larger cabinets could have as many as two hundred drawers with more than a dozen secret chambers. By the early seventeenth century, the container had in effect become as precious as the objects inside.

The architectural form and decoration of the Flagg cabinet suggest that it served chiefly as a safe place for a woman's valuables and jewels. The top lid opens to reveal a mirror at the back, and the center drawers conceal secret drawers for smaller objects. The allegorical ivory panels display the three Theological Virtues: Faith, Hope, and Charity. The figure of Charity, the third and greatest of the three, is shown prominently in the center with two suckling infants, while Faith and Hope hold their respective attributes of a cross and an anchor. All three Virtues are based on the descriptions and accompanying illustrations in Cesare Ripa's *Iconologia*, first published in 1593 and again in 1603 with woodcut illustrations.[3] Ripa's handbook was widely available in numerous editions and translations by the early seventeenth century. The presence of the Theological Virtues on the Flagg cabinet may have served as a reminder that pleasure and worldly gain must not take precedence over Christian principles.[4] LW

1. For the development of table cabinets, consult Riccardi-Cubitt 1992, *passim*.

2. Ibid., pp. 11-12.

3. Ripa 1758-60, pp. VIII-IX, p. 84, no. 84, p. 175, no. 75.

4. For related cabinets, see Riccardi-Cubitt 1992, p. 189, no. 29; Sotheby's New York, January 9-10, 1996, p. 272, lot 398; Sotheby's London, May 29, 1998, p. 51, lot 53; Sotheby's New York, January 9, 1991, lot 216.

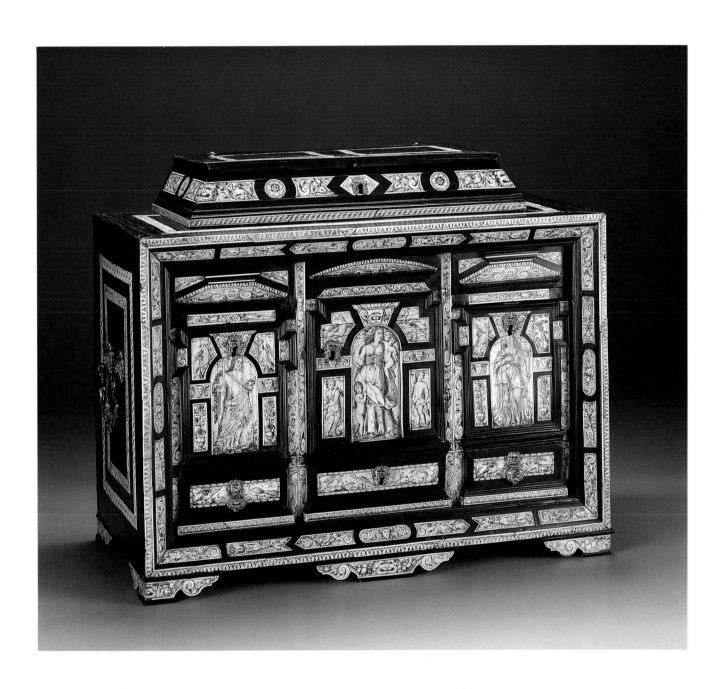

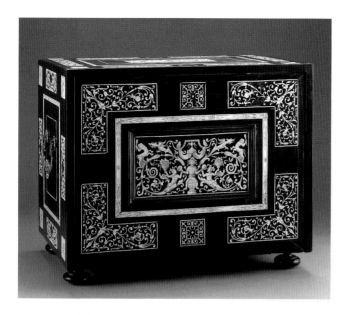

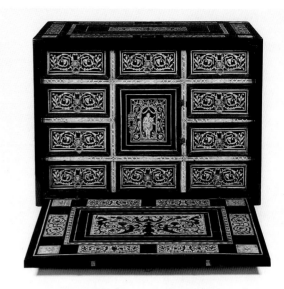

43. *Table Cabinet with Front-fall Door*

Germany or Nothern Italy
Early 17th century
Ebony, ivory, and gilt bronze mounts
Closed: 16 1/4 x 20 x 12 7/8 in. (41.3 x 50.8 x 32.7 cm)
M1989.120

DESCRIPTION: This ebony and ivory inlaid table cabinet has a locking fall-front door that opens downward to reveal a cupboard door surrounded by ten drawers. The door's central exterior panel depicts a jester straddling a barrel with attendant demifigures, centaurs, griffins, birds, and acanthus scrolls. Subsidiary ivory bands and panels of arabesques enrich the corners of the facade. The same designs appear in reverse on the inside of the panel. A youthful Apollo garbed in a tunic and holding a lyre embellishes the cupboard door, while swirling arabesques enliven the flanking drawers. The sides of the cabinet have square decorated registers, petal reserves, and bronze volute handles; the top is similarly ornamented. The cabinet is supported on turned wood feet.

CONDITION: The cabinet has recently been conserved and is in a state of good preservation. There are shrinkage cracks in the cabinet's exterior and miscellaneous repairs have been made to the ivory and ebony veneer. All of the surfaces were uniformly sanded in an early restoration, which has diminished the ivory's natural patina. Inside of the cabinet, the small drawers have been reconstructed and the handles replaced. The feet are of later date. The key is original.

PROVENANCE: Reportedly from the Fugger collection; purchased from Blumka Gallery, New York, 1968.

COMMENTARY: This type of table cabinet, with concealed drawers behind a hinged fall-front door, has its origins in the fifteenth-century Spanish *vargueño* or "writing box." Originally a writing desk with shelves, the *vargueño* gradually evolved into a smaller, easily transportable cabinet that could be used to carry writing materials and other valuables, while its hinged flap could serve as a support for writing.[1] The vast Hapsburg empire in the sixteenth century helped spread this form throughout Western Europe, where it underwent regional transformations. In Italy and Germany, the functional aspect of the writing desk merged with the Renaissance concept of the *studiolo* or humanist chamber to create a table cabinet with a fall-front door that was used to store "curiosities," such as small artworks and natural wonders.

The Flagg cabinet's decoration suggests that it was intended for a sophisticated patron. The ingenious black-and-white inlays not only had witty appeal, but may also reflect contemporary Spanish court dress, which had become fashionable throughout Europe in the early seventeenth century.[2] The presence of Apollo, god of poetry and music, alludes to the rational and civilized side of man's nature. Cabinets of this caliber were often commissioned as diplomatic gifts or exchanged among royalty.[3] LW

1. Riccardi-Cubitt 1992, pp. 24, 36-38.

2. Ibid., p. 49.

3. For related cabinets, see Sotheby's London, July 18, 1980, p. 214, lot 214; Sotheby's New York, June 22, 1989, p. 234, lot 234; Sotheby's New York, January 13, 1995, lot 1163; Sotheby's New York, January 9-10, 1996, p. 273, lot 399; Kreisel 1968, vol. 1, p. 338, no. 379, pl. 379.

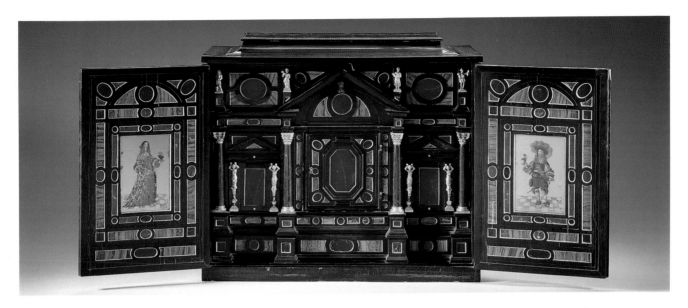

44. *Table Cabinet with Pietra Dura*

Possibly Italy
19th century
Ebony, lapis lazuli, tiger's eye marble, silver, tortoise-shell, gilt bronze, and polychrome
Closed: 22 x 25 5/8 x 12 1/2 in. (55.9 x 65.1 x 31.8 cm)
M1991.98

DESCRIPTION: A pair of ripple molded doors open to reveal a palatial facade with twenty-one compartments and brilliantly colored stone inlays. The interior door panels are inset with geometric inlays of lapis lazuli, tiger's eye marble, tortoise-shell, and painted mirrors that display respectively a lady and a gentleman in seventeenth-century dress. The tripartite facade is punctuated by a large broken pediment, a center cupboard door flanked by lapis lazuli columns, and smaller flanking pediments supported by caryatids. The cupboard door opens onto a richly ornamented compartment that is guarded by caryatid figures and sheathed with engraved brass plates and a mirror. This entire chamber can be removed for access to eight hidden drawers, which in turn can be lifted out to expose yet another secret chamber. On either side of the cupboard door are four drawers accented with caryatid figures and smaller pediments, and directly above the latter are narrow drawers supported by Corinthian columns. The gabled roof lifts to reveal a mirror on the underside of the lid; a secret drawer from inside the roof slides out to the right. Three disguised drawers pull out from the cabinet's base. Gilt bronze figurines of the seasons accent the upper facade.

CONDITION: Some stonework has been resecured and veneer losses compensated with ebony. Vertical shrinkage cracks appear on the doors' exterior and in the wood surrounding the stone inlays. The painted figures have suffered extensive losses. The gold-flecked cadmium red paint covering the interiors of the drawers came into use after the first half of the nineteenth century.

PROVENANCE: Purchased from A La Vielle Russie, New York, 1968.

COMMENTARY: This elaborate, palatial table cabinet with inset stonework imitates cabinetry work of seventeenth-century Florence. The workshop of *commesso di pietre dure* (inlaid semiprecious stones and marble) started in the mid-sixteenth century under the Medici and rose to prominence in the seventeenth century with cabinetry designs that combined *pietra dura*, gilt bronze mounts, and dark ebony surfaces in architectonic forms that resembled miniature palaces with sumptuous surfaces and complex inner chambers.[1] Innovations in Roman Baroque architecture, such as broken pediments and recessed niches, occur throughout their designs. Agate, amethyst, rock-crystal, jasper, and lapis lazuli were among the favorite materials of the workshop.

The Flagg cabinet is an excellent example of interest in the nineteenth century in reviving the Florentine technique of *pietra dura*. The materials used are exquisite and rare, but the drawer construction, in particular the dovetailing; the types of nails, screws, and hinges; and the interior polychrome all suggest that the cabinet dates from the late nineteenth century. The production of high quality *pietra dura* cabinets was revitalized in the nineteenth century for travelers on the Grand Tour, and it seems likely that the Flagg piece is from that period. LW

1. See Riccardi-Cubitt 1992, pp. 73-77 for an account of *pietra dura* cabinets.

45. *Girdle with Biblical Plaquettes*

Probably Hungary or Germany
Late 16th century
Parcel-gilt silver
Overall: 2 5/8 x 31 3/4 in. (5.7 x 80.6 cm)
Each plaquette: 2 5/8 x 1 1/8 in. (6.7 x 2.9 cm)
M1991.82

DESCRIPTION: This cast and chased silver gilt girdle is composed of ten hinged, rectangular plaquettes and a circular end plaquette or buckle, representing Charity with two suckling infants enframed by columns and a rope twist border with five projecting balls. A hook soldered on the back fastens the belt by slipping into a hinged looped clasp adorned with a pair of stags. The plaquettes depict David and Goliath (repeated three times), the Good Samaritan (twice), the Vision of St. Paul (twice), Gideon and the Fleece (twice), and one unidentified scene with a robed figure blessing a kneeling figure. The plaquettes are ornamented with zigzag borders and have pilasters formed of caryatid figures between them.

CONDITION: The buckle shows normal wear and rubbing around the clasp and projecting balls. There are some losses to the gilding on the front of the plaquettes; scratches and minor casting flaws and cracks occur throughout the plaquettes and on the connecting pilasters. The reverse is ungilded.

MARKS AND INSCRIPTIONS: Several of the plaquettes are marked on the back with an F set within a diamond-shaped frame, a control mark used in Brno/Brünn of the Austro-Hungarian Repunzierungspunzen of 1806-1807.[1] The plaquettes are scratched on the back right edge with assembly marks in the form of Roman numerals. The buckle backplate is scratched with an unidentified LO[A?]T 50.

PROVENANCE: Purchased from a dealer in Germany before 1939.

COMMENTARY: Costume and objects of personal adornment were rich and varied for both men and women during the Renaissance. Common forms of jewelry included necklaces, link-chains and girdles, pendants, hat badges, hair ornaments, and earrings. Such luxury items conveyed social standing at a time when class distinctions were beginning to lessen in areas of Western Europe.[2]

Girdles or belts became an essential part of dress during the early Middle Ages. The belt, usually of plain leather, cinched together the simple unfitted garments. After the twelfth century, the leather girdle for both men and women became an important item of jewelry decorated with metal links, clasps, buckles, and occasionally silver or gold ornaments.

Beginning in the late thirteenth century, extravagant girdles might even be entirely of gold or silver. In the fourteenth century they were elaborately ornamented with long tongues that often hung to the floor. A century later girdles were a shorter waist-length style with a buckle for fastening.[3] Since pockets were still unknown, girdles were often designed with special hooks and clasps for the attachment of money purses, keys, weapons, rosary beads, or even devotional books.[4]

Sixteenth-century jewelry is distinguished by an extraordinary unity of style, due in great part to the initial training of many artists in goldsmiths' workshops. During the second half of the sixteenth century, the publication in Nuremberg and Augsburg of engraved pattern books for jewelers and goldsmiths contributed to a standardization of forms. Religious and figural themes for girdles gained increased importance during the sixteenth century, though after the Reformation such subjects tended toward the generalized representation of virtues, as few patrons wished to have their religious commitments evident at first glance.[5]

The Flagg plaquettes display religious subjects dealing with virtuous male behavior that would have appealed to a man from a ruling house. They are based on goldsmiths' models and were very likely supplied by a workshop that specialized in producing stock decorations for caskets, inkwells, and jewelry cases.[6] For example, Charity is based upon Peter Flötner's allegorical model, and Gideon and the Fleece is based on an Upper Rhenish copper model.[7] The absence of a maker's mark on the Flagg piece may suggest that it was made by a goldsmith or jeweler familiar with South German practices but working in Eastern Europe where guild requirements were generally looser. The design of Gideon's armor, datable to about 1570, would place the Flagg piece in the last quarter of the sixteenth century.[8] By the early seventeenth century, figurative jewelry and goldsmith production had begun to go out of style in favor of metalwork with inset jewels. LW

1. Tardy 1977, p. 398. I would like to thank Richard Edgcumbe, letter, May 18, 1998, for identifying the Austro-Hungarian control mark.

2. For a general history of costume, see New York 1975, pp. 69-73; Phillips 1996, pp. 75-96.

3. Lightbown 1996, p. 520; New York 1975, pp. 74-75.

4. New York 1975, p. 74.

5. Hackenbroch 1996, p. 521.

6. Yvonne Hackenbroch, letter, May 20, 1998. For related plaquettes, see Berlin 1981, p. 125, no. 47; Nuremberg 1989, pp. 131-58; Christie's London, December 5, 1989, lot 32 (attrib. to Transylvania).

7. For the goldsmiths' models mentioned here, see Bange 1926, p. 93, no. 7046, pl. 12; London 1995, p. 97, no. 42c.

8. Richard Edgcumbe, letter, May 18, 1998.

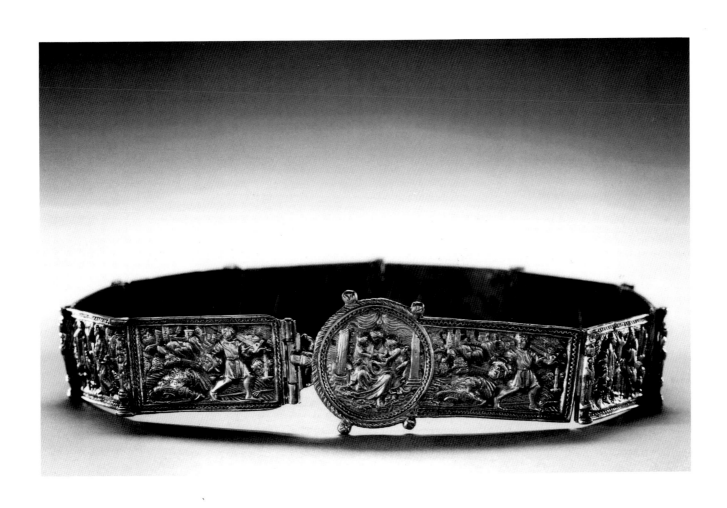

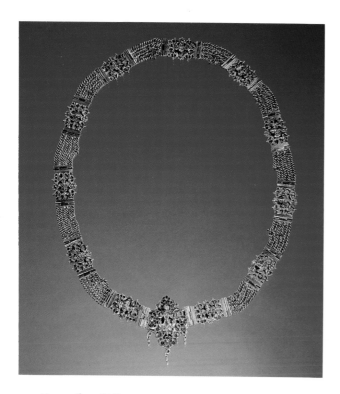

46. *Link Chain with Plaquettes*

Probably Hungary
ca. 1600
Silver, parcel-gilt silver, and enamel
3 1/4 x 39 1/4 in. (8.3 x 99.7 cm)
Buckle: 2 3/4 x 2 3/4 in. (7.0 x 7.0 cm)
M1991.88

DESCRIPTION: This silver and parcel-gilt silver link chain or belt consists of a large ornamented clasp and eleven gilt plaquettes alternating with ten, triple-row links of silver. All of the components are individually hinged together. The cartouche-shaped clasp is dominated by a silver harpielike term surrounded by four enameled rosettes, applied gilt foliate scrolls, and hung with three pendant or tassel drops. The smaller plaquettes are similarly ornamented with foliate scrolls and a silver winged cherub head. They are attached to underlying plates on the reverse by pins which pass through the cherub heads, rosettes, and the figure on the clasp. The chain fastens by means of a pierced clasp on the proper right side which attaches to the adjacent plaquette.

MARKS AND INSCRIPTIONS: The reverse of the clasp is engraved with 38 LO[A?]T and the letters MS. The backplate of each plaquette is scratched with Roman numerals for assembly.

CONDITION: There are significant losses of blue enamel in the rosettes, and minor scratches and surface abrasions throughout.

PROVENANCE: Purchased from Ernst Pinkus Antiques, New York.

COMMENTARY: The availability of precious metals in Hungary was paralleled by flourishing goldsmith and jewelry production from the fourteenth to the seventeenth century. At the height of the Middle Ages, Hungary's output of gold was the highest in Europe, and by the fifteenth century their work was much admired throughout Europe. Under Turkish domination in the sixteenth century, many Hungarian goldsmiths settled in Transylvania and parts of the Uplands. Invigorated by contact with German and Turkish goldsmiths, Hungarian artisans found new forms of technical and artistic expression that came to be known as specifically Hungarian.[1]

A common form of Hungarian jewelry for both men and women was the link chain hung with jeweled or enamelwork pendants. Chains were worn around the neck, fastened to the bodice, or looped low on the hips as belts. The Flagg example was probably worn as a belt by a Hungarian noblewoman. Such chains have innumerable variations: elaborate links shaped like tiny amphorae or small globules, and still others were reeded.[2] By the late sixteenth century, they were often decorated with plaquettes enlivened by filigree and a unique enamelwork developed in Transylvania, and known as "Transylvanian." This ornamental, colorful technique is characterized by flower or organic shapes created from round or flattened twist wires filled with opaque enamel.[3] It was typically used in the ornamentation of silver jewelry, clothing accessories, tankards, and goblets.[4]

The Flagg chain is consistent with Hungarian goldsmith practices around 1600. The cherub heads, for example, are found on other Hungarian and German belts of the period.[5] There is even a goldsmith's lead model for a similar head in the Bayerischen Nationalmuseum.[6] A number of related examples with alternating chains and plaquettes are located in the Hungarian National Museum, Budapest.[7] LW

1. Héjj-Détári 1965, pp. 7-8, 33-34.

2. Ibid., p. 36.

3. Speel 1998, pp. 76-77.

4. For information on this technique, consult Mihalik 1961, pp. 28-32.

5. For related works, see Egger 1984, pp. 50-51, fig. 29; Héjj-Détári 1965, p. 61, no. 29, pl. 29.

6. Seelig 1989, no. 154.

7. Mihalik 1961, pp. 30-31, nos. 42, 43, pls. 42, 43.

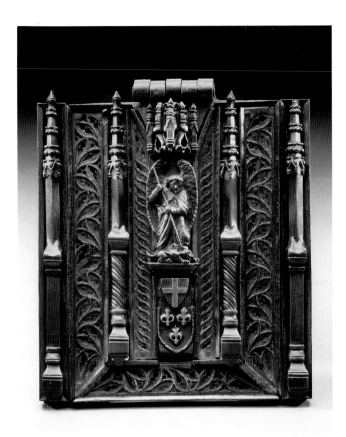

47. *Lockplate with St. Michael Slaying the Dragon*

France
ca. 1475-1575
Cast, wrought, cut, and chiseled iron
8 x 7 x 2 1/2 in. (20.3 x 17.8 x 6.4 cm)
M1991.72

DESCRIPTION: Inspired by Late Gothic architecture, this lockplate is divided into three vertical compartments flanked by four piers. The traceried panels between and below these pinnacles further echo medieval architectural forms. The central panel, into which the hinge and hasp components of the lock are unobtrusively integrated, is composed of an overhanging canopy of crocketed buttresses beneath which stands a sculptural relief of the Archangel Michael Slaying the Dragon. St. Michael's wings and determined expression are spendidly rendered. Immediately below appears the keyhole guard, bearing an escutcheon consisting of a cross set within a shield and three fleurs-de-lys beneath.

CONDITION: The shield on the keyhole guard, emblazoned with the cross of the Order of St. George, is a

later replacement. Also modern are the four pinnacles, one of which lacks its finial. A portion of the original lock mechanism is still preserved on the reverse of the backplate.

PROVENANCE: Purchased from Blumka Gallery, New York, 1967.

COMMENTARY: Lavishly adorned lockplates, such as the Flagg example, were created in France in response to the demand by nobles and wealthy merchants for both simple and complex keys and locks. This need for privacy and security also contributed to the elevated status and respect enjoyed by the locksmiths themselves. In order to maintain high manufacturing standards, the guild of iron-workers required that apprentices submit a presentation piece in the form of a lock and key to demonstrate competency before being admitted into the guild.

Many of these talented and itinerant artisans migrated from court to court in search of employment. The outstanding quality of this lockplate and the inclusion of the French royal fleurs-de-lys within its ornamental vocabulary indicate that it might have been undertaken within such a courtly milieu, where it would have been mounted on a large wooden trunk or strongbox, perhaps one owned by a member of the French monarchy, a courtier, or a foreign ambassador.[1]

The Flagg lockplate reflects the highly specialized nature of early European locksmithing, a craft that merged mechanical ingenuity with artistic beauty. The keyhole guard tilts easily outward to uncover a crudely cut keyhole. Originally, the key would have disarmed an inner locking device, releasing the elongated hasp so that it could be opened and raised over and away by means of the revolving hinge from the top of the lockplate. Formed from three separate panels, the hefty backplate enabled the entire lockplate to be completely encased within the wooden chest. It would have been installed at the front of the chest with the hinge attached to the outer edge of the cover.

A particularly close example of a lockplate with the Archangel Michael is in the Saint Louis Art Museum.[2] Other examples with figures of saints, Christ, and kings exist in numerous public and private collections.[3] JRB

1. For the type of wooden chest on which locks of this kind would have been installed, see London 1978b, pt. 1, p. 79, pl. 19; Rouen 1968, pls. 391, 394.

2. Saint Louis 1953, p. 50; Lawrence 1969, pp. 91-92, no. 119, pl. 64.

3. Related examples include Gerspach 1904, p. 39, fig. 53; Bruning 1922, pp. 22-23, fig. 20; Berlin 1963, no. 43; Rouen 1968, pls. 38, 39; London 1978b, pt. 1, pp. 114-115, pls. 41, 42; Florence 1989, pp. 280-81, nos. 72, 73.

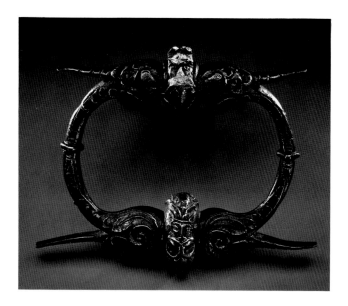

48. *Buckle-shaped Door-Knocker*

France
Mid-16th century
Wrought, cut, and chiseled iron
5 7/8 x 7 1/2 x 7 1/2 in. (14.9 x 19 x 19 cm)
M1991.83

DESCRIPTION: The design of this buckle-shaped door-knocker harmoniously blends naturalistic and fantastic forms. Its upper, spiked and gashed projection is headed by a power-fully modeled, ferociously scowling male mask flanked by low-relief profile busts of a mustached man and an open-mouthed woman gazing directly across at one another from the winged extensions. Ring-shaped framing bars punctuated at mid-section with simple moldings and decorated with foliate motifs curve downwards at each side to meet the counterbalancing lower projection. Here, the bulbous wings are filled with pseudo-acanthus-leaf clusters. At the direct center, a highly dynamic and expressive grotesque mask serves as the hand-lift of the knocker. The apex of the long-stemmed mounting rod that issues from behind the upper projection is articulated with acanthus leaves and volute flourishes. An opening at the bottom and a grooved aperture at the top of the rod were used to affix the knocker to a door.

CONDITION: There is some minor pitting in isolated areas. Certain details on the high spots of the most functional and susceptible portions of the door-knocker have been slightly rubbed away due to constant handling.

PROVENANCE: Samuel Yellin, Philadelphia; purchased from Blumka Gallery, New York, 1968.

COMMENTARY: Albeit a simple, utilitarian object, this door-knocker is also an exceptionally accomplished and visually alluring work of art. It is especially noteworthy for the overall robust quality of its workmanship and for the manner in which the individual components of its novel imagery are clearly and intelligibly orchestrated. Remarkable, too, is the ingenuity with which the blacksmith has manipulated the iron through the cutting and sharpening of individual forms to produce lustrous surface effects which make the entire object resonate with glistening silvery highlights.

Door-knockers like this engaging specimen have long been classified as having been manufactured in France during the sixteenth and seventeenth centuries.[1] Of buckle-and-ring shape, many of them also feature grotesque heads. The choice to include such sinister masks may not have been arbitrary, but rather a conscious decision to introduce an apotropaic device to ward off potential intruders.

Comparable examples include two door-knockers in the Bargello in Florence, published as French sixteenth-century works.[2] Two others belonging to the Musée Le Secq des Tournelles in Rouen are considered by d'Allemagne to be of Parisian origin and datable to the seventeenth century.[3] The two in Rouen are outfitted, however, with backplates ornately pierced with scroll and nautical details. The dolphins on their volutes were inspired by those found on the Venetian Renaissance bronze door-knockers that were popular in that maritime city. Thus, the absorption of this undeniably Italianate influence in the generally more stylish decorative format of the two knockers in Rouen attests to their more cosmopolitan origin. The ones in Milwaukee and Florence were probably made in a more provincial location in France at a somewhat earlier time. JRB

1. For compatible knockers, see Florence 1895, p. 29, pl. 79; Rouen 1924, vol. 1, nos. 399, 417, pl. 118; vol. 2, p. viii; Höver 1967, p. vii, pl. 93; Rouen 1968, pls. 114, 117, 118; Pankofer 1973, p. 67.

2. Consult, for example, Florence 1895, p. 29, pl. 79; Höver 1967, p. vii, pl. 93.

3. See Rouen 1924, vol. 1, nos. 399, 417, pl. 118; vol. 2, p. viii; Rouen 1968, pl. 118.

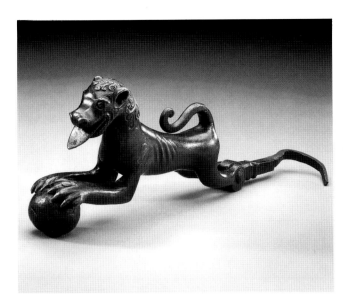

49. *Door-Knocker in the Form of a Lion*

Nuremberg or Augsburg
16th century
Wrought, cut, and chiseled iron
6 x 14 1/2 x 2 1/2 in. (15. 2 x 36. 8 x 6.4 cm)
L270.1993

DESCRIPTION: Superbly forged, this heavy door-knocker assumes the guise of a lion in a pouncing, predatory posture, firmly clutching a separately wrought ball which serves as the handclasp and striking mechanism. The enlarged and expressive head contrasts with the far more schematically conceived and broadly handled body. Located behind the beast is a hinged and revolving suspension bar of square section with a decorative molding. Originally, this now sickle-shaped mounting bracket would have been completely embedded within a massive wooden door with the lion's head hanging downward.

CONDITION: A layer of patina on the uppermost areas of the piece is a later addition. The sounding ball has endured significant damage from repeated usage, and the originally straight mounting bracket has been bent into a curve. The metal striking plate or boss that would have been independently attached to the door beneath the ball is missing.

PROVENANCE: Samuel Yellin, Philadelphia; purchased from Blumka Gallery, New York.

COMMENTARY: This rare door-knocker is an interesting example of early modern European wrought-iron work wherein the pieces have been independently forged and hand-worked at the anvil and then fire-welded and riveted together. The Flagg piece is analogous to only a couple of other lion-shaped iron door-knockers and a roof gable ornament from the sixteenth century.[1] Laborious processes were involved in the fabrication of wrought-iron door-knockers, and it is understandable why these functional objects were more frequently cast in bronze.

Certain seminal characteristics of the Flagg knocker–including the linear grooves defining the lion's mane and the anatomical subdivisions of the haunches, as well as the deeply gouged eyes, ears, and nostrils–are in basic accord with a broad spectrum of animal bronzes cast from wood models in Nuremberg and Augsburg during the sixteenth century.[2] The way in which the lion's tongue extends so prominently is a recurring feature used by goldsmiths in Renaissance Germany and elsewhere (see entry 23). This detail alludes to the blacksmith's likely exposure to contemporary goldsmithing practices. Equally perceptible is the artisan's adherence to conservative modes of artistic expression as reflected in the overall lingering Late Gothic style of the piece itself. Its folkloric charm and toylike character are best evinced in such borrowings as the looped tail of the lion, a motif that derives from medieval German aquamanilia or cast brass water ewers, which like this knocker often took the shape of a lion.[3] JRB

1. See Rouen 1924, vol. 1, pls. 105, 106, 114; vol. 2, p. viii; Rouen 1968, pls. 105F, 106, 114.

2. Selected comparisons would include the bronzes of animals published in Berlin 1923, pp. 23-24, no. 5945; Bange 1949, pp. 22-23, 116, 118, 143-44, nos. 44, 60, 160-62, 164; Weihrauch 1967, pp. 279-80, fig. 332; Berlin 1968, no. 142; New York 1985, p. 31, no. 12; New York 1986, p. 384, no. 184; Stockholm 1992, p. 124, no. 50; Cros 1996, p.157, fig. 49. Insightful and concise surveys about the bronze and brass casting industries in medieval and Renaissance Germany can be found in Oklahoma City 1985, pp. 19-26; New York 1986, pp. 75-80.

3. Compare the handles and tails on the lion aquamanilia illustrated in de Winter 1985, pp. 97, 113-114, fig. 143, col. pl. 21; New York 1986, pp. 79, 138, no. 18, fig. 88.

50. *Keys*

a) Germany
17th century
Forged and cut iron
6 1/4 x 1 3/4 x 3/4 in. (15.9 x 4.4 x 1.9 cm)
M1991.89

b) France
18th century
Forged and cut iron
5 3/4 x 1 3/4 x 1 3/4 in. (14.6 x 4.4 x 4.4 cm)
L281.1993

c) France
17th century
Forged and cut iron
4 1/2 x 2 1/8 x 1/4 in. (11.4 x 5.4 x .6 cm)
M1991.99

DESCRIPTION: These French and German keys of forged and cut iron are decorated with a profusion of Gothic ornament. (a) The long tubular shank of this key is surmounted by a tiered capital and a round handle pierced with scrollwork. The bit or locking plate has paired notches in an overall zigzag pattern. (b) The elaborately wrought and cut handle has the form of an inverted, truncated pyramid that springs from a circular disc that in turn rests on a rectangular base. The thin webs of the pyramid are pierced and cut out with a Gothic tracery design. The locking mechanism at the end of the short hollow shank is cut with an abstract pattern and thin, comblike teeth. (c) The circular handle is pierced with a star-pattern tracery surmounted by a suspension loop. The stout shank has a rectangular bit with notches cut on the bottom and sides.

CONDITION: All three keys display various stages of ferrous corrosion in the pierced work and along the shank and bits. (b) The highly detailed eighteenth-century key has the most compromised condition with a severely corroded turned post inside the handle.

PROVENANCE: Purchased from Blumka Gallery, New York, 1967/68.

COMMENTARY: The commercial revolution of the Renaissance made available more and more property that needed to be protected against theft. At the same time, and no doubt related to the same social forces, the development of private life created a demand for secrecy, for cabinets and chests in which to store objects of personal value. In response to both developments, the lock and key provided a valuable utilitarian service.

However, the aesthetic dimension of these objects was not overlooked, especially in France, where locksmiths were acknowledged to be the greatest masters. A French apprentice, to prove himself worthy of guild membership, had to produce an elaborate masterpiece lock and key that might take up to two years to make. The bows of such keys, as in the Flagg example (b), most often took the form of inverted pyramids with virtuoso displays of skill in the spirals and pierced tracery work. The key, with its capitals, pyramids, and pilasters, could take as long to produce as a lock.[1]

The endorsement of locksmithing by certain of the French kings helped to promote standards and technical achievements in ironwork not witnessed by other countries.[2] From an early age, Louis XIII produced locks and keys as a hobby, and in 1639 installed the locksmith Rossignol at Fontainebleau as a royal locksmith. His doomed descendant Louis XVI agreed with Jean-Jacques Rousseau that every man should know some manual craft, and set about learning several, including locksmithing. Mme. Jeanne-Louise Campan wrote in her *Memoires* that Louis XVI " admitted into his private apartment a common locksmith, with whom he made keys and locks; and his hands, blackened by that sort of work, were often, in my presence, the subject of sharp remonstrances, and even sharp reproaches, from the Queen."[3] LW

1. For related examples, see Frank 1950, pp. 87-107, pl. 38, nos. 149, 151, 152; Rouen 1968, pl. 79.

2. Frank 1950, pp. 50-77.

3. Campan 1900, vol. 1, p. 180.

51. *Nest of Weights*

Probably Georg Mittmann (master 1666-died 1681)
Nuremberg
Last third of the 17th century
Cast bronze
8 1/4 x 5 1/4 x 6 1/2 in. (21 x 13.3 x 16.5 cm)
M1991.90

DESCRIPTION: This nest of weights consists of a box or master cup with a hinged cover and hasp lock that contains a series of eight graduated cups fitted into each other. Each weight is half as heavy as the next larger one, and the entire inner nest weighs exactly twice as much as the case when complete. Each cup is calibrated and marked according to the weight of the coin it is used to measure. The lid of the master cup is surmounted by a swing handle that issues from the backs of two stylized figure supports. Paired seahorses form the clasp and stylized sea-serpents form the hinge of the hasp. The exterior is punched and chased throughout with concentric bands of geometric patterns and serrated borders. The widest, center band is stamped with huntsmen, staghounds, deer, birds, and trees.

CONDITION: The weights show usual wear and surface scratches. Several of the cups have been drilled out on the bottom or inset with lead plugs to achieve their desired weights. Tinted lacquer has left the master cup lid with an uneven surface appearance. The smallest capping weight or disc is missing.

MARKS AND INSCRIPTIONS: The master cup is stamped on the lid with the number 16 and the maker's mark of Georg Mittmann, and on the bottom with the number 8, three fleurs-de-lys, and the control mark for Paris (a crowned

P).[1] These marks repeat randomly on the interior weights, and all of the cups are stamped or incised on the bottom or the rim with their respective weights.

PROVENANCE: Purchased from Arthur Davidson, London.

COMMENTARY: Cup-shaped weights of bronze or brass were used in Europe for at least four hundred years. Their nesting configuration made it possible for merchants and money-changers, who frequently traveled throughout Europe from one commercial fair to another, to have a portable and compact set of weights.[2]

When money consisted exclusively of coined gold or silver, its value depended on the exact weight of the coin. A stamped denomination meant nothing to a money-changer from another country who was interested only in the coin's weight. In a nest of weights used for monetary purposes, each cup was calibrated according to the weight of the coin it was to measure. Pound, livra, lira, ruble, and mark, well known today as monetary units, were originally terms of metallic weight.

All nested weights from the fifteenth to the seventeenth century were made in Nuremberg, a city renowned for craftsmanship and precision. Weights produced there are typically stamped on the lid of the master cup with the maker's mark as well as a control mark for the country where the weights were to be used.[3] The various marks on the Flagg set indicate that the nest was made in Nuremberg by Georg Mittmann and calibrated for use in Paris. LW

1. Kisch 1965, pp. 175, 179, no. 24. Although this mark was used by both Georg Mittmann and Georg Schüller (master 1633) in the mid- and late seventeenth century, the ornamentation on the Flagg nest would suggest Mittmann's hand. For comparable works and additional references to Mittman, see Sotheby's New York, January 12 and 15, 1991, lot 236; Lockner 1981, p. 113, no. 864.

2. For further information on nests of weights, see Kisch 1965, pp. 122-29; New York 1975, p. 130.

3. New York 1975, p. 130.

OBJECTS OF DEVOTION

52. *Processional Cross*

Limoges, France
Late 13th to early 14th century
Gilt bronze and semiprecious stones
23 7/8 x 13 7/8 x 3/4 in. (60.6 x 35.2 x 1.9 cm)
M1991.71

DESCRIPTION: This gilt bronze floriated cross has a square center with broad fleur-de-lys shaped arms for the addition of decorative plaques. The main face, or obverse of the cross, has a repoussé figure of the Crucified Christ identified by the monogram IHS/XRS. The diamond-shaped reserves or plaques attached to each of the arms are embellished with unfaceted precious stones, or cabochons of rock-crystal surrounded by semiprecious stones. The larger cabochons penetrate the body of the cross, and are thus visible from both sides. On the obverse face, the cabochons of the transverse arms are dome-shaped, while on the longer arms they are beveled. The same stones on the reverse are flat. The four arms of the cross are engraved on either side with half-length figures of winged angels flanked by rosettes. The reverse has an engraved three-quarter-length figure of Christ in Majesty. The entire cross is further engraved with bands of punched ornamentation of stippling and incised with acanthuslike flourishes.

The highly stylized figure of Christ, which is attached to the cross by three small nails, replicating the piercing of his hands and feet, is a separate work of repoussé. His chest is rather abstract in form, and his hands somewhat crudely shaped. Christ's torso has also been subtly engraved to show the anatomical details of his chest and abdomen. His head leans to the left and is framed by long hair created by the stippling, or texturing, of the surface using a roulette or matting wheel. Christ wears a loincloth, knotted on the left side, a high open crown recalling the imperial crown of Byzantium, and his feet, shown crossed at almost right angles (right over left), are nailed to a foot stand. His eyes are inlaid with two pearls of blue enamel.

CONDITION: The cross has been regilded, partly obscuring the incised lines of the original engraved decoration. There are numerous dents and abrasions along the edges of the cross, particularly on the base which was fitted into a now lost processional sleeve. Ten of the sixteen semiprecious stones that once adorned the diamond-shaped plaques are now missing, as are all but one of the raised cabochons originally adorning the verso. There is a hole between Christ's nose and mouth, and the nail fastening his left hand to the cross is a modern replacement.

INSCRIPTIONS: The monogram IHS/XRS [IOTA HISA SIGMUS, XI RO SIGMA] meaning Jesus Christ, King of the Jews, is inscribed in two horizontal registers on a square plaque above Christ's head.

PROVENANCE: Bayerisches Nationalmuseum, Munich; purchased from Edgar Mannheimer, Zurich, 1971.

COMMENTARY: In the Middle Ages one of the most important centers for the production of processional crosses, reliquaries, and enameled goods was Limoges, France. The processional cross is, in general, larger than the altar or reliquary cross, and has a distinct function in ceremonies. It was commonly paraded through the streets along with important reliquary statues on major religious holidays.[1] These crosses were specifically designed with mounts, or placed into a shaft or sleeve, and then carried along with banners, reliquaries, thuribles, holy water, candles, and other items of ritual display.[2] Not only did these gilt crosses create a strong iconic impression, they also had a musical component. Small circular bells were hung from numerous holes located on either side of the vertical arms of the cross and along the underside of the transverse arms, further heightening the dramatic impact.

Early medieval crosses were made of gilded wood and embellished with enameled plaques, while later examples such as the Flagg cross are made entirely of metal. Consistent with a date in the late thirteenth or early fourteenth century, the Flagg processional cross is gilt bronze with a repoussé figure of Christ. The repoussé technique, one of the earliest developed by metalsmiths, involves hammering out from the under side of a metal surface to create a work of high relief. The inclusion of a plaque engraved with both IHS and XPS to identify Christ also reaffirms this date, since in later examples the inscription is reduced to simply IHS.[3]

In the Musée de l'Evêché in Limoges are three processional crosses that are comparable to the Flagg cross, though slightly smaller in size.[4] Similar details include floriated arms, a repoussé figure of Christ with feet crossed at right angles, and the incorporation of cabochons. AS

1. According to Ilene Forsyth, the famous gilt statue of St. Foy (ca. 984) was repeatedly carried in processions "trailed by bearers of golden crosses, Gospel books, lighted candles and sounding oliphants." See Forsyth 1972, p. 40; Bouillet 1897, p. 100.

2. The various objects borne in procession are mentioned by Forsyth 1972, pp. 41- 42.

3. Thoby 1953, p. 35.

4. Limoges 1996, pp. 40-43, 48-49, nos. 7, 8, 11.

53. *Monstrance*

(Possibly after a design by Hans Süss von Kulmbach,
ca. 1485-1522)
Nuremberg
ca. 1520
Silver and glass
42 x 12 x 7 1/2 in. (106.7 x 30.5 x 19 cm)
M1991.78

DESCRIPTION: This silver tower monstrance consists of
a high pedestal supporting a glass receptacle surrounded by
multitiered canopies, pinnacles, and flying buttresses. The
base is formed from two fleurs-de-lys creating a six-lobed foot
which is slightly elevated by a perforated foliate border. From
the base extends a hexagonal stem with engraved decoration
and attached reinforcing sleeves slightly above midpoint. An
open arcade of ogee arches with crockets and finials also
surrounds the stem, which then flares to become the base for
a glass container hinged in place and flanked by attenuated
spiral columns.

Three niches created by the elaborate openwork spires house
individual saints in a hierarchical fashion. To the left and
right are a bishop with a crozier and the Virgin and Child.
The two smaller haloed figures on either side of the mon-
strance represent St. Paul with a sword, symbol of authority
and instrument of his martyrdom, and St. Peter holding the
keys of the Church. Three silver foliate balls hang below each
figure on either side. Above the host container, which is
surmounted by an ogee-arch canopy, is a haloed figure of
Christ bearing the marks of his crucifixion. Emaciated and
wearing only a loincloth, he displays the crown of thorns and
wounds to his side and hands. This portrayal of Christ as the
Man of Sorrows or Ecce Homo type reinforces the function of
the monstrance as the receptacle of the host used in the
celebration of the Eucharist.

CONDITION: The silver has been repaired in several
places and replacement screws have been added. The bottom
element of the lower projecting sleeve of the stem is modern,
as are parts of the uppermost section of the monstrance. Two
of the pinnacles above the arched buttresses decorating the
open arcade surrounding the stem are missing. Some repairs
have been made to the hinges of the pierced scroll holding the
modern glass which housed the no longer extant host or relic
stand. The small Virgin and Child is not original to the piece,
and the bishop's brass crozier is modern.

PROVENANCE: Private collection, Switzerland;
purchased from Blumka Gallery, New York, 1970.

PUBLICATIONS: Leeds-Hurwitz, Wendy. *Semiotics and
Communication: Signs, Codes, Cultures.* Hillsdale, New Jersey,
1993, p. 24, fig. 2.1 (as ca. 1480).

COMMENTARY: In 1215 the Fourth Lateran Council
codified the Roman Catholic Doctrine of Transubstantiation,
or belief that the Eucharistic bread and wine becomes the
actual body and blood of Jesus. This led to the elevating of the
sacred host representing the body of Christ during Mass,
thereby making the dogma a visual reality for the celebrants.
With this practice the container for the host or consecrated
wafer became increasingly elaborate. The first covered vessel
used in this ceremony, known as a ciborium, was soon replaced
by the larger and more elaborate monstrance. The housing of
the host in a monstrance for the celebration of the Eucharist
became common after the Feast of Corpus Christi which,
introduced by Pope Urban IV in 1264, became universal after
the promulgation of the bulle of Pope Clement V in 1311.[1]

Perhaps the most elaborate of liturgical vessels, monstrances
have been fashioned as large as five feet tall. Like a reliquary
it is a container for a holy relic or object of veneration, but
whereas reliquaries are often in the shape of the venerated
body part, the monstrance showcases the sacred host elevated
on a disc-shaped stand behind glass or rock-crystal. The
elaborate nature of Gothic tower monstrances required that
they be assembled from component parts. The Flagg
monstrance is formed from a multitude of small parts pinned,
screwed, or eased into position. The glass container, for
example, is held in place by a silver mount with three hinges
at both the top and bottom of the main face or obverse side.
Both the upper section and the base are detachable, as are the
individual hand-tooled finials.

An abundance of finials gives the upper portion of the Flagg
monstrance a pyramidal shape with clear emphasis on the
central vessel, typical of Late Gothic tower monstrances from
the Rhineland. A *Design for a Monstrance* showing one similar
to the Flagg example, now in the Staatliches Museum in
Schwerin, was drawn by the German artist Hans Süss von
Kulmbach around 1518-22.[2] The pen-and-ink design, which
covers four sheets of paper, is the largest of Kulmbach's extant
drawings and his only surviving plan for a goldsmith's work.[3]
Before his death in 1522, Kulmbach was the leading designer
of altarpieces and stained glass in Nuremberg, and possibly the
designer of this monstrance. AS

1. McCracken 1974, p. 280.

2. See Winkler 1942, no. 86, figs. 86, 86a; Perpeet-Frech 1964, no. 213
(as ca. 1510-1515); New York 1986, p. 59, fig. 69. The date has been
corrected to reflect the scholarship of Barbara Butts, author of
"Dürerschüler" Hans Süss von Kulmbach, Ph.D. dissertation, Harvard
University, Cambridge, Massachusetts, 1985.

3. This information and the scale of the entire piece, which measures
58 x 17 in. (147.3 x 43.2 cm), was provided by Barbara Butts, letter,
June 1, 1998.

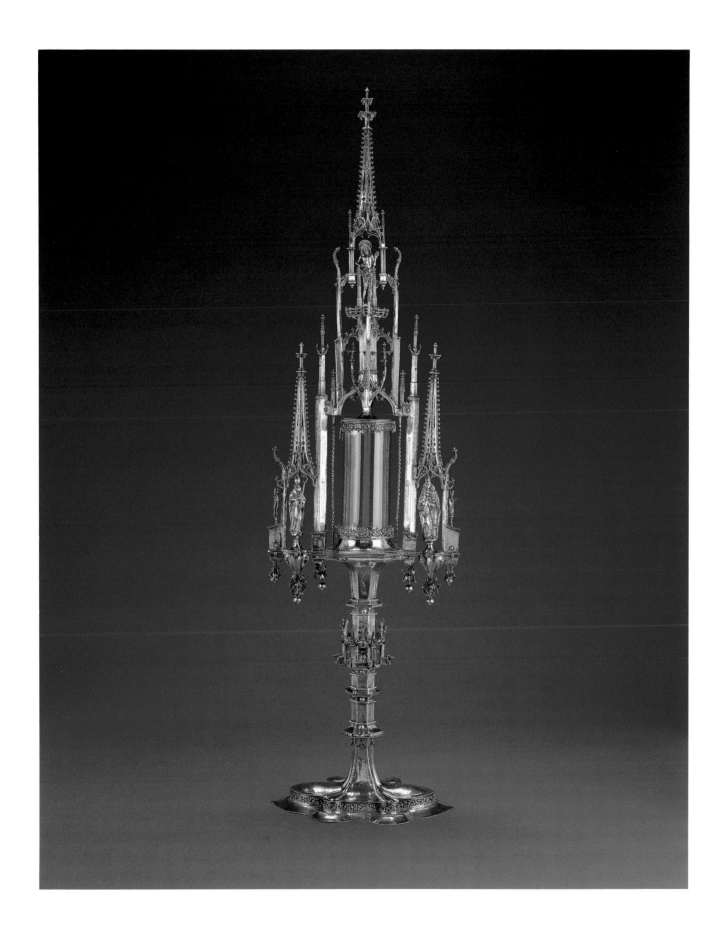

54. *Virgin and Child*

Malines, Brabant (Mechelen, Belgium)
Early 16th century
Polychromed and gilded walnut
16 3/4 x 6 1/4 x 3 1/2 in. (42.5 x 15.9 x 8.9 cm)
M1991.54

DESCRIPTION: This frontally conceived *Virgin and Child*, carved from walnut and extensively gilded, rests on a six-sided polychromed and gilded base. The Virgin stands on a crescent moon and small grass turf. Cradling the Child who holds the gospels, she is represented as an attractive young woman with a high forehead and fine complexion. She is clothed in golden robes like the Child, and her hair is held in place by a *bourrelet* or padded headdress of alternating bands of gold and red, a feature common to devotional images produced in Malines.

CONDITION: This piece is in excellent condition with only a slight chip on the left side, and some inpainting to the Virgin's face. The original polychrome is intact on the figures, though it has flaked off the shorter sides of the base and rubbed off the projecting folds of drapery. Minor worm infestation appears on the back, chest, and sides of the Virgin.

MARKS INSCRIPTIONS: AVE MARIA GRACIA PLENA [Hail Mary Full of Grace] is repeated in semi-Gothic gold lettering along the trim of the Virgin's mantle and on the middle register of the base; capital M, the town mark for Malines, appears in the upper register.

PROVENANCE: Von Pannwitz collection, Hartecamp Castle, Holland; purchased from Rosenberg & Stiebel, New York, 1964.

EXHIBITIONS: Winston-Salem, North Carolina, Gallery of the Public Library of Winston-Salem and Forsyth County, "Collectors' Opportunity," 1963.

PUBLICATIONS: Otto von Falke. *Die Kunstsammlung von Pannwitz*, vol. 2. Munich, 1925, no. 128 (as early 16th century, Rhineland). Winston-Salem, North Carolina, Gallery of the Public Library of Winston-Salem and Forsyth County. *Collectors' Opportunity*. Text by Senta Dietzel Bier. Winston-Salem, 1963, p. 40.

COMMENTARY: Malines (or Mechelen) in north central Belgium, just south of Antwerp, was an important center for the production of gold, silver, lace, and polychromed sculpture. It belonged to the independent duchy of Brabant until the territory was divided between The Netherlands and Belgium in 1830, when the city became part of Belgium. The Dukes of Burgundy and particularly Philip the Good (1396-1467) were responsible for the unification of The Low Countries, until the area was seized by Emperor Charles V in 1519. Throughout this artistic and economic Golden Age, Brussels, Antwerp, and Malines were famous for their elaborately carved wooden altarpieces, retables, and smaller devotional statues such as the Flagg *Virgin and Child*. These were produced in large numbers and then sold or traded on the open market. Significant numbers were sent to the Roman Catholic countries of Spain and Portugal, particularly after Philip II inherited The Low Countries in 1556.[1]

Among the extant polychromed statues sculpted in Malines in the late fifteenth and early sixteenth centuries, this one is of exceptionally high quality. The condition of the gilding attests to the care taken by its artists. To eliminate the wood grain and create a smooth surface, polychromed sculptures were gessoed before being painted. Once painted and gilded, they were commonly varnished to protect them from fading or chipping. Polychroming a sculpture often cost more than the figure itself, because of the high cost of the gold and pigments and the laborious nature of their application.[2] Here the blue in the gown is probably azurite or lapis lazuli, the two semiprecious minerals commonly used to create the intense blues in this type of statuary.

Devotional images of the Virgin and Child, Mary Magdalen, and female saints such as Catherine and Ursula produced in Malines during this period are found in collections across Europe and the United States.[3] Statues of the Virgin were often stamped with the capital letter M, symbol of the Malines guild. Godenne classifies several of these statues of the Virgin by the Latin STELLA MARIS, meaning "Star of the Sea."[4] The crescent moon symbolizing chastity also identifies this figure as the Virgin of the Immaculate Conception.[5] The two statues most similar to the Flagg *Virgin and Child* are the *Virgin of the Immaculate Conception* found in the Musées royaux d'art et d'histoire in Brussels and the *Mary Magdalen* at the Musée de Dijon in France.[6] Like the Flagg figure, these two are extensively gilded, and have similar Gothic inscriptions running the length of their mantles, suggesting that they may have been produced in the same workshop. AS

1. The statuettes of Malines found in the Museu Nacional de Arte Antiga in Lisbon come from the early twentieth-century collections of the Portuguese poet Guerra Junqueiro and Ernesto de Vilhena. See Lisbon 1978 for more on these collections and the statues of Malines in Portugal.

2. Steyaert 1994, p. 15.

3. For an inventory of these works, see Godenne 1957-76.

4. See Godenne 1957-76, vol. 64 (1960), nos. 98, 99; vol. 66 (1962), nos. 118, 131; vol. 73 (1969), nos. 2/154, 2/169; vol. 76 (1972), no. 2/180; vol. 78 (1974), no. 2/249.

5. Rev. 12:1-2.

6. These two figures are illustrated in Lisbon 1978, pp. 32, 44, figs. 6, 18.1.

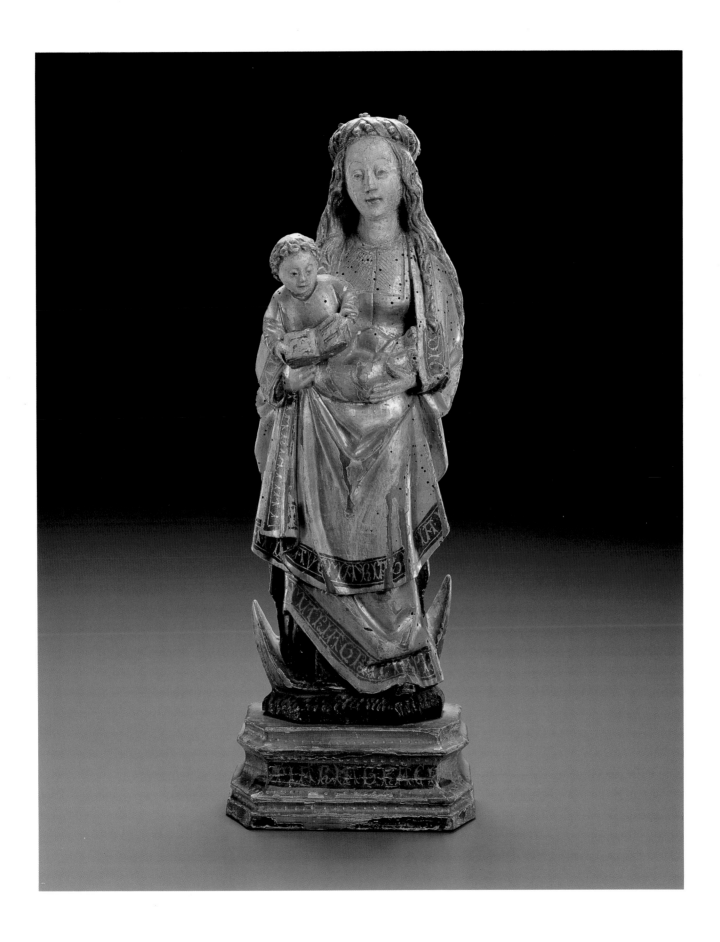

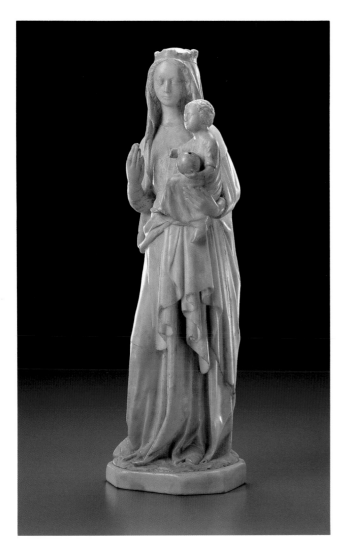

55. *Alabaster Virgin and Child*

Probably Liège (Belgium)
ca. 1350-80
Alabaster with marble base
19 1/4 x 6 x 4 1/4 in. (48.9 x 15.2 x 10.8 cm)
L275.1993

DESCRIPTION: This alabaster *Virgin and Child* rests on an eight-sided marble base. The Virgin is represented as an attractive young woman with soft features and elongated body posed in a slight contrapposto. She wears a plain, belted gown with a mantle and a veil held in place by a simple crown. The Christ Child is garbed in a long tunic and has his right arm raised in benediction. In his left hand he holds an orb symbolizing sovereign authority. The back of the statue has been hollowed out, suggesting that it was once attached to a wall or to a larger altarpiece or tabernacle.

CONDITION: The sculpture is cracked and chipped, and has been extensively repaired. The Virgin's arm has been partially reconstructed and the object once held in her hand is no longer extant. Christ is missing his right forearm, and the orb he holds is missing its cross. The Child's face has surface pitting. There is also a natural vein in the alabaster which runs along the right side of the Virgin's face. The base is of later date.

PROVENANCE: Purchased from Rosenberg & Stiebel, New York, 1965.

EXHIBITIONS: New York, The Metropolitan Museum of Art, The Cloisters, "Medieval Art from Private Collections," 1968-69.

PUBLICATIONS: New York, The Metropolitan Museum of Art, The Cloisters. *Medieval Art from Private Collections*. Text by Carmen Gómez-Moreno, New York, 1968, no. 37 (as Lower Rhenish or Mosan).

COMMENTARY: The Flagg *Virgin and Child* is an excellent example of carved alabaster, a finely grained, relatively translucent stone with white, yellowish, and pink tonalities.[1] It is highly valued because it is soft when first quarried, polishes well, and is rich in color. This particular piece has some streaking or mottling like marble, and a brilliant reddish color caused by iron-oxide staining near the base where the drapery begins to part. Alabaster and ivory were especially valued for their inherent beauty, and sculptures made from them are usually left partially or wholly unpainted, as in this example.[2]

Although alabaster was used throughout Western Europe, the Flagg sculpture can be identified as Mosan, referring to the art produced in the Meuse valley in the diocese of Liège from the reign of Notger (972-1008), first Prince-Bishop of Liège, until the French Revolution. This principality included parts of present-day Belgium, Germany, and France. A closely related *Virgin and Child* (ca. 1360), identified as marble, but possibly alabaster, came from the Cathedral of St. Lambert in Liège (razed 1794).[3] The two statues exhibit the same graceful character and show the Virgin and Child with similar hair, delicate facial features, and soft curving drapery. AS

1. Alabaster is a lime sulfate or crypto-crystalline form of gypsum whereas marble is a calcium carbonate. A chemical reaction occurs when calcium carbonates like marble, limestone, and chalk are exposed to acid, but there is no reaction when alabaster, a lime or calcium sulfate, is subject to the same test. A hydrochloric acid test revealed that the figural group of this sculpture is alabaster and its base marble.

2. Steyaert 1994, p. 15.

3. See Liège 1951, pp. 224-25, no. 434, pl. 62. I would like to thank Paul Williamson for is assistance in dating this piece.

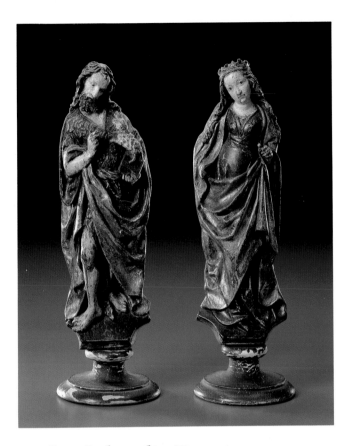

56. *St. John the Baptist and a Female Saint*

Nuremberg
Late 15th century
Polychromed and gilded boxwood
8 1/4 x 2 3/4 in. (21 x 7 cm)
8 1/2 x 2 3/4 in. (21.6 x 7 cm)
L276.1993

DESCRIPTION: These small figures of St. John the Baptist and a female saint, carved out of boxwood, painted, and extensively gilded, are fragments from a larger altarpiece. They stand on carved trefoil bases and are doweled into polychromed circular wooden pedestals. The female saint is an attractive young woman with pale skin, long flowing hair, and a low crown. She wears a blue gown and is swathed in a long and voluminous mantle. Her slight contrapposto stance suggests that she once stood on the right side of a central grouping. The figure of the bearded prophet John the Baptist wears only a camel hide belted around his waist and a flowing mantle which he holds under his right arm. His hair is matted like the penitential camel skin that he wears, and his left leg and foot, visible between the folds of his cloak, are bare. His attributes are the Lamb of God and the Bible.

CONDITION: The two sculptures are in very good condition. The female saint is missing her right hand and there is some paint loss to her left hand, right breast, and draperies. The silver-leaf highlighting on her blue gown has oxidized. Paint loss and minor retouching also occur on the figures' hands, faces, and along the leg of John the Baptist. The female saint's crown is damaged, and her attributes are missing. Small drill holes used to mount the figures are visible at the back of each statue. The wooden pedestals are not original.

PROVENANCE: Purchased from Blumka Gallery, New York, 1967.

EXHIBITIONS: New York, The Metropolitan Museum of Art, The Cloisters, "Medieval Art from Private Collections," 1968-69.

PUBLICATIONS: New York, The Metropolitan Museum of Art, The Cloisters. *Medieval Art from Private Collections*. Text by Carmen Gómez-Moreno. New York, 1968, nos. 65, 66 (as Bavarian or Austrian).

COMMENTARY: These polychromed figures of St. John the Baptist and a female saint are carved almost in the round, but their flat, unfinished backs indicate that they were once incorporated into a larger sculptural setting. Throughout the Middle Ages and Renaissance, small carved figures such as these were made for shrines and altarpieces commissioned by wealthy burghers, guilds, and confraternities for chapels that they founded and dedicated to their patron saints. The scale of the Flagg saints suggests that they were not part of a high altar, but from a smaller private devotional altar, perhaps located within one of the side chapels of a parish church.

Gómez-Moreno describes these types of saints as appliqué figures because they were individually hand-crafted and placed into larger sculptural configurations as freestanding figures.[1] Such statues were created in imitation of the near life-size statues found in high altars throughout Germany and Eastern Europe. Similarities exist, for example, between the Flagg *St. John* and a larger version of the same saint found in the Johanniskirche in Nuremberg, ca. 1470.[2] The late Gothic retable of the high altar in the Klosterkirche, Blaubeuren, Germany, by Michel Erhart, ca. 1493-94, also includes a bearded figure of St. John that is comparable in its stance and general type.[3] AS

1. New York 1968, p. 31.

2. This statue of St. John the Baptist is believed by some scholars to be an early work of Veit Stoss, and arguably the one that helped him establish his reputation. For a more complete discussion, see New York 1986, p. 160, no. 34.

3. Baxandall 1974, pp. 68, 258, fig. 42, pl. 19.

57. *St. Ursula House Altar*

Probably Cologne or Rhineland, Germany
ca. 1520-60
Polychromed wood and oil on panel
Open: 20 7/8 x 11 1/4 x 16 1/2 in. (53 x 28.6 x 42 cm)
Closed: 20 7/8 x 11 1/4 x 5 in. (53 x 28.6 x 12.7 cm)
M1991.58

DESCRIPTION: Inside this small shrine is a statue of St. Ursula surrounded by her entourage: a diminutive pope and two bishops to her right and four small virgins on her left. Ursula's size and gentle embrace identify her as a protectress. Two ornate columns flank the entrance to the shrine. A scallop-shell design lines the semicircular roof. The left painting on the inside of the hinged doors illustrates the martyrdom of the saint and her maidens as they are pelted with arrows by the Huns, pictured on the right panel. A less refined Annunciation appears on the exterior doors: Gabriel occupies one panel and the Virgin with the Holy Spirit comprises the other. Various stylistic elements suggest that the shrine is a composite piece.

CONDITION: The central figure is missing her right forearm and a fragment of the right shoulder. There is some paint loss to the head and the shape suggests that there was once a headpiece. The surrounding figures have been repainted on the faces and on the protruding areas of drapery. Traces of former worm infestation occur throughout. The encasement has been heavily reconstructed and may be later than the figures. The interior paintings are in very good condition with only minor retouches in the sky. The exterior paintings are probably later. The two carved coats of arms on the base have been completely effaced. The door hinges are new.

PROVENANCE: Purchased from Blumka Gallery, New York, 1968.

COMMENTARY: Dedicated to St. Ursula, this house altar was probably commissioned by a wealthy burgher for private devotional use. Smaller shrines such as this were produced in emulation of the elaborate Late Gothic high altarpieces of the fourteenth and fifteenth centuries.

The legend of Ursula has little foundation in fact.[1] In one account she was a sixth-century Christian princess; another has her martyred in Cologne in 237 by Huns returning from defeat at Chalons–a battle that took place in 451. One legend makes her the daughter of a British king, another has her bethrothed to the king's son. When Ursula, a great beauty, finally agreed to marry, she demanded that she first travel for three years, on one account to prolong her chastity, on another account to visit the shrines of the Christian saints.

She was accompanied on her peregrinations by 11,000 (or perhaps only eleven) virgins, perhaps in a convoy of eleven ships.[2] On their return journey, the travelers were massacred at Cologne by Huns who had beseiged the city. Ursula was initially spared, but when she refused to marry the Huns' leader she was shot with three arrows.

In the twelfth century, a site in Cologne was found to contain the remains of a large number of people.[3] These bones were immediately venerated as the relics of Ursula's chaste company. Some difficulty arose when bones of children and men were uncovered, but piety prevailed when a contemporary mystic had a vision of the massacre, and revealed that the virgins were accompanied by Pope Cyriacus and a number of dukes, bishops, and even Ursula's bethrothed, all of whom had been attracted by the piety of her company. Ursula became Cologne's patron saint, and the subject of many of the city's altarpieces.

The stylistic elements of the Flagg shrine reflect both its composite nature and probable Rhenish origin. The interior painted panels, for example, appear to be somewhat provincial, Rhenish versions of the naturalism that developed in Flemish painting during the late fourteenth and fifteenth centuries. The finely detailed facial features, clothing, and weaponry all reflect a similar concern with materiality. The affected poses and extravagant dress of the carved figures also appear to be modeled on the luxurious costumes and mannered stances that are common in fifteenth-century Flemish images of saints.[4]

The shrine's encasement combines Late Gothic and Renaissance elements. The whimsical, undulating columns resemble late fifteenth-century Flemish architecture and enframements, while the more classical shell niche did not enter the Northern European vocabulary until the early sixteenth century.[5] These various stylistic and thematic components suggest that the Flagg shrine was probably produced in Cologne or the Rhineland, and that the encasement may postdate the sculpture inside by several decades. LW

1. For the legend of St. Ursula, see Tervarent 1930, *passim*; Delpy 1910, *passim*; Réau 1959, vol. 3, pt. 3, pp. 1296-1301; Holladay 1997, pp. 67-118. For a general survey of art in Cologne, see Budde 1986, *passim*. I would like to thank Joan A. Holladay for her bibliographic suggestions.

2. The legend seems to have been formulated in the tenth century, at which time the phrase XI MM VV (eleven virgin martyrs) was misinterpreted as XI MILLIA VIRGINIUM (11,000 virgins). See London 1977, p. 163.

3. Tervarent 1930, vol. 1, pp. 21-32.

4. For comparable sculptures, see Sotheby's London, April 18, 1996, lot 20; Manske 1978, pp. 162-63, no. 2, pl. 2; Konrad 1928, p. 12 no. 41, pl. 41.

5. For a similar enframement, see Böhler 1995, no. 7.

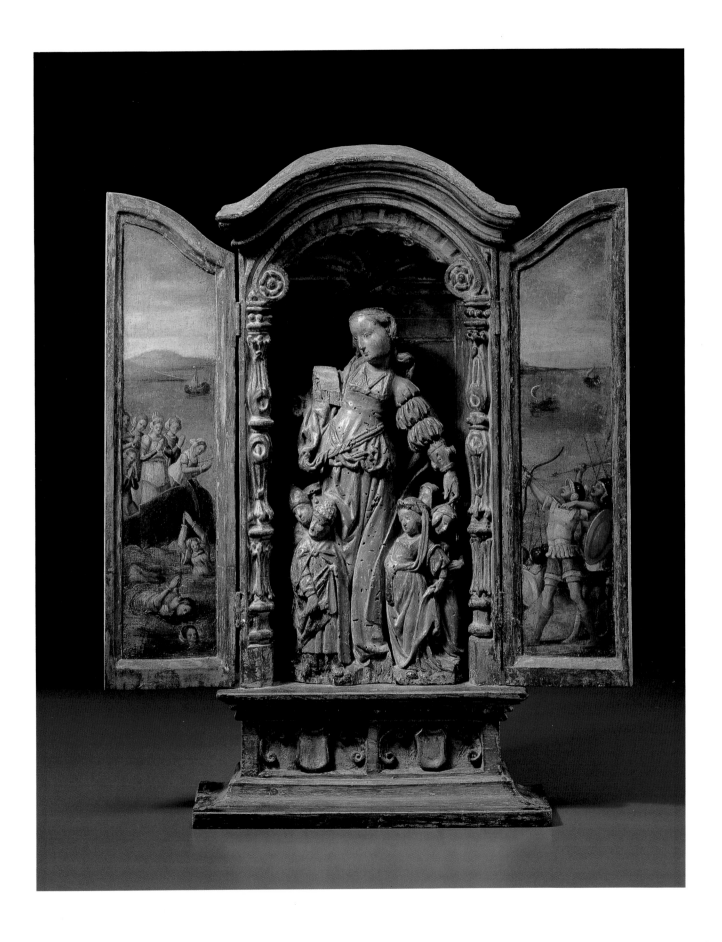

58. *Tabernacle Door with God the Father and the Last Supper*

Probably Circle of Matthias Wallbaum (ca. 1554-1632)
Augsburg
ca. 1600-1625
Cast and gilt bronze
16 1/2 x 8 5/8 x 2 in. (41.9 x 22 x 5.1 cm)
M1985.80

DESCRIPTION: At the apex of this hefty and brilliantly gilded bronze relief, God the Father reigns in majestic glory, flanked by hovering seraphim. His right hand is raised in benediction, his left hand clasps the cruciform orb, a symbol of divine and temporal sovereignty. His rayed triangular nimbus is a reference to the Trinity. Emerging from the celestial clouds is the dove of the Holy Spirit, emitting a beam of light directly above the head of Jesus. Thus, the three members of the Trinity are brought into vertical alignment, and a smooth visual and iconographic transition from the heavenly to the earthly sphere is achieved.

Within a colonnaded and cobble floored hall, a Leonardesque Jesus sits surrounded by his twelve apostles at the Last Supper. St. Peter stands to Christ's right, and the young St. John appears on his left. Seated across the table is Judas Iscariot, identifiable by the money pouch hanging at his side. The climactic moment depicted is when Christ proclaims "one of you will betray me" (Matt 26:21). The disciples' reactions range from incredulous indignation to theatrical swooning and hysterical gesticulation. A cast keyhole is visible at the front left side, and a small metal pad has been brazed onto the back upper right corner to prevent the door from slamming.

CONDITION: Now broken in half, the relief was originally cast in one piece. Traces of sprues on the reverse indicate that molten bronze was poured into the mold from the back. The metal substrate is unstable, porous, and brittle. There are extensive casting and stress corrosion cracks on both sides. One of the two metal straps riveted onto the reverse for reinforcement has failed. Depressions and disruptions left by the hinges are detectable along the right edge, which has also been trimmed and extensively filed. Numerous sculptural elements—such as God's right hand, Christ's right index finger, Judas's head, and the cross on top of the orb—are loose or have been reset with solder or pins. The mounting holes at the four corners are of recent date.

PROVENANCE: Purchased from N. Sakiel and Son, New York, 1965.

COMMENTARY: The wealth of a Christian cathedral, church, or monastery was once determined by both its land holdings and ecclesiastical treasures.[1] These included stationary and portable furnishings. While costly liturgical objects were stored between services in the sequestered church treasury, the sacramental offerings remained in the sanctuary in a tabernacle–a locked, cupboardlike niche usually conveniently located behind the main altar. The doors of these tabernacles were often lavishly adorned with biblical themes or Christian symbols of redemption and salvation.[2] Inasmuch as the rite of Communion has its origins in the Last Supper, it is a most fitting subject for a tabernacle door.

Our large, resplendent plaque is of strikingly high quality. The extreme sculptural modeling of the foreground figures, which almost project to full plasticity, is particularly astounding. Other highlights include the deep and expansive spatial penetration, densely populated composition, rich detailing, and goldsmithlike surface effects. In style, the relief shares cogent analogies with a few bronze and lead plaquettes of early seventeenth-century South German and Netherlandish origin.[3] Yet, the Flagg tabernacle door finds its strongest stylistic connections with works by the illustrious Augsburg goldsmith Matthias Wallbaum (ca. 1554-1632), whose surviving oeuvre of about eighty authenticated pieces includes superbly wrought house altars, reliquaries, domestic caskets, and eucharistic vessels.

A composition of the Last Supper that was frequently repeated with variations and additions by Wallbaum and his workshop on a number of objects, including a silver tabernacle door in the Cathedral of St. Stanislas in Wilna (Vilnius, Poland), is closely affiliated with our bronze door.[4] Each of the reliefs or composite works in which this scene of the Last Supper is incorporated contains figural types, dramatically charged poses, and angular drapery folds similar to those found on the Milwaukee plaque. Wallbaum's style was widely copied and imitated by numerous other artists working in diverse materials. The Flagg tabernacle door is probably the creation of a remarkably gifted bronze sculptor trained as a goldsmith, who flourished within Wallbaum's immediate orbit. JRB

1. Select studies dealing with the history and/or the contents of Western European church and monastic treasures include, for example, Swarzenski 1953, *passim*; Stoddard 1972, pp. 363-90; de Winter 1985, *passim*.

2. Other Renaissance bronze tabernacle doors are published, for instance, in Washington 1986, pp. 65-67, 122-24, nos. 5, 24.

3. See Weber 1975, vol. 1, pp. 353, 393, nos. 853-55, 975; vol. 2, pls. 231, 280.

4. For Wallbaum's reliefs of the Last Supper, consult Löwe 1975, pp. 15, 19-20, 33-34, 90-92, nos. 5-9, 68, figs. 12, 80, 81.

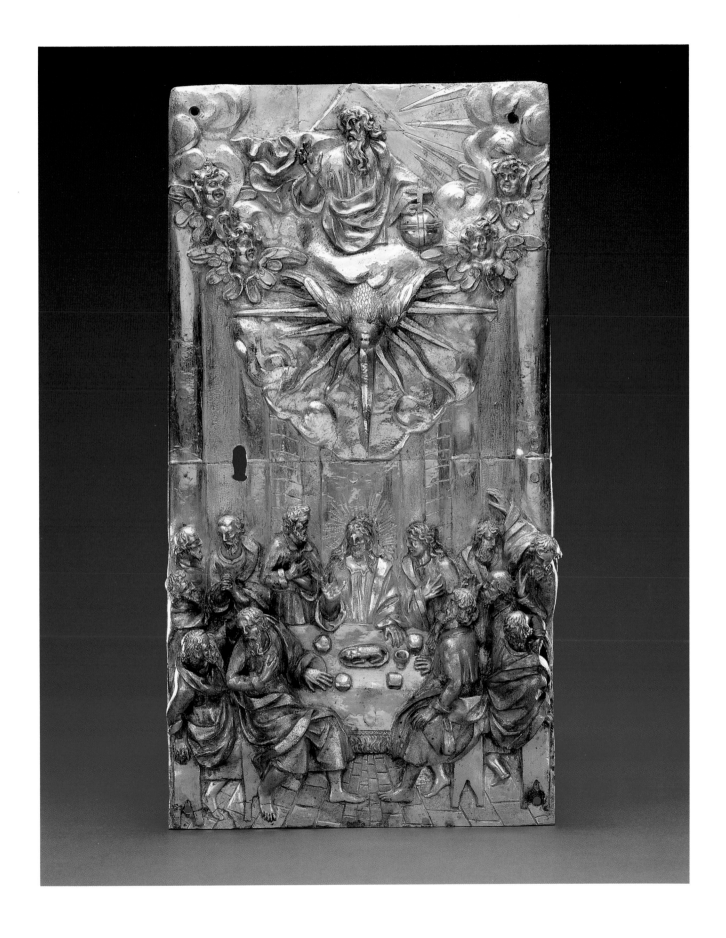

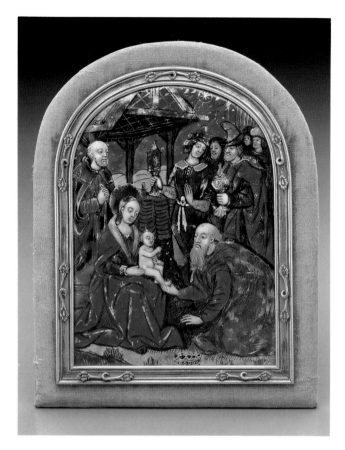

59. *Plaque with the Adoration of the Magi*

Workshop of Nardon Pénicaud (ca. 1470-1543)
Limoges, France
ca. 1520
Enameled and gilded copper with velvet frame
8 1/2 x 6 3/4 x 1/2 in. (21.5 x 17.1 x 1.3 cm)
M1980.179

DESCRIPTION: In this enamel plaque of the Adoration of the Magi, the Christ Child is found just to the left of center sitting on his mother's lap while a king, whose crown is visible in the foreground, kneels before him, coddling the Child's right foot. Joseph stands behind Mary with his hands clasped, while on the right side the three Magi bear gifts, including a ciborium and a monstrance. The star of Bethlehem and the manger are visible in the background. The enamel is highly translucent and rich: a brilliant dark blue was used for the Virgin's mantle and night sky and a turquoise for the foreground and more distant hills.

CONDITION: The plaque has been hammered out at the side along Joseph's shoulder. Miscellaneous coldwork repairs appear along the edges, on the kneeling figure of the Magus,

and on Joseph. Much of the gilding has been lost and the back of the plaque has suffered minor losses to the enamel. The reddish-brown velvet frame is of later date.

PROVENANCE: Purchased from Wilhelm Heinrich, Frankfurt, 1970.

COMMENTARY: The revival of the art of enamel painting in Limoges in the early sixteenth century was the renascence of an industry long associated with the city. From the early twelfth century until the sack of Limoges in 1371, the city was known for *champlevé* enamelwork. However, by the late fifteenth century, a new technique of enamel painting on small copper or bronze plaques had emerged that would flourish in the following century in part because of the innovative work of the Nardon Pénicaud workshop, and the high demand for enameled goods, both secular and ecclesiastical.

While the Limoges *Adoration of the Magi* in the Flagg collection has the appearance of a pax or small tablet used in the celebration of the Eucharist, it is actually a panel from an enameled polyptych, a multipaneled, hinged altarpiece, commonly produced in Limoges in the early sixteenth century. It has the same shape as the two smaller side panels flanking the Crucifixion scene of the double-tiered triptych from the Pénicaud workshop (The Frick Collection, New York).[1]

Led by Nardon Pénicaud (ca. 1470-1543), the earliest enamel-painting family of Limoges included several generations of artists named Jean, among others, making it at times difficult to distinguish the individual hands of this atelier.[2] Nevertheless, the artist of the Flagg piece is probably the same Limoges enameler from the workshop of Nardon Pénicaud who produced the Entombment of Christ plaque recently sold at auction.[3] In both, the artist used strong outlines and the same curving stroke to create the mouths of the individual figures. AS

1. Los Angeles 1993, p. 25, fig. 7.

2. While there is some question about the various relationships within the Pénicaud family, it was probably Nardon, and not his brother Jean I (ca. 1480- after 1541), who was the father of Jean II (ca.1515- ca.1588), the older brother of Léonard and Pierre (before 1542- after 1590). According to Verdier, Nardon's will, dated 1541, divided his estate among his three sons: Jean (II), Léonard, and Pierre. See Baltimore 1967, p. xix.

3. This plaque was part of the Blumka Gallery Sale, Sotheby's New York, January 9-10, 1996, p. 164, lot 134.

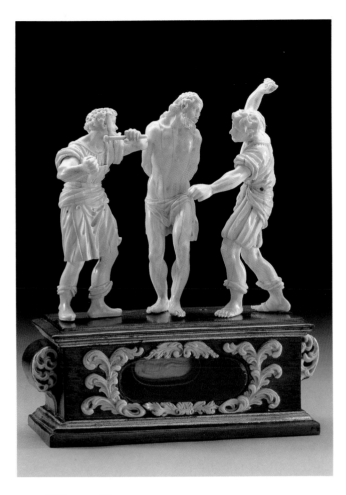

60. *Flagellation*

Germany or The Low Countries
ca. 1620
Ivory on gilded walnut base
9 x 7 1/2 x 3 in. (22.9 x 19 x 7.6 cm)
M1981.163

DESCRIPTION: Beautifully carved ivory figures of Christ and two tormentors dressed as Roman soldiers stand atop a rectangular walnut base in this representation of the Flagellation. The tormentor on the left appears ready to bludgeon Christ with an oversized baton, while his counterpart leans forward ready to strike with a raised arm. Christ, whose hands are tied behind his back, stares directly at him with an anguished look. The Christ figure is bearded and his tall, muscular body has been carefully modeled and meticulously detailed. The figures are held on the wooden base by copper pins. The partially gilded base is made up of individual panels glued together with a distinct foot and molded socle. Ivory appliqué work decorates the volutes on the shorter sides and the central window, which reveals a small oval ivory relief of the Dead Christ attached to the cabinet's rear wall.

CONDITION: There are minor cracks in the ivory as well as a few nicks and scratches to the base. Several chipped and damaged areas of ivory have been replaced either with a later ivory or a modern resin, such as the left arm of the right figure, a raised edge of drapery on the left tormentor's sleeve, and a section of the foliate scroll on the left side of the base window. The soldier on the right is missing his instrument of torture and the column to which Christ was originally tied is no longer extant. The small holes around the tunics of the two tormentors suggest that attributes or possibly chains or ropes were once attached. Drill holes on the bottom of the base indicate that the whole piece may once have been mounted on a larger platform or perhaps a small cabinet.

PROVENANCE: Purchased from Mr. Barny, New York, 1965.

COMMENTARY: As commanded by the Roman governor Pontius Pilate, Christ was first tied to a column and whipped before being crucified to appease the citizenry. The Flagellation is thus a prefiguration of the death of Christ, and an important part of the Passion cycle.[1] As a theme, the Flagellation was popularized as devotional imagery in the seventeenth century by artists Alessandro Algardi (1595-1654) and François Duquesnoy (1597-1643) whose silver and bronze examples were widely copied throughout Western Europe.[2] While stock images of the Flagellation were often cast in bronze or silver, and mounted on ebony or walnut bases, the Flagg example is a singular work of ivory. As a material, ivory was highly prized by sculptors because of its fine grain, durability, and the ease with which it polishes.

As a devotional piece, the Flagg *Flagellation* was designed with a hollow tomblike base to display an effigy of Christ, not unlike a reliquary which showcases a sacred object or relic. In medieval and Renaissance Europe, a holy relic was any physical part of a martyr or saint, or an object of veneration, like an important remnant from their life. The base of this *Flagellation* may have been created to house such a memento: it is hollow and has a central window, making it possible to view the small ivory relief of the Dead Christ which completes the Passion cycle first introduced by the Flagellation scene above. AS

1. The flagellation or scourging of Christ prior to his crucifixion is mentioned by each of the four evangelists, albeit briefly. See specifically Matt. 27:26; Mark 15:15; Luke 23:16 and 23:22; and John 19:1. These references to the flogging were further embellished by later authors, which no doubt helped contribute to the increased popularity of the theme in both the sculpture and painting of the sixteenth and seventeenth centuries.

2. For a thorough discussion of the works by these two artists and their influence, see Montagu 1966-67, *passim*.

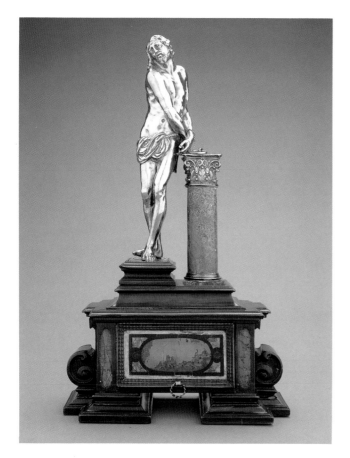

61. *Christ at the Column*

Albrecht von Horn (ca. 1581-1665)
Augsburg
ca. 1650
Silver, oak, *pietra paesina*, and marble
16 x 9 1/2 x 4 1/2 in. (40.6 x 24 x 11.4 cm)
M1980.176

DESCRIPTION: This hollow-cast silver figure of Christ is bound and tied to a marble column in a scene reminiscent of the Flagellation. His muscular torso, arms, and head twist strenuously in opposing directions to create a feeling of discomfort in an otherwise static composition. His elaborately punched loincloth is tied loosely around the hips with a rope. A silver wire binds and tethers his hands to a ring mounted on top of the marble column's Corinthian-style capital. The figure of Christ is stabilized on the platform by two long silver dowels or spikes that project downward from the bottoms of his feet into the oak base. These were cast integrally with the figure. The multitiered base has flanking ornamental volutes and a center drawer inlaid with polished *pietra paesina*. The two vertical panels on either side of the drawer have the same inlaid stonework. A silver twist pull opens the drawer.

CONDITION: Casting flaws occur on the figure of Christ, most noticeably on both arms above the elbows. The stone inlay on the drawer has been extensively repaired.

MARKS AND INSCRIPTIONS: The maker's mark of Albrecht von Horn, the initials AH, and the assay mark of Augsburg for the year 1650 are punched on top of the column.[1] There is also an unexplained letter A within a diamond on top of the column, and a rectangle containing the superimposed letters P R on both foot tenons.

PROVENANCE: Purchased from Adolf Klein, Frankfurt.

COMMENTARY: The demand for small-scale cast religious figures coincided in Germany with the proliferation of private studies and cabinets for their display, as well as in response to personal and ecclesiastical devotional needs. Statuettes like this *Christ at the Column* were especially valued in the sixteenth and seventeenth centuries because they combined the classic male nude with Baroque pathos and a taste for realistic detail. The production of such works arose during the early 1520s in the goldsmith and metalcasting centers of Augsburg and Nuremberg.

Like other goldsmiths Albrecht von Horn based his figures on well-established types. His model for the Flagg sculpture was an ivory *Christ at the Column* (ca. 1640-50) by David Heschler (1611-1667), which in turn was based on a now lost work by Heschler's master, the German sculptor Georg Petel.[2] Petel's version was itself one of many interpretations of a statue by the Flemish sculptor François Duquesnoy (1597-1643).[3] Albrecht von Horn's twisting figure, with its expression of anguished resignation, although faithful to the Heschler model, recalls Duquesnoy in its more attenuated and nervous articulation.

Christ figures in boxwood, bronze, ivory, or silver were often mounted on bases incorporating clocks, glass fronts, or drawers for storage. The inlaid base of the Flagg piece is typical of cabinet-making in mid-century Augsburg, where the natural veining of the *pietra paesina* was favored for inlays because of its pictorial resemblance to craggy, mountainous landscapes.[4] Comparable small sculptures by Albrecht von Horn are located in museums in Augsburg, Munich, and Milan. EFG

1. Seling 1980, vol. 3, p. 153, no. 1307.

2. For the various versions, see Feuchtmayr and Schadler 1973, p. 165, no. 102, figs. 211, 212.

3. For bibliography on the Duquesnoy statue and its derivatives, see Christie's London, July 4, 1995, lot 78.

4. Kreisel 1968, vol. 1, pp. 174, 337, fig. 365; Riccardi-Cubitt 1992, pp. 57, 76, pl. 19.

62. *Corpus*

Workshop or Circle of Guglielmo della Porta (died 1577)
Possibly Rome
Third quarter of the 16th century
Cast and gilt bronze
17 1/2 x 13 1/2 x 3 1/2 in. (44.5 x 34.3 x 8.9 cm)
M1991.63

DESCRIPTION: Cast from a wax model, this outstanding devotional sculpture of the Crucified Christ or *Corpus Christi* suspended aloft by his upwardly spanned arms conveys a profound mood of pathos. The sense of agony is expressed in Christ's head drooping heavily against his body, the clenched hands eerily frozen in the throes of death, and the droplets of blood spilling from the gash on his right side. Conversely, Christ's delicate and ethereal facial features are highly idealized, and these physiognomical elements, as well as the cascading waves of the abundant hair, the wispy curls of the beard, and even the diminutive finger- and toenails are exquisitely articulated. The loincloth or perizonium arranged in an overlapping series of crisply delineated folds and knotted swathes tied loosely around the figure's low-slung hips is likewise flawlessly executed. Chisels and punches were used here to capture the diverse textures of the rope belt, the fabric, and the woven fringe of the loincloth.

The somewhat reduced scale of the head accentuates the heroically conceived and powerfully muscled physique with its clearly defined pectorals, protruding ribcage, and thickly set legs. Although the corpus was originally meant to be seen primarily from the front only, the figure is modeled completely in the round. The gentle spiral torsion of the body with its fluently integrated organic transitions offers a variety of alluring viewpoints from numerous angles, including that of the impeccably worked and ravishingly finished back of the figure.

CONDITION: The gilding is severely worn. Chaplets used in the casting process have rusted through on the upper chest, and several others are also visible on the backs of the arms. Some minor casting flaws are evident throughout with the most obtrusive one located under Christ's right arm. A small hole behind the head originally held the now lost nimbus. A square metal plug of some age has been inserted into the back of the figure above the loincloth in order to cosmetically seal the aperture which would have functioned originally as a mortise for hanging the corpus on its now missing cross. Vestiges of modern silver polish remain in the deepest interstices.

PROVENANCE: N. Sakiel and Son, New York; purchased from Blumka Gallery, New York, 1971.

COMMENTARY: In Western Europe the serial production of small bronze crucifixes destined for both private and public devotion can be traced back to the early Middle Ages. The widespread diffusion of these inherently pious and gravely somber sculptures continued unabated throughout the Renaissance, and they became increasingly popular during the Counter Reformation. Their spiritual intensity, utter austerity, and direct legibility were in perfect accord with the more conservative attitudes about religious art that were adopted by the Catholic Church at the Council of Trent in early December of 1563.

Two of the major exponents of the small-scale bronze corpus in late Renaissance Italy were the Florence-based sculptor Giovanni da Bologna or Giambologna (1529-1608) and the Rome-situated sculptor Guglielmo della Porta (died 1577).[1] Their output established standard compositional types of bronze corpora repeated not only by their immediate followers, but also by countless other sculptors and goldsmiths throughout Europe. Middeldorf was the first scholar to attribute to Guglielmo della Porta a bronze corpus in a Florentine private collection that is the same exact model as the gilt bronze corpus in the Flagg collection.[2] Other examples of this type in both bronze and silver are of widely varying scale and often disclose adjustments in the position of the arms and hands as well as in the arrangement of the loincloths, confirming that the corpora were cast from a large number of linked yet variant models. These small-scale crucifixes, nevertheless, form a cohesive group that share a multitude of distinguishing characteristics, including the same tranquil facial expression, small tilted head, massive Michelangelesque anatomy, gently curving body, and fastidious detailing. These corresponding formal and stylistic traits have led Gramberg, Chlíbec, Avery, and others to attribute them to Guglielmo della Porta.[3]

This attribution rests largely on their often striking resemblance to drawings of the Crucifixion or the Deposition in della Porta's sketchbooks.[4] Further evidence includes a letter of 1569 to the Tuscan sculptor and architect Bartolomeo Ammanati (1511-1592) in which della Porta states that he created numerous silver and bronze corpora, and the eighteen crucifixes mentioned in the posthumous inventory of the sculptor's estate.[5] A possible alternative attribution for the Flagg and related corpora to the Italian sculptor Pompeo Leoni (ca. 1533-1608) has recently been suggested by Estella Marcos. Calling attention to a bronze corpus—seemingly identical to ours—that forms part of a Calvary Group in the Monasterio de Santa Maria del Parral in Segovia, Estella Marcos postulates that it may be a work by Leoni.[6] While this opinion deserves consideration, Moran Turina refutes the attribution of the corpus in Segovia to Leoni, so future study is needed to determine whether the original invention of this model and its cognates should be given to Leoni.[7]

Our knowledge about the early life and artistic activities of Guglielmo della Porta is sketchy and somewhat contradictory.[8]

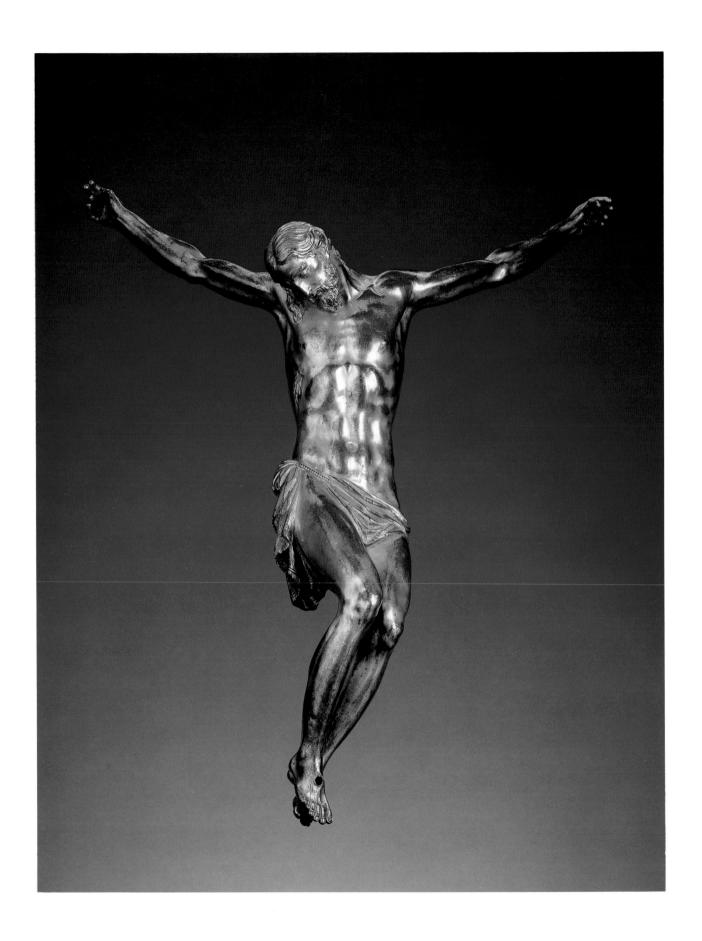

Although the date of his birth is unknown, it is conjectured that he was apprenticed to his father, Gian Giacomo della Porta (active 1513-1554/55), who was employed as an engineer and sculptor in the stonemasons' lodge of Milan Cathedral in the 1520s. Guglielmo himself is first mentioned in 1534, when he was working in collaboration with his father and the sculptor Niccolò da Corte (died ca. 1550) on the baldacchino in the Chapel of St. John the Baptist and the funerary monument to Giuliano Cybo in the Cathedral of Genoa. By 1546 Guglielmo had resettled permanently in Rome, where, until his death in 1577, he carried out a sizable number of monumental sculptures and portrait busts. Many of these were undertaken for members of the Farnese family, and in particular for Alessandro Farnese, Pope Paul III (1468-1549), whose tomb, completed only in 1575, remains Guglielmo della Porta's masterwork. In addition to these principal endeavors–which stylistically disclose the influence of della Porta's early Lombard training and his subsequent indebtedness to Michelangelo Buonarroti (1475-1564)– Guglielmo was also engaged in the restoration of classical antiquities and the making of small bronzes. At present no bronze statuettes of secular subjects can be attributed with assurance to this sculptor. Only small-scale bronze sculptures embracing devoutly emotive Christian themes and images–of which the Flagg corpus is a prima facie example–can be associated with his name. JRB

1. On the crucifixes of Giambologna, see London 1978a, pp. 26, 45-47, 140-46, nos. 98-111; Avery 1987, pp. 199, 202. Regarding those by Guglielmo della Porta, consult Gramberg 1981, pp. 95-114.

2. Middeldorf 1977, pp. 82-84, n. 41, figs. 13, 14.

3. For examples of the various bronze and silver corpora attrbuted to della Porta, see Gramberg 1981, pp. 97-98, fig. 3; Prague 1993, pp. 52-53, no. 55; Avery 1995, pp. 73-75, no. 46; Prague 1997, p. 518, no. 2. 229. Numerous other examples have also surfaced on the international art market: see, for instance, those itemized in Sotheby's London, April 21, 1988, 60-61, 64, lots 146, 156; Sotheby's London, July 4, 1991, p. 62, lot 149; Christie's New York, January 14, 1992, lot 157; Christie's London, December 7, 1993, p. 61, lot 107; Christie's London, December 13, 1994, p. 81, lot 138; Christie's London, July 4, 1995, p. 51, lot 92; Sotheby's New York, June 14, 1996, lot 133; Christie's London, December 2, 1997, p. 81, lot 105; Christie's New York, January 28, 1998, p. 90, lot 146.

4. See Gramberg 1964, vol. 1, pp. 46, 60-64, 66, 88-89, 91-92, 95-98; vol. 2, no. 44; vol. 3, nos. 74, 75, 77-80, 85-88, 91, 92, 96, 151, 152, 154, 159, 163, 172, 175, 179.

5. Regarding della Porta's correspondence with Ammanati, consult Gramberg 1964, vol. l, pp. 122-28, no. 228; Gramberg 1981, p. 96; Avery 1995, p.74, no. 46. For the 1578 inventory of della Porta's property, see Middeldorf 1977, pp. 82, 84, no. 39; Gramberg 1981, pp. 97, 102, 112; Avery 1995, p. 74, no. 46. An earlier inventory of 1577, listing the contents of della Porta's house, including bronze and silver crucifixes, is printed by Masetti Zannini 1972, pp. 300-301, 303-305.

6. Estella Marcos 1993, pp. 148-49, figs. 7, 8.

7. Madrid 1994, pp. 158-60, no. 23.

8. Basic surveys dealing with Guglielmo della Porta's oeuvre include, for instance, Venturi 1937, vol. 10, pp. 524-67; Pope-Hennessy 1985b, vol. 3, pp. 88-89, 97, 114, 115, 396-400, 430, 462, figs. 145-146, pls. 98-101; Kruft 1996, vol. 25, pp. 254-57.

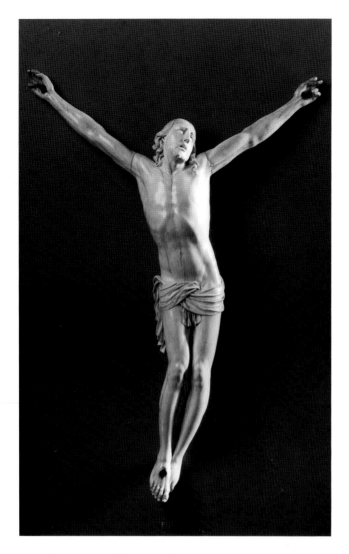

PROVENANCE: Purchased from Blumka Gallery, New York.

COMMENTARY: The image of the Crucified Christ as a symbol of redemption has been one of art's most venerable subjects. In the years following the Reformation, the iconography of carved and painted crucifixes expanded to encompass a wider range of emotions and piety. In addition to the more pessimistic *Christo Morto* types (see entry 62), the *Christo Vivo* versions like this one show the dying Christ submitting to God's will. Representations of the dying Christ typically place a greater emphasis on his physical torment, and lack the wound in his side caused by the spear thrust which verified his death. The representation of Christ's suffering while still alive on the cross is thought to derive from a drawing by Michelangelo (1475-1564) that dates to about 1540. Countless artists were inspired by this image of suffering in their own explorations of this moving subject.[1]

The slant of Christ's outstretched arms and the angle of his head help to create a flamelike upward thrust of the body, expressing heavenward ascension and countering the downward pull articulated in the veins and tendons of the arms and neck. The natural curve of the ivory tusk has been exploited in the figure's graceful swing. While figures with raised vertical arms were often carved from a single piece of ivory, the arms here are separately carved and attached. The influence of the leading seventeenth-century Franco-Flemish sculptor François Duquesnoy (1597-1643) is evident in the suavely modeled musculature and meticulous anatomical detail. The loincloth—required during the Counter-Reformation for reasons of modesty and often exploited as a piece of virtuoso carving—is here handled with a classic restraint that characterizes the work as a whole and suggests a French origin.

Like many later seventeenth-century European crucifixes, this corpus is based on two main prototypes, François Duquesnoy's ivory *Dying Christ* (ca. 1626), inspired by Peter Paul Rubens's Antwerp *Crucifixion* of 1615, and the so-called Pallavicini *Christo Vivo* (ca. 1647), attributed to the Roman sculptor Alessandro Algardi (1595-1654).[2] Both these works were widely known through replicas and engravings, and they undoubtedly also influenced the work of the German sculptor Balthasar Permoser (1651-1732), to whom the Flagg corpus was once erroneously attributed.[3] EFG

63. *Ivory Corpus*

France or The Low Countries
Mid-17th century
Ivory
16 1/2 x 12 x 2 in. (41.9 x 30.5 x 5.1 cm)
M1991.59

DESCRIPTION: Originally suspended on a cross, this figure represents the Crucified Christ, his head is thrown back and to the side with open mouth and eyes rolled upward. The separately carved arms are attached to the torso with dowels. The loincloth is folded over the hips. The palms are pierced by nails; a single nail pierces both feet; and a drill has been used to define such details as the navel and the locks of hair.

CONDITION: The tips of the last two fingers of the left hand and the tip of the right index finger are missing. The piece is in very good condition.

1. For an expanded discussion of the *Christo Morto* and *Christo Vivo* types and their evolution, see Arnoldi 1974, pp. 57-80; Brussels 1977, pp. 321-32.

2. The versions by Duquesnoy and Algardi are discussed in Arnoldi 1974, p. 80, figs. 24, 32; Berlin 1978, pp. 21-25, no. 7, figs. 9, 66, 68, 69.

3. Brunswick 1931, p. 53, no. 80.

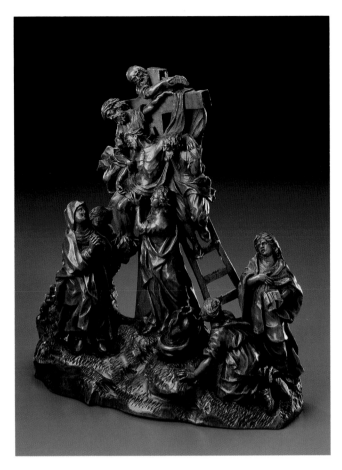

64. *Descent from the Cross*

Southern Germany
Late 17th century
Stained boxwood
12 x 9 x 5 in. (30.5 x 22.9 x 12.7 cm)
M1986.140

DESCRIPTION: This stained boxwood sculpture consists of nine figures arranged in a triangular composition: four women form the base of the triangle; the two ladders set diagonally to the cross form the sides. Christ's body forms a second diagonal. The arrangement of the five male figures mirrors the form of the cross, which functions as the vertical axis. The roughly finished back indicates that this sculpture was intended to be viewed from the front and the sides.

CONDITION: A long crack extending down the entire back of the piece is visible from the front in the split rungs of the ladder. The piece was stained rather than painted, both revealing the beauty of the material and protecting its surface.

PROVENANCE: The Reverend W. Jerdone Braikenridge (sale, Christie's London, February 27, 1908, lot 8); Jacques

Seligmann, Paris; purchased from Blumka Gallery, New York, 1965.

EXHIBITIONS: Bristol, England, "The Bristol Industrial Exhibition," 1861.

COMMENTARY: This sculpture is skillfully carved from a single piece of boxwood, a hardwood widely used in seventeenth- and eighteenth-century Germany and Austria for small devotional works. Originally, it probably formed part of a series illustrating the Passion of Christ. Its small scale and good condition suggest that it was installed in a private chapel or home. The deeply undercut and dynamic folds of the draperies allow light to reflect off the wood's faceted angles, intensifying the energy created by the animated draperies. Chisel marks are visible, especially in the body of Christ, yet the entire surface is smooth. These technical approaches are typical of the South German sculptural tradition.

The Gospel of John (19:38-40) was the artist's biblical source, since only John mentions the actions of a third man, Nicodemus, in addition to Joseph of Arimathea and St. John the Apostle. The fourth man in the Flagg piece remains unidentified, but he is probably the patron for whom the piece was carved or the artist's self-portrait.[1] His clothing, most notably the waistcoat, is contemporary, in contrast to the Roman garb worn by the others. At the top of the left ladder, Nicodemus reaches across to free the fabric which has become entangled around the cross. Lowering the body of Christ, on the left and right respectively, are Joseph of Arimathea and the unidentified man.[2] At the base of the cross, St. John supports the body. The four female figures are gathered below on the rough, grassy terrain of Calvary. Mary Magdalen, with bare feet and long, flowing hair, kneels and bathes the feet of Christ with her hair.[3] The Virgin Mary prays as she looks upon the lifeless body of her son. Her two sisters, Mary Cleophas and Mary Salome, are relegated to the far right of the composition.

Those figures concentrating on their specific tasks (the men lowering the body of Christ and the woman preparing the herbs for interment) have somber yet determined expressions. The remaining three women are expressively agitated, poignantly acting out their grief on bent knee, clasping their hands or clutching their breast. JVS

1. A number of Renaissance and Baroque artists–Michelangelo, Titian, and Rembrandt–included their portraits in scenes of the Deposition, either in the guise of Joseph of Arimathea or a bystander.

2. Réau 1958, vol. 3, pt. 2, pp. 760-61. Joseph of Arimathea is usually portrayed as a wealthy man, while Nicodemous is represented in more common attire.

3. Ibid., pp. 846-59.

SCULPTURE

65. *Tympanum with the Virgin and Child*

Possibly Burgundy, France
15th century
Limestone
29 x 46 x 11 in. (73.7 x 116.8 x 27.9 cm)
M1991.56

DESCRIPTION: This limestone tympanum-shaped relief represents the enthroned Virgin and Child, kneeling donors, and surrounding groups of lay people, with musical angels playing the portable organ and a cithern on either side. The central section projects beyond the rest of the composition and there are areas of blank space above the flanking figures. The crowned Virgin holds the Child on her left side and caresses his right foot in her hand. The Child is engrossed in feeding grapes to the small bird held in his right hand.

CONDITION: There is extensive plasterwork and grouting around the figures and along the top and bottom. The heads of the Virgin and Child have been reset and there are visible seams of reconstruction along the curved edge of this piece. The two kneeling donors have lost their hands and there are some pieces missing from the Virgin's crown. Evidence of polychrome still exists on some of the figures.

PROVENANCE: George Gray Barnard Cloisters Collection, 1925; purchased from French & Company, New York, 1968 (as fifteenth-century Netherlandish).

COMMENTARY: The term tympanum refers to the semicircular stone or masonry filling in the space between the lintel of a doorway and the enframing arch. It is used to describe the Flagg piece primarily because of its distinctive shape. A common architectural feature of medieval churches and cathedrals, the tympanum was an ideal field for sculptural embellishment.

Up until the twelfth century, the tympana of most medieval churches were reserved for presenting Christ in Majesty or as Judge. In the late twelfth and early thirteenth century, the Virgin Mary or Madonna became increasingly important for the Church and eventually the most highly venerated and often depicted of all biblical figures. The dramatic growth in the cult of Mary is evident in the number of statues created in her image. In France, the growth of the Marian cult is reflected in the dedication of monumental cathedrals in Paris, Chartres, Reims, and Amiens to "Our Lady" or "*Notre-Dame.*" At Senlis, the main portal of the cathedral depicts the Coronation of the Virgin, but more commonly the Virgin is shown enthroned with the Christ Child, as in this example.

This tympanum is slightly smaller than most, and while it might have appeared above a church portal, this particular piece may have a more complicated history.[1] The Virgin is presented frontally on a throne with architectural features. Two blind trefoil arches at its base represent a detail added to connote or represent the Church which the Virgin personifies. Considered the intercessor before God for the souls of the dead, she is often represented in memorial sculpture. At the foot of the throne are two small kneeling donor figures. Their small scale is not uncommon as variation in the size of figures was a conventional medieval device used to represent the relative importance of individuals within a composition.

The inclusion and arrangement of these figures suggests that we may be looking at a composite piece and one that was not originally a tympanum, but a carved memorial relief.[2] The central section featuring the enthroned Virgin may have come from a recessed tomb. In the Middle Ages, burial within the church, while often limited to the choir or sanctuary, was marked by a chamber, vault, wall niche, or shrine. The lay people on either side of the tympanum's musical angels have their hands clasped in prayer as if mourning the passage of a friend or relative, and like the donor couple, they are shown in supplication before the Virgin. Iconographical details reiterate this theme: the Child feeds grapes to a small bird, an ancient symbol of the human soul, and commonly a goldfinch, which is also a reference to the resurrection of Christ.[3] The music-making angels also suggest a memorial or funeral rite.

While the above argues that there is a clear theme, the style of the Virgin contrasts with that of the lay people and may be from an earlier period or modeled after an earlier work. The style and costume of the surrounding figures are characteristic of the fifteenth century. Three of the eight figures wear padded head circlets, or *torse*, common in Burgundian and Netherlandish art. The disparate elements of the Flagg tympanum suggest that it is a composite piece that was probably assembled in the nineteenth century to look like a larger and more important sculpture.[4] AS

1. Several scholars have provided their thoughts on this particular piece. Both Linda Seidel, conversation, January 14, 1995, and William Forsyth, letter, January 25, 1998, believe that this is a composite piece, while Françoise Baron suggested in a letter of May 25, 1994 that the tympanum might be nineteenth century.

2. This idea was first suggested by William H. Forsyth, letter, January 25, 1995.

3. Gillerman 1989, p. 133.

4. The tympanum is part of the Limestone Sculpture Provenance Project which tests core samples to determine stone profiles and possible quarry locations. Samples from the Flagg piece have been sent to the Brookhaven National Laboratory for approximate dating by Neutron Activation Analysis (NAA). The results of this test were not available at the time of publication.

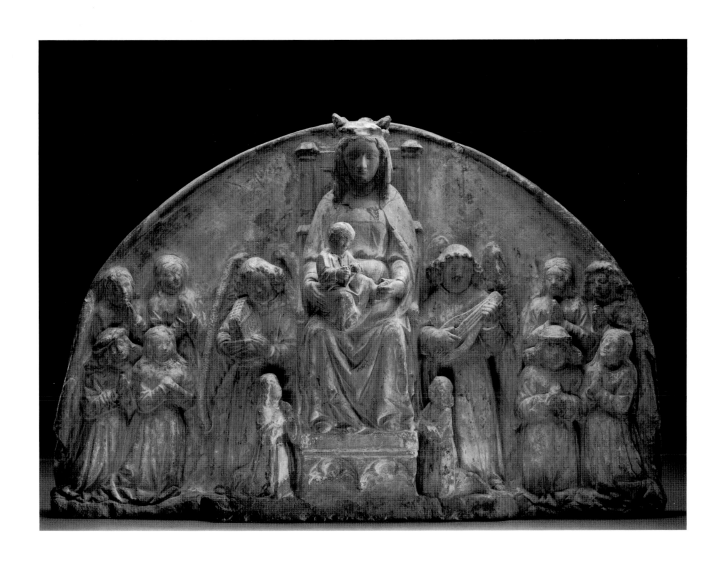

66. *St. George Slaying the Dragon*

Tyrol, Austria
ca. 1475-90
Polychromed limewood
48 1/2 x 21 x 9 3/4 in. (123.2 x 53.3 x 24.8 cm)
M1991.57

DESCRIPTION: This standing warrior saint is carved from a single block of wood. His back has been hollowed out along the torso, suggesting that the sculpture once adorned one of the large, wooden retables that were the crowning achievement of Late Gothic Germanic art. The inclined head, broad stance, and emphatic downward gesture of the figure are consistent with a low and distant viewpoint. The raised hand of the saint originally held a metal lance that was thrust into the jaws of the dragon. The separately carved dragon and plinth are original to the piece. The entire sculpture was once polychromed: George's armor was probably a bright bluish-silver, his leggings a brilliant red, and the dragon a bilious green.

CONDITION: The figure is generally in good condition. Only the lance and probably a halo are missing. The figure has been repainted a number of times. The most recent layers of polychrome are severely chipped and only fragments of the original paint are discernible. The original pale pink flesh-tones of the face are concealed beneath a thick layer of rosy-pink paint. The tip of the saint's nose has been replaced and the figure is missing several fingertips and both thumbs. Glued repairs appear on the dragon's haunch and on the saint's hands and face. Numerous worm holes pit the backside of the figure and minor wood splits occur throughout the sculpture, especially on the pedestal.

EXHIBITIONS: New York, The Metropolitan Museum of Art, The Cloisters, "Medieval Art from Private Collections," 1968-69.

PUBLICATIONS: New York, The Metropolitan Museum of Art, The Cloisters, *Medieval Art from Private Collections*. Text by Carmen Gómez-Moreno. New York, 1968, no. 54.

PROVENANCE: Lucien Demotte, Paris; purchased from Blumka Gallery, New York, 1964.

COMMENTARY: This work depicts a legendary warrior saint said to have lived in Asia Minor in the third century. Venerated in the Greek Orthodox Church from early times, in 1222 George's feast day was made a national festival in Britain (where according to one legend he had traveled).[1] His popularity in Western European art dates from roughly that period. The metaphor of the saintly knight slaying the dragon doubtless symbolizes the victory of good over evil. The trampling of the dragon underfoot may also represent the triumph of Christianity over paganism. The dragon was a mythological creature, a species of serpent, that generally possessed a bulbous body, two wings, two legs with lion's claws, a long, strong tail, and a small crested head with a small mouth. In addition to breathing fire, dragons were dangerous because of their powerful tails and because they could, serpentlike, wind themselves around a victim–even an elephant it was thought–to cause suffocation.[2]

St. George Slaying the Dragon is an excellent example of the large-scale wooden sculptures that characterized Germanic art in the late Middle Ages. A wide range of woods–oak, walnut, poplar, and pine–were used for carving throughout Western Europe.[3] However, sculptors in southern Germany often used the fine-grained and durable limewood indigenous to that region to produce effects that far surpassed those achieved by their counterparts elsewhere in Europe. Although wood was easier to carve than stone, the material presented its own set of problems. For example, when wood loses its moisture content it shrinks, which can result eventually in cracking and splitting. To overcome this problem, sculptors removed all superfluous wood from the work, especially the heartwood at the log's center. This explains why the vast majority of larger medieval wood sculptures were hollowed out from the back.

Even more so than the stone sculptures of the same period, wood sculpture was intended to be brightly and realistically painted to appear as lifelike as possible. The wood surface was disguised by covering the joints, knots, and nails with linen or canvas. Then gesso was layered on top so that the painted surface would be smooth.[4] The sculptor's quest for realism appears in the Flagg piece, even in the suit of armor. While costume is not always helpful in dating or identifying a work, the form of the breastplate, the tassets covering the hips and upper thighs, and other details indicate that the sculptor modeled his design on German plate armor produced ca. 1460-80. The leather strap and buckle fastening the two parts of the breastplate is, however, a typically Italianate feature. The fusion of Germanic and Italian influences helps identify the armor as, in all likelihood, Tyrolean, and thus places the sculpture in the same region.[5] LW

1. Réau 1958, vol. 3, pt. 2, pp. 571-79.

2. Katonah 1995, pp. 15-16.

3. Lugano 1987, p. 24.

4. Lugano 1992, pp. 310-313.

5. I would like to thank Walter Karcheski, Jr. for his help in identifying and dating the armor. For comparable examples of Tyrolean and South German sculpture, see ibid., pl. 61. Examples offered at recent auctions include Neumeister, June 19, 1990, lot 33; Neumeister, December 10, 1991, lot 15; Sotheby's London, December 3, 1997, p. 32, lot 53.

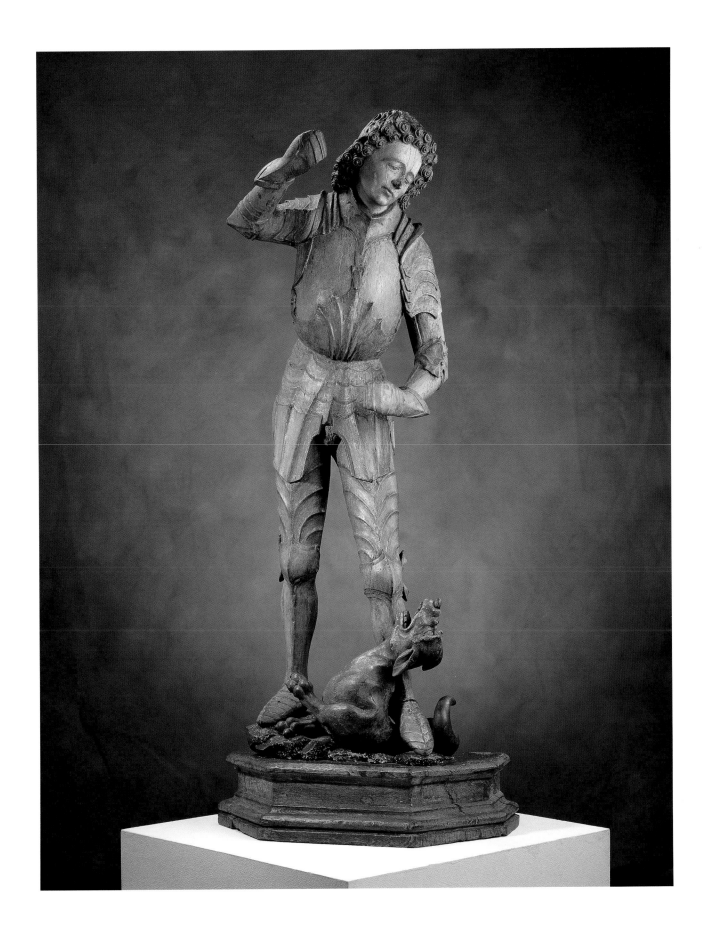

PROVENANCE: Purchased from Schaeffer Gallery, New York.

COMMENTARY: Probably a panel from an altarpiece wing, this *Annunciation* is typical of much Late Gothic Germanic relief sculpture from the Tyrol, a region at the crossroads between Italy and Germany. Its location meant a transitional variety of artisans were employed in the sculpture trade, and consequently the attribution of specific works to individual masters is often impossible.[1] Even though the artist is unknown, there is a general resemblance in figure type and format to the work of two Tyrolean sculptors, Nartzis von Bozen (active 1482/83-1517) and Hans Klocker (active ca. 1480-1500).[2] The provincial style of this *Annunciation* has a strong visual appeal in its intensified naturalism and the unidealized expressiveness of the figures. The sacred communication between Gabriel and Mary is conveyed with a moving intensity through the linear emphasis of the design, the compression of the voluminously robed figures into the foreground, and the spreading abstract drapery patterns. Similar stylistic and expressive qualities appear in altar wing *Annunciations* by von Bozen and Klocker.[3]

The Flagg relief conforms to long established traditions for representing the Annunciation.[4] These include the excited gestures of the Virgin and the Archangel; the rays emanating from the dove toward the Virgin; the prie-dieu and book (symbolizing Mary's wisdom), which date back to ninth-century descriptions of Mary reading Scripture as Gabriel appears; and the interior domestic setting. Like many contemporary *Annunciations*, this relief depicts the Virgin in a state of disquiet, as she hears Gabriel's salutation: "Hail Mary, thou art highly favoured, the Lord is with thee: blessed art thou among women." This state of "disquiet," according to medieval religious literature, came not from incredulity or awe at the sight of the apparition, but wonder at the angel's grand and lofty salutation.[5] EFG

1. Baxandall 1974, p. 38.

2. Müller 1976, pp. 33, 36-37, pls. 153, 155, 168-71; Scheffler 1967, no. 19, pl. 6, fig. 6.

3. Schiller 1971, vol. 1, fig. 118; Müller 1976, fig. 171.

4. Schiller 1971, vol. 1, pp. 38-52.

5. For a fuller explanation of the Virgin's successive spiritual and emotional states, see Baxandall 1988, pp. 48-56.

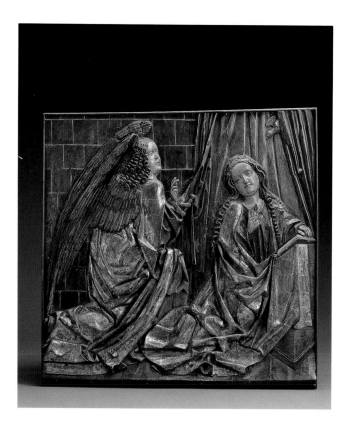

67. *Annunciation*

Tyrol, Austria
ca. 1500
Polychromed and gilded pine
33 3/4 x 34 2/3 in. (86 x 88 cm)
M1974.234

DESCRIPTION: This carved relief panel depicts the Annunciation as the Archangel Gabriel appears to the Virgin Mary (Luke 1:26-38). Bright green curtains against a brick wall enframe the Virgin Mary as she kneels at her prie-dieu; her right hand is raised and her left hand rests on a prayer book. The dove of the Holy Spirit emerges from behind the curtain on the right as the kneeling angel Gabriel raises his right hand in benediction. The carving is generally low except for the figures' right hands which project from the surface in full relief, adding to the drama and meaning of their gestures. The sharp, angular draperies and the tight ringlets of the figures' hair create beautifully abstracted patterns. The entire surface of the relief is polychromed and gilded.

CONDITION: The entire upper-right corner of the wood panel above the Virgin's head has been replaced due to worm infestation. The gilding on the draperies is severely worn and all of the surfaces have been repainted. Mary's right hand has been broken off and reglued. A hole at the top of Gabriel's staff suggests that an ornament was once attached.

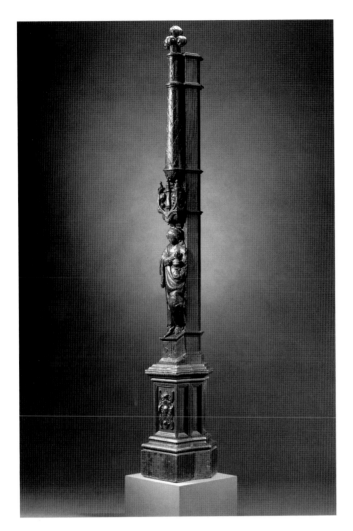

68. *Post with Mary Magdalen*

Probably Flanders
1546
Stained oak
77 1/2 x 9 x 12 1/2 in. (196.9 x 22.9 x 31.8 cm)
M1991.69

DESCRIPTION: This tall, slender oak post is composed of several parts: a six-sided post decorated with a separately carved figure of Mary Magdalen rests on a slightly larger base adorned on the front with a crest. The Magdalen, with her head turned and cast downward, holds her attribute, an ointment jar, to the left side of her body in a slightly contrapposto pose. She is fashionably garbed in a sixteenth-century Flemish-style dress with brocaded bodice, puffy sleeves, and pointed shoes. Her long hair is not loose, but neatly braided and tucked behind her shoulders. The elaborately carved canopy immediately above her head imitates the ornamental tracery motifs of Gothic architecture,

and the carved and decorated post continuing above the figure repeats the same motifs on a larger scale and is topped with a floral knop. The center of the supporting base is hollow and was probably fitted onto a raised platform.

CONDITION: The post is in good condition, except for minor losses to the figure's right hand, the left corner of the platform, and the mid-section of the canopy's right pinnacle. The wood has a number of cracks and some minor worm infestation. Nail holes and notches have been filled in with putty and wood.

MARKS AND INSCRIPTIONS: The date 1546 is carved into the platform below the figure.

PROVENANCE: Purchased from Albrecht Neuhaus, Kunst und Antiquitäten, Würzburg, 1970.

COMMENTARY: This sculpture was once part of a church interior decoration, such as an altar or confessional screen, portal, or an *aumbry*.[1] Notches on either side indicate that the post was once joined to other structural components, with the figure placed above eye level to allow the saint to gaze gently down at the worshipper. The figure's vertical position beneath a canopy echoes the sculpted jamb figures that grace the portals of French Gothic cathedrals.

Mary Magdalen was one of the most controversial women in the history of Christianity. The interpretation of the Magdalen has ranged from prostitute to apostle. During the sixteenth and seventeenth century, some European artists, particularly in Italy, presented the Magdalen as a sensual, almost Venus-like figure. Other interpretations focused on her later life when she had renounced all material goods and lived as a hermit. Finally, she has been represented as an apostle of Christ, either teaching or studying. In Flemish art, she is most often represented in deep contemplation, teaching or reading, and is usually attired in fine clothing, corresponding to her royal lineage as described by Jacobus de Voragine.[2] She is most consistently portrayed weeping, praying, or remembering her transgressions as well as the teachings of Christ. It is her penitence, one of the seven Holy Sacraments of the Catholic Church, that makes her such an important figure in Catholic art, especially during the Counter Reformation.[3] Such an image of the penitent Magdalen would have been especially appropriate for the decoration of a confessional screen. JVS

1. Typically found in Flemish and Northern European churches, an *aumbry* is a decorated recess or niche near the altar used to display vessels containing the consecrated host. See Lane 1984, p. 32.

2. Malvern 1975, p. 91.

3. Haskins 1993, p. 16.

69. *Road to Calvary with St. Veronica*

Antwerp
ca. 1510-20
Polychromed and gilded oak
30 x 51 1/2 x 12 1/2 in. (76.2 x 130.8 x 31.8 cm)
M1971.12

DESCRIPTION: This horizontal composition, representing St. Veronica offering the sudarium to Christ on the road to Golgotha, comprises four groupings or blocks that are doweled into position along the base. The core group consists of St. Simon of Cyrene and a flagellator, who were conscripted to aid in carrying the cross, Christ, St. Veronica, and the soldier immediately behind her. The horseman and the pedestrian in the foreground are each independently attached, as is the soldier at the end of the block, whose sheared left arm suggests another figure may have balanced the one now missing at the other end. All of the figures are beautifully polychromed and gilded; the unfinished back of the base indicates that they were once part of a larger retable.

CONDITION: Minor worm infestation is visible on the backs of the figures. Some repainting appears on the protruding parts of the figures and faces. The mounted soldier has been braced by modern metal clamps behind the legs of the horse, and there are old nails behind many of the figures. The soldiers' lances are modern.

MARKS AND INSCRIPTIONS: A splayed hand, the hallmark for Antwerp carvers, is branded into the base between Christ's feet.[1]

PROVENANCE: Purchased from Blumka Gallery, New York, 1970.

COMMENTARY: This dramatic group was part of an elaborate Late Gothic winged altarpiece, a form that reached its zenith around 1500 in Brussels and Antwerp. It has been linked with changes in liturgical practices that aimed at greater audience involvement.[2]

A fully developed altarpiece of this type might have as many as fourteen or fifteen sections integrating panel painting and sculpture within an architectural enframement. Flanked by carved or painted wings, shallow boxlike cases were divided into compartments often stacked in tiers and containing brightly painted and gilded sculptures. Christ's Passion was a frequent theme. Christ Carrying the Cross was usually shown to the left of a central Crucifixion scene twice its height. The exceptionally wide format of this group is explained by the probability that the horseman originally belonged to this central scene, while the two right-hand figures were originally in the background.[3]

This sculpture was formerly attributed to Jan Borman (active ca. 1479-ca. 1520), whose Brussels workshop was highly influential in The Netherlands and especially in Sweden. The style compares closely to a 1516 altarpiece in Västerås, Sweden, which has been variously attributed to Borman's atelier and to the workshop of Master Gielisz in Antwerp, called the giant of Netherlandish altarpiece entrepreneurs.[4] Both the Antwerp hallmark on the base of this sculpture and the stylistic differences undercut the Borman attribution, pointing rather to Master Gielisz or to a still unknown workshop in Antwerp that is also connected with the Västerås altarpiece and a Passion altarpiece in St. John's Cathedral, 's-Hertogenbosch, The Netherlands, both of which contain figures nearly identical to the Flagg group.[5]

Many altarpieces were standardized products marketed through international trade fairs rather than made for private patrons. By the early sixteenth century, workshops in Antwerp and other centers employed a number of specialized artisans to produce a single retable: one responsible for the overall design and execution, another to make the shallow outer box, one or more sculptors to carve the figures, a gilder, and a painter. Stock figures were used in different altarpieces and settings. The Veronica in the Flagg piece, for example, doubles as the Magdalen at the foot of the cross in other retables.[6] Model or pattern books contained designs for entire compositions as well as individual figures, and often incorporated motifs from paintings and prints.[7] As the high quality of this group attests, such practices were not necessarily detrimental, but allowed the carver to focus on sharp definition and expressive nuance. EFG

1. Different cities had different marks guaranteeing quality. The Antwerp hand for carved wood was introduced in 1471 as a castle with two small hands, which represented the municipal coat of arms. See Antwerp 1993, vol. 1, p. 21; Jacobs 1986, p. 21.

2. Jacobs 1986, pp. 83-107; Antwerp 1993, vol. 1, pp. 15-16.

3. Hans Nieuwdorp, letter, November 8, 1994.

4. Devigne 1932, p. 166, no. 6; Roosval 1933, pp. 154-56; Andersson 1980, p. 201, fig. 126.

5. Hans Nieuwdorp, letter, November 8, 1994; Antwerp 1993, vol. 1, p. 53, no. 7.

6. For the figure of Veronica as the Magdalen, see de Borchgrave d'Altena 1946, fig. 41. An almost identical figure of Veronica, a fragment from an Antwerp altarpiece, was sold at Sotheby's New York, January 13, 1995, lot 1009.

7. For an example of a group based on these designs, see Boccador and Bresset 1972, vol. 2, p. 214.

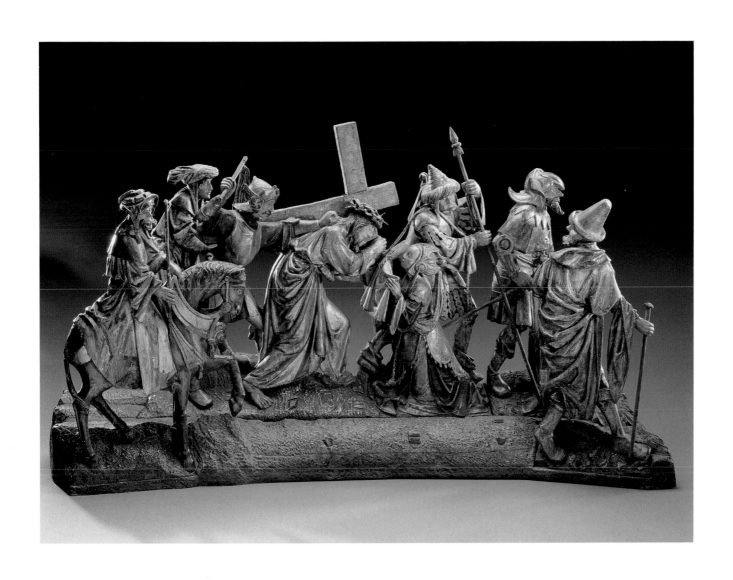

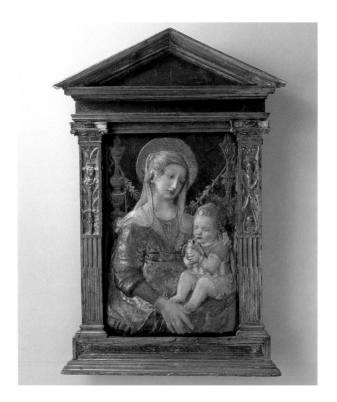

70. *Madonna of the Candelabra*

Workshop of Antonio Rossellino (1427-1479)
Florence
ca. 1460-75
Polychromed and gilded stucco with parcel-gilt and painted wood frame
50 x 34 1/2 x 6 1/4 in. (127 x 87.2 x 15.9 cm) with frame
M1984.142

DESCRIPTION: Within a carved and pedimented tabernacle frame, this cast low relief shows the three-quarter-length Madonna gazing down at the Christ Child seated on her lap upon a tasseled cushion, a bird clutched in both hands. Behind the haloed figures is a garland suspended between two flaming candelabra, each festooned with a string of beads. The Child wears a blue, red, and white striped sash and red bead bracelet. The Madonna, robed in blue, red, and gold brocade, wears a white veil on her head. Three hooks or nail heads visible on the Virgin's painted girdle indicate that a belt, probably made of metal, was once fastened to the relief.

CONDITION: Both relief and frame reveal extensive repainting and regilding.

PROVENANCE: Stefano Bardini, Florence; Raoul Tolentino, Rome (sale, American Art Association, New York, April 21-26, 1920, lot 796); Joseph Brummer, New York; Baron Cassel van Doorn, New York; purchased from Blumka Gallery, New York.

PUBLICATIONS: London, Victoria and Albert Museum. *Catalogue of Italian Sculpture in the Victoria and Albert Museum.* Text by John Pope-Hennessy. London, 1964, vol. 1, p. 132; Paris, Musée Jacquemart-André, Institut de France. *Sculpture italienne.* Text by Françoise de La Moureyre-Gavoty. Paris, 1975, no. 40.

COMMENTARY: A lost marble relief of ca. 1460-65 by the Florentine Renaissance sculptor Antonio Rossellino is the source of the composition known as the Madonna of the Candelabra.[1] The youngest and most gifted of a large family of sculptors, Antonio is best known for his portrait busts and funerary monuments, and for Madonna and Child reliefs ascribed to the artist on the basis of similarities with three documented works. The attribution of the Madonna of the Candelabra to Rossellino is based on its stylistic affinities with the attributed *Altman Madonna* (1457-61; The Metropolitan Museum of Art, New York) and with the documented *Madonna and Child* surmounting his most famous work, the tomb of the Cardinal of Portugal in San Miniato al Monte, Florence (1461-66), from which the candelabra and garland motif derive.

The many repetitions of this endearing composition attest to its enormous popularity in fifteenth-century Florence.[2] Reductions in bronze, as well as full-scale replicas in inexpensive, malleable materials such as stucco, gesso, terra cotta, and *cartapesta* were made in abundant quantities to meet a demand for devotional objects intended for domestic use by an increasing number of middle-class citizens in Renaissance Florence. These "squeezes," made in the artist's studio from molds of a marble original, were sent out to painters who maintained a profitable sideline in the gilding and poly-chroming of reliefs and their frames.[3] Such replicas did much to disseminate the new Renaissance style and imagery. Inspired by antiquity, classical architectural and ornamental motifs (such as the candelabra), as well as a graceful naturalness in religious depictions of mother and child, were fully developed by 1470. By then the infant, often holding a bird (alluding to the Holy Spirit or the future Passion and possessing talismanic properties against disease) and nestled against a seated, knee-length mother, was a well-established formula. Like much fifteenth-century Florentine sculpture, this relief is as pictorial in its line, color, and treatment of space as contemporary painting was sculptural in its search for volume. EFG

1. Pope-Hennessy 1985b, vol. 2, p. 283, pl. 60.

2. Many versions are listed in London 1964, no. 110; Florence 1967, pp. 151-52.

3. See Pope-Hennessy 1980, pp. 91, 223; Seymour 1966, pp. 10, 221, no. 16.

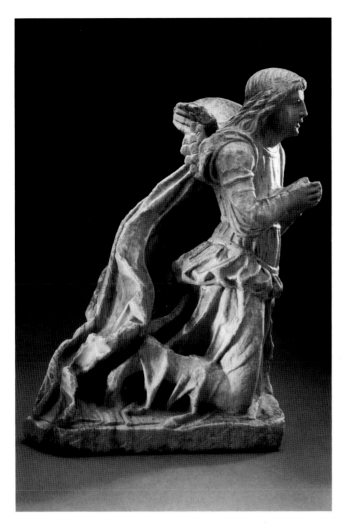

71. *Kneeling Angel*

Lombardy, Northern Italy
Late 15th century
Limestone
15 1/8 x 12 x 8 in. (38.4 x 30.5 x 20.3 cm)
M1991.61

DESCRIPTION: This kneeling angel with hands clasped in prayer is summarily carved with an emphasis on the right profile. There is no left leg and almost the entire front of the angel is uncarved, suggesting that it is a fragment from a larger group where it was overlapped by other figures. The deep undercutting of the folds on the right side heightens the visibility of the figure and implies that it was meant to be seen from below. The angel wears a high-waisted, double-belted tunic. The broad face is carved more carefully, focusing on the angel's attitude of adoration. The attempt at conveying an emotional response, albeit in an elementary way, conforms to Renaissance theoretical ideas concerning "moving the soul."[1]

CONDITION: The wings and draperies are chipped throughout, and general abrasions and scratches appear on all the surfaces. There are claw chisel marks on the back and some plaster infills on the back, side, and front of the figure. The base has a short insert carved on the underside to stabilize the figure once set into place. Dark spots of encrustation on the surface, particularly on the garments, suggest that the figure may have been polychromed.

PROVENANCE: Purchased from Blumka Gallery, New York, 1968.

COMMENTARY: The Flagg angel is probably a fragment from a larger relief sculpture representing a Nativity or a Lamentation. Perhaps, too, the figure could be associated with a ciborium or tomb. The work has been linked to the late fifteenth-century Milanese sculptors Cristoforo and Antonio Mantegazza, who were associated with the "cartaceous" style, so named because the angular, flattened figures and drapery bring to mind crumpled paper.[2] To be sure, the folds have some relationship to the style of the Mantegazza, but the angel, unlike the intense and agitated figures produced by these sculptors, is static and almost classically restrained.[3]

The facial type instead finds an analogue in the work of the Lombard sculptor Giovanni Antonio Amadeo (1447-1522), who was associated with the Mantegazzas.[4] Amadeo had worked with both Mantegazzas in executing the facade of the Certosa di Pavia in the 1470s, and between 1492 and 1499, Amadeo and Antonio Mantegazza directed the decoration of the facade. Amadeo's use of the cartaceous style in the early 1480s may be evidence of the Mantegazzas' influence, although other late fifteenth-century Milanese sculptors also practiced the style, including Piatti, with whom Amadeo collaborated extensively. The squarish hands and the broad facial features found in a relief from the Amadeo workshop depicting the Presentation in the Temple in the church of S. Lanfranco, Pavia, dated 1498, bear some similarities to the Flagg piece.[5]
BW

1. Alberti 1966, p. 77.

2. Alice Duncan, Christie's New York, appraisal, March 1993.

3. For the Mantegazzas, see Pope-Hennessy 1985b, vol. 2, pp. 325-26.

4. For Amadeo, see ibid., pp. 323-25. On their collaboration on the Certosa di Pavia, see Morscheck 1978, *passim*.

5. This relief is reproduced by Seymour 1966, pl. 134. For an example of a northern Italian terra cotta, datable to ca. 1500, that may also be related to the Flagg sculpure, see Sotheby's London, December 7, 1995, lot 69.

72. *Bust of a Nobleman*

Probably Padua or Venice, Northern Italy
1556
Polychromed terracotta
30 x 24 3/4 x 11 1/2 in. (76.2 x 62.9 x 29.2 cm)
M1990.124

DESCRIPTION: This is a portrait bust of an alert and self-confident nobleman with close-cropped hair and a short beard. He wears a fur stole and a doublet with slashed, puffed sleeves. The marvelous tactility of the bust is underscored by the still intact buttons. Suspended from the square-link gold chain around the nobleman's neck are two Venetian orders–the Cavaliere di San Marco, represented by the lion of St. Mark, and the Cavaliere de Doge, represented by a twelve-point cross similar to a Maltese cross.[1] The bust rises from a scrollwork base hollowed out at the back. The pupils of the eyes are drilled and the irises are outlined. The head was probably fashioned separately and attached, a common practice for a terra cotta of this size.

CONDITION: The terra cotta is in excellent condition and the polychrome is stable. The flesh-tones appear original, and the buttons on the garment retain some of their original gilding and red glazing. The pupils have been repainted and the garment has been overpainted. Some paint losses appear on the shoulders and toward the back of the head. There are minor repairs to the collar and nose. The right rear of the base is chipped and there are scattered chips along the right and left sides of the base. A small crack is located on the forehead near the center hairline. Thermoluminescent analyses conducted at Oxford University Research Laboratory indicate that the bust was fired 350 to 500 years ago.

MARKS AND INSCRIPTIONS: R P F is inscribed on the base. At the bottom, inside the base, is the inscription 1556 DE MAZO, probably inscribed after firing. The date 1556 is also inscribed inside the bust, below the neckline.

PROVENANCE: Reportedly from a palace in Padua; Stefano Bardini, Florence, 1918 (sale, American Art Galleries, New York, April 23-27, 1927, lot 325 [as by Alessandro Vittoria]); J. Hinkle Smith, Philadelphia (sale, S. T. Freeman and Company, Philadelphia, 1970); purchased from Edward R. Lubin, New York, 1971 (as by Danese Cattaneo).

COMMENTARY: This bust is of very high quality, but the name of its creator remains elusive. Initially it was attributed to the sculptor Alessandro Vittoria (1525-1608) and then to Danese Cattaneo (1509-1573). Although the scroll base reflects the northern Italian ambiance of Vittoria and Cattaneo, the Flagg bust is not as fluidly handled as the works of these masters, and the static, frontal pose is uncharacteristic of the more active movement that Vittoria and Cattaneo favored.[2] Pope-Hennessy has suggested an Emilian origin and the possibility that the artist was Antonio Begarelli (died 1565), but the meticulous handling of the bust seems to belie this association.[3] Luchs saw some resemblance to the work of the Paduan sculptor Francesco Segala (ca. 1535-1592), whose work has also been linked to the sculpture of Cattaneo.[4] Segala was producing important sculpture by the 1550s: his busts of Girolamo Negri (1557; S. Francesco, Padua) and Francesco Robertello (1567; Basilica del Santo, Padua) are analogous to the Flagg bust in their broad frontality and stillness.[5] Yet the attribution to Segala is complicated by the inscription R P F (R P *fecit* "made it"). A "G. P." (Girolamo Pagliari) was associated with Segala, but the initials R P remain tantalizingly unattached to a sculptor of the period.[6]

The identity of the sitter is equally problematic. Gregori suggested that the bust resembled Giovanni Girolamo Albani (1509-1591), a Bergamese nobleman who is depicted wearing the same Venetian orders in a portrait by Giovanni Battista Moroni (ca. 1563-70; Roncalli Collection, Rome).[7] The Flagg bust is actually closer in facial type, however, to a portrait medal of Giovanni de Nores, count of Tripoli (National Gallery of Art, Washington, DC), as pointed out by Bliss.[8] However, de Nores died in 1544 and it remains questionable if a likeness produced over a decade later would have had resonance for a Paduan nobleman.[9] BW

1. Giucci 1840, vol. 3, pp. 41-42.

2. Compare, for example, Vittoria's bust of Tommaso Rangone (1571) or Cattaneo's portrait of Lazzaro Buonamico. For Vittoria, see Pope-Hennessy 1985b, vol. 3, p. 416, pl. 124; for Cattaneo, see Venturi 1937, vol. 10, pp. 12, 15-16, fig. 9.

3. John Pope-Hennessy, letter, April 24, 1972.

4. Alison Luchs, letter, June 19, 1989; for Cattaneo and Segala, see Venturi 1937, vol. 10, pp. 1-35, 180-206.

5. Pietrogrande 1952-53, pp. 111-112, 117-121.

6. For Pagliari and Segala, see Venturi 1937, vol. 10, pp. 203-204.

7. Mina Gregori, letter, February 20, 1990.

8. Joseph R. Bliss, letter, July 1995.

9. On de Nores, see *Dizionario Biografico degli Italiani*, vol. 38, 1990, p. 768. There is the vexing question of the enigmatic inscription DE MAZO. Pope-Hennessy believed it was a misspelling of the word *Marzo* (March) and indicated the month in which the bust was made. On the other hand, perhaps this is a dialectic form of the diminutive "*mazzuolo*," a sculptor's tool. Could DE MAZO indicate that the bust was produced with the use of this tool in 1556? See John Pope-Hennessy, letter, April 14, 1972; for the term "*mazzuolo*," see Baldinucci 1681, p. 93.

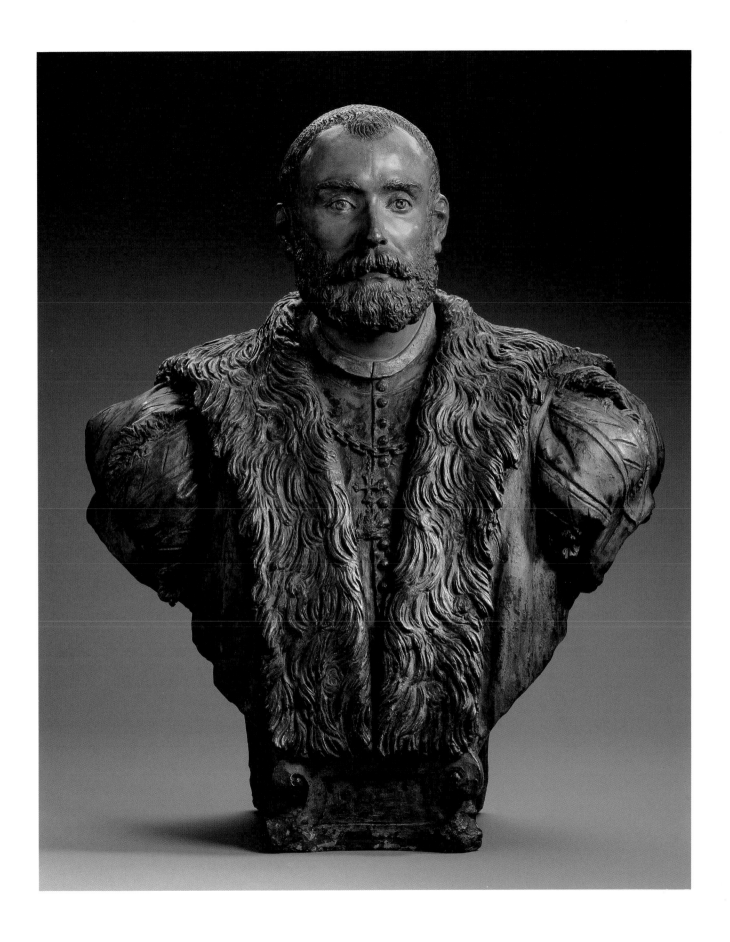

73. *Florence Triumphant Over Pisa*

Workshop of Giovanni da Bologna (1529-1608)
Florence
ca. 1575-1600
Terracotta
19 3/4 x 9 x 10 in. (50.2 x 22.9 x 25.4 cm)
M1991.62

DESCRIPTION: This is a copy in reddish-brown terra cotta after Giovanni da Bologna's famous marble statue of the same subject (ca. 1570; Museo Nazionale, Florence). However, instead of the fox lying submissively at the feet of Pisa found in the original, a dog has been substituted. The allegorical figure of Florence, with its exaggerated contrapposto intertwined with the abject figure of Pisa, is a quintessential example of the "*figura serpentinata*," a pose emphasizing continuous spiraling movement, used by Michelangelo and elaborated by Giovanni da Bologna.

The piece is fluidly modeled with flickering highlights on the shoulders and hair of the figures. The meticulous detail, most notably the chains that bind the wrists of conquered Pisa, underscores tactility. The spontaneity of treatment is evident in the traces of the modeler's fingerprints on the square rockwork base and the incisions from the modeling tool on the facial features.

CONDITION: There are a number of small repairs, cracks, and chips throughout the figures. The figure of Florence has old repairs to a break at the left shoulder and to the wrist. The male figure of Pisa has a crack and a possible repair at the right ankle and a crack and a possible repair slightly above the buttocks. The dog's right foot has also been repaired. The base is slightly scratched, as are the upper back and shoulders of the female figure. Thermoluminescent analysis conducted at Oxford University confirms that the piece is 300 to 550 years old.

PROVENANCE: Baron de Rothschild, Paris; purchased from Rosenberg & Stiebel, New York, 1964.

COMMENTARY: The group *Florence Triumphant Over Pisa* was part of a monumental decorative cycle, including Michelangelo's *Victory*, created to welcome Giovanna d'Austria as the royal bride of Francesco de' Medici in 1565.[1] Three large triumphal arches, a fountain that poured red wine, and processions of soldiers and knights complemented the statuary.[2] The marriage consummated Medici royal pretensions, raising the family to the rank of a European royal house. The aggrandizement is underscored by the victory over Pisa, an event that resonated through Florentine *cinquecento*

history. At the beginning of the century, Michelangelo's now lost *Battle of Cascina* presented an image of Pisan defeat.[3] And in 1593 Giovanni da Bologna's pupil Francavilla depicted a subservient Pisa receiving succor from Ferdinando de' Medici.[4]

The Flagg terra cotta, however, is not an exact replica of the Giovanni da Bologna.[5] Instead of the fox, symbolic of treachery and low cunning, a dog cowers at the feet of vanquished Pisa.[6] Since dogs were associated with the guardians of a city in the venerable iconographic handbook of Vincenzo Cartari (1556), perhaps it serves as an additional symbol of defeat.[7] The Flagg terra cotta differs from other versions of the theme as well. For example, a terracotta *modello* in Berlin, ascribed by Brinckmann to a follower of Giovanni da Bologna, is only 29.5 cm high and lacks a symbolic animal.[8] Copies in Modena, the Musée Granet in Aix-en-Provence, the Lord Acton Collection (bequeathed to New York University), and The Metropolitan Museum of Art differ as well.[9] Nor does the Flagg terra cotta correspond to early eighteenth-century variants by Soldani.[10]

Consequently, a specific attribution of the work remains problematic. Avery has suggested that the sculpture may have been by Francavilla, or may have been a part of a group "made in the 16th century as academic studies by Giambologna's pupils trying to approximate his style, and/or in preparation for versions on a small scale in bronze."[11] The latter seems most likely, especially since there was also a lively interest in collecting terracotta *modelli*. Cosimo de' Medici had a cupboard full of "curiosities of clay," and Rafaello Borghini filled his elegant villa Il Riposo with many *modelli*.[12] BW

1. London 1978a, p. 14.

2. Cochrane 1973, p. 91.

3. For Michelangelo, see Tolnay 1969, vol. 1, pp. 217-218.

4. London 1978a, p. 227.

5. Avery 1987, p. 276.

6. On the symbolism of the fox, see Haverkamp Begemann 1975, p. 136.

7. Cartari 1647, p. 237.

8. Brinckmann 1923, vol. 1, p. 84, pl. 32.

9. London 1964, p. 467.

10. For Soldani's variants on the group, see Christie's London, June 25, 1980, lot 37; Schultze 1986, p. 120; New York 1970, vol. 3, p. 240.

11. Charles Avéry, conversation, December 1993; Charles Avery, letter, December 4, 1993; H. Keutner 1955, p. 17. *Francavilla was never a slavish imitator of the master and it seems unlikely that this sculpture is by him.*

12. Pope-Hennessy 1985a, p. 225; Avery 1987, pp. 237-38.

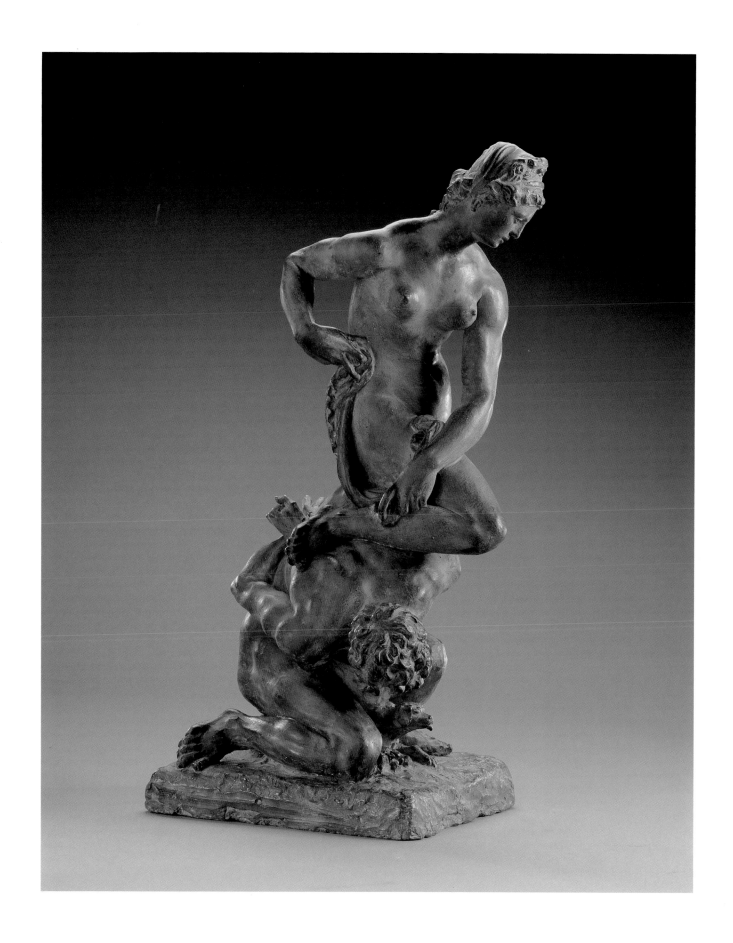

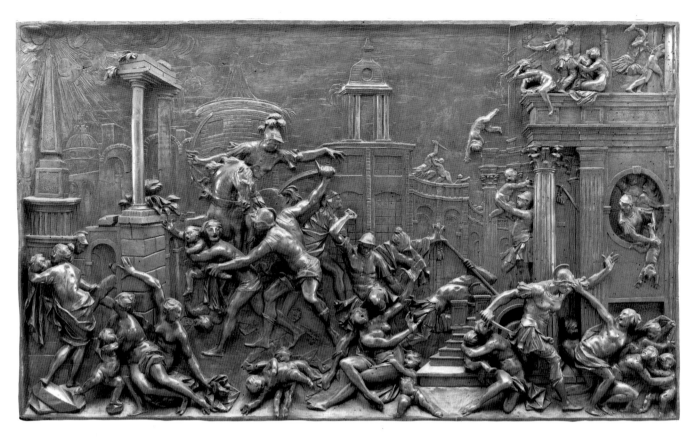

74. *Massacre of the Innocents*

Probably Southern Germany or Northern Italy
Late 17th century
Stained walnut
23 1/2 x 40 1/2 x 1 1/2 in. (59.7 x 102.9 x 3.8 cm)
M1991.64

DESCRIPTION: This wood sculpture presents the Massacre of the Innocents (Matt. 2:16) in four groups of figures in high relief and one in low relief. The four clusters form a triangle, weighing more heavily on the left. The low relief cluster is deployed around a temple, whose mass balances the triangle. The strong diagonals of the gesturing figures connect the elements of the composition. Uniformed soldiers and classical architecture, including an obelisk, define the court of Herod.

CONDITION: The piece is in very good condition. There is a crack in the upper left corner and evidence of worm infestation, especially in the lower corners.

PROVENANCE: Purchased from French & Company, New York, 1957.

COMMENTARY: The Massacre of the Innocents was a popular subject among Renaissance and Baroque artists, not only for its religious significance, but also for its dramatic action. The Flagg piece shows numerous influences, specifically Raphael (1483-1520) and Nicolas Poussin (1593/94-1665). Raphael's early drawings of the subject, engraved by Marcantonio Raimondi, show the same twisting figures and round open mouths of the victims and their mothers. Moreover, direct comparisons of figural groups can be made: The soldier striking at the fleeing mother and child beneath the horse in the Flagg sculpture is a reversed image of a similar group in a Raphael study.[2] The strident soldier at the lower left can be directly compared to a figure in the extreme right foreground of *Funeral of the Emperor* by Giovanni Lanfranco (1582-1647), a follower of Raphael.

This work is also comparable to Nicolas Poussin's *Massacre of the Innocents* in the Musée Condé, Chantilly, which shows similarly desperate mothers arranged at various levels within the composition. The plump infants with expressive faces further link the Flagg panel to the Baroque era as they resemble Baroque putti, the most notable examples being those by Duquesnoy.[3] Sculptural panels such as the Flagg example were used to decorate estates, ecclesiastical centers, and state monuments. JVS

1. I would like to thank Jean-René Gaborit for his kind assistance in establishing the possible countries of origin.

2. See Gere 1987, figs. 19, 19a.

3. Wittkower 1982, p. 276.

75. *Marriage of Adam and Eve*

Konrad Eberhard (1768-1859)
Probably Munich or Allgäu, Germany
ca. 1830-40
Bavarian soapstone
31 1/2 x 27 x 2 3/8 in. (80 x 68.6 x 6 cm)
M1991.31

DESCRIPTION: Carved from a single piece of Bavarian soapstone, this bas-relief sculpture shows God the Father in the center with outstretched arms and an unfurled cloak that embraces the flanking figures of Adam and Eve. Traditional symbols foreshadowing the Fall and Redemption of Human-kind surround the figures: the serpent, the Tree of Knowledge, and the redeeming Eucharistic grapes. The magnificent frame represents the "beasts of the field" in the lower realm and the "birds of the sky" above (Gen. 2:18). The subject does not conform to the iconography of the Creation of Adam and Eve, the Temptation, or the Expulsion, but may instead represent the Marriage of Adam and Eve with an emphasis on the promise of redemption.[1]

CONDITION: The overall condition is very good. A hairline crack is located above Adam's head, and some chipping and abrasion occur along the outer edges of the frame.

PROVENANCE: Reportedly from the collection of Bertel Thorvaldsen; purchased from James Graham and Sons, New York, 1966 (as by Bertel Thorvaldsen).

COMMENTARY: Although this sculpture is much later in date than most works in the Flagg collection, its medievalizing subject would have appealed to Richard Flagg. Konrad Eberhard was one of the Lukasbrüder, a group of German artists working in Rome more commonly referred to as the Nazarenes, who viewed art as a servant of religion and emulated artists such as Dürer, Perugino, and Raphael.[2] Through this association and his friendship with the painter Julius Schnorr von Carolsfeld (1794-1872), Eberhard introduced a medievalizing style and sentiment into his classical vocabulary, exemplified in the *Marriage of Adam and Eve*. Eberhard apparently returned to this subject repeatedly in an attempt to reconcile the classical nude with his own religious fervor.[3]

Eberhard was born in the small southern German town of Hindelang in 1768.[4] He received his earliest training from his father, Johann Richard Eberhard, then moved in 1799 to Munich and began working with the sculptor Roman Anton Boos. During the seven years he spent at the Akademie der Bildenden Künste in Munich, he attracted the attention of Ludwig I and won a stipend for two years of study in Rome, where he practiced a Neoclassical style and subsequently met the Lukasbrüder.

In 1819 Eberhard returned to Munich where he assisted with decorations for the Glyptothek and executed plans for the Tomb of Princess Carolina and a cycle of Homeric reliefs for the Casino Massimo al Laterano (the Villa Giustiani) in Rome. In 1821 he returned to Rome to complete these projects. By 1826 Eberhard had returned to Munich to become a professor of sculpture at the Akademie. His work over the next decade took on an increasing religious tenor. With the death of his brother and long-time collaborator, Franz, in 1836, Eberhard withdrew from the Akademie in order to concentrate on devotional commissions for churches in the Allgäu. The best repositories of his work are the Eberhard Museum in Hindelang, and the Neue Pinakothek and the Schloss Nymphenburg in Munich. LW

1. The Marriage of Adam and Eve was a popular subject in medieval Northern Europe. See Heimann 1975, pp. 11-40.

2. For the Nazarenes, see Rosenblum and Janson 1984, pp. 82-84; Andrews 1964, *passim*.

3. I would like to thank Robert E. McVaugh for pointing out Eberhard's continuing interest in this subject.

4. Arnold 1964, *passim*.

FURNITURE

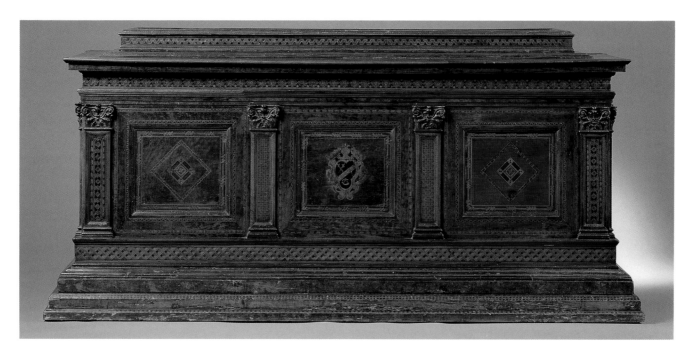

76. *Cassone*

Florence
ca. 1480
Walnut, fruitwood intarsia, oak base, and a pine core
44 x 93 x 30 1/4 in. (112 x 236.2 x 76.8 cm)
M1978.30

DESCRIPTION: This chest, or *cassone*, is fashioned from various woods and rests on a separate oak base. Its walnut exterior is richly decorated with architectural motifs and intarsia. Inlaid Corinthian pilasters embellish three sides, and divide the main face into three panels. The center panel has a cartouche with a crested coat of arms, while the flanking panels have recessed diamond designs. Friezes of perspectival interlace wrap around the base and lower portion of the *cassone*, while star-shaped and geometric designs ornament the lid and enframe the front and side panels. The lid has a stepped design with a molded border. The unfinished back was intended to be placed against a wall.

CONDITION: The intarsia is in unusually good condition. The coat of arms is probably of later date. The interior has been relined with a pine core, the hinges (now detached from the lid) are later, and modern nails and screws were used for reinforcement. The base is probably not original to this piece, but may be contemporary.

PROVENANCE: Mrs. Irving T. Snyder, Coronado, California (sale, Sotheby Parke-Bernet Los Angeles, April 7-8, 1975, lot 230); private collection, Los Angeles; purchased from Sotheby Parke-Bernet New York (December 8-9, 1978, lot 408).

COMMENTARY: Domestic furniture for the wealthy fifteenth-century Florentine echoed the city's massive *palazzi* in form and its churches in decoration. Intarsia, a form of marquetry that applies geometric perspective to inlaid designs, reached its apogee at this time in Florence when its use extended to the decoration of entire rooms. Its illusions proved particularly attractive in wood work because of the rich tonal contrasts created by the various woods.[1]

Cassoni were typically used for storage, and many were made specifically as dowry chests; a crest or coat of arms frequently signaled a marital alliance among the nobility. This unidentified coat of arms is probably a seventeenth-century replacement reflecting the arms of the new proprietor, a practice common with expensive furniture. It appears on a credenza of similar design in a private collection, suggesting that these two pieces may have formed a matching set, in keeping with contemporary fashion.[2] Strips of intarsia of the same design were cut to fit given pieces and create furniture ensembles. The form of the Flagg *cassone* with its rich moldings, inlaid designs, and rectangular panels between pilasters was especially popular in late fifteenth-century Florence.[3] EFG

1. See Washington 1991, pp. 247-49, nos. 145, 146.

2. The credenza once belonged to the collection of William Randolph Hearst, and was sold at Sotheby Parke-Bernet New York, December 7-8, 1951, lot 231.

3. Odom 1918-19, vol. 1, p. 98.

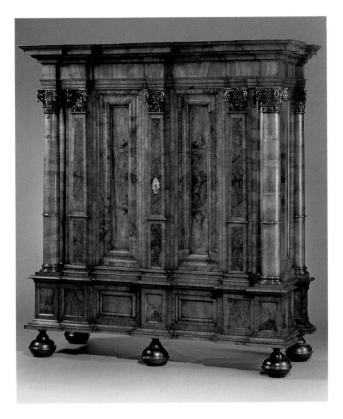

77. *Schrank*

Frankfurt
ca. 1700-20
Walnut veneer over an oak and pine core
93 1/2 x 88 1/2 x 34 7/8 in. (237.5 x 224.8 x 88.6 cm)
M1977.187

DESCRIPTION: Inspired by Baroque architecture, this *Schrank*, or wardrobe, has a stepped breakfront cornice, a similarly molded pedestal, and two paneled doors flanked by tapering pilasters with composite capitals. Two freestanding corner columns, composed of multiple turned wood drums, enframe the facade and help to create a plastic, undulating effect with contrasting areas of light and dark that is characteristic of Baroque architecture. The surface dynamism is further animated by the beautifully figured walnut veneer panels. The right door is opened first by inserting a key into the lockplate; then the left is opened by turning an interior handle which releases a vertical rod running along the backside. The *Schrank* rests on six large bun feet.

CONDITION: This piece has been recently restored and is in excellent condition. A crack on the left door panel has been repaired and some loose veneer reaffixed. The inner shelving is missing, and modern shelving brackets and screws have replaced the original fittings. The entire surface has been waxed to even out the tonalities of the finish. The lock and key are original.

PROVENANCE: Bernhard Zubrod (father of Erna Flagg), Frankfurt; given to Richard and Erna Flagg.

COMMENTARY: The *Schrank*—used as storage for household goods, clothes, and linens—was often the most important piece of furniture in early European homes.[1] This large, stately wardrobe was the successor to the *cassone* or trunk and the precursor to the walk-in closet. In late seventeenth- and eighteenth-century Germany, the *Schrank* was considered so important a piece of furniture that apprentices were required to produce one as their masterpiece for acceptance into the carpenters' guild.[2]

The *Schrank* evolved from the late medieval cupboard, which consisted of simple shelves and paneled doors, and was used mainly in churches and monasteries to store books, vestments, and liturgical objects. By 1500 several distinct categories of cupboards had developed to accommodate the growing availability of material goods: the bookcase, the china cupboard, and the wardrobe. By the late sixteenth century, the wardrobe had emerged in Germany as a distinct piece of furniture with a two-tiered facade, four paneled doors, and richly carved surfaces.[3] In the course of the seventeenth century, this form matured swiftly into the traditional *Schrank*, with its identifiable single-tiered facade, double doors, low pedestal, and architectural ornamentation.

Nestled in a densely forested region of Germany, Frankfurt was the most important center for the production of *Schranks* in the eighteenth century. Strict guild regulations and abundant sources of wood contributed to works of the highest caliber and an overall stylistic uniformity. The Flagg *Schrank* is an excellent example of the early "Frankfurter" style between 1700 and 1720, which is characterized by projecting corner columns and pilasters, a breakfront gable, and richly figured walnut veneers. Its basic components are rigorously architectural in form. *Schranks* produced after 1725 gained in monumentality, and their columns and pilasters tended to disappear in favor of molded, wavelike surfaces. The Flagg *Schrank* is especially noteworthy as one of the few examples in North America of the early architectonic style. The best repositories of *Schranks* are located in the Hessisches Landesmuseum, Darmstadt, and the Historisches Museum, Frankfurt.[4] LW

1. I would like to thank Gerhard Bayer and Sheila Schmitz-Lammers for their kind assistance in preparing this entry.

2. Consult Kreisel 1968, vol. 1, pp. 242-45 for the origins of the *Schrank*.

3. Gerhard Bayer, lecture, Milwaukee Art Museum, September 10, 1998.

4. For comparable examples, see Kreisel 1968, vol. 1, pp. 243-45, pls. 533, 534; Sotheby's London, December 3, 1997, lot 71.

ADDITIONAL WORKS IN THE FLAGG COLLECTION

The following checklist includes all items of European decorative art, sculpture, and painting donated by Richard and Erna Flagg that are not featured in the catalogue. These works are organized chronologically within those three categories. The outstanding Flagg collection of Haitian art, donated to the museum in 1991, will be published in a separate, forthcoming catalogue.

I. PAINTINGS

Madonna and Child
Follower of Lorenzo di Credi (1458-1537)
Florence
ca. 1490
Oil on panel
20 x 13 1/2 in.
(50.8 x 34.3 cm)
M1988.130

Crucifixion
Germany
15th century
Oil on panel
15 1/4 x 7 3/4 in.
(38.7 x 19.7 cm)
M1994.286

Resurrection
Germany
15th century
Oil on panel
15 1/2 x 8 in.
(39.4 x 20.3 cm)
M1994.287

*Triptych of Moses and the Tables of the Law
and Josiah and the Book of the Law*
Jan Swart (van Groningen)
(ca. 1500-1553)
Groningen, The Netherlands
ca. 1550
Oil on panel
49 1/2 x 65 3/8 in.
(125.7 x 166 cm)
M1972.229

Self-Portrait with Wife and Children
(After Caspar Netscher, 1639-1684)
The Netherlands
ca. 1665-70
Oil on canvas
22 1/2 x 17 3/8 in.
(57.2 x 44.1 cm)
M1995.682

Landscape with Castle
Adriaen Hendriksz. Verboom
(ca. 1628-1670)
The Netherlands
17th century
Oil on panel
25 3/4 x 20 7/8 in.
(65.4 x 53 cm)
M1963.150

The Marriage Trap
Jan Victors (1619-1676)
Amsterdam
ca. 1640-60
Oil on canvas
28 1/4 x 38 1/2 in. (71.8 x 97.8 cm)
M1974.233

The Fertility of the Egg
"Pseudo Bocchi," follower of Faustino Bocchi (1659-1742)
Venice
Early 18th century
Oil on canvas
25 1/2 x 47 1/2 in. (64.8 x 120.7 cm)
M1963.26

Miniature Portrait of a Young Girl
John Barry
(active 1784-1827)
England
ca. 1790
Watercolor on ivory with gold case
2 1/4 x 1 3/4 in.
(5.7 x 4.5 cm)
M1961.90

Village Family at a Meal
Jozef Israëls (1824-1911)
Groningen, The Netherlands
ca. 1880
Oil on canvas
24 1/2 x 47 in.
(62.2 x 119.4 cm)
M1986.139

II. DECORATIVE ARTS AND SCULPTURE

Canopic Jar Cover
Egypt
ca. 1300 B.C.
Limestone
4 3/4 x 5 1/2 x 5 1/2 in.
(12.1 x 14 x 14 cm)
M1992.123

Standing Figure of Osiris
Egypt
ca. 1800 B.C.
Bronze
6 1/2 x 1 3/4 x 1 3/4 in.
(16.5 x 4.5 x 4.5 cm)
M1991.53

Madonna and Child
Follower of Lorenzo Ghiberti (1378-1455)
Italy
Late 15th century
Polychromed stucco
29 1/2 x 21 1/2 x 9 in.
(74.9 x 54.6 x 22.9 cm)
M1973.618

Madonna and Child
Follower of Desiderio da Settignano
(1428-1464)
Florence
Late 15th century
Polychromed stucco
24 3/8 x 15 x 3 in.
(61.9 x 38.1 x 7.6 cm)
M1965.36

Column with Trophies
Venice
ca. 1500
Marble
48 3/4 x 10 x 10 in.
(123.8 x 25.4 x 25.4 cm)
M1991.60

Altarpiece of the Virgin and Child with Saints
Southern Germany
ca. 1500
Lindenwood with cloth backing
Open: 59 3/4 x 102 x 12 3/4 in.
(151.8 x 259 x 32.4 cm)
Closed: 59 3/4 x 51.2 x 12 3/4 in.
(151.8 x 130.8 x 32.4 cm)
M1977.166

House Altar of the Adoration of the Magi
Antwerp or Malines (Mechelen)
ca. 1560-80
Polychromed and gilded alabaster with
pearls and semiprecious stones
14 1/4 x 7 3/4 x 3 1/4 in.
(36.2 x 19.7 x 8.3 cm)
M1991.55

Candleholder in the Form of a Landesknecht
Nuremberg
Possibly 16th century
Brass
9 1/2 x 5 1/2 x 4 3/4 in.
(24.1 x 14 x 12.1 cm)
M1991.80

Plate
Probably Frankfurt, Germany
Late 17th or early 18th century
Tin-glazed earthenware
1 3/8 x 11 3/4 x 11 3/4 in.
(3.5 x 29.8 x 29.8 cm)
M1997.231

Lobed Dish
Probably Frankfurt, Germany
Late 17th or early 18th century
Tin-glazed earthenware
2 1/2 x 13 1/2 x 13 1/2 in.
(6.4 x 34.3 x 34.3 cm)
M1997.227

Lobed Dish
Probably Hanau, Germany
Late 17th or early 18th century
Tin-glazed earthenware
2 x 10 1/2 x 10 1/2 in.
(5.1 x 26.7 x 26.7 cm)
M1997.229

Plate
Probably Frankfurt, Germany
Late 17th or early 18th century
Tin-glazed earthenware
2 1/2 x 15 1/2 x 15 1/2 in.
(6.4 x 39.4 x 39.4 cm)
M1997.230

Coffret
Germany
Probably 19th century
Etched and gilded steel
4 3/4 x 7 x 3 7/8 in.
(12.1 x 17.8 x 9.8 cm)
M1984.144

Mantel Clock
Swiss movement, French dial, and
German casework
Late 18th century
Gilded bronze or brass, steel, enameled
copper, and glass
28 x 14 x 9 in.
(71.1 x 35.6 x 22.9 cm)
M1996.500

Platter with the Triumph of Neptune
Hanau, Germany
19th century
Silver with parcel-gilt silver
1 1/2 x 17 1/2 x 14 7/8 in.
(3.8 x 44.5 x 37.8 cm)
M1982.2

Stained Glass Panel
Switzerland
Probably 19th century
Stained glass
16 x 12 in.
(40.6 x 30.5 cm)
M1991.103

Stained Glass Panel with Armorial
Germany
Probably 19th century
Stained glass
15 1/2 x 12 in.
(39.4 x 30.5 cm)
M1991.81

Armillary Sphere Supported by Hercules
Germany
Probably late 19th century
Silver
6 3/4 x 3 x 3 in.
(17.1 x 7.6 x 7.6 cm)
M1991.91

Reliquary
France
Probably late 19th century
Gilt bronze, enamel, glass, oil on copper,
fabric, and fur
13 3/4 x 7 x 5 3/4 in.
(34.9 x 17.8 x 14.6 cm)
M1980.177

Plate
Urbino, Italy
ca. 1875-1900
Tin-glazed earthenware with polychromed
decoration
1 1/8 x 13 x 13 in.
(2.9 x 33 x 33 cm)
M1995.669

III. FURNITURE

Cabinet
Brussels
ca. 1500
Polychromed oak
58 x 54 x 22 in.
(147.3 x 137.2 x 55.9 cm)
M1991.68

Credenza
Nuremberg
ca. 1620
Walnut, elm, Hungarian ash, marquetry
inlay, and iron and brass lockplates
43 x 69 x 23 3/4 in.
(109.2 x 175.3 x 60.3 cm)
M1991.97

Schrank
Hamburg, Germany
ca. 1680-1700
Oak and walnut
97 1/2 x 102 x 37 1/2 in.
(109.2 x 259.1 x 95.3 cm)
M1967.132

Jacobean-Style Sideboard
England
ca. 1850
Oak
45 3/4 x 52 x 16 1/2 in.
(116.2 x 132.1 x 41.9 cm)
M1991.65

Refectory Table
France
Late 19th century
Walnut
35 x 60 x 33 in.
(88.9 x 152.4 x 83.8 cm)
M1991.75

GLOSSARY OF TERMS

Altarpiece: The painted, carved, or decorated artwork situated upon and behind an altar. When viewed at a distance, altarpieces sometimes appear to be joined to the altar with elaborate architecture enframements that include pinnacles and gables. Their development started after the tenth century when the clergy moved to the front of the altar during the celebration of the liturgy.

Anchor-recoil: A simple and efficient form of escapement most commonly found in clocks regulated by a pendulum and made after 1671. The name is derived from the anchor-shaped pallets. See Escapement.

Arbor: The shaft or axle upon which watch or clock wheels, pinions, and escapement pallets are mounted.

Armillary Sphere: A model of the celestial sphere composed of fixed rings that represent the great circles of the tropics, meridian, and ecliptic.

Astrolabe: A scientific instrument used to determine the coordinates and movements of celestial bodies in relation to the earth, thereby permitting the calculation of time and latitude. Commonly used by navigators, astronomers, and surveyors until the mid-eighteenth century. Astrolabe dials were sometimes fitted to clocks.

Automaton (pl. Automata): A mechanism, often in human or animal form, preprogrammed to perform certain functions, seemingly of its own accord.

Back Cock: A bracket used to support the back pivot of the pallet arbor in a clock or watch.

Balance Wheel: An oscillating wheel which serves to regulate the timekeeping of a watch or clock. See Escapement.

Barrel: See Mainspring Barrel.

Bracket Clock: A spring-driven clock designed to sit upon a wall-mounted bracket. The earliest bracket clocks were often set in cases of ebonized fruitwood or ebony veneered oak, with the design of the bracket complementing the profile of the clock's case.

Bristle Regulator: The forerunner of the hairspring. A hog's bristle was used to interrupt any excessive oscillations of an escapement's balance wheel in an attempt to regulate the period of oscillation. See Escapement.

Cabochon: A term used to describe precious stones that are cut and polished with a domed shape and flat base. These unfaceted stones were often used in the decoration of medieval metalwork.

Candelabrum (pl. Candelabra): A branched candlestick or a decorative motif resembling one.

Caparison: An ornamental covering for a large animal, such as a horse or camel.

Cartouche: An ornamental, scroll-like form or tablet with curled edges that often contains an inscription, monogram, or coat of arms.

Cassone (pl. Cassoni): An Italian term for a large, wooden storage chest that was often elaborately painted, carved, or inlaid with a type of marquetry called intarsia. *Cassoni* date from the fifteenth

and sixteenth centuries, and were sometimes made as part of a woman's dowry.

Casting: A process for forming three-dimensional objects or portions of objects by pouring molten metal into a mold.

Cavetto (pl. Cavetti): An Italian term for the recessed central portion of a platter or similar object.

Champlevé: A French term for the enamel technique in which opaque enamel is poured into recessed areas on a metal sheet, and then fired to create an enamel surface. The fired enamel is polished to the same level as the surrounding metal.

Chaplet: A pin or rod used in the hollow casting of bronze that locates the core and prevents it from touching the sides of the mold.

Chapter Ring: The ring of hour numerals on a clock dial.

Chasing: The process of modeling or decorating a metal surface with a hammer and sharp tool, which is also a finishing stage in casting and repoussé work.

Chinoiserie: Western imitations or evocations of Chinese art, generally applied as decoration and rendered in accordance with European taste, and with little concern for accuracy. Such figures and motifs were especially popular in Europe during the seventeenth and eighteenth centuries.

Ciborium: (a) A canopy of wood or stone that rests on four columns, especially one covering an altar. Also

known as a baldachin. (b) A covered chalice or cup designed to hold the consecrated wafers used in the celebration of the Eucharist.

Christo Morto: An Italian term for the dead figure of the Crucified Christ.

Christo Vivo: An Italian term for the suffering figure of the Crucified Christ.

Cloisonné: A French term for the enamel technique in which opaque enamel is poured into compartments formed by metal bands on the surface of an object. The metal dividers remain exposed for distinct sections of color.

Coffret: A French term meaning chest or strongbox used to store money, valuables, or cherished trinkets and baubles.

Contrapposto: An Italian term used to describe the position of the human body when one leg bears the weight while the other is relaxed. Contrapposto in a figure's stance suggests the potential for movement.

Corpus (pl. Corpora): A Latin word for the body of Christ.

Count Wheel: A notched wheel or ring in the striking train of a clock that governs the number of times the bell is struck.

Credenza: An Italian word from medieval Latin meaning a buffet or side board.

Cristallo: A type of soda glass invented in Venice in the fifteenth century. Originally a pale yellow, soda glass was made colorless by the addition of manganese as a decolorizing agent. The resulting clear glass was named *cristallo* for its resemblance to rock-crystal. This type of glass is extremely thin and fragile.

Crocket: A decorative molding found in Gothic architecture, usually on pinnacles and finials.

Crucifix: As derived from the Latin word *crucifixus*, meaning cross-shaped, a crucifix is a painted, sculpted, or other representation of the cross mounted with the figure of the Crucified Christ.

Declination: The celestial equivalent of terrestrial latitude.

Dinanderie: A type of metalwork named after the town of Dinant in present-day Belgium which was a major metalworking center until its destruction in 1466.

Dominical Letter: The letters A through G were used to denote the Sundays of a calendar year. By assigning to the first seven days of January the corresponding letters of the alphabet, the Dominical Letter for that year was determined as being the letter assigned to the Sunday. It was used to calculate the date of Easter.

Dragon Hand: A hand in the form of a dragon found on the astrolabe dial of a clock. It was used to determine the probability of the occurrence of a lunar eclipse by indicating the moon's nodes, or those points where the moon's path crosses that of the sun (the ecliptic). The dragon's head indicates an ascending node, while the tail marks a descending node. The dragon's shape reflects an ancient belief that eclipses were caused by a dragon swallowing the sun or moon.

Dromedary: A domesticated camel from North Africa or Western Asia that has only one hump.

Ebony: A heavy, dark wood that was introduced to Europe in the sixteenth century from Africa. It occurs in a variety of shades, ranging from jet-black to a brownish-yellow, and is usually brittle and difficult to work.

Ebonized Wood: Any light-colored wood that has been stained black to imitate ebony.

Enamel: A glasslike compound of silica, potash, or soda, lead, and borax with metallic oxides added as colorants, fused to a metal, glass, or ceramic base by firing. Enamel techniques include *cloisonné, champlevé,* and painting. The widespread use of enamelwork encouraged alliances with goldsmiths, glassmakers, and other artisans.

Enghalskruge: A German name for a narrow-necked jug.

Engraving: A process for producing two-dimensional decoration on metal or glass by cutting the design into the surface with a burin or other sharp instrument. See Etching.

Epact: The age, in days, of the calendar moon at the beginning of a new year. The number is used to calculate the date of Easter for that year.

Escapement: A mechanism that slows down the release of power from a clock's driving force so that it may be employed in moving those parts of a clock movement that indicate time.

Escape Wheel: The final wheel of a wheel train which interacts with an escapement's pallets in order to reduce the speed at which the train runs. See Escapement.

Escutcheon: (a) A badge or shield displaying a coat of arms. (b) The metal plate surrounding the keyhole of a small casket or larger piece of furniture.

Etching: A process that uses acid to bite a design into a metal or glass surface. The resulting pattern of finely incised lines resembles engraving. See Engraving.

Ewer: A type of jug, usually with an ovoid body, looped handle, and pouring spout. It is sometimes accompanied by a matching basin for use or display.

Façon de Venise: A French term meaning "in the style of Venice." The term was coined in the sixteenth century to describe glasswares made

throughout Europe in imitation of Venetian glass.

Fly: An air brake at the end of a striking train used to govern the speed at which the train runs.

Fusee: A cone-shaped, spirally grooved pulley used in a spring-driven movement to give a constant power to the wheel train by progressively increasing mechanical advantage as the mainspring unwinds and loses power. When a clock is wound, a chain or gut line connected to the mainspring barrel is pulled onto the spiral groove of the fusee, from the largest diameter to the smallest. As the clock runs, the line is slowly pulled back onto the barrel by the unwinding mainspring.

Gadrooning: Convex curves or flutes often found in metalwork, glass, and other decorative arts as a mode of ornamentation.

Gesso: A mixture of finely ground plaster and glue used to prepare the surface of a wooden panel, canvas, or sculpture for painting.

Gilding: The technique of using gold leaf or finely ground gold mixed with mercury to decorate metal, glass, wood, or other surfaces. Certain techniques allow the gold to be fired in a kiln for secure bonding.

Grisaille: A French term used to describe monochromatic painting in shades of gray, especially popular in enamel painting.

Grotesque: A fanciful type of decoration composed of small, loosely connected motifs that often include bizarre human figures, animals, and ornamental swags. It derives from ancient Roman painted and low-relief decoration, which came to light during the Renaissance. These decorative forms were first used in Italy but spread quickly throughout Northern Europe by way of engravings.

Guilds: Legal organizations of craftspeople and artisans that flourished in the later Middle Ages and the Renaissance. They established standards for training and production that were often quite rigorous. See Masterpiece.

Guilloche: A continuous scroll pattern. It was originally used as a frieze enhancement in classical architecture, and it was revived during the Renaissance from the mid-sixteenth century onward.

Hairspring: A usually spiral spring attached to an escapement's balance wheel to increase its timekeeping accuracy. See Escapement.

Hammer Tail: A small lever attached to the end of a bell hammer. Its movement by means of pegs or pins on one of the wheels of the striking train causes the bell to be struck.

Herm (or Term): A three-quarter-length human figure that surmounts a tapering pedestal. It was first used in classical architecture and was revived during the Renaissance and Baroque eras.

Hog Bristle: See Bristle Regulator.

Horology: A term that refers to both the science of time and its measurement as well as the art of designing and making timepieces.

Inlay: A wood or metalworking technique whereby one material is inset or embedded into another to create a polychrome or illusionistic effect. See Marquetry.

Intarsia: A nineteenth-century term used to describe a form of Italian marquetry that applies geometric perspective or pictorial ornamentation to inlaid designs, often found in *cassoni* and cabinetwork.

Ivory: Usually defined as the tusk of an elephant, though the term may be expanded to include any similarly fine-grained, white or cream-colored tusk of another animal, such as a rhinoceros or walrus. Ivory was considered a rare and exotic material during the Middle Ages and the Renaissance and was favored for carved devotional images and costly domestic artifacts.

Jacquemart: A French word used to describe the model of a human figure that strikes or appears to strike time on a bell. Sometimes contracted to "jack."

Krug: A German term for a drinking jug.

Lattimo: An Italian word for "milk" that was used to describe a type of opaque white glassware or glasswares infused with this "milky" white glass in the form of filigree canes or trailed threads.

Leading-off Rod: A linkage between the movement and the hands of a timepiece, most often found in tower clocks.

Limoges: City in west central France that became an important center for the production of enamelwork and porcelain. From the twelfth century until the fourteenth century, Limoges was the leading center of ecclesiastical enamelwork in Europe. This was supplanted in the late fifteenth and sixteenth centuries by the production of painted enamels and secular enamel-work, and still later by porcelain. The pieces produced there are so stylistically distinct that they are usually referred to as Limoges work.

Mainspring: The source of motive power in a spring-driven clock.

Mainspring Barrel: A closed drum containing a clock's mainspring.

Mantel Clock: A type of clock typically produced in France, Holland, and the United States that is designed to sit on a broad mantelpiece. The earliest examples in France were known

as *"religieuses"* and were architectural in form.

Marquetry: The technique of applying decorative patterns to a wooden surface using veneers of differently colored woods and other materials such as ivory or mother-of-pearl. It was first practiced in Italy during the Renaissance, but spread quickly thereafter throughout Europe. See Inlay.

Masterpiece: A masterpiece was a work made to certain specifications and submitted as an examination piece for admission into a trade guild. A successful submission entitled the maker to the designation of "master." See Guilds.

Monstrance: An elaborate liturgical receptacle, usually made of gold or silver and often architectural in form, with a glass or rock-crystal container at its center for the display of the consecrated host.

Motion Work: The train of wheels in a clock that connects the hands to the clock movement and ensures that each hand moves in correct relationship to the other hands.

Movement: The mechanisms of a clock or watch, usually contained within a case.

Nef Ewer: A type of ewer made in the form of a nef or rigged sailing ship, often embellished with figural details and latticework.

Ogee: An architectural term used to describe the double reverse curve assuming an elongated S-shape used in the arched openings and moldings of Late Gothic architecture.

Pallets: Those planes in an escapement that interact with the teeth of the escape wheel in order to reduce the wheel's rate of rotation. See Escapement.

Pietra Dura: An Italian term meaning hard or semiprecious stone used to describe an inlay technique from the sixteenth century that uses a variety of colored stones. These stone mosaics were often used for the decoration of cabinet panels and in table-tops.

Pietra Paesina: An Italian term (literally "landscape stone") for an Albarese limestone, which, after being polished, reveals a natural pattern of veining that resembles the outlines of a rocky mountainous landscape.

Pinion: A wheel having sixteen or fewer teeth. The teeth of a pinion are called "leaves."

Planetary Aspects: The angular relationship between the zodiacal positions of any two planetary celestial bodies, usually depicted as a line diagram. This relationship was used for determining astrological data.

Plates: Many of the wheels and mechanical linkages of a clock's movement are pivoted between the plates. Together with pillars, the plates form the frame of a clock.

Pokal: A German type of covered goblet or cup on a high stem. *Pokals* were vessels of distinction, suitable for ceremonial or presentation purposes. Goldsmiths executed them as masterpiece requirements for guild membership. See Masterpiece.

Polychrome: Literally, decorated with many colors. The term is generally used to describe the painted surface of wood or stone statuary, glass, or metalwork.

Polyptych: A term used to describe an altarpiece with more than three sections that are usually hinged together. See Triptych.

Prunt: A term for a blob of glass that is applied to the exterior of a glass vessel for ornamental purposes. The prunt is often worked with tools to create textured, decorative motifs.

Putto (pl. Putti): An Italian word for the figure of a male baby, often winged, that was a popular motif in Renaissance and Baroque art.

Relic: The physical remains of martyrs, saints, or an object associated with their life that is often housed in an elaborate reliquary for veneration. The preservation of relics has been an integral part of Christianity since late antiquity.

Reliquary: A container for the preservation and display of a relic. See Relic.

Repoussé: A French term for a metal-working technique involving the hammering out from the back side of a metal sheet or plate to create a rich pictorial relief. The result is finished by chasing from the front.

Retable: An architectural screen or ledge above and behind an altar for the display of artworks.

Rete: A movable pierced plate on an astrolabe or an astrolabe clock dial. The rete is engraved with the zodiac ring and a star map.

Right Ascension: The celestial equivalent of terrestrial longitude.

Rinceau (pl. Rinceaux): A French term for decorative foliage, primarily scrolls, that are painted, molded, or carved, and were popular with European ornament designers.

Rock-Crystal: A clear, colorless variety of quartz that can be cut and highly polished. The carving of rock-crystal became widespread in Europe in the sixteenth and seventeenth centuries.

Scagliola: An Italian term for an imitation marble created from a mixture of marble chips, pulverized selenite, plaster of Paris, and glue that is heated and then highly polished. Known in antiquity, this material was revived in the sixteenth century for its illusionistic and artistic possibilities.

Schauplatte: A German term for an oval-shaped display platter commonly found in Germany.

Schrank: A German term for a large wooden wardrobe with two paneled doors, typically used for the storage of clothing, linens, and household items.

Sfumato: An Italian term, derived from the word "smoke," for the smudging or softening of sharp outlines in painting by gradually fusing one shade into another. Its most famous exponent was Leonardo da Vinci.

Stackfreed: A device used to equalize the power of an unwinding mainspring by means of a gradually lessening opposing force. A roller at the end of a blade spring presses against the edge of a cam. The profile of the cam ensures that as the power from the unwinding mainspring decreases, frictional resistance is also decreased by the same amount. The use of a stackfreed enables an indicator to be fitted, showing when the mainspring needs to be wound.

Stippling: A method of drawing, engraving, or painting using incised dots or short strokes of varying density. In stipple engraving, a roulette or matting wheel is used to create areas of tonality or texture on a leather, copper, or gold surface.

Tabernacle: Initially, the portable shelter that the Israelites used to carry the Ark of the Covenant through the desert. Later this word was also used to describe the richly decorated niche or encasement, often behind the altar, where the consecrated host and wine were stored after the celebration of the Eucharist. Tabernacles may also have been used to store relics or small holy images.

Table Clock: A spring-driven clock designed to be placed upon a table and often having dials on two or more sides. They originated during the mid-sixteenth century in The Low Countries, France, and Germany. Some of these clocks could give astronomical and calendrical information. Tabernacle clocks–a variety of table clock–are upright in form and have their dial on the side.

Tankard: A tall, straight-sided or barrel-shaped drinking vessel with a single handle and often a hinged cover. These were usually made of silver or pewter, though they also appear in pottery, ivory, and glass. Tankards have been used widely in Northern Europe since the Middle Ages for beer and other beverages.

Tazza (pl. Tazze): An Italian term for a wide, shallow bowl with a low, stemmed foot. *Tazze* were commonly used to serve fruits, sweetmeats, or other delicacies. They were made from various materials, including silver, glass, precious stones, and painted enamels.

Tempera: A painting technique in which ground pigments are combined with egg yolk as a binder. Tempera was widely used for panel painting before the sixteenth century.

Terra Cotta: An Italian term meaning "baked earth" that is applied to a hard earthenware used for pottery, sculpture, or as a building material. The word may also designate the brownish-red color of a material.

Tic-tac: A form of anchor-recoil escapement where the pallets span between one and three teeth of the escape wheel. See Escapement.

Train: The collective term for a set of interconnected wheels and pinions in a clock movement.

Train Bars: Many of a clock movement's wheels and mechanical linkages are pivoted between the train bars, with each train of wheels having its own pair of bars. Together with the pillars, the train bars form the frame of a clock.

Triptych: A term used to describe an altarpiece with three sections or panels that are usually hinged together.

Trompe l'oeil: A French term used to describe a style of painting or marquetry that aims to create the illusion of three-dimensional reality on a two-dimensional surface.

Tympanum (pl. Tympana): (a) An engraved plate used in conjunction with the rete of an astrolabe or clock to give the celestial coordinates and information about the stars. The plate was usually engraved on both sides, with each side laid out for a specific latitude. Some clocks were provided with more than one tympanum so that the astrolabe dial could be used in all of the temperate northern latitudes. (b) This term refers to the carved stone or masonry located between the lintel of a doorway and the enframing arch above it. Tympana were exploited as decorative spaces for sculpture, painting, and mosaics.

Verge Escapement: One of the oldest clock escapements. Though robust and easy to make, the verge escapement is sensitive to variations in its motive power and is not capable of precise regulation. Clocks and watches with this escapement are poor timekeepers, and the escapement was often removed and replaced by one more accurate and up-to-date.

Virtues: The three Theological Virtues–Faith, Hope, and Charity–and the four Cardinal Virtues–Prudence, Justice, Fortitude, and Temperance–are allegorically represented in art by human figures. These abstract peronalities or personifications derive from such medieval literary sources as the *Psychomachia* of Prudentius and the writings of St. Augustine. Opposing the seven Virtues are the seven Vices: Pride, Covetousness, Lust, Anger, Gluttony, Envy, and Sloth.

Zodiac: A celestial band divided into twelve astrological signs (known as the Signs of the Zodiac) centered on the ecliptic, the apparent annual path of the sun around the earth.

BIBLIOGRAPHY

Allentown 1980
Allentown Art Museum. *Beyond Nobility: Art for the Private Citizen in the Early Renaissance.* Text by Ellen Callmann. Allentown, Pennsylvania, 1980.

Alberti 1966
Alberti, Leon Battista. *On Painting.* Translated by J. Spencer. New Haven and London, 1966.

Amsterdam 1952
Rijksmuseum. *Catalogus van goud en zilverwerken: Benevens zilveren, loden en bronzen plaquetten.* Text by C. J. Hudig and Th. M. Duyvené de Witklinkhamer. Amsterdam, 1952.

Amsterdam 1986
Rijksmuseum. *Koper & Brons.* Text by Onno ter Kuile. Amsterdam, 1986.

Amsterdam 1996
Rijksmuseum. *Duits Steengoed/German Stoneware.* Text by Ekkart Klinge. Amsterdam, 1996.

Andersson 1964-80
Andersson, Aron. *Medieval Wooden Sculpture in Sweden.* 3 vols. Stockholm, 1964-80.

Andrews 1964
Andrews, Keith. *The Nazarenes: A Brotherhood of German Painters in Rome.* Oxford, 1964.

Antwerp 1983
Koninklijke Bibliotheek. *De meest opmerkelijke boekbanden uit eigen bezit: catalogus van de tentoonstelling gehouden in de expositiezalen van de Koninklijke Bibliotheek.* Text by Jan Storm van Leeuwen. 's-Gravenhage, The Netherlands, 1983.

Antwerp 1993
Museum voor Religieuze Kunst. *Antwerp*

Altarpieces 15th-16th Centuries. 2 vols. Edited by Hans Nieuwdorp. Antwerp, 1993.

Appelbaum 1964
Appelbaum, Stanley, ed. *The Triumph of Maximillian I: 137 Woodcuts by Hans Burgkmair and Others.* New York, 1964.

Arnold 1964
Arnold, Christian. *Konrad Eberhard 1768-1859, Bildhauer und Maler: Leben und Werk eines Allgäuer Kunstlergeschlects.* Augsburg, 1964.

Arnoldi 1974
Arnoldi, Francesco Negri. "Origine et diffusione del Crocefisso barocco con l'imagine del Cristo vivente." *Storia dell' Arte* 20 (1974), pp. 57-80.

Atkins 1881
Atkins, Samuel E. and Overall, William Henry. *Summer Count of the Worshipful Company of Clock Makers of the City of London.* London, 1881.

Atkins 1931
Atkins, Charles Edward. *The Company of Clock Makers Register of Apprentices.* London, 1931.

Augsburg 1968
Rathaus and Holbein-Haus. *Augsburger Barock: Ausstellung unter dem Patronat von International Councils of Museums (ICOM).* Text by Christina Thon. Augsburg, 1968.

Augsburg 1980
Rathaus and Zeughaus. *Welt im Umbruch: Augsburg zwischen Renaissance und Barock: Ausstellung der Stadt Augsburg in Zusammenarbeit mit der Evangelisch-Lutherischen Landeskirche in Bayern anlasslich des 450. Jubilaums der Confessio Augustana unter dem Patronat des International Councils of Museums*

(ICOM). 3 vols. Text by Bruno Bushart et al. Augsburg, 1980.

Avery 1987
Avery, Charles. *Giambologna: The Complete Sculpture.* New York, 1987.

Avery 1995
Avery, Charles. "Renaissance and Baroque Bronzes from the Alexis Gregory Collection." *Harvard University Art Museums Bulletin* 4 (Fall 1995), pp. 1-96.

Baillie 1969
Baillie, Granville H. *Watchmakers and Clockmakers of the World.* Second edition. London, 1969.

Baldinucci 1681
Baldinucci, F. *Vocabulario Toscano dell'Arte del Disegno.* Florence, 1681.

Baltimore 1967
The Walters Art Gallery: Catalogue of the Painted Enamels of the Renaissance. Text by Philippe Verdier. Baltimore, 1967.

Baltimore 1985
The Walters Art Gallery. *Masterpieces of Ivory from the Walters Art Gallery.* Text by Richard H. Randall, Jr. Baltimore, 1985.

Bange 1926
Bange, Ernst F. *Peter Flötner.* Leipzig, 1926.

Bange 1949
Bange, Ernst F. *Die deutschen Bronzestatuetten des 16. Jahrhunderts.* Berlin, 1949.

Barcelona and Madrid 1992
Reales Atarazanas de Barcelona. *Tapices y Armaduras del Renacimiento: Joyas de las colecciones reales.* Text by J. H. Ferrero and C. Herrera. Barcelona and Madrid, 1992.

Baron 1980
Baron, Françoise. "Une Vierge lorraine du XIV siècle." *La Revue du Louvre*, 1980, pp. 174-75.

Bartsch 1978-
Strauss, Walter L., ed. *The Illustrated Bartsch*. New York, 1978.

Bassermann-Jordan 1964
Bassermann-Jordan, Ernst von. *The Book of Old Clocks and Watches*. New York, 1964.

Baxandall 1974
Baxandall, Michael. *South German Sculpture 1480-1530*. London, 1974.

Baxandall 1988
Baxandall, Michael. *Painting and Experience in Fifteenth-Century Italy*. Oxford, 1988.

Bayer 1959
Bayer, Adolf. *Die Ansbacher Fayence-Fabriken*. Brunswick, Germany, 1959.

Beard 1935
Beard, Charles R. "Heraldry: Arms on a Fifteenth-Century Box." *Connoisseur* 96 (October 1935), pp. 238-39.

Becker 1961
Becker, Carl. *Jobst Amman, Zeicher und Formschneider, Kupferatzer und Stecher*. Nieuwkoop, The Netherlands, 1961.

Beeson 1977
Beeson, C. F. C. *English Church Clocks 1280-1850*. Ashford, England, 1977.

Bell 1960
Bell, R. C. *Board and Table Games from Many Civilizations*. New York, 1960.

Bendel 1940
Bendel, Max. *Tobias Stimmer*. Zurich, 1940.

Bergamo 1984
Galleria Lorenzelli. *Tra/E. Teche, pissidi, cofani e forzieri dall'Alto Medioevo al Barocco*. Text by Pietro Lorenzelli and Alberto Veca. Bergamo, Italy, 1984.

Berlin 1923-30
Staatliche Museen. *Die Bildwerke in Bronze und in anderen Metallen, Arbeiten in Perlmutter und Wachs, geschnittene Steine*. Part 2 of *Die Bildwerke des deutschen Museums*. Text by Ernst F. Bange. Edited by Theodore Demmler. Berlin, 1923-30.

Berlin 1963
Kunstgewerbemuseum, Schloss Charlottenburg. *Kunstgewerbe Museum. Ausgewählte Werke*. Introduction by Arno Schönberger. Berlin, 1963.

Berlin 1968
Staatliche Museen. *Kataloges de Kunstgewerbemuseums*. Vol. 3, *Bronzen und Plaketten von Ausgehenden 15. Jahrhundert bis zur Mitte des 17. Jahrhunderts*. Text by Klaus Pechstein. Berlin, 1968.

Berlin 1978
Staatliche Museen. *Die italienischen Bildwerke des 17. und 18. Jahrhunderts*. Text by Ursula Schlegel. Berlin, 1978.

Berlin 1981
Die Brandenburgisch-Preussische Kunstkammer. *Schatzkammer der Residenz Munich*. Berlin, 1981.

Bliss 1990
Bliss, Joseph R. "Two Limoges Enamels from Mentmore Towers." *Arts in Virginia* 29 (1990), pp. 28-33.

Bober 1963
Bober, Phyllis. "Census of Antique Works of Art Known to Renaissance Artists." *The Renaissance and Mannerism, Acts of the 20th International Congress of the History of Art* 2 (1963), pp. 82-89.

Bobinger 1969
Bobinger, Maximillian. *Kunstuhrmacher in Alt-Augsburg*. Vol. 2. Augsburg, 1969.

Boccador 1974
Boccador, Jacqueline. *Le Statuaire médiévale en France de 1400 à 1530*. Zug, Switzerland, 1974.

Boccador and Bresset 1972
Boccador-Liéveaux, Jacqueline and Bresset, Edouard. *Statuaire médiévale de collection*. 2 vols. Zug, Switzerland, 1972.

Bode 1921
Bode, Wilhelm von. *Italian Renaissance Furniture*. New York, 1921.

Böhler 1995
Böhler, Julius. *Skulpturen altenmeister*. Munich, 1995.

Bordeaux 1973
Musée des Arts Décoratifs. *La Clef et la serrure*. Text by Jacqueline Du Pasquier. Bordeaux, 1973.

Borst 1983
Borst, Otto. *Alltagsleben im Mittelalter/Everyday Life in the Middle Ages*. Frankfurt, 1983.

Boston 1991
Museum of Fine Arts. *Catalogue of Medieval Objects: Metalwork*. Text by Nancy Netzer with technical essay by Richard Newman. Boston, 1991.

Bouillet 1897
Bouillet, Auguste, ed. *Liber miraculorum sancte Fidis*. Collection de textes pour servir à l'étude et à l'enseignement de l'histoire, fasc. 21. Paris, 1897.

Breck 1931
Breck, Joseph. *The Cloisters: A Brief Guide*. The Metropolitan Museum of Art, New York, 1931.

Brett 1986
Brett, Vanessa. *The Sotheby's Directory of Silver, 1600-1940*. London, 1986.

Brinckmann 1923-25
Brinckmann, Albert E. *Barock-Bozzetti*. 4 vols. Frankfurt, 1923-25.

Bruning 1922
Bruning, Adolf. *Die Schmiedekunst bis zum Ausgang des 18. Jahrhunderts*. Leipzig, 1922.

Brunswick 1931
Herzog Anton Ulrich-Museum. *Die Braunschweiger Elfenbeinsammlung des Herzog Anton Ulrich-Museums in Braunschweig*. Text by Christian Scherer. Leipzig, 1931.

Brussels 1977
Musée d'Art Ancien. *La Sculpture au siècle de Ruben*. Text by E. Dhanen et al. Brussels, 1977.

Bruton 1981
Bruton, Eric. *The Wetherfield Collection of Clocks*. London, 1981.

Bruton 1989
Bruton, Eric. *History of Clocks and Watches*. New York, 1989.

Budde 1986
Budde, Rainer. *Köln und seine Maler, 1300-1500*. Cologne, 1986.

Burack 1984
Burack, Benjamin. *Ivory and Its Uses*. Tokyo, 1984.

Butsch 1969
Butsch, Albert Fidelis. *Handbook of Renaissance Ornament: 1290 Copyright-free Designs for Artists and Craftsmen*. Introduction by Alfred Werner. New York, 1969.

Butts 1985
Butts, Barbara Rosalyn. "*Dürerschüler Hans Süss von Kulmbach.*" Ph.D. dissertation, Harvard University, Cambridge, Massachusetts, 1985.

Caiger-Smith 1973
Caiger-Smith, Alan. *Tin-Glaze Pottery in Europe and the Islamic World*. London, 1973.

Campan 1900
Campan, Jeanne-Louise. *Memoirs of the Court of Marie Antoinette, Queen of France*. 2 vols. Boston, 1900.

Cartari 1647
Cartari, V. *Imagini delli dei gl'antichi*. Venice, 1647.

Ceram 1983
Ceram, Maurizio. *Il mobile italiano dal XVI al XIX secolo*. Milan, 1983.

Chambon 1953
Chambon, Raymond. "Un Verre du XVIe siècle en forme de navire." *Silicates Industriels* 18 (December 1953), pp. 221-23.

Chambon 1955
Chambon, Raymond. *L'Histoire de la verrerie en Belgique du IIme siècle à nos jours*. Brussels, 1955.

Chastel 1972
Chastel, Andre, ed. *Actes du Colloque International sur l'Art de Fontainebleau*. Paris, 1972.

Chicago 1991
The Art Institute of Chicago. *European Decorative Arts in The Art Institute of Chicago*. Text by Ian Wardropper and Lynn Springer Roberts. Chicago, 1991.

Cleveland 1975
Cleveland Museum of Art. *Renaissance Bronzes from Ohio Collections*. Text by William D. Wixom. Cleveland, 1975.

Cochrane 1973
Cochrane, E. *Florence in the Forgotten Centuries*. Chicago and London, 1973.

Cologne 1976
Kunstgewerbemuseum der Stadt Köln. *Steinzeug: Katalogus des Kunstgewerbemuseums Köln*. Vol. 4. Edited by Gisela Reineking-von Bock. Cologne, 1976.

Cologne 1986
Wallraf-Richartz-Museum. *Katalog der altkölnischen Malerei im Wallraf-Richartz-Museum*. Catalogue by Frank G. Zehnder. Cologne, 1986.

Coole and Neumann 1972
Coole, P.G. and Neumann, E. *The Orpheus Clocks*. London, 1972.

Coradeschi 1994
Coradeschi, Sergio. *The Little-Brown Guide to Silver*. Boston, 1994.

Corning 1955
The Corning Museum of Glass. *Glass Drinking Vessels from the Collections of Jerome Strauss and the Ruth Bryan Strauss Memorial Foundation*. Corning, New York, 1955.

Corning 1958
The Corning Museum of Glass. *Three Great Centuries of Venetian Glass*. Text by Paul N. Perrot. Corning, New York, 1958.

Corning 1990
The Corning Museum of Glass. *Masterpieces of Glass: A World History from the Corning Museum of Glass*. Text by Robert J. Charleston. Corning, New York, 1990.

Cracow 1972
Museum Narodowne. *Stare Srebra*. Text by Jadwiga Bujaska. Cracow, 1972.

Cros 1996
Cros, Philippe. *Bronzes de la Renaissance italienne*. Paris, 1996.

Dacos 1969
Dacos, Nicole. *La Découverte de la Domus Aurea et la formation des grotesques à la Renaissance*. Studies of the Warburg Institute. Vol. 31. London, 1969.

d'Allemagne 1928
d'Allemagne, Henri René. *Les Accessoires du costume et du mobilier depuis le treizième jusqu'au milieu du dix-neuvième siècle*. 3 vols. Paris, 1928.

Dauterman 1961-62
Dauterman, Carl Christian. "Snakes, Snails, and Creatures with Tails." *The Metropolitan Museum of Art Bulletin* 20 (1961-62), pp. 272-85.

de Borchgrave d'Altena 1926
de Borchgrave d'Altena, J. *Notes et documents pour servir à l'histoire de l'art et de l'iconographie en Belgique*. Vol. 1, *Sculptures conservées du pays mosan*. Veviers, Belgium, 1926.

de Borchgrave d'Altena 1945
de Borchgrave d'Altena, J. *Madones anciennes conservées en Belgique, 1025-1425*. Brussels, 1945.

de Borchgrave d'Altena 1946
de Borchgrave d'Altena, J. *La Passion de Christ dans la sculpture en Belgique du XI au XVIe siècles*. Brussels and Paris, 1946.

de Borchgrave d'Altena 1948
de Borchgrave d'Altena, J. *Les Retables brabançons, 1450-1550 conservés en Suède*. Brussels, 1948.

de Borchgrave d'Altena 1959
de Borchgrave d'Altena, J. "Statuettes malinoises." *Bulletin van Koninklijke Musea voor Kunst en Geschiedeni* 31 (1959), pp. 1-98.

de Winter 1985
de Winter, Patrick M. *The Sacral Treasures of the Guelphs*. Cleveland, 1985.

de Winter 1988
de Winter, Patrick M. *European Decorative Arts 1400-1600: An Annotated Bibliography*. Boston, 1988.

Delpy 1910
Delpy, E. *Die Legende von du hl. Ursula in der Kölner malerschule*. Cologne, 1910.

Denhaene 1990
Denhaene, Godelieve. *Lambert Lombard, Renaissance et humanisme à Liège*. Antwerp, 1990.

Descheemaeker 1993
Descheemaeker, Bernard. "Sixteenth-century painted enamels from Limoges ... Observations Based on the Work of Pierre Reymond (1512-after 1583)." *The Maastricht Fair Handbook.* Maastricht, The Netherlands, 1993.

Detroit 1997
The Detroit Institute of Arts. *Images in Ivory.* Edited by Peter Barnet. Detroit, 1997.

Devigne 1932
Devigne, Marguerite. *La Sculpture mosane du XII au XVIe siècle. Contribution à l'étude de l'art dans la région de la Meuse Moyenne.* Paris and Brussels, 1932.

Dizionario Biografico 1960-93
Dizionario Biografico degli Italiani. 48 vols. Published by Instituto della Enciclopedia Italiana. Rome, 1960-93.

Donath 1911
Donath, Adolf. *Psychologie des Kunstsammelns.* Berlin, 1911.

du Cerceau 1556
du Cerceau, Jacques Androuet. *Petites Grotesques (1556), Grandes Grotesques (1556), Livres de Grotesques.* Paris, 1556.

Ducret 1962
Ducret, Siegfried. *German Porcelain and Faience.* Translated by Diana Imber. New York, 1962.

Durham 1991
Duke University Museum of Art. *The Brummer Collection of Medieval Art.* Text by Caroline Bruzelius and Jill Meredith. Durham, North Carolina and London, 1991.

Egger 1984
Egger, Gerhart. *Bürgerlicher Schmuck.* Munich, 1984.

Ehresmann 1977
Ehresmann, Donald L. *Applied and Decorative Arts: A Bibliographic Guide to Basic Reference Works, Histories, and Handbooks.* Littleton, Colorado, 1977.

Estella Marcos 1993
Estella Marcos, Margarita M. "Algo más sobre Pompeyo Leoni." *Archivo Español de Arte* 66 (1993), pp. 133-49.

Falke 1908
Falke, Otto von. *Das Rheinische Steinzeug.* 2 vols. Berlin, 1908.

Falke 1925
Falke, Otto von. *Die Kunstsammlung von Pannwitz: Skulpturen und Kunstgewerbe.* 2 vols. Munich, 1925.

Feuchtmayr 1973
Feuchtmayr, Karl and Schadler, Alfred. *Georg Petel.* Berlin, 1973.

Flint 1985
Flint Institute of Arts. *Samuel Yellin in Context.* Text by Richard J. Wattenmaker. Flint, Michigan, 1985.

Florence 1895
Museo Nazionale del Bargello. *Florence. Collection Carrand au Bargello.* Edited by Giorgio Sangiorgi. Rome, 1895.

Florence 1967
Museo Horne. *Il Museo Horne a Firenze.* Text by Filippo Rossi. Milan, 1967.

Florence 1989
Museo Nazionale del Bargello. *Arti del Medio Evo e del Rinascimento. Omaggio ai Carrand 1889-1989.* Text by Giovanna Gaeta Bertalà, Beatrice Paolozzi-Strozzi, et al. Florence, 1989.

Forster 1848
Forster, Henry Rumsey. *The Stowe Catalogue. Priced and Annotated.* London, 1848.

Forsyth 1936
Forsyth, William H. "Medieval Statues of the Virgin in Lorraine Related in Type to the Saint-Dié Virgin." *Metropolitan Museum Studies* 5 (1936), pp. 235-58.

Forsyth 1968
Forsyth, William H. "A Group of Fourteenth-Century Mosan Sculptures." *Metropolitan Museum Journal* 1 (1968), pp. 41-59.

Forsyth 1972
Forsyth, I. H. *The Throne of Wisdom. Wood Sculptures of the Madonna in Romanesque France.* Princeton, New Jersey, 1972.

Frank 1950
Frank, Edgar B. *Old French Ironwork: The Craftsman and His Art.* Cambridge, Massachusetts, 1950.

Frankfurt 1981
Museum fur Kunsthandwerk. *Barockes Tafelsilber: Ausstellung.* Text by Hildegard Hoos. Frankfurt, 1981.

Frankfurt 1987-88
Museum für Kunsthandwerk. *Kerzenleuchter aus acht Jahrhunderten.* Text by Hildegard Hoos. Frankfurt, 1987-88.

Frauberger 1913
Frauberger, Heinrich. *N. R. Fränkel's Uhrensammlung.* Dusseldorf, 1913.

Friedlander 1975
Friedlander, Max J. *Early Netherlandish Painting.* 14 vols, plus supplement. New York, 1975.

Friedman 1946
Friedman, Herbert. *The Symbolic Goldfinch: Its History and Significance in European Devotional Art.* Washington, D.C., 1946.

Gall 1965
Gall, Günter. *Leder im europäischen Kunsthandwerk. Ein Handbuch für Sammler und Liebhaber.* Brunswick, Germany, 1965.

Gall 1967
Gall, Günter. "Leather Objects in the Philadelphia Museum of Art." Translated by Susan G. Detweiler. *Philadelphia Museum of Art Bulletin* 62 (July-September 1967), pp. 260-75.

Gareau 1992
Gareau, Michel. *Charles Lebrun: First Painter to King Louis XIV.* New York, 1992.

Gauthier 1972
Gauthier, Marie-Madeleine. *Emaux du Moyen-Age occidental.* Fribourg, Germany, 1972.

Gauthier 1987
Gauthier, Marie-Madeleine. *Catalogue international de l'œuvre de Limoges.* Vol. 1, *L'Epoque romane.* Paris, 1987.

Gere 1987
Gere, J. A. *Drawings by Raphael and His Circle from British and North American Collections.* New York, 1987.

Gerspach 1904
Gerspach, Edouard. *Musée National de Florence au Bargello. La collection Carrand.* Paris, 1904. Reprinted as "La Collection

Carrand les deux Carrand." *Les Arts* 31 (July 1904), pp. 1-32; "La Collection Carrand au Musée National de Florence." *Les Arts* 32 (August 1904), pp. 1-32.

Gillerman 1989
Gillerman, Dorothy, ed. *Gothic Sculpture in American Collections.* Vol. 1, *The New England Museums.* New York and London, 1989.

Giucci 1840
Giucci, G. *Iconografia Storia degli Ordini.* 3 vols. Rome, 1840.

Godenne 1957-1976
Godenne, Willy. "Préliminaires à l'inventaire général des statuettes d'origine malinoise présumées des XVe et XVIe siècles." *Handelingen van de Koninklijke Kring voor Oudheidkunde, Letteren en Kunst van Mechelen.* Vol. 61 (1957), pp. 47-127; Vol. 62 (1958), pp. 51- 80; Vol. 63 (1959), pp. 30-54; Vol. 64 (1960), pp. 108-129; Vol. 66 (1962), pp. 67-156; Vol. 72 (1968), pp. 43-87; Vol. 73 (1969), pp. 43-87; Vol. 76 (1972), pp. 1-80; Vol. 77 (1973), pp. 87-155; Vol. 78 (1974), pp. 93-104; Vol. 80 (1976), pp. 71-105.

Gramberg 1964
Gramberg, Werner. *Die Düsseldorfer Skizzenbücher des Guglielmo della Porta.* 3 vols. Berlin, 1964.

Gramberg 1981
Gramberg, Werner. "Notizien zu den Kruzifixen des Guglielmo della Porta und zur Entstehungsgeschichte des Hochaltarkreuzes in S. Pietro in Vaticano." *MünchnenJahrbuch fur der bildenden Kunst* 32 (1981), pp. 95-114.

Gruber 1992-94
Gruber, Alain. *L'Art décoratif en Europe.* 2 vols. Paris, 1992-94.

Gruber 1994
Gruber, Alain, ed. *The History of Decorative Arts: The Renaissance and Mannerism in Europe.* New York, 1994.

Gündel 1940
Gündel, Christian. *Die Goldschmiedekunst in Breslau.* Berlin, 1940.

Gunther 1968
Gunther, Robert T. *Early Science in Oxford.* Vol. 5, *Chaucer and Messahalia on the Astrolabe.* London, 1968.

Guye 1971
Guye, Samuel and Michel, Henri. *Time and Space: Measuring Instruments from the 15th to the 19th Century.* London and New York, 1971.

Hackenbroch 1979
Hackenbroch, Yvonne. *Renaissance Jewellery.* London, 1979.

Hackenbroch 1986
Hackenbroch, Yvonne. "Reinhold Vasters, Goldsmith." *Metropolitan Museum Journal* 19-20 (1986), pp. 163-268.

Hackenbroch 1996
Hackenbroch, Yvonne. "Jewellery: 1500-1630." *The Dictionary of Art.* Vol. 17 (1996), pp. 520- 22.

Hartford 1986
Wadsworth Atheneum. *J. Pierpont Morgan, Collector: European Decorative Arts from the Wadsworth Atheneum.* Edited by Linda Horvitz Roth. Hartford, 1986.

Haskins 1993
Haskins, Susan. *Mary Magdalene: Myth and Metaphor.* London, 1993.

Haverkamp Begemann 1975
Haverkamp Begemann, Egbert. *Corpus Rubenianum Ludwig Burchard.* The Achilles Series. London, 1975.

Hayward 1964
Hayward, John Forrest. "The Mannerist Goldsmiths: 3. Antwerp, Part 1." *Connoisseur* 156 (June 1964), pp. 92-96.

Hayward 1976
Hayward, John Forrest. *Virtuoso Goldsmiths and the Triumph of Mannerism, 1540-1620.* London, 1976.

Hedicke 1913
Hedicke, R. *Cornelis Floris und die Florisdekoration.* Berlin, 1913.

Heimann 1975
Heimann, Adelheid. "Die Hochzeit von Adam und Eva im Paradies nebst einigen anderen Hochzeitzbildern." *Wallraf-Richartz-Jahrbuch* 37 (1975), pp. 11-40.

Hejj-Détári 1965
Hejj-Détári, Angéla. *Old Hungarian Jewelry.* Translated by Lili Halápy. Budapest, 1965.

Hejj-Détári 1976
Hejj-Détári, Angéla. *Hungarian Jewelry of the Past.* Budapest, 1976.

Hernmarck 1977
Hernmarck, Carl. *The Art of the European Silversmith, 1430-1830.* 2 vols. London, 1977.

Hetteπ 1960
Hetteπ, Karel. *Old Venetian Glass.* London, 1960.

Höhr-Grenzhausen 1986
Keramikmuseum Westerwald. *Reinhold und August Hanke: Westerwalder Steinzeug Historismus-Jugenstil.* Höhr-Grenzhausen, Germany, 1986.

Holladay 1997
Holladay, Joan A. "Relics, Reliquaries, and Religious Women: Visualizing the Holy Virgins of Cologne." *Studies in Iconography* 18 (1997), pp. 67-118.

Hollstein 1954
Hollstein, F. W. H. *German Engravings, Etchings, and Woodcuts, ca. 1400-1700.* Vol. 1, *Aachen-Altdorfer.* Vol. 2, *Altzenbach-B. Beham.* Amsterdam, 1954.

Homer 1963
Homer, R. F. "Nests of Weights." *The Antique Collector,* February 1963, p. 26.

Houser 1983
Houser, Caroline. *Greek Monumental Sculpture.* New York and London, 1983.

Houston 1966
University of Saint Thomas. *Made of Iron.* Text by Dominique de Menil et al. Houston, 1966.

Höver 1967
Höver, Otto. *Wrought Iron: Encyclopedia of Ironwork.* Translated by Amy C. Weaver. New York, 1967.

Impey and MacGregor 1985
Impey, Oliver and Mac Gregor, Arthur. *The Origins of Museums: The Cabinet of Curiosities in Sixteenth- and Seventeenth-Century Europe.* New York, 1985.

Jacobs 1986
Jacobs, Lynn Frances. *Aspects of Netherlandish Carved Altarpieces, 1380-1530.* Ph.D. dissertation. New York University, New York, 1986.

Jopek 1988
Jopek, Norbert. *Studien zur deutschen Alabasterplastik des 15. Jahrhunderts.* Manuskripte zur Kunstwissenschaft in der Wernerschen Verlagsgesellschaft 21. Worms, Germany, 1988.**Jullian 1954**
Jullian, R. *Le Musée de Lyon.* Paris, 1954.

Katonah 1995
Katonah Museum of Art. *Medieval Monsters: Dragons and Fantastic Creatures.* Text by Janetta Rebold Benton. New York, 1995.

Keutner 1955
Keutner, H. "Il San Matteo nel Duomo di Orvieto: Il modello e l'opera eseguita." *Bolletino dell'Istituto Storica Artistico Orvietano* 2 (1955), p. 17.

King 1978
King, Henry and Millburn, John R. *Geared to the Stars: The Evolution of Plantariums, Orreries and Astronomical Clocks.* Toronto, 1978.

Kisch 1965
Kisch, Bruno. *Scales and Weights: A Historical Outline.* New Haven and London, 1965.

Kjellberg 1979
Kjellberg, Pierre. "Emaux et modèles." *Connaissance des Arts* 329 (July 1979), pp. 54-63.

Klein 1975
Klein, Adalbert. *Deutsche Fayencen.* Brunswick, Germany, 1975.

Koechlin 1924
Koechlin, Raymond. *Les Ivoires gothiques français.* 3 vols. Paris, 1924. Reprint, 1968.

Koetschau 1924
Koetschau, Karl T. *Rheinische Steinzeug.* Munich, 1924.

Kohlhaussen 1928
Kohlhaussen, Heinrich. *Minnekastchen im Mittelalter.* Berlin, 1928.

Kohlhaussen 1968
Kohlhaussen, Heinrich. *Nürnberger Goldschmiedekunst des Mittelalters und der Dürerzeit. 1240 bis 1540.* Berlin, 1968.

Konrad 1928
Konrad, Martin. *Meisterwerke der skulptur in Flandern und Brabant.* Berlin, 1928.

Kreisel 1968
Kreisel, Heinrich. *Die Kunst des deutschen Möbels.* Vol. 1, Von den Anfangen bis zum Hockbarock. Munich, 1968.

Kruft 1996
Kruff, Hanno-Walter. "Della Porta." *The Dictionary of Art.* Vol. 25 (1996), pp. 254-57.

Kuhn 1965
Kuhn, Charles Louis. *German and Netherlandish Sculpture, 1280-1800: The Harvard Collections.* Cambridge, Massachusetts, 1965.

Lane 1984
Lane, Barbara G. *The Altar and the Altarpiece: Sacramental Themes in Early Netherlandish Painting.* New York, 1984.

Lawrence 1969
University of Kansas, Spencer Museum of Art. *The Waning of the Middle Ages: An Exhibition of French and Netherlandish Art from 1350 to 1500 Commemorating the Fiftieth Anniversary of the Publication of the Waning of the Middle Ages by Johan Huizinga.* Text by John L. Schrader. Lawrence, Kansas, 1969.

Lawrence 1988
University of Kansas, Spencer Museum of Art. *The World in Miniature: Engraving by the German Little Masters, 1500-1550.* Edited by Stephen H. Goddard. Lawrence, Kansas, 1988.

Lee 1964
Lee, Ronald A. *The Knibb Family, Clock Makers.* London, 1964.

Leeds-Hurwitz 1993
Leeds-Hurwitz, Wendy. *Semiotics and Communication: Signs, Codes, Cultures.* Hillsdale, New Jersey, 1993.

Legner 1978-80
Legner, Anton. *Die Parler und der Schone stil 1350-1400: Europaische Kunst unter den Luxemburgen.* 5 vols. Cologne, 1978-80.

Liège 1951
A.S.B.L. Le Grand Liège. *Art mosan et arts anciens du pays de Liège.* Liège, Belgium, 1951.

Lightbown 1996
Lightbown, R. W. "Jewellery: Before 1500." *Dictionary of Art.* Vol. 17 (1996), 518-20.

Limoges 1996
Musée de l'Eveche. *Cuivres d'orfèvres: Catalogue des oeuvres médiévales en cuivre non émaillé des collections publiques du Limousin.* Text by Véronique Notin. Limoges, France, 1996.

Lisbon 1978
Museu Nacional de Arte Antiga. *Imagens de Malines.* Lisbon, 1978.

Lockner 1981
Lockner, Hermann P. *Die Merkzeichen der Nürnberger Rotschmiede.* Munich, 1981.

Lomazzo 1584
Lomazzo, G. P. *Trattato dell'arte de la Pittura.* Milan, 1584.

London 1931, 1981
The Wallace Collection. *The Wallace Collection: Sculpture.* Text by James Gow Mann. London, 1931. Supp. 1981.

London 1956
The Wallace Collection. *The Wallace Collection: Furniture.* Text by F. J. B. Watson. London, 1956.

London 1964
Victoria and Albert Museum. *Catalogue of Italian Sculpture in the Victoria and Albert Museum.* 3 vols. Text by John Pope-Hennessy with Ronald Lightbown. London, 1964.

London 1976
The British Museum. *British Museum Guide.* Foreword by John Pope-Hennessy. London, 1976.

London 1977
The National Gallery. *Late Gothic Art from Cologne.* Text by Frank Günter Zehnder and Anton Legner. Translated by Heidi Grieve. London, 1977.

London 1978a
Arts Council of Great Britain, Victoria and Albert Museum. *Giambologna, 1529-1608: Sculptor to the Medici.* Text by Charles Avery, Anthony Radcliffe, et al. London, 1978.

London 1978b
Victoria and Albert Museum. *Ironwork, Part 1, From the Earliest Times to the End of the Medieval Period. Part 2, Continental Ironwork of the Renaissance and Later Periods.* Text by J. Starkie Gardner. Edited with supplementary bibliography

by Marian Campbell. London, 1922-30. Reprint, 1978.

London 1979
The British Museum. *The Golden Age of Venetian Glass.* Text by Hugh Tait. London, 1979.

London 1981
P. & D. Colnaghi and Co. *Objects for a "Wunderkammer."* Edited by Alvar González-Palacios. London, 1981.

London 1985
Victoria and Albert Museum. *An Introduction to Ironwork.* Text by Marian Campbell. London, 1985.

London 1986
The British Museum. *Catalogue of the Waddesdon Bequest in the British Museum.* 3 vols. Vol. 1, *The Jewels;* Vol. 2, *The Silver Plate;* Vol. 3, *The "Curiosities."* Text by Hugh Tait. London, 1986.

London 1995
Trinity Fine Arts Ltd. *An Exhibition of Old Master Drawings and European Works of Art.* London, 1995.

London and Fribourg 1977
The James A. de Rothschild Collection at Waddesdon Manor. *Glass and Stained Glass.* Text by R. F. Charleston and Michael Archer. *Limoges and Other Painted Enamels.* Text by Madeleine Marcheix and R. F. Charleston. London and Fribourg, 1977.

Loomes 1994
Loomes, Brian. *Painted Dial Clocks.* Woodbridge and Suffolk, England, 1994.

Los Angeles 1980
The Hahns Cohn Collection. *Glass 500 B.C. to A.D. 1900. The Hans Cohn Collection.* Text by Axel von Saldern. Los Angeles, 1980.

Los Angeles 1984
Los Angeles County Museum of Art. *The Treasury of San Marco, Venice.* Edited by Davis Buckton, with Christopher Entwistle and Rowena Prior. Los Angeles, 1984.

Los Angeles 1993
Los Angeles County Museum of Art. *The Painted Enamels of Limoges: A Catalogue of the Collection of the Los Angeles County Museum of Art.* Text by Susan L. Caroselli. Los Angeles, 1993.

Los Angeles 1997
The J. Paul Getty Museum. *European Glass in The J. Paul Getty Museum.* Text by Catherine Hess and Timothy Husband. Los Angeles, 1997.

Löwe 1975
Löwe, Regina. *Die Augsburger Goldschmiedewerkstatt des Matthias Walbaum.* Munich, 1975.

Lugano 1987
The Thyssen-Bornemisza Collection. *Medieval Sculpture and Works of Art.* Text by Paul Williamson. Edited by Simon de Pary. London, 1987.

Lugano 1992
The Thyssen-Bornemisza Collection. *The Thyssen-Bornemisza Collection: Renaissance and Later Sculpture with Works of Art in Bronze.* Text by Anthony Radcliffe, Malcolm Baker, and Michael Maek-Gérard. Edited by Irene Martin. Translated in part by E.F.N. Jephcott. London, 1992.

MacGregor 1985
MacGregor, Arthur. *Bone, Antler, Ivory and Horn.* Totowa, New Jersey, 1985.

Madrid 1994
Museo del Prado. *Los Leoni (1509-1608). Escultores del Renacimiento italiano al servicio de la corte de España.* Text by José Miguel Moran Turina et al. Madrid, 1994.

Malvern 1975
Malvern, Marjorie M. *Venus in Sackcloth.* Carbondale, Illinois, 1975.

Manske 1978
Manske, Hans-Joachim. *Der Meister von Osnabrück: Osnabrücker Plastik um 1500.* Osnabrück, Germany, 1978.

Mariacher 1970
Mariacher, Giovanni. *Glass from Antiquity to the Renaissance.* Translation by Michael Cunningham. London, 1970.

Marlier 1954
Marlier, Georges. *Erasme et la peinture flamande de son temps.* Preface by Luis Reis-Santos. Damme, Belgium, 1954.

Marquet De Vasselot 1921
Marquet de Vasselot, Jean-Joseph. *Les Emaux limousins de la fin du XVe siècle.* 2 vols. Paris, 1921.

Maryon 1987
Maryon, Herbert. *Metalwork and Enamelling. A Practical Treatise on Gold and Silversmith's Work and Their Allied Crafts.* New York, 1971.

Masetti Zannini 1972
Masetti Zannini, Gian Ludovico. "Notizie biografiche di Guglielmo della Porta in Documenti Notarili Romani." *Commentari: Rivista di critica e storia dell'arte* 23 (1972), pp. 299-305.

Massinelli 1983
Massinelli, Anna Maria. *Il Mobile Toscano 1200-1800.* Milan, 1983.

Maurice 1976
Maurice, Klaus. *Die deutsche Räderuhr. Zur Kunst und Technik des mechanischen Zeitmessers in deutschen Sprachraum.* 2 vols. Munich, 1976.

Maza 1966
Maza, Francisco de la. *Antinoo el ultimo dios del mundo clásico.* Mexico City, 1966.

McCracken 1974
McCracken, Ursula E.; Randall, Lilian M.C.; and Randall, Richard H., eds. *Gatherings in Honor of Dorothy E. Miner.* The Walters Art Gallery. Baltimore, 1974.

Middeldorf 1977
Middeldorf, Ulrich. "In the Wake of Guglielmo della Porta." *Connoisseur* 194 (February 1977), pp. 75-84.

Mihalik 1961
Mihalik, Sándor. *Old Hungarian Enamels.* Budapest, 1961.

Milan 1981
Museo Poldi-Pezzoli. *Il Museo Poldi-Pezzoli.* Edited by Guido Gregorietti. 2 vols. Milan, 1981.

Milwaukee 1975
Milwaukee Art Museum. *The New Milwaukee Art Center Inaugural Exhibition.* Milwaukee, 1975.

Milwaukee 1986
Milwaukee Art Museum. *Guide to the Permanent Collection.* Edited by Rosalie Goldstein. Milwaukee, 1986.

Milwaukee 1989
Milwaukee Art Museum. *Renaissance into Baroque: Italian Master Drawings by the*

Zuccari, 1550-1600. Text by E. James Mundy. Milwaukee, 1989.

Milwaukee 1991
Milwaukee Art Museum. "The Richard and Erna Flagg Collection." *Milwaukee Art Museum Annual Report,* 1991, pp. 73-75.

Molthein 1905
Molthein, Walcher von. "Deutsches Steinzeug der Renaissance in seiner Imitation und Fälschung." *Antiquitäten-Rundschau.* Vol. 3, pp. 25-27 (1905), 289-91, 301-303, 313-17.

Monroe 1977
Monroe, William H. "Painted Renaissance Enamels from Limoges." *Bulletin of The Art Institute of Chicago* (November-December 1977), pp. 12-14.

Montagu 1966-67
Montagu, Jennifer. "A *Flagellation* Group: Algardi or du Quesnoy." *Bulletin des Musées Royaux d'art et d'histoire* 38-39 (1966-67), pp. 153-92.

Montreal 1993
Montreal Museum of Fine Arts. *Century of Splendour: Seventeenth-Century French Painting in French Public Collections.* Paris, 1993.

Morscheck 1978
Morscheck, Charles R. *Relief Sculpture for the Façade of the Certosa di Pavia, 1473-1499.* New York, 1978.

Moscow 1969
Gosudarstvennyj Ermitazh. *Painted Enamels of Limoges: XV and XVI Centuries: The State Ermitage Collection.* Text by Olimpiada Dmitrievna Dobroklonskaya. Moscow, 1969.

Moscow 1975
Gosudarstvennyj Muzej Moskovskogo Kremlja. *Deutsche Silberkunst des XVI.-XVIII. Jahrhunderts in der Sammlung der Rüstkammer des Moskauer Kreml.* Text by Galina Anatoljewna Markowa. Moscow, 1975.

Müller 1976
Müller, Theodor. *Gotische Skulptur in Tirol.* Bozen, Italy, 1976.

Munich 1958
Schatzkammer der Residenz München. *Schatzkammer der Residenz München.* Text by Hans Thoma. Munich, 1958.

Munich 1959
Bayerischen Nationalmuseums. *Die Bildwerke in Holz, Ton und Stein von der Mitte des XV. bis gegen Mitte des XVI. Jahrhunderts.* Vol. 13, 2. Text by Theodor Müller. Munich, 1959.

Munich 1986
Deutsches Museum von Meisterwerken der Naturwissenshaft und Technik. *Uhren und Automaten.* Text by Peter Friess et al. Munich, 1986.

Munich 1993
Münchener Stadtmuseum. *Die anständige Lust. Von Esskultur und Tafelsitten.* Edited by Ulrike Zischka, Hans Ottomeyer, and Susanne Baumler. Munich, 1993.

Munich 1994
Bayerischen Nationalmuseums. *Silber und Gold: Augsburger Goldschmiedekunst für die Höfe Europas.* 2 vols. Text by Lorenz Seelig. Edited by Reinhold Baumstark and Helmut Seling. Munich, 1994.

New Brunswick 1989
Jane Voorhees Zimmerli Art Museum. Rutgers, State University of New Jersey. *The Carver's Art, Medieval Sculpture in Ivory, Bone and Horn.* Edited by Archer St. Clair and Elizabeth Parker McLachlan. New Brunswick, New Jersey, 1989.

Newman 1977
Newman, Harold. *An Illustrated Dictionary of Glass.* London, 1977.

Newman 1987
Newman, Harold. *An Illustrated Dictionary of Silverware.* London, 1987.

New York 1962
The Metropolitan Museum of Art. *Bronzes, Other Metalwork and Sculpture in the Irwin Untermyer Collection.* Text by Irwin Untermyer with an introduction by Yvonne Hackenbroch. New York, 1962.

New York 1968
The Metropolitan Museum of Art, The Cloisters. *Medieval Art from Private Collections.* Text by Carmen Gómez-Moreno. New York, 1968.

New York 1970
The Frick Collection. *The Frick Collection: An Illustrated Catalogue.* Vol. 3, *Sculpture: Italian.* Text by John Pope-Hennessy and Anthony F. Radcliffe. New York, 1970.

New York 1975
The Metropolitan Museum of Art, The Cloisters. *The Secular Spirit: Life and Art at the End of the Middle Ages.* Foreword by Thomas Hoving and an introduction by Timothy B. Husband and Jane Hayward. New York, 1975.

New York 1977
The Frick Collection. *The Frick Collection: An Illustrated Catalogue.* Vol. 8, *Limoges Painted Enamels.* New York, 1977.

New York 1980
The Metropolitan Museum of Art, The Cloisters. *The Wild Man: Medieval Myth and Symbolism.* Text by Timothy B. Husband and Gloria Gilmore-House. New York, 1980.

New York 1982
The Metropolitan Museum of Art. *Radiance and Reflection: Medieval Art from the Raymond Pitcairn Collection.* Text by Jane Hayward and Walter Cahn. New York, 1982.

New York 1984a
The Metropolitan Museum of Art. *The Jack and Belle Linsky Collection in The Metropolitan Museum of Art.* Text by Clare Vincent et al. New York, 1984.

New York 1984b
The Metropolitan Museum of Art. *The Wildman.* Text by Timothy B. Husband. New York, 1984.

New York 1985
Rosenberg & Stiebel, Inc. *A Bronze Bestiary.* Text by Penelope Hunter-Stiebel. New York, 1985.

New York 1986
The Metropolitan Museum of Art. *Gothic and Renaissance Art in Nuremberg 1300-1550.* Text by William D. Wixom et al. New York, 1986.

New York 1997
Blumka Gallery. *Medieval and Renaissance Sculpture and Works of Art.* New York, 1997.

Nicolas 1857
Nicolas, Harris. *The Historic Peerage of England.* Vol. 1. Revised by William Courthope. London, 1857.

Norfolk 1989
The Chrysler Museum. *A Concise History of Glass Represented in the Chrysler Museum Glass Collection.* Text by Nancy O. Merill. Norfolk, Virginia, 1989.

Northampton 1978
Smith College Museum of Art. *Antiquity in the Renaissance.* Text by Wendy S. Sheard. Northampton, Massachusetts, 1978.

Nuremberg 1989
Germanischen Nationalmuseums. *Anzeiger des Germanischen Nationalmuseums.* Nuremberg, 1989.

Nuremberg and Munich 1985
Germanisches Nationalmuseum. *Wenzel Jamnitzer und die Nürnberger Goldschmiedekunst 1500-1700; Goldschmiedearbeiten- Entwürfe, Modelle, Medaillen, Ornamentstiche, Schmuck, Porträts.* Edited by Gerhard Bott. Nuremberg and Munich, 1985.

Ocean City 1992
Philadelphia College of Art Alumni Association. *Samuel Yellin, Metalworker.* Text by Jack Andrews. Ocean City, New Jersey, 1992.

O'Dell-Franke 1977
O'Dell-Franke, Ilse. *Kupferstiche und Radierungen aus der Werkstatt des Virgil Solis.* Wiesbaden, Germany, 1977.

Odom 1918-19
Odom, William MacDougal. *A History of Italian Furniture from the Fourteenth to Early Nineteenth Centuries.* 2 vols. New York, 1918-19.

Oklahoma City 1985
Oklahoma Museum of Art. *Songs of Glory: Medieval Art from 900-1500.* Organized by David Mickenberg. Oklahoma City, 1985.

Osborne 1985
Osborne, Harold, ed. *The Oxford Companion to the Decorative Arts.* Oxford, 1985.

Ottawa 1972
The National Gallery of Canada. *Fontainebleau: L'Art en France 1528-1610.* Ottawa, 1973.

Pankofer 1973
Pankofer, Heinrich. *Schlüssel und Schloss: Schonheit, Form und Technik im Wandel der Zeiten, aufgezeigt an der Sammlung Heinrich Pankofer, München.* Munich, 1973.

Panofsky 1966
Panofsky, Erwin. *Early Netherlandish Painting: Its Origins and Character.* 2 vols. Revised edition. Cambridge, Massachusetts, 1966.

Paris 1950
Musée du Louvre. *Musée National du Louvre. Description raisonnée des sculptures du Moyen-Age et de la Renaissance.* Vol. 1. Text by Marcel Aubert and Michèle Beaulieu. Paris, 1950.

Paris 1975
Musée Jacquemart-André. *Sculpture italienne.* Text by Françoise de la Moureyre-Gavoty. Paris, 1975.

Paris 1981-82
Le Grand Palais. *Les Fastes du Gothique.* Text by Françoise Baron. Paris, 1981-82.

Pechstein 1978
Pechstein, Klaus. "The 'Welcome' Cup— Renaissance Drinking Vessels by Nuremberg Goldsmiths." Translated by Nicholas Fry. *Connoisseur* 199 (November 1978), pp. 180-87.

Penny 1992
Penny, Nicholas. *Catalogue of European Sculpture in the Ashmolean Museum, 1540 to the Present Day.* Vol. 1, *Italian*; Vol. 2, *French and other European Sculpture* (excluding Italian and British); Vol. 3, *British.* New York, 1992.

Perpeet-Frech 1964
Perpeet-Frech, Lotte. *Die gotischen Monstranzen im Rheinland.* Dusseldorf, 1964.

Philippowich 1961
Philippowich, Eugen von. *Elfenbein. Ein Handbuch für Sammler und Liebhaber.* Brunswick, Germany, 1961.

Philippowich 1966
Philippowich, Eugen von. *Kuriositäten und Antiquitäten.* Würzburg, Germany, 1966.

Phillips 1996
Phillips, Clare. *Jewelry: From Antiquity to the Present.* London, 1996.

Pholien 1899
Pholien, Florent. *La Verrerie et ses artistes au pays de Liège.* Liège, Belgium, 1899.

Pietrograde 1953
Pietrograde, Giacomo. "Francesco Segala." *Bolletino del Museo Civico di Padua* 31-43 (1952/53), pp. 111-12.

Pignatti 1962
Pignatti, Terisio. *Mobili italiani del Rinascimento.* Milan, 1962.

Planiscig 1921
Planiscig, Leo. *Die Venezianische Bildhauer der Renaissance.* Vienna, 1921.

Pope 1939
Pope, Arthur Upham, ed. *A Survey of Persian Art: From Prehistoric Times to the Present.* Vol. 3, *The Art of the Book, Textiles, Carpets, Metalwork, Minor Arts.* London and New York, 1939.

Pope-Hennessy 1980
Pope-Hennessy, John. *The Study and Criticism of Italian Sculpture.* New York, 1980.

Pope-Hennessy 1985a
Pope-Hennessy, John. *Cellini.* New York, 1985.

Pope-Hennessy 1985b
Pope-Hennessy, John. *An Introduction to Italian Sculpture.* Pt. 1, *Italian Gothic Sculpture*; Pt. 2, *Italian Renaissance Sculpture*; Pt. 3, *Italian High Renaissance and Baroque Sculpture.* New York, 1985.

Prague 1993
National Museum of Prague. *Italské renesancní bronzy.* Text by Jan Chlíbec. Prague, 1993.

Prague 1997
Museum of Decorative Arts, Prague Castle Administration. *Rudolf II and Prague. The Court and the City.* Edited by Eliska Fucikova et al. Prague, 1997.

Rackham 1935
Rackham, Bernard. *Catalogue of the Glaischer Collection of Pottery and Porcelain in the Fitzwilliam Museum.* 2 vols. Cambridge, Massachusetts, 1935.

Randall 1993
Randall, Richard H., Jr. *The Golden Age of Ivory: Gothic Carvings in North American Collections.* New York, 1993.

Réau 1955-59
Réau, Louis. *Iconographie de l'art chrétien.* 3 vols. Paris, 1955-59.

Riccardi-Cubitt 1992
Riccardi-Cubitt, Monique. *The Art of the Cabinet.* London, 1992.

Richter 1982
Richter, Ernst-Ludwig. *Silber: Imitation–Kopie Fälschung–Verfälschung.* Munich 1982.

Richter and Kommer 1979
Richter, Ernst-Ludwig and Kommer, Björn R. "Der Spätmittelalterliche Hofbecher und Seine Nordischen Epigonen. Kritische Bemerkungen zu einer Gruppe von Silberbechern mit Lübecker und Bremer Beschauzeichen." *Jahrbuch der Hamburger Kunstsammlungen* 24 (1979), pp. 63-76.

Ripa 1758-60
Ripa, Cesare. *Baroque and Rococo Pictorial Imagery. The 1758-60 Hertel Edition of Ripa's* Iconologia. Introduction and translations by Edward A. Maser. New York, 1971.

Rome 1981
Instituto Nazionale per la Grafica-Calcografia. *Incisori Mantovani del 500.* Text by Stefania Massari. Rome, 1981.

Roosval 1933
Roosval, Johnny. "Retables d'origine neérlandaise dans les pays nordiques." *Revue Belge* 3 (1933), p. 154.

Rosenberg 1922-28
Rosenberg, Marc. *Der Goldschmiede Merkzeichen.* 4 vols. Frankfurt, 1922-28.

Rosenblum and Janson 1984
Rosenblum, Robert and Janson, H. W. *Nineteenth-Century Art.* New York, 1984.

Rouen 1924
Musée Le Secq des Tournelles. *Ferronnerie ancienne.* 2 vols. Edited by Henri René d'Allemagne. Paris and Rouen, 1924.

Rouen 1968
Musée Le Secq des Tournelles. *Decorative Antique Ironwork: A Pictorial Treasure.* Text by Henri René d'Allemagne. Introduction, bibliography, and translation of captions by Vera K. Ostoia. New York, 1924.

Saint Louis 1953
Saint Louis Art Museum. *Handbook of the Collections.* Saint Louis, 1953.

Salomon 1969
Salomon, Bernard. *Bernard Salomon, Peintre et tailleur d'histoires: Illustrations pour l'Ancien Testament.* Geneva, 1969.

San Francisco 1990-91
Fine Arts Museums of San Francisco. *Great Dutch Paintings from America.* Text by Ben P. J. Broos et al. San Francisco, 1990-91.

Sanz 1979
Sanz, Maria Jesus. "Vasos renacentistos de cristol de roca en el Museo Lázaro Galdiano." *Goya revista de arte* 152 (September-October 1979), pp. 66-77.

Scheffler 1967
Scheffler, Gisela. *Hans Klocker.* Innsbruck, 1967.

Schenk 1970
Schenk, Adolf. *Die Uhrmacher von Winterthur und ihre Werke.* Winterthur, Switzerland, 1970.

Schiffer 1978
Schiffer, Peter; Schiffer, Nancy; and Schiffer, Herbert. *The Brass Book: American, English and European Fifteenth Century through 1850.* Exton, Pennsylvania, 1978.

Schiller 1971
Schiller, Gertrude. *Iconography of Christian Art.* London, 1971.

Schottmuller 1921
Schottmuller, F. *Furniture and Interior Decoration of the Italian Renaissance.* New York, 1921.

Schroder 1983
Schroder, Timothy B. *The Art of the European Goldsmith: Silver from the Schroder Collection.* New York, 1983.

Schroder 1988
Schroder, Timothy B. *Recent Acquisitions: The Gilbert Collection of Gold and Silver, The Los Angeles County Museum of Art.* Los Angeles, 1988.

Schultze 1986
Schultze, S. *Die Bronzen der Fürstlichen Sammlung Liechtenstein.* Frankfurt, 1986.

Seeling 1989
Seeling, Lorenz. *Modell und Ausführung in der Metallkunst.* Munich, 1989.

Seling 1980, 1994
Seling, Helmut. *Die Kunst der Augsburger Goldschmiede 1529-1868, Meister, Marken, Werke.* 4 vols. Munich, 1980, 1994.

Seymour 1966
Seymour, Charles, Jr. *Sculpture in Italy 1400-1500.* Baltimore, 1966.

Simone 1969
Simone, France. *The French Renaissance.* London, 1969.

Smith 1994
Smith, Jeffrey Chipps. *German Sculpture of the Later Renaissance c. 1520-1580: Art in the Age of Uncertainty.* Princeton, New Jersey, 1994.

Souchal 1977
Souchal, François. *French Sculptors of the 17th and 18th centuries.* Translated by Elsie Hill and George Hill. Oxford, 1977.

Speel 1998
Speel, Erika. *Dictionary of Enamelling.* Hants, England, 1998.

Spitzer 1890-92
Spitzer, Frédéric. *La Collection Spitzer: Antiquité, Moyen-Âge, Renaissance.* 6 vols. Paris, 1890-92.

Spitzer 1893
Spitzer, Frédéric. *Catalogue des objets d'art et de haute curiosité antiques, du moyen- âge et de la renaissance composant l'importante et précieuse Collection Spitzer.* 2 vols. Essays by Edmond Bonnaffé and Emile Molinier. Chevalier and Mannheim, Paris, April 17-June 16, 1893.

Steyaert 1994
Steyaert, John William. *Late Gothic Sculpture: The Burgundian Netherlands.* Ghent, 1994.

Stimson 1988
Stimson, Alan. *The Mariner's Astrolabe: A Survey of Known, Surviving Astrolabes.* Utrecht, 1988.

Stocker 1998
Stocker, Margarita. *Judith: Sexual Warrior. Women and Power in Western Culture.* New Haven, Connecticut, 1998.

Stockholm 1992
Nationalmuseum. *European Bronzes, 1450-1700.* Text by Lars Olof Larsson. Stockholm, 1992.

Stoddard 1972
Stoddard, Whitney S. *Art and Architecture in Medieval France. Medieval Architecture, Sculpture, Stained Glass, Maunscripts, the Art of the Church Treasuries.* New York, 1972.

Stuttgart 1987
Württembergisches Landsmuseum. *European Glass from 1500-1800: The Ernesto Wolf Collection: Württembergisches Landsmuseum, Stuttgart.* Text by Brigitte Klesse and Hans Mayr. Vienna, 1987.

Swarzenski 1953
Swarzenski, Hans. *Monuments of Romanesque Art. The Art of Church Treasures in North-Western Europe.* Chicago, 1953.

Tait 1981
Tait, Hugh. *The Waddesdon Bequest: The Legacy of Baron Ferdinand Rothschild to the British Museum.* London, 1981.

Tait 1983
Tait, Hugh. *Clocks and Watches.* London, 1983.

Tardy 1977
Tardy (Henri Lengelle). *Les Poinçons de garantie internationaux pour l'argent.* Paris, 1977.

Taylor 1929
Taylor, Francis Henry. "The Study Collections of Wood Carving." *The Pennsylvania Museum Bulletin* 24, 127 (April 1929), pp. 7-15.

Tervarent 1930
Tervarent, Guy de. *La Légende de Sainte Ursule dans la littérature et l'art du Moyen-Age.* 2 vols. Paris, 1930.

Thewalt 1903
Thewalt, Karl. *Katalog der Reichhaltigen, nachgelassenen Kunst-Sammlung des Herrn Karl Thewalt in Köln.* Introduction by Otto von Falke. Lempertz' Buchhandlung & Antiquariat, Cologne, November 4-14, 1903.

Thieme-Becker 1907-1950
Thieme, Ulrich and Becker, Felix. *Allgemeines Lexikon der bildenden Künstler von der Antike bis zur Gegenwart.* 37 vols. Leipzig, 1907-1950.

Thoby 1953
Thoby, Paul. *Les Croix limousines de la fin du XII siècle au début du XIV siècle.* Paris, 1953.

Tinti 1929
Tinti, Mario. *Il mobilio fiorentino.* Milan and Rome, 1929.

Tolnay 1969
Tolnay, Charles de. *Michelangelo.* Vol. 1. Princeton, New Jersey, 1969.

Toronto 1982
Art Gallery of Ontario. *The Arts of Italy in Toronto Collections 1300-1800.* Text by David Mactavish et al. Toronto, 1982.

Truman 1979
Truman, Charles. "Reinhold Vasters, the Last of the Goldsmiths." *Connoisseur* 200 (1979), pp. 154-61.

Turner 1982
Turner, E. *An Introduction to Brass.* London, 1982.

Turner 1987
Turner, A. *Early Scientific Instruments: Europe 1400-1800.* London, 1987.

Turner 1996
Turner, Jane, ed. *The Dictionary of Art.* 34 vols. New York, 1996.

Unger 1990
Unger, Ingeborg. "Zur Wiederbelebung des Siegburger Renaissance Steinzeugs in der 1. Hälfte des 19. Jahrhunderts durch den Seigburg er Töpfer Peter Lövenich." *Heimatblätter des Siegkrieses* 58 (1990), pp. 7-93.

Urech 1972
Urech, Edouard. *Dictionnaire des symboles chrétiens.* Neuchâtel, Switzerland, 1972.

Venice 1997
Galleria Acquaria. *Dragons, Serpents and Sea Monsters in 19th Century Murano Glass.* Edited by Rosella Junck and Claudio Gianolla. Venice, 1997.

Venturi 1937
Venturi, Adolfo. *Storia dell'arte Italiana.* Vol. 10, pt. 3, *La Scultura del Cinquecento.* Milan, 1937.

Vienna 1910
Kunsthistorisches Museum. *Werke der Kleinplastik in der Skulpturensammlung des A.H. Kaiserhauses.* 2 vols. Text by Julius Ritter von Saldern. Vienna, 1910.

Vienna 1924
Kunsthistorisches Museum. *Die Bronzeplastiken: Statuetten, Reliefs, Geräte und Plaquetten.* Text by Leo Planiscig. Vienna, 1924.

Vienna 1932
Kunsthistorisches Museum. *Goldschmiedearbeiten des Mittelalters, der Renaissance und des Barock: Arbeiten in Gold und Silber.* Vol. 1. Text by Ernst Kris. Vienna, 1931.

Vincent 1964
Vincent, Clare. "Precious Objects in Iron." *Metropolitan Museum of Art Bulletin* 22 (April 1964), pp. 272-86.

Vloberg 1956
Vloberg, M. *La Vierge et l'Enfant dans l'art français.* Paris, 1956.

Voet 1966
Voet, Elias, Jr. *Nederlandse goud-en zilvermerken.* The Hague, 1966.

von Saldern 1995
von Saldern, Axel. *Glas: Antike bis Jugendstil: Die Sammlung im Museum für Kunst und Gewerbe Hamburg.* Stuttgart, 1995.

Walcher von Moltheir 1927
Walcher von Moltheir, A. "Geschlagene Messingbecken." *Altes Kunsthandwerk.* Vol. 1. Vienna, 1927.

Ward-Jackson 1967
Ward-Jackson, Peter. "Some Main Streams and Tributaries in European Ornament from 1500-1750." *Victoria and Albert Bulletin*, pt. 1, 3 (May 1967), pp. 58-71; pt. 2, 3 (July 1967), pp. 90-103; pt. 3, 3 (October 1967), pp. 121-34.

Washington 1980
Smithsonian Institution. *The Clockwork Universe: German Clocks and Automata 1550-1650.* Text by Klaus Maurice and Otto Mayr. Washington, D.C., 1980.

Washington 1986
Smithsonian Institution. *Renaissance Master Bronzes from the Collection of the Kunsthistorisches Museum, Vienna.* Text by Manfred Leithe-Jasper and Douglas Lewis. Washington, D.C., 1986.

Washington 1991
National Gallery of Art. *Circa 1492: Art in the Age of Exploration.* Edited by Jay A. Levenson. New Haven and Washington, D.C., 1991.

Washington 1998
National Gallery of Art. *A Collector's Corner.* Text by Arthur K. Wheelock. Washington, D.C., 1998.

Watsdorf 1962
Watsdorf, Erna von. *Johann Melchior Dinglinger der Goldschmeid des deutschen Barock.* 2 vols. Berlin, 1962.

Weber 1969-70
Weber, Ingrid Szeilklies. "Bildvorlagen fur Silberreliefs an Arbeiten von Paul Hubner und Kornelius Erb, Heute im Palazzo Pitti und im Britischen Museum. Eine Studie zur Arbeitsweise in nachmittelalterlichen Goldschmiedewerkstatten." *Mitteilungen des Kunsthistorischen Institutes in Florenz.* Vol. 14 (1969-70), pp. 323-68.

Weber 1975
Weber, Ingrid Szeilklies. *Deutsche, Niederländische und Französische Renaissanceplaketten 1500-1650: Modelle für Reliefs an Kult-, Prunk-, und Gebrauchsgegenständen.* 2 vols. Munich, 1975.

Weihrauch 1967
Weihrauch, Hans R. *Europäische Bronzestatuetten 15.-18. Jahrhundert.* Brunswick, Germany, 1967.

Weiss 1897
Weiss, August. *Das Handwerk der Goldschmiede in Augsburg bis zum Jahre 1681.* Vol. 24, *Beiträge zur Kunstgeschichte.* Leipzig, 1897.

White 1960
White, T. H. *The Bestiary: A Book of Beasts.* New York, 1960.

Wilm 1923
Wilm, Hubert. *Die Gotische Holzfigur.* Leipzig, 1923.

Winkler 1942
Winkler, Friedrich. *Die Zeichnungen des Hans Süss von Kulmbach und Hans Leonhard Schäufeleins (Denkmäler deutscher Kunst).* Berlin, 1942.

Winston-Salem 1963
Gallery of the Public Library of Winston-Salem and Forsyth County. *Collectors' Opportunity.* Text by Senta Dietzel Bier. Winston-Salem, North Carolina, 1963.

Wisner 1984
Wisner, Henryk. *Zygmunt III Waza.* Warsaw, 1984.

Wittkower 1982
Wittkower, Rudolf. *Art and Architecture in Italy 1600-1750.* New Haven, Connecticut, 1982.

Worcester 1969
Worcester Art Museum. *The Virtuoso Craftsman: Northern and European Design in the Sixteenth Century.* Text by John David Farmer. Worcester, Massachusetts, 1969.

Wyler 1937
Wyler, Seymour B. *The Book of Old Silver: English, American, Foreign.* New York, 1937.

Zerner 1969
Zerner, Henri. *Ecole de Fontainebleau: Etchings and Engravings.* Translated by Stanley Baron. New York and London, 1969.

Zschelletzschky 1975
Zschelletzschky, Herbert. *Die "Drei Gottlosen Maler" von Nürnberg: Sebald Beham, Barthel Beham und Georg Pencz. Historischen Grundlagen und ikonologische Probleme ihrer Graphik zu Reformation und Bauernkriegzeit.* Leipzig, 1975.

INDEX

Museums and Churches

Private Collectors and Dealers

Regional Provenance

Religious Objects and Themes

Secular Objects and Themes

PHOTOGRAPH CREDITS

All of the original photographs
reproduced in this book were taken by
John Nienhuis, Milwaukee, with the
exception of the following: The Corning
Museum of Glass, New York: Collection
of the Juliette K. and Leonard S. Rakow
Research Library. *Katalog der
Reichhaltigen, nachgelassenen Kunst-
Sammlung des Herrn Karl Thewalt in Köln.*
Cologne, 1903. Plate 7 from Lempertz'
Auction Catalogue. See entry 27, p. 76;
P. Richard Eells, Milwaukee, entries: 13
(p. 50), 41, 43, 75; Efraim Lev-er,
Milwaukee: entry 10; Larry Sanders,
Milwaukee: entries 2, 7, 11, 12, 24, 30-
32, 38, 42, 53, 60, 61; Gene Schuttey for
Aida Studios, Sheboygan, Wisconsin,
p. 18.